W9-CPO-509

ICONS OF AMERICAN ARCHITECTURE

Recent Titles in
Greenwood Icons

Icons of Horror and the Supernatural: An Encyclopedia of Our Worst Nightmares
Edited by S.T. Joshi

Icons of Business: An Encyclopedia of Mavericks, Movers, and Shakers
Edited by Kateri Drexler

Icons of Hip Hop: An Encyclopedia of the Movement, Music, and Culture
Edited by Mickey Hess

Icons of Evolution: An Encyclopedia of People, Evidence, and Controversies
Edited by Brian Regal

Icons of Rock: An Encyclopedia of the Legends Who Changed Music Forever
Scott Schinder and Andy Schwartz

Icons of R&B and Soul: An Encyclopedia of the Artists Who Revolutionized Rhythm
Bob Gulla

African American Icons of Sport: Triumph, Courage, and Excellence
Matthew C. Whitaker

Icons of the American West: From Cowgirls to Silicon Valley
Edited by Gordon Morris Bakken

Icons of Latino America: Latino Contributions to American Culture
Roger Bruns

Icons of Crime Fighting: Relentless Pursuers of Justice
Edited by Jeffrey Bumgarner

Icons of Unbelief: Atheists, Agnostics, and Secularists
Edited by S.T. Joshi

Women Icons of Popular Music: The Rebels, Rockers, and Renegades
Carrie Havranek

Icons of Talk: The Media Mouths That Changed America
Donna L. Halper

ICONS OF AMERICAN ARCHITECTURE

From the Alamo to the World Trade Center

Volume One

Donald Langmead

Greenwood Icons

GREENWOOD PRESS
Westport, Connecticut · London

Library of Congress Cataloging-in-Publication Data

Langmead, Donald.
 Icons of American architecture : from the Alamo to the World Trade Center / Donald
Langmead.
 v. cm. — (Greenwood icons)
 Includes bibliographical references and index.
 ISBN 978-0-313-34207-3 (set : alk. paper) — ISBN 978-0-313-34209-7
(vol. 1 : alk. paper) — ISBN 978-0-313-34211-0 (vol. 2 : alk. paper)
 1. Architecture—United States. 2. Architecture and society—United States. I. Title.
 NA705.L35 2009
 720.973—dc22 2008040909

British Library Cataloguing in Publication Data is available.

Library of Congress Catalog Card Number: 2008040909
ISBN: 978-0-313-34207-3 (set)
 978-0-313-34209-7 (vol. 1)
 978-0-313-34211-0 (vol. 2)

First published in 2009

Greenwood Press, 88 Post Road West, Westport, CT 06881
An imprint of Greenwood Publishing Group, Inc.
www.greenwood.com

Printed in the United States of America

The paper used in this book complies with the
Permanent Paper Standard issued by the National
Information Standards Organization (Z39.48-1984).

10 9 8 7 6 5 4 3 2 1

This book is dedicated to Robert Scarborough, a true professional

Contents

Volume Two

List of Photos

Series Foreword

Worshipped and cursed. Loved and loathed. Obsessed about the world over. What does it take to become an icon? Regardless of subject, culture, or era, the requisite qualifications are the same: (1) challenge the status quo, (2) influence millions, and (3) affect history.

Using these criteria, Greenwood Press introduces a new reference format and approach to popular culture. Spanning a wide range of subjects, volumes in the Greenwood Icons series provide students and general readers a port of entry into the most fascinating and influential topics of the day. Every title offers an in-depth look at twenty-four iconic figures, each of which captures the essence of a broad subject. These icons typically embody a group of values, elicit strong reactions, reflect the essence of a particular time and place, and link different traditions and periods. Among those featured are artists and activists, superheroes and spies, inventors and athletes, the legends and mythmakers of entire generations. Yet icons can also come from unexpected places: as the heroine who transcends the pages of a novel or as the revolutionary idea that shatters our previously held beliefs. Whether people, places, or things, such icons serve as a bridge between the past and the present, the canonical and the contemporary. By focusing on icons central to popular culture, this series encourages students to appreciate cultural diversity and critically analyze issues of enduring significance.

Most important, these books are as entertaining as they are provocative. Is Disneyland a more influential icon of the American West than Las Vegas? How do ghosts and ghouls reflect our collective psyche? Is Barry Bonds an inspiring or deplorable icon of baseball?

Designed to foster debate, the series serves as a unique resource that is ideal for paper writing or report purposes. Insightful, in-depth entries provide far more information than conventional reference articles but are less intimidating and more accessible than a book-length biography. The most revered and reviled icons of American and world history are brought to life with related

sidebars, timelines, fact boxes, and quotations. Authoritative entries are accompanied by bibliographies, making these titles an ideal starting point for further research. Spanning a wide range of popular topics, including business, literature, civil rights, politics, music, and more, books in the series provide fresh insights for the student and popular reader into the power and influence of icons, a topic of as vital interest today as in any previous era.

Preface and Acknowledgments

ON THE MEANING OF ICONS

The state of South Australia, where I have always lived, is 1½ times the area of Texas. It was settled by Europeans in 1836 and its population, most of which is concentrated in the capital, Adelaide, is now just over 1.5 million. In 2001, perhaps to establish consequence in that sparse newness, the National Trust (sponsored by a parochial bank), began to compile the BankSA Heritage Icons List, to "record, recognise and protect items that have made a significant contribution to the State's cultural identity." The initial list of "icons" included the "Balfour's frog cake"—as its name might suggest, the confection made by a local bakery is a frog-shaped cupcake covered with sticky pale green frosting and filled with apricot jelly and pink artificial cream. But an *icon*? Really?

The list now has been augmented by another fifty or so "contributors to the State's cultural identity"—too many to enumerate, but one bears special mention, if only to emphasize the point: the "pie floater" became an icon in 2003. Claimed to be uniquely South Australian, and boasting a 130-year history this evening delicacy is consumed at curbside "piecarts" and comprises a minced meat pie floating in a bowl of viscous green pea soup; it is garnished with tomato ketchup (for the pie) and vinegar (for the soup). But an *icon*?

At the beginning of the twenty-first century *iconic* has become one of the most overemployed, overrated, and misused words in the English language. A mid-2008 search for it on Google yielded 16.1 million hits. There is an international epidemic of iconitis. David Marsh, the editor charged with ensuring the use of good English in Britain's *Guardian*, observed in August 2007 that in the preceding year the newspaper had used the adjective *iconic*

493 times, and the nouns *icon* or *icons* 670 times, in relation to such diverse things as the Countdown TV theme; a Rossini opera; hawks; wolves; the Los Angeles stormwater system; and "the cut above the eye David Beckham sustained after being hit by a flying boot." He also noted that hairdressers, celebrities, managers, and management consultants had "iconic" jobs. The word has been devalued to become a modish way of saying "famous," "memorable" or in fact anything other than mundane. The real idea of iconic is very different.

In its original use, *icon*, derived from the Greek word for an image, described the religious pictures characteristic of Eastern Orthodox Christianity. Orthodox iconography allowed no room for virtuosity or artistic creativity but insisted (as it still does) upon conformity to standards prescribed by Church tradition. That is because it was directed toward a higher purpose and the communication of higher ideas. So everything within the image—colors, facial appearances, poses—had an explicit and consistent symbolic aspect that made its meaning instantly recognizable within its cultural context. No icon existed for its own sake, that is, merely as a work of art; it always pointed to something else of greater significance. In Russia, icons were described, not as being "painted," but as being "written." No words (except, occasionally, for traditional calligraphic titles and abbreviations) were needed to convey the meaning. That symbolic meaning was already established and reinforced in the minds and hearts of those who saw it.

Symbols, by definition, speak for themselves. Isn't that what *makes* them symbols? In Alice Springs in Central Australia there is a church built as a memorial to a twentieth-century pioneer, Dr. John Flynn, the founder of the Flying Doctor Service. According to the Northern Territory's Department of Natural Resources Environment and the Arts, the building is "rich in symbolism," reflecting Flynn's life and achievements. Yet soon after the building was completed its architect found it necessary to publish a sixteen-page pamphlet *explaining* the symbolism. Why? Should not icons have evident meanings?

The icons of Eastern Orthodoxy have been able to hold their meaning because of orthodoxy across ethnicity, language, and generations. When such boundaries are crossed or even blurred, meanings change. In our world—the global village—universality of meaning has become impossible to maintain. For example, to the Westerner the color *red* is an icon of danger, whereas to the Chinese it is an icon of good luck; to the modern nation of Israel, the Star of David is an icon of national pride; to millions of Jews in Hitler's Germany it was an icon of death. The meanings of icons change; they become different things to different people, metamorphosed by experiences and generational change. In America, that often has proven true in responses to the iconic meaning of architecture. The true icons of American architecture are not necessarily buildings that would be chosen by architects as the "best" or even those chosen by other people under the cajoling of architects.

WHAT IS AN ICON OF ARCHITECTURE? OR AN ARCHITECTURAL ICON? OR . . .

After discussion with the editors at Greenwood and much reflection, the twenty-four structures presented here as icons of American architecture were selected not because they are necessarily great (or even good) architecture, but solely because they point to unique aspects of American culture—for the most part, but not always, lofty values—beyond themselves. That is, they are icons of America first, and pieces of architecture second. In many cases, their sheer size has fixed them in the public consciousness. The final choice of just twenty-four was difficult; of course, not everyone will agree with the selection. But then, I am an architect and a foreigner to boot; it's uncertain which makes me more alien.

An architect's approach to buildings is different from that of other people. In his *An Outline of European Architecture* published in 1942 the erstwhile high priest of British architectural historians, Sir Nicholas Pevsner, pronounced that "a bicycle shed is a building; Lincoln Cathedral is architecture" and asserted that the term *architecture* applies only to buildings "designed with a view to aesthetic appeal." There was a degree of arrogance in that. And it simplistically begs the question: "What happens when a building like a stable is embellished with a distinctive color scheme or pattern (merely painted on) or a horseshoe is nailed to the door?" Does it then become architecture? After all, an aesthetic choice has been made.

Happily, since Pevsner made his black-and-white categorization there has been much more careful thought about the nature of architecture. Critics and historians now see shades of gray. Two early seminal books were Amos Rapoport's *House Form and Culture*, of 1969 and Bruce Allsopp's *A Modern Theory of Architecture*, of 1977. Each differentiates, with various intermediate nuances, between folk or vernacular architecture—the home-grown product, as it were, of "nonarchitects"—and high-style or composed architecture, made by professionals and adhering to a formal aesthetic. This is not the place to expand further on the differences; suffice it to say that as general rule the former is architecture that is *loved*, because it signifies the heart values of it builders; the latter is architecture that is *admired*.

Architects tend to be attracted to the kind of architecture that is admired. That predilection was confirmed by a poll conducted by the American Institute of Architects (AIA) in 2007. The Institute engaged the Rochester, NY-based market research company, Harris Interactive, to identify "America's favorite works of architecture." The devil was in the manipulative detail of the methodology. For about a month in late 2006 a random sample of about twenty-five hundred AIA members—that is, architects—were interviewed online and asked to name up to twenty of *their* favorite buildings in fifteen preselected categories. That yielded 247 buildings that were then selectively presented to just over eighteen-hundred people in a public survey that took only a week;

each participant was asked to evaluate photographs of seventy-eight structures chosen from the full architect-compiled list. Standard statistical analysis then was applied to calculate "America's Favorite Architecture." One is reminded of the remark attributed to Henry Ford about his Model-T: "Any customer can have a car painted any color that he wants so long as it is black."

Sadly, none of the buildings in this book can be classed as vernacular architecture. That was an editorial decision. It was not my choice to exclude iconic indigenous structures like Mesa Verde Cliff Palace in Colorado, the Cahokia mounds in Illinois, or such architectural types as the tipis of the Plains Nations, the hogans of the Navajo, the Inuit igloos, or (after European settlement) the log cabins, covered wooden bridges, and red barns of rural America.

Apart from that, the parameters of choice were established largely by the seven defining properties of icons set down by Dennis Hall and Susan Grove Hall in *American Icons: An Encyclopedia of the People, Places, and Things that Have Shaped Our Culture* (Greenwood, 2006); the reader is referred to their fascinating work. To repeat the Halls' hypothesis would be of little point; of course, not every one of the twenty-four structures dealt with in the following pages possesses *all* the properties of an icon. An attempt has been made to identify the respective claim of each to American "icon-ness." Although all twenty-four structures have an architectural element, there may be some debate over whether some—for example, the Statue of Liberty, Hoover Dam, or Brooklyn Bridge—are strictly *architecture.*

It would be remiss to ignore the emerging idea of what has been dubbed— albeit inaccurately and undeservedly—"iconic architecture"—another misused expression in architectural discourse. In December 2004, reviewing the year's architectural "achievements" in Britain's *Telegraph* newspaper, the late Giles Worsley accused, "Architects around the world have been creating flashy 'look-at-me' buildings in an attempt to make their mark." He asked, "Do we want icons? Or rather, do we want [so-called] iconic architecture, big blowsy buildings that grab you by the throat and say 'look at me'? Buildings with curves, jagged edges, blobs, bulges, flashy materials and bright colours? Buildings that create an instant, unforgettable image for a city or an institution?"

Such buildings are not icons. To reiterate, true icons point, not to themselves, but to ideas beyond and bigger than themselves.

ACKNOWLEDGMENTS

My deepest thanks are due to Coby, my wife of 46 years, who (as always) has patiently borne with my preoccupation, tolerated continual interruptions to her own routine to act as a sounding board, and done much, much more. Over the many months taken to prepare the manuscript, she has supported and encouraged me, and nursed me through periods of failing health—in short, done all that she could.

I also sincerely thank the editorial staff at Greenwood, especially Debra Adams, who recalled my earlier importunate emails about a quite different book and had the courage to ask a foreigner to write about American architecture. She was approachable, encouraging, and helpful, answering my awkward questions, allaying my apprehensions, and offering sound advice. Special thanks, too, to Elizabeth Kincaid, who provided a true smorgasbord of images from which I made my sometimes eccentric choices of illustrations for the book; in that, she reprised a role that she played so well once before. I am grateful to Kim Hoag for such careful editing of the manuscript.

The University of South Australia, at which I now hold an Adjunct Professorship, continues to provide valuable logistical support, which is gratefully acknowledged.

Donald Langmead
Paradise, South Australia
August 2008

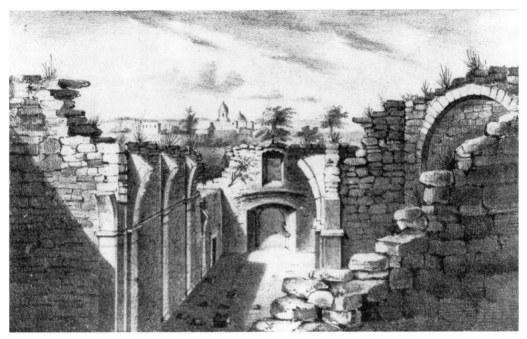

The Alamo, San Antonio, Texas

"Remember the Alamo!"

In any contest between myth and history, myth mostly wins. Setting aside the conscious (or unconscious) biases of the historian, interpreting evidence to decide what *probably* happened in the past may reveal the truth, but often it does not stir the soul. Myth, on the other hand, can be turned on the lathe of what we wish was so; the action may be our own, fashioning what will comfort us, or others', creating what will control us. "Remember the Alamo!" is an enduring battle cry, used first by the Texans at the Battle of San Jacinto on April 21, 1836. People now more often remember what has become fixed in American—and especially Texan—*mythos* about the Alamo. Kevin R. Young, president of the Alamo Battlefield Association, wrote in 1999 that there are *two* Alamos: that of the historical event and that of popular culture. Pointing out that "the significance of the historical event is often overshadowed by the popular culture event," he continued,

> The historical Alamo is a dramatic example of time and place. In a short span of time, several key personalities came together . . . to interact in what we remember as the Alamo siege and battle. . . . The dramatic forces of a small band of colonists, some native Texans and American volunteers fighting for what they considered their "higher rights" against an nationalized Army attempting to quell a revolt and protect their nation, with a largely neutral local population caught in the middle, is compelling enough. But then add the strong personalities of [the] opposing commanders and the siege of the Alamo takes on its own importance.[1]

He further observed, "In many ways the significance of the Alamo [as an event] is not what happened there historically but how the passing and future generations tend to remember it."

WHAT *IS* THE ALAMO?

Historian Stephen L. Hardin explains that there are difficulties in identifying the exact site of the Battle of the Alamo because of "semantic ambiguity" in descriptions of the site; some accounts use "Alamo" for only the church building, and others for the whole mission compound. He wryly comments early historians "were forced to rely on oral tradition and outright speculation," giving rise to misconceptions now fixed in the popular image of the Alamo. Certainly for most people in Texas, America, and beyond the name conjures the west façade of the church. And the site has changed much since 1836. After the battle the church was little more than rubble. Following years of debate over annexation by the United States, Texas became the twenty-eighth state at the very end of 1845. In the 1850s the U.S. government roofed the Alamo church, which it had leased in 1848 for use as an army commissary and storage depot. The now well known gable was added to the distinctive but unfinished west façade—little more was recognizable as architecture.

The Catholic Church sold the building to the State of Texas, with the remainder of the Alamo property except the conventual building, in 1883.

In 1847 the U.S. Quartermaster Department repaired the dilapidated convent (aka the Long Barrack) for army use; when the military relocated, businessman Honoré Grenet bought it from the Catholic Church in 1877 and, adding a wooden second story, converted it to a general store. He died in 1886, and his heirs sold it, and it passed through several hands until a potential buyer proposed to demolish it to make way for a hotel. But in 1903 Texan Clara Driscoll "put up the thousands of dollars necessary to prevent the sale." Two years later the Texas Legislature appropriated $65,000 for the purchase of the convent property and placed it, together with the Alamo church, in the "custody and care" of the De Zavala Chapter of the Daughters of the Republic of Texas (DRT). In 1913 the post-1836 accretions were removed, leaving only the convent walls standing. As part of general renovations, they were repaired and the building roofed in 1968. The Alamo is now a state historic site under the stewardship of the DRT. With some surrounding lands, the other San Antonio River missions constitute San Antonio Missions National Historical Park; their churches are still places of worship.

So the Alamo was already a ruin—repaired, rebuilt, and redefined, but a ruin for all that—long before it became an icon of American architecture. So intense is the emotional quality of the place, whether spontaneous or induced, that there is a sense in which the architecture is irrelevant. The buildings, especially the church, are merely the focus of powerful ideas that continue to be fed by myth and history. San Antonio is America's seventeenth most popular tourist destination, with twenty million visitors a year; the city's Convention and Visitors Bureau boasts that the church at the Alamo is "one of the most photographed facades in the nation." An official Texas tourism report of January 2008 named the Alamo as one of the two "top spots" for out-of-state visitors and Texans alike.

THE MAKING OF AN ICON

Young, questioning how "a Mexican civil war turned into a war of independence. . . . on the frontier borderlands, lasting less than six months [could become] such a pivotal event in the nineteenth-century development of the United States and Mexico," remarked, "What also stands out [is] that one battle . . . actually dominates the period." He suggested that the Alamo became "part of the creation myth story of Texas" because though after their defeat in the Civil War many Southern States "fell back on their heroes of the Revolutionary War, Texas fell back on its own revolutionary experience." That, he concluded, was the moment when the Alamo of history merged with the Alamo of popular culture. As Stephanie Matyszczyk cautions:

History teaches us that when we look to the past, we must look at it from all possible points of view in order to understand the entire story that [it] is trying to tell. Most accounts of the Alamo tell the story from the Texan point of view and more often than not, the Mexican side . . . is barely touched upon. . . . It is the mythologization of the Battle of the Alamo which has greatly contributed to what the Alamo has come to symbolize for many people today. The Battle of the Alamo has come to symbolize American freedom and liberty and "Remember the Alamo" has become not only a national slogan, but a pop culture phenomenon. The problem with this is that when the time comes to remember the Alamo, what people remember is incorrect.[2]

As noted, in 1905 the Texas State Legislature, under a bill titled Providing for the Purchase, Care, and Preservation of the Alamo, formally charged the DRT with the responsibility of maintaining the site "in good order and repair, without charge to the State, as a sacred memorial to the heroes who immolated themselves upon that hallowed ground." But the Alamo had caught the popular imagination, at least in Texas, much earlier.

King Solomon's observation, "there is no end to the writing of books," resonates when confronted by the amount of literature about the Alamo. A glance at the DRT Library catalogue reveals 1,450 books; although many are serious studies—autobiographies, biographies, eyewitness accounts, collections of historical documents, and historical studies, some intended for adults, some for children—the list also includes sixty-two fictional titles, directed to both readership groups; there are even ghost stories. The library also holds collections of no fewer than seventeen journals devoted to the Alamo. Although new evidence helps recent historians approach the truth, "traditional popular depictions, including novels, stage plays, and motion pictures," as Hardin observes, "emphasize legendary aspects that often obscure the historical event."

The first substantial work of fiction appears to be Augusta J. Evans' *Inez: A Tale of the Alamo*, published in 1855. The earliest play—written in verse—was Francis Nona's *The Fall of the Alamo* of 1879. It was followed in 1886 by Hiram H. McLane's *The Capture of the Alamo*, "a historical tragedy, in four acts" intended to raise funds for a never-realized monument. A citation from its prologue reveals why it never found a place in great American literature: "And this our purpose too we have,/ Besides to honor those so brave;/ By in this form to you to tell,/ How Travis and his comrades fell;/ To see if Shakspeare [*sic*] has a fame/ To which no others may lay claim." Clearly, other works are too numerous to list here. Suffice it to say that well over two hundred new titles have appeared in the twenty-first century. At the time of writing (2008) the Library of Congress lists a dozen more about to be released.

In 1911 moviemakers discovered the Alamo; William F. Haddock directed the now lost one-reeler, *The Immortal Alamo* (aka *The Fall of the Alamo*), whose story "plays fast and loose with the actual incidents," filmed on a ranch south of San Antonio. *The Siege and Fall of the Alamo*, the only movie known to have been shot at the actual location, was released in 1914.

The following year the great D.W. Griffith produced the 50-minute big-budget epic, *Martyrs of the Alamo*, directed by William "Christy" Cabanne; it is the earliest surviving Alamo film. Robert N. Bradbury's "jingoistic and simplistic" *With Davy Crockett at the Fall of the Alamo* was released in 1926.

Sound was added to the famous battle in the "uneven" *Heroes of the Alamo*, produced and distributed by Anthony J. Xydias as a Sunset Production in 1937; Columbia Pictures bought it in 1938, and changing everything except the story, rebadged, and rereleased it as their own production. In the same year Stuart Paton filmed the insightful 20-minute documentary, *The Alamo: Shrine of Texas Liberty* (aka *The Fall of the Alamo*). Shot entirely on location at Mission San Jose, the educational film was produced on an extremely low budget; many extras were taken from the local unemployment line, paid $2 a day and asked to provide their own costumes. The soundtrack was a "lame" narration and an organ score.

Black and white turned to color with Universal Pictures' *The Man from the Alamo* (1953), called by one critic "despite historical inaccuracies . . . an imaginative application of the Alamo story." Two years later Frank Lloyd directed *The Last Command* (with the esoteric alternative title *San Antonio de Béxar*); also in color, it purported to be a biography of James "Jim" Bowie, of Bowie knife fame.

But all previous movies were eclipsed in 1960 when John Wayne directed (and starred as Davy Crockett) in Todd-AO technicolor blockbuster *The Alamo* (1960), complete with stereophonic sound. The film, writes one historian, was as "immensely popular as it was laughably inaccurate." But Bruce Winders, curator at the Alamo, remarks that Wayne's movie introduced the story to an international audience in a way that historians never could. Every year, visitors to the Alamo from across the world tell how they learned about the Alamo from John Wayne. Many cinema buffs continue to hold the film in as much awe as the Alamo itself. But in the next 40 years both moviemakers and cinemagoers became more sophisticated.

So when a new version of the old story was announced in March 2002, Texas journalist David McLemore warned in the *Dallas Morning News* that any depiction of the "heady mix of fact and legend entwined around the 1836 battle [would strike] close to the bone" in Texas, and noted the widely divergent opinions among historians, novelists, and just plain Alamo buffs about the value of another movie. Citing some of those views, he exposed inherent problems in making a successful movie about the event: "It's a siege, which is inherently boring. And instead of one hero, you have three. An honest version will have to consider the bravery showed by the Mexican side. It is an immensely complicated human story. . . . You can't tell the Alamo story without looking at the myth. The problem is when the lines get blurred."

According to most critics, the film missed the mark. In the event, after extensive disputes the $140 million heavily edited, 2-hour epic was directed, not by Ron Howard as originally planned, but by John Lee Hancock.

Produced by Touchstone Pictures and Imagine Entertainment, it was released in 2004. *The Boston Globe* reviewer, lamenting that "what was once to be an R-rated mega-budget extravaganza, [ended as] a PG-13-rated over-budget extravaganza," a "deeply compromised film, if not a broken one." *The New York Times* agreed: "In re-enacting, with a heavy heart and a heavy hand, the actual events surrounding the storied 1836 battle . . . the [oppressively solemn] movie is both elegiac and trivial. This is an accomplishment . . . of the sort that no one plans." Most reviews followed the same pattern. David Sterritt, *The Christian Science Monitor*'s film critic, titled his piece, "Forget the Alamo, please," and complained, "Moviemakers have been telling the story . . . since the days of silent film, and this week's version probably won't be the last. But here's hoping I'm wrong—at least until someone comes up with a truly accurate account."

As noted, only one of these big-screen movies was filmed at the Alamo. The DRT "do not permit commercial activity on the grounds." But neither do they have any say about content and approach in the movies. Republic Studios' *The Last Command* was the first Alamo film shot on a "back lot" at James T. "Happy" Shahan's ranch at Brackettville, 120 miles west of San Antonio. A replica of the Alamo compound was built there for Wayne's 1960 epic; since then it has been the location for films made for cinema and television.

Of course, several television programs, factual and fictional, have been made about the Alamo. ABC screened a black-and-white documentary, *Spirit of the Alamo* in 1960, hosted by John Wayne as a promotion for his movie. Critic John Corry called NBC's 1987 miniseries, *The Alamo: Thirteen Days to Glory* "a very decent production" and "a respectable addition to Alamo repertory"—a reflection upon its fictional nature. The Alamo inevitably formed a part of ABC's three-part *Texas*, broadcast in 1995. The miniseries didn't attract the same critical acclaim; *Variety* wittily dismissed it as a "docudrama, boiled down . . . from James Michener's massive novel *Texas*, [centered] on a fictional romantic triangle, with soapsuds bubbling along the Brazos River." In 1996 Discovery Channel produced a well-received documentary, *The Battle of the Alamo*; its director Nina Seavey "negotiated the right to shoot [the special] inside the walls of the Alamo, the only film crew ever allowed to do so." In 2000 Scholastic Productions made an episode of its *Dear America* TV series, based on Sherry Garland's 1998 children's novel, *A Line in the Sand: The Alamo Diary of Lucinda Lawrence, Gonzales, Texas, 1835*. PBS's *Remember the Alamo–American Experience*, that "investigates the history, myth and popular culture of the Alamo" and *The Alamo Documentary: A True Story of Courage* and were both shown in 2004—not coincidentally, just as the blockbuster movie appeared on the big screen.

In the light of their jealous and zealous protection of the Alamo, it seems inconsistent that the DRT do not object to the mostly trivial and trashy souvenirs that are peddled in San Antonio. Many such things are on sale in their own gift shop, right on the Alamo grounds; because they operate without

municipal, state, or federal support, perhaps the end is thought to justify the means. One vendor in downtown San Antonio categorizes items to make online selection easier for the discerning buyer; it may be assumed that one can obtain Alamo memorabilia from the comfort of home—"remember the Alamo" without actually going there! Anyway, all categories are prefaced with the magical words "The Alamo": T-shirts, gifts, baby gifts, birthday gifts, hats, presents, hoodies, gift ideas, mouse pads, magnets, tees, coasters, stickers. Another souvenir shop promises, "We can customize any gift in our store for you. . . . We can add names, phrases, dates to any image for no additional cost." It has Alamo boxer shorts and even thongs! But the kitsch to end all kitsch is the Alamo Dirt Bottle, bearing the label "dirt from the San Antonio area."

THE ALAMO: TO START AT THE BEGINNING . . .

The Alamo, and events before and after the famous battle, must be seen in the context of the emergence of an independent Mexico. Immediately after the conquest of Central America the Spanish moved north, seeking riches and converts to Christianity, probably in that order. Sailing from Jamaica in 1519, Alonso Álvarez de Pineda explored the Texas coastline, although he seems not to have charted his discoveries. About a decade later, shipwrecked on what is now Galveston Island, Alvar Núñez Cabeza de Vaca for 8 years lived among Native Americans as a slave, a trader, and eventually "a great spiritual leader." He was the first European explorer of what is now Texas and the southwestern United States. In 1540–1542 Francisco Vásquez de Coronado, in a futile search for the fabled, nonexistent Seven Cities of Cibola, explored the region further. Then the Spanish turned their backs on it for almost 150 years.

Their interest was revived after 1685, when a French expedition from Canada, under Rene-Robert Cavelier, explored the Mississippi River to its embouchure in the Gulf of Mexico. The newcomers built Fort St. Louis at Matagorda Bay, providing a beachhead for France's claim to Texas. According to one writer, Spain, threatened by the French expansion, "responded by extending its settlements into what is now Texas, thereby creating a buffer between the wealth of Mexico and French Louisiana." In April 1689, setting out to establish Spanish claims, Alonso de León, the governor of Coahuila state, found Fort St. Louis abandoned. The crisis had passed.

As a matter of policy, the Spanish established themselves in their northern provinces of California and Texas by founding missions to convert the indigenous people to Christianity and to Hispanic culture. Close to most missions, they built a *presidio*—a fortified garrison—to protect the missionaries and the Indian community. It was "hoped that with the help of these now-loyal Indians a relatively small number of [soldiers] would be needed to defend the empire's frontier." In March 1690 de León led another expedition, to

establish the Mission San Franciso de les Tejas in East Texas; it was completed in late May. Visiting it a year or so later, General Domingo Terán de los Ríos, the first governor of Texas, discovered that the friars had founded another mission, Santisimo Nombre de Maria, 5 miles to the east. For a number of reasons both were abandoned in 1693, and for two more decades the Spanish again ignored Texas.

In 1715, the Viceroy Marqués de Valero, alarmed by renewed French incursions, appointed Domingo Ramón to lead an expedition to reestablish the Texas missions. Ramón set out in February 1716 with twenty-five soldiers, forty civilians—men, women, and children—as well as eight priests and three lay brothers from the Franciscan colleges at Querétaro and Zacatecas. The new missions would be more than 400 miles from the nearest Spanish settlement of San Juan Bautista. Early in July the party established Nuestro Padre San Francisco de los Tejas, and by the end of the year, Nuestra Señora de la Purísima Concepción, Nuestra Señora de Guadalupe, and San José de los Nazonis. Two more, Nuestra Señora de los Dolores and San Miguel de Linares de los Adaes, followed in early 1717.

In April 1718 Martin de Alarcón, the new governor of Texas, undertook another expedition of seventy souls, including ten families and more Franciscans from Querétaro. On May 1 he and Father Antonio San Buenaventura y Olivares founded the San Antonio de Valero Mission on San Pedro Creek, west of the San Antonio River. Four days later Alarcón established the Presidio San Antonio de Béxar, and within a week, the settler families, clustered around the presidio and mission, chartered the Villa de Béxar (now the city of San Antonio). A year later the mission was moved to the east side of the river, and when a fierce storm destroyed buildings there in 1724, it was again relocated, a "distance of two gun shots" to the north of the Villa. What was built there would become famous as the Alamo.

In 1720 San José y San Miguel de Aguayo had been established south of San Antonio de Valero. In 1731 three more East Texas missions—Nuestra Señora Purísima Concepción de Acuña, San Juan Capistrano, and San Francisco de la Espada—all of which had failed because of drought, malaria, or French attacks, were relocated along the San Antonio River, creating the largest concentration of missions in North America. All were officially under the protection of the Presidio San Antonio de Béxar.

National Parks Service (NPS) historians James Ivey and Marlys Thurber explain that the missions trained Native Americans as artisans and workers in farming and ranching sheep, goats, and cattle, blacksmithing, masonry, and weaving—industries essential for maintaining the political and military structure of the eastern Spanish-American frontier, "a region at the far end of a long and expensive supply line."

Because the Presidio San Antonio de Béxar was never completed (or for that matter, never adequately manned) the monks of the San Antonio missions built their own defenses against attack from such warlike Southern

Plains tribes as the Apache and the Comanche. Consequently, despite its principally religious purpose, San Antonio de Valero also "manifested clear military overtones." Eight-foot high, two-foot thick stone and adobe walls enclosed a rectangular main plaza, around 480 feet long by 160 wide; access was through a turreted fortified gate in the south wall. The converted Indians were safe in this compound; most of their houses, flanked by a loggia, were built along the western wall. Others lined the northern and part of the eastern walls; still others stood in the center of the quadrangle. According to Hardin, around the middle of the 1800s the Indian pueblo included thirty finished adobe houses and a number of brush huts.

The church and convent building stood in a separate courtyard to the east. Church building had begun as soon as the mission's final site was fixed in 1724. Located immediately north of the church, the convent, housing the monks' quarters, administrative functions, and guest rooms, took 20 years to complete. By the time that the mission was secularized in 1793, it consisted of two-story wings forming an L along the west and south edges of a cloister garth.

Construction of a stone church began in 1744, but by 1756 the unfinished building was in such a parlous condition—parts had even collapsed—that a more ambitious replacement was started. It too was discontinued when the mission began to decline in the late 1780s. What remains, and the record of surviving documents, indicates that the plan was a traditional Latin cross with an aisleless nave, short transepts, and a shallow sanctuary. The rough-dressed limestone walls were 3 to 4 feet thick and reinforced by buttresses, probably to support a vaulted ceiling; it seems that it was planned to crown the crossing with a dome. The vaults and dome, and a second-story choir loft at the west end, probably were never built. The neighboring missions, some of which are intact (but incomplete) provide a clue to unrealized intentions at San Antonio de Valero: all had domes and all had towers symmetrically flanking the west door. Thus, although the west front facing the mission plaza was never finished, the design of the church of San Antonio de Valero may be imagined; according to a 1793 description, it was "a showy and impressive piece of Tuscan architecture," with arched doors surrounded by elaborate floral carvings, twisting columns, and shell-topped niches for statuary. The central façade and front corners of the church had quoins of ashlar. At least some of that is evident in the surviving fabric.

Father Juan Morfi had described the unfinished mission buildings in 1778, as containing a small two-story convent 50 *varas* square—*vara* was anything between 32 and 43 inches—with an arched gallery giving access to rooms—the missionaries' cells, a porter's lodge, a refectory, kitchen, and "domestic offices." Off a second patio to the north there was a workshop with spinning wheels and four looms and a store room. Morfi wrote that the church had been "ruined through the ignorance of the builder" but a replacement was being built on the same site. Services were temporarily being conducted in a small sacristy between the church and the convent.

As Spain's military-economic interests in Texas diminished, so did its interest in the missions. In November 1792 the colonial government instructed that the San Antonio missions were to be "secularized"—that is, that the settlements should become civilian rather than religious communities—and that their assets should be distributed to the surviving converted Indians; laid waste by European diseases, their numbers had drastically declined. Many continued to farm and assimilated with the immigrants; others themselves emigrated to other parts of Mexico. In fact, only the Mission San Antonio de Valero was fully secularized immediately and the Franciscans left; the others followed in 1824 after Mexico won its independence.

After the monks departed, the disused Mission San Antonio de Valero's architectural fabric soon decayed. Under new management, so to speak, in the beginning of the nineteenth century it became known as the Alamo. Former Béxar County Archivist John O. Leal asserts that there was never a "deciding moment in history" when that happened; rather, it evolved through usage. Official documents between 1803 and 1807 often used "El Alamo" in reference to the cavalry contingent sent to protect the San Antonio settlements— *La Segunda Compañía Volante de San Carlos del pueblo del Alamo* came from Alamo De Parras. Leal explains that "among the Mexican military in San Antonio, 'Valero' fell from usage altogether . . . From the Anglos' corruption of Spanish we get . . . Alamo, from 'El Alamo' shortened from the name of the squad." A popular alternative theory is that the name derives from the Spanish *álamo* (cottonwood or poplar) and refers to a nearby grove of those trees. But, warns Leal, "the 1807 references may well have been before the planting of the [grove], possibly killing any hopes by the legend lovers that the name came from the nearby row of cottonwoods."

MEXICAN INDEPENDENCE AND THE RISE OF ANTONIO SANTA ANNA

As one historian has written, the Spanish lost the colony of New Spain— from what is now Panama in the south to modern Oregon in the north—"by losing the support of colonial elites." In 1808, when Napoléon Bonaparte's brother Joseph replaced Ferdinand VII on the Spanish throne, Mexico's *criollos* (locally-born Spaniards) saw a chance to secure sovereignty. They had been planning to seize power from the *gachupines* (Spanish-born Mexicans) who enjoyed privileges simply because of where they were born. But the *criollos* were preempted by Miguel Hidalgo y Costilla, "the father of his country," a 57-year-old Catholic priest in the village of Dolores. Before dawn on September 16, 1810, he had the village's *gachupines* arrested and called upon the "exploited and embittered" lowest caste—indigenous and mixed-race people—to rise against their oppressors and "recover the land that was stolen from their forefathers." An anonymous writer explains, "Hidalgo's passionate declaration, 'Mexicanos, viva México!' was a swift, unpremeditated decision that he was calling these people to revolution was a radical change in

the original . . . plot devised by the *criollos*." In summer 1811 the turbulent priest would be executed in Chihuahua.

A key figure in subsequent developments was Antonio López de Santa Anna Pérez de Lebrón, the notorious Santa Anna, born into a middle-class *criollo* family in Jalapa in Veracruz. After rudimentary schooling he was apprenticed to a Veracruz merchant, but he was diffident about education and commerce. Rather, as Donald J. Mabry points out, "a man of action, he loved soldiering. It was exciting, decisive, and rewarding." Young Santa Anna was loyal to the crown—well, for as long as it suited him—and therefore opposed to the incipient movement for independence. At the age of 16, in 1810 he enlisted as a cadet in the Fijo de Veracruz infantry regiment; by 1812 he was made first lieutenant and 4 years later promoted to brevet captain. According to his biographer Wilfred Callcott, he "spent the next five years battling insurgents and policing the Indian tribes of the *Provincias Internas*," distinguishing himself in several campaigns.

In March 1821, declining an invitation from José Miranda to join the rebels, Santa Anna broke the siege of Orizaba and was rewarded with the rank of brevet lieutenant-colonel. A few days later a large revolutionary force arrived in the region; it was loyal to the former Royalist officer Agustín de Iturbide, a *criollo* who had deserted. Historian Jim Tuck writes, "Seeing which way the wind was blowing, Santa Anna made the first of many betrayals that would characterize his career." He joined Iturbide on the condition that he could retain his new rank. Within about a month he was commanding the rebel army's 11th Division. After more than a decade of fighting, Mexico became an independent nation. But that hardly diminished conflicts, and for the next decade or more the country was ravaged by civil wars and intrigues. Santa Anna was involved in them all. Here, an overview must suffice.

Iturbide became emperor in May 1822. Moving to Mexico City, the sycophantic Santa Anna "exploited his situation for personal gain," even courting the Emperor's 60-year-old sister (he was 28). In October Iturbide promoted the "quarrelsome and opportunistic young colonel" to brigadier general and sent him to Veracruz, first as military commander of the city and then as civilian commander of the whole province. But relying as it did upon the force of arms, the unpopular emperor's reign was brief. In December Santa Anna and Iturbide fell out. Tuck states that "an angry Santa Anna . . . proclaimed himself a champion of liberty and 'declared' against [the emperor]." He defected to the republicans, led by Guadalupe Victoria, and took with him "the custom houses revenues and the support of the wealthy Veracruz merchants." In March 1823 Iturbide was forced to abdicate and he left the country.

The new republican government first sent Santa Anna to San Luis Potosí. But when he "openly supported the federalist faction," he was recalled to Mexico City and placed under house arrest. Through the influence of powerful friends he was reinstated as brigadier general and made military governor of Yucatán. Within a few months he unilaterally declared war on Spain and tried to invade Cuba; again ordered back to the capital, he was given charge

of army engineers. So he resigned in 1825 and returned to civilian life on his estate near Jalapa, where he acquired more land and became a prosperous gentleman farmer. In 1825 he married 14-year-old Inés García; they would have four children.

In Mexico, Freemasonry formed "the organizational basis of the political factions." The York Rite lodges supported the liberals, the Scottish Rite lodges the conservatives. Santa Anna first joined a York Rite body, but when the balance of political power shifted, he shifted too, joining a Scottish Rite lodge. Tuck observes that his "immediate concern was to be on the winning side [and] switching allegiance never troubled him." In 1827–1828, when he helped President Victoria suppress a rebellion led by the Vice President Nicolás Bravo and the Scottish lodges, Santa Anna was rewarded with the governorship of Veracruz. In 1828 the conservative Manuel Gómez Pedraza won the presidential election; but, under threat from Santa Anna and others, he soon relinquished his victory and fled Mexico. Vicente Guerrero, the vice president, took his place and Santa Anna again was rewarded for his help, this time by promotion to the highest military rank. The following year Spain attempted to reconquer Mexico, and in September Guerrero despatched Santa Anna to Tampico to repel the invaders. Originally 2,700-strong, the Spanish had lost many men to tropical diseases; the rest quickly surrendered. But Santa Anna, the egotistical "hero of Tampico," claimed a famous victory.

The conservative, Anastasio Bustamante, overthrew Guerrero in 1830. Making himself dictator, he expelled his adversaries, persecuted the liberals, and established a secret police force. But in the following year he organized Guerrero's abduction and execution, and the popular outrage showed Santa Anna which way the wind was blowing. Declaring himself a liberal, in 1832 he raised an army in Veracruz to depose Bustamante; the ensuing civil war ended in December when Pedraza, Bustamante, and Santa Anna agreed that Pedraza would assume the presidency temporarily and Bustamante would go into exile. Pleading illness, the Machiavellian Santa Anna went home to Jalapa to await the 1833 presidential election; he was confident of the outcome, convinced that he was the "most popular and powerful man in the country." He was elected as a liberal, but finding the mundane tasks of governing "boring and irksome," he delegated them to his vice president, Valentín Gómez Farías. Then, again using the pretext of poor health, he withdrew to a hedonistic lifestyle at his hacienda. Conservatives revolted when Farías, through the so-called Laws of '33, tried to "dismantle the vestiges of the colonial past" and ended special privileges. Santa Anna was obliged to return and suppress the rebellion.

TROUBLE IN TEXAS

Texas had been a thorn in the Mexican government's side for some time. Separated from Mexico City by hundreds of miles of virtual desert, it was

hard to govern. Through the 1820s U.S. citizens were acquiring cheap land in Mexico, whose remote frontiers were impossible to secure. Attempting to preempt the "Americanization" of Texas, the Mexican government made land grants to a group led by the Austin family on condition that the members become Mexican and Roman Catholic. The effort failed, for both legal and illegal immigrants violated the law.

Hostilities soon developed. A month after the Battle of Velasco of June 26, 1832—"an armed prelude to the Texas Revolution"—José de las Piedras, the Mexican commander at Nacogdoches, had attempted to settle disturbances there and at Anahuac on Galveston Bay; the Texans rejected his demand that all citizens surrender their weapons. On August 1 their 300-strong force besieged de las Piedras' garrison; after a battle the Mexicans were put to flight. By 1835, the Anglo immigrants greatly outnumbered Mexicans, and many wanted Texas to be part of the United States.

Santa Anna had taken up the presidency again in 1834, albeit briefly—altogether, he was president eleven times! Declaring that Mexico was unready for democracy, he established a Centralist autocracy. In January 1835 he once more feigned illness and returned to Jalapa, but in May "when the liberals of Zacatecas defied his authority . . . [he] moved to crush them," then launched a nationwide repressive campaign. He abolished the 1824 Constitution, replacing it with an ultraconservative instrument. In May 1835 he abolished state governments, making them into military departments. It was clear that dissent would not be countenanced. Although many states protested, only the people of distant Coahuila y Texas took action.

Santa Anna ordered the apprehension of any Anglo-American citizens of the state who were conducting business in the capital, Monclova. Historian W. R. Williamson writes that by July, Texans in San Felipe and Nacogdoches were "beating the drum for war." The Battle of Concepción took place at the end of October. Early in December Texan volunteers under Stephen Austin besieged the San Antonio headquarters of General Martín Perfecto de Cós, the Mexican commander in the north. After five days of skirmishing the Centralists surrendered; the Texans occupied the Alamo and strengthened the fortifications already carried out by Cós. Santa Anna marched on Texas. Two forts, each "ready to alert the Texas settlements of an enemy advance," blocked his way: the Alamo and the Nuestra Señora de Loreto Presidio at Goliad.

THE PANTHEON OF FRONTIER GALLANTS

History and myth have established three men as "the pantheon of frontier gallants," larger-than-life combatants in the Battle of the Alamo: David (Davy) Crockett arrived from Tennessee to join Colonel James Rezin Bowie and Colonel William Barret Travis. Comparatively little has been written about the

latter two. Bowie was a fortune hunter, known for his fraudulent land deal-
ings and Travis an unprincipled lawyer; "youngest of the three, [he had]
brought little but potential with him to Texas." Crockett, on the other hand,
was already a legend—"a bona fide folk hero"—surrounded by tall tales,
largely of his own creation. What happened at the Alamo provided the raw
material from which writers and moviemakers could build each of them into
an icon of Texas and American history.

James "Jim" Bowie was born in 1796, probably in Logan County, Ken-
tucky. The Bowie family moved first to Missouri, and then in around 1809 to
southeastern Louisiana, where James' father bought a plantation. In January
1815 Jim and his older sibling Rezin (pronounced "reason") were about to
join Andrew Jackson's forces to fight the British when the War of 1812 ended.
For three years from 1818, with another brother John, they formed a partner-
ship with the New Orleans smuggler and pirate Jean Lafitte to smuggle slaves
into Louisiana from Texas. According to historian Jeff Bailey, Bowie used the
profits from that trade to speculate in Louisiana property, but because many
of his land claims were bogus, he and John moved to Arkansas "under a cloud
of suspicion," where they started over. It remains uncertain exactly when
Bowie, who spoke Spanish, first went to Texas; some sources say that it was
in 1828, after recovering from the Sandbar brawl—now notorious for its
myths about the Bowie knife—near Natchez , Mississippi. What *is* clear is
that on February 20, 1830, he took the oath of allegiance to Mexico and the
following October became a Mexican citizen. In April 1831 he married Ursula
Maria de Veramendi, the daughter of the vice governor, and they settled in
San Antonio. Ursula, her parents, and her two children died in a cholera epi-
demic in 1833.

William Barret Travis was born in South Carolina in 1809. Eight years later
his father moved the family of eleven children to Alabama, where Travis was
educated. He was articled to James Dellet, a Claiborne lawyer, later becoming
his partner and running a branch office at nearby Gosport. In October 1828
he married Rosanna Cato and settled down—for a while. He founded and
edited the Claiborne *Herald* (it seems to have failed by 1829) and was
appointed adjutant in the Alabama Militia. But his marriage was already in
trouble, each partner accusing the other of infidelity. Travis soon left his wife,
son, and unborn daughter to move to Texas, arriving as an illegal immigrant
early in 1831. He established a law office in Anahuac. As he made business
trips through Texas Travis formed links with opponents of the anti-immigration
legislation. As tension mounted between the Mexican government and Anglo
settlers, this group—the "War Party"—sought a confrontation. In the after-
math of a political disturbance at Anahuac, Travis moved his practice to San
Felipe, where in 1834 he was elected secretary to the *ayuntamiento*, the prin-
cipal governing body. Late in June 1835 he led a successful assault on Ana-
huac's military garrison. He later commanded a unit and advised on the
organization of cavalry; declining a commission as a major of artillery in the

Texas army, he was later made lieutenant colonel. He met Rebecca Cummings, whom he agreed to marry as soon as he was free from Rosanna. But when they divorced in fall 1835 he had become so "embroiled in the rapidly moving events of the Texas Revolution" that the second marriage never took place.

Crockett was born in August 1786 in Greene County, East Tennessee. When a flood washed away their house and mill, his father moved the family to Jefferson County, where he opened a tavern. In 1798 Davy started school; a persistent truant, he spent only 4 days there before running away from home—a "strategic withdrawal" prompted by fear of being punished by his father for brawling—and stayed away until 1802, taking various jobs to sustain himself. On his return, he worked for about a year to pay off his father's debts, before returning to school 4 days a week (for 6 months) and working for John Kennedy, his father's former creditor, on the other two.

In October 1805 he was about to marry Margaret Elder, but she jilted him; 8 months later he married Mary (Polly) Finley. He moved his family—he had two sons, John Wesley and William—to Lincoln County in 1811 and again to Franklin County in 1813. Crockett's military career began in September as a scout in the militia: on August 30 Creek Indians massacred hundreds of settlers and soldiers at Fort Mims, Alabama. Crockett fought in the ensuing Creek war. He again signed up as a scout, to fight the British in the War of 1812 and in May 1815 he was made lieutenant in the Franklin County Militia. Soon after his return home Polly, having given birth to a daughter, Margaret, died of malaria.

Before the year's end the penurious Crockett married Elizabeth Patton, a well-to-do widow with two children. The following year they moved to what became Lawrence County. In November 1817 he was appointed Justice of the Peace, an office that he retained until 1819. He also was elected colonel in the Fifty-Seventh Regiment of the County Militia in 1818, the year in which he became Lawrenceburg's town commissioner. Three years later he stood for the state House of Representatives and after the 1821–1822 session the family moved to West Tennessee and he was reelected for another term. In August 1825 he unsuccessfully nominated for the U.S. House of Representatives in the Nineteenth Congress; but he won a seat as a Jacksonian in the Twentieth, and was reelected to the Twenty-First (1827–1831) and the Twenty-Third Congress (1833–1835), by then having become an anti-Jacksonian Whig.

Meanwhile, the Crockett *mythos* had begun to grow—a phenomenon that he did not discourage, as it helped his political ambitions. *The Life and Adventures of Colonel David Crockett of West Tennessee*, published in 1833, was a collection of hyperbolic tales about the adventures of the legendary *Davy* rather than the historical *David* Crockett. Nevertheless, the real Crockett had achieved much, but when he lost his 1835 congressional campaign he turned his back on federal politics. He set out for San Antonio, where he signed an oath of allegiance to the "Provisional Government of Texas or any future

republican—a word insisted upon by Crockett—government that may be hereafter declared." Crockett would soon extol Texas as "the garden spot of the world. The best land and the best prospects for health I ever saw, and I do believe it is a fortune to any man to come here." On January 9, 1836 he wrote to his daughter, "I have but little doubt of being elected a member to form a constitution for this province. . . . I had rather be in my present situation than to be elected to a seat in Congress for life." He hoped to become the new territory's land agent.

But hostilities had begun between Texas and the Mexican Centralist government. The Anglo-Texans were politically split between Whig supporters—the War party, already mentioned—and those standing for President Jackson—the Peace party. At first, Crockett had no intention of joining the fight for independence, but rather than join Sam Houston (a Jacksonite), he chose to team up with Travis, who had disregarded Houston's orders to withdraw from the Alamo. Michael Lofaro wryly remarks, "What was more, he loved a good fight."

THE BATTLE OF THE ALAMO

In January 1836, ordered by Governor Henry Smith to recruit a "legion of cavalry"—one hundred men to reinforce the contingent of seventy-eight at San Antonio—Travis was able to muster only twenty-nine; he asked to be relieved. Smith refused. When Bowie arrived at the Alamo on January 19 he and Travis quarreled over authority. They had known each other since 1833, when property law matters brought them together in San Felipe and "they were able to effect an uneasy truce of joint command." Travis took command of the regulars, Bowie of the volunteers, and they shared authority over garrison orders and correspondence.

General Sam Houston wanted Bowie (since 1832 a colonel in the Citizen Rangers, a volunteer force) to abandon and destroy the Alamo. Williamson writes that as far as Houston knew, "the situation was grim." Colonel James Clinton Neill, the Alamo's former commander, complained that his men "lacked clothing and pay, and [he] talked of leaving. Mexican families were leaving Béxar. Texas volunteers had carried off most of the munitions and supplies." But Bowie and Travis decided to defend the Alamo instead. As Hardin puts it, "on 2 February Bowie wrote Smith that he and Neill had resolved to 'die in these ditches' before they would surrender the post"; Neill had convinced him that the outpost was all that protected the Texan settlements from the Mexicans. The garrison had some 150 men; Travis arrived with his thirty on February 3, and 5 days later Crockett rode in with twelve more. Thirty-five men of the Gonzales Ranging Company were to increase the number of defenders to about 190.

The Mexican Centralist army—its strength has been variously put between eighteen hundred and an unlikely six thousand—crossed the Rio Grande and

laid siege to the Alamo on February 23, about 3 weeks before the Texans expected it. But prepared for Santa Anna's imminent assault, Travis had "strengthened the walls, constructed palisades to fill gaps, mounted cannons, and stored provisions inside the fortress." When the Mexican general sent a demand for surrender, Travis "answered the demand with a cannon shot." The enemy artillery began pounding the perimeter walls. On February 24 Bowie was confined to his bed, suffering from a serious respiratory illness, and Travis found himself in sole command. His force held on for 12 days, while he continued to plead with his superiors for the promised reinforcements. His February 24 letter "To the People of Texas and All Americans in the World" read in part,

> I call on you in the name of Liberty, of patriotism and everything dear to the American character, to come to our aid, with all dispatch. . . . I am besieged by a thousand or more of the Mexicans under Santa Anna. I have sustained a continual bombardment and cannonade for twenty-four hours and have not lost a man. The enemy has demanded surrender at discretion, otherwise, the garrison are to be put to the sword, if the fort is taken. . . . Our flag still waves proudly from the walls. I shall never surrender or retreat. Victory or death.

The last words were underscored three times. In fact, his call was not unheeded; one writer says that "more than 200 volunteers had gathered at Gonzales to march to the Alamo's relief, when news of its fall reached the town." The response was too late.

On Saturday March 5 Santa Anna announced his intention to storm the defenses the next morning. Convinced that the Texans would soon be worn into submission, his alarmed officers objected that there was "no valid military justification for the costly attack on a stronghold bristling with cannons." The self-styled "Napoleon of the West" ignored their advice and at around five o'clock on Sunday morning "he hurled his columns at the battered walls" of the Alamo. Mexican Lieutenant José Enrique de la Peña, an eyewitness of the battle, recalled,

> Santa Anna made the decision to use four columns of troops for the attack. . . . The first, under command of General Cos and made up of a battalion from Aldama and three companies from the San Luis contingent, was to move against the western front which faced the city. The second, under Colonel Duque and made up of the battalion under his command and three other companies from San Luis was entrusted with a like mission against the front facing the north. . . . These two columns had a total strength of 700 men. The third, under command of Colonel Romero and made up of two companies of fusiliers from Matamoros and Jiménez battalions . . . came up to 300 or more men; it was to attack the east front. . . . The fourth column, under command of Colonel Morales and made up of over 100 chasseurs, was entrusted with taking the entrance to the fort and the entrenchments defending it. The Sapper Battalion and five grenadier companies made up the reserve of 400 men.

When the assault on the Alamo began . . . all the columns were able to reach the walls of the Alamo, except for the third. [It] was held back by cannon fire and forced to find another entrance. It was then, upon seeing the difficulties that the third column was having, that Santa Anna gave the order for Colonel Amat to move in with the reserves. It was also at this time that Santa Anna also ordered into battle his general staff and everyone who was at his side.[3]

By eight o'clock every Alamo fighting man lay dead. Santa Anna had ordered that no prisoners be taken. The Texan losses were 189, although recent evidence suggests that the actual number could have been almost 260. In the afternoon, the Mexicans piled up all but one of the bodies—a Mexican—and burned them. Santa Anna's official report claimed that six hundred rebel corpses were found; then, truth is always the first casualty in war. About fifteen women and children and some slaves were spared; each of the women and children was given $2 (almost $50 at today's values) and a blanket, and guaranteed safe passage through Santa Anna's lines. Most historians place the number of Mexican casualties at two hundred dead and four hundred wounded; a few prefer the rather improbable combined number of perhaps sixteen hundred; Santa Anna reported seventy dead and three hundred wounded.

Travis died early in the battle from a single bullet in the head. Bowie was shot several times in the head as he lay helpless and breathless on his bunk. For a long time, tradition held that Crockett fell early in the conflict, but the eyewitness account by de la Peña (published in English in 1997) has it differently. He wrote that Crockett was among seven survivors who were paraded before Santa Anna. When an officer told the general that this was "the naturalist David Crockett" the indignant *presidente* ordered Davy and the others killed. Some soldiers, "hoping that once the fury of the moment had blown over these men would be spared," refused to do it but others "fell upon these unfortunate, defenseless men just as a tiger leaps upon his prey," and tortured them to death with swords and bayonets. Their bodies were burned. But what did they achieve?

Some fictional sources still perpetuate the idea that the defenders of the Alamo gave Sam Houston time to mobilize his forces. However, as historian Henry W. Barton pointed out in 1959, Houston's authority was limited to the regular army, and he had no legal right to give orders to the volunteers already in the field. The general "dispatched recruiters to raise the regular army as well as agents to acquire arms, uniforms and other supplies." As a general temporarily without an army, he took leave from the end of January 1836, during which he negotiated a treaty with the Cherokees. During much of the siege of the Alamo he was a delegate to the constitutional convention at Washington-on-the-Brazos, where the Texas Declaration of Independence was signed on March 2. The new government confirmed him as commanding general of the Texas Army. As noted, by the time that he reached Gonzales on March 11 to lead reinforcements to the Alamo, it had already fallen.

Hardin believes that though the men of the Alamo were valiant soldiers, there is no evidence (in words attributed to John Wayne) that they "joined together in an immortal pact to give their lives that the spark of freedom might blaze into a roaring flame." He asserts, "Despite all the 'victory or death' hyperbole, they were not suicidal. [They] willingly placed themselves in harm's way to protect their country. Death was a risk they accepted, but it was never their aim. Yet, even stripped of chauvinistic exaggeration . . . the battle of the Alamo remains an inspiring moment in Texas history. . . . [People] worldwide continue to remember the Alamo as a heroic struggle against overwhelming odds—a place where men made the ultimate sacrifice for freedom."

THE FALL AND FALL OF SANTA ANNA

On April 21 Santa Anna's army was defeated by Houston at the Battle of San Jacinto. In *Papers of the Texas Revolution* John H. Jenkins stirringly claimed, "There was a general cry which pervaded the ranks—'Remember the Alamo!' . . . These words electrified all. The unerring aim and irresistible energy of the Texan army could not be withstood. It was freemen fighting against the minions of tyranny, and the results proved the inequity of such a contest." The Texans lost nine men and eighteen were wounded; six hundred fifty Mexicans died, and six hundred prisoners were taken. In an attempt to escape, Santa Anna discarded his gold braid-encrusted scarlet-and-blue uniform and disguised himself in a private's tunic. But he was apprehended the next day.

Clarence Wharton described the negotiations between the *ad interim* government of Texas and the captive president. Santa Anna advised his second-in-command, General Vicente Filisola, "I have agreed with General Houston for an armistice until matters can be so regulated that the war will cease forever." The two Treaties of Velasco were "speedily concluded." The first simply provided that "all hostilities would cease, and that Santa Anna would not exercise his influence to cause arms to be taken up against the people of Texas during the present war for independence." The second provided that he would be immediately returned to Mexico, "and that he would prepare things in the Mexican cabinet so that a commission sent by the Texas government should be received, and that by means of negotiations all differences between Texas and Mexico should be settled and independence of Texas acknowledged. The Rio Grande was agreed upon as the boundary." Wharton added, "These bargains struck, El Presidente embarked on a schooner . . . on June 3, 1836. . . . He was quite happy at having traded these treaties for his life." Returning in disgrace to Mexico, he lost the presidency and retired to his hacienda at Manga de Clavo. Later, true to form, he claimed that "the treaties meant nothing because he had signed under duress and only as a private citizen." Mexico rebutted them but in 1837 the United States recognized Texas independence.[4]

But Santa Anna's career was not yet over, and it is worth briefly reviewing his further dealings with the United States. In the 1838 so-called Pastry War his left leg was hit by French grapeshot during a bombardment of Veracruz and had to be amputated. He became the "hero of Veracruz." Right then, Mexico needed a hero. The national government was ineffective, frustrated by local political bosses; so in 1839 President Bustamante named Santa Anna acting president. He waited until 1841 before ousting Bustamante and assuming dictatorial power. On October 6 he arrived in Mexico City in a carriage drawn by white horses to rule in person, "with his greed equaled only by his extravagance." He incensed the elite, the Church, and the army; he raised taxes and sold fake mining shares to foreign investors. But the increased revenues were spent on ostentatious extravagances. When the treasury was bare in 1842 the army, demanding to be paid, rebelled. Santa Anna went into hiding, but government troops captured him in 1845, and he was banished for 10 years.

Ironically, the means for his reinstatement as national leader was provided by the United States, then seeking to acquire some of Mexico's territory. The United States annexed Texas in 1845, and President James K. Polk's administration supported Texas' earlier claim that the Rio Grande was the frontier. That would give Santa Fe, New Mexico also to America. When Mexico refused to sell, Polk sent troops into the disputed region. Shots were exchanged, but the United States was not sure that it could win a war with Mexico. From exile, Santa Anna persuaded the United States that only he could settle the dispute over Texas. Polk ordered American warships to allow the general safe passage to Veracruz. But Santa Anna, always consistent in character, double-crossed him. He immediately began to mobilize against the United States and in August 1846, within a month of his return, he was leading his troops northward. Valentín Gómez Farías, then Mexico's president, named him *generalissimo*.

Santa Anna regained the presidency in December. In February 1847, at the head of an army of eighteen thousand, he lost the battle of Buena Vista to General Zachary Taylor. Retreating, he returned to Mexico City to regroup and turn east, only to be defeated again at Cerro Gordo by Winfield Scott, then advancing on the capital. Secret negotiations failed, and the city fell in September. The Treaty of Guadalupe Hidalgo of February 2, 1848, ended the war. Mexico ceded all territory north of the Rio Grande and the Gila River across the Colorado to the Pacific—almost half the country. The United States paid Mexico $15 million and took over $3.25 million in claims by U.S. citizens against the former Mexican government.

Again in disgrace, Santa Anna resigned. In April 1848 he went into exile in Jamaica, where remained until 1850 before moving to New Granada (modern Colombia). Much of his Mexican property had been confiscated, so he "quietly built a new estate in South America and waited until his countrymen so mismanaged the nation that they would let him return." In January 1853 the conservative Centralist Party recalled him but "again power turned his head."

Tuck writes that they "wanted a European prince to rule over Mexico . . . [and] until a selection could be made, Mexico would need a military dictator to keep order. . . . [The Centralist leader, Lucas] Alamán felt that Santa Anna was the only figure with enough experience to do the job. In February Santa Anna again took control." At the end of the year the general decreed that his dictatorship should be extended indefinitely and demanded to be addressed as "His Most Serene Highness." To increase his army, without consultation he sold territory south of the Gila River to the United States for $10 million. Tuck continues, "Alamán, the only man who could control [him], died in June. Without Alamán to restrain him, Santa again depleted the treasury with his wild extravagance. In 1854 a *junta* of liberals . . . drove him out of office and into exile."

For 11 years the ever-duplicitous Santa Anna plotted his return to Mexico. He "invested most of his property" in a vessel that he sailed to New York and offered to become "the nucleus of a planned invading force from the United States." In 1866 the U.S. government, opposed to the French-backed emperor of Mexico, Archduke Maximilian, again enabled him to return to Mexico; his countrymen promptly returned him to Cuba, and the liberals deposed the erstwhile emperor without his help. Until 1874 Santa Anna lived in Havana and Puerto Plata, Cuba, the Dominican Republic, and Nassau. His role in Mexican politics was over. In 1874 he was allowed to return to Mexico City. Tuck wryly remarks, "The first thing he did was to demand a large pension on grounds of 'past services to the nation.'" Santa Anna lived in obscurity, almost blind, and "in part, on the charity of relatives and friends" until his death in June 1876.

Many American historians portray "the most famous and infamous" of nineteenth-century Mexicans in a way that opens them to suspicion of bias. Mabry observes that "to U.S. citizens, especially Texans, his reputation is unsavory. Mexicans tend to have mixed opinions. Most . . . agree that he was a man without integrity, an opportunist." But Tuck admits that "he was not without courage, was a superb organizer, and his colossal ego and reckless extravagance undoubtedly served him well in a *macho* society. . . . As for the numerous betrayals and doublecrosses that marked his career, they could be explained as actions of one with a finely honed sense of real politik" and remarks, "If ever a man embodied *chutzpah*, it was Antonio López de Santa Anna."

NOTES

1. Young, Kevin R, "Alamo's Significance," *The Alamo Forum*. www.tamu .edu/ccbn/ccbn/dewitt/adp/central/forum/forum36.html#significance2

2. Matyszczyk, Stephanie, "The Alamo as a Pyrrhic Victory: The Mexican Experience in the Battle of the Alamo," *Lethbridge Undergraduate Research Journal*, 1(no. 2), 2007.

3. De la Peña, Jose Enrique, *With Santa Anna in Texas: A Personal Narrative of the Revolution*. Translated and edited by Carmen Perry. College Station: Texas A & M University Press, 1997.

4. Wharton, Clarence R., *El Presidente: A Sketch of the Life of General Santa Anna*. Austin, TX: Gammel's, 1926.

FURTHER READING

Baugh, Virgil E. *Rendezvous at the Alamo: Highlights in the Lives of Bowie, Crockett, and Travis*. Lincoln: University of Nebraska Press, 1985.

Callcott, Wilfrid Hardy. *Santa Anna: The Story of an Enigma Who Once Was Mexico*. Hamden, CT: Archon, 1964.

Castañeda, Carlos E., ed. *The Mexican Side of the Texas Revolution*. Washington, DC: Documentary Publications, 1971.

Crisp, James E. *Sleuthing the Alamo: Davy Crockett's Last Stand and Other Mysteries of the Texas Revolution*. New York: Oxford University Press, 2005.

Davis, William C. *Lone Star Rising: The Revolutionary Birth of the Texas Republic*. College Station: Texas A & M University Press, 2006.

Davis, William C. *Three Roads to the Alamo: The Lives and Fortunes of David Crockett, James Bowie, and William Barret Travis*. New York: HarperCollins, 1998.

Fowler, Will. *Santa Anna of Mexico*. Lincoln: University of Nebraska Press, 2007.

Hansen, Todd, ed. *The Alamo Reader: A Study in History*. Mechanicsburg, PA: Stackpole, 2003.

Hardin, Stephen L. *The Alamo 1836, Santa Anna's Texas Campaign*. Westport, CT: Praeger, 2004.

Hopewell, Clifford. *James Bowie, Texas Fighting Man: A Biography*. Austin, TX: Eakin, 1994.

Huffines, Alan C. *Blood of Noble Men: The Alamo Siege and Battle: An Illustrated Chronology*. Austin, TX: Eakin, 1999.

Lemon, Mark, et al. *The Illustrated Alamo 1836: A Photographic Journey*. College Station: Texas A & M University Press, 2007.

Lofaro, Michael A., ed. *Davy Crockett*. Knoxville: University of Tennessee Press, 1985.

McDonald, Archie P. *Travis*. Austin, TX: Jenkins, 1976.

Olsen, James S., and Randy Roberts. *A Line in the Sand: The Alamo in Blood and Memory*. New York: Free Press, 2001.

Peña, José Enrique de la. *With Santa Anna in Texas: A Personal Narrative of the Revolution*. College Station: Texas A & M University Press, 1997.

Santa Anna, Antonio López de. *The Eagle: The Autobiography of Santa Anna*. Austin, TX: State House Press, 1988.

Todish, Timothy J. *Alamo Sourcebook, 1836: A Comprehensive Guide to the Alamo and the Texas Revolution*. Austin, TX: Eakin, 1998.

Turner, Martha Anne. *William Barret Travis: His Sword and His Pen*. Waco, TX: Texian, 1972.

Winders, Richard Bruce. *Sacrificed at the Alamo: Tragedy and Triumph in the Texas Revolution*. Abilene, TX: State House Press, McMurry University, 2004.

INTERNET SOURCES

Alamo. www.thealamo.org/main.html

Lofaro, Michael A. "Crocket, David." *Handbook of Texas Online.* www.tshaonline .org/handbook/online/articles/CC/fcr24.html

Mabry, Donald J. "Antonio López de Santa Anna (1794-1876)." www.historicaltex-tarchive.com/sections.php?op=viewarticle&artid=159.

Tuck, Jim. "Master of Chutzpah: The Unsinkable Antonio Lopez de Santa Anna." www .mexconnect.com/mex_/history/jtuck/jtsantaanna.html

Alcatraz, San Francisco, California

"On a clear day, you can see Alcatraz."

Alcatraz is among San Francisco's most popular tourist destinations, with 1.4 million visitors taking day or night tours each year. Many of the city's shops sell souvenirs—refrigerator magnets, key rings, shot glasses, coffee mugs, postcards, models of the island (incongruously including snow domes), replica handcuffs and guns, spoons, chocolate bars, puzzles, and caps and t-shirts emblazoned "Alcatraz" or bearing portraits of some of its more infamous residents. The U.S. Library of Congress holds about fifty fiction and nonfiction English-language titles about the prison, for adults and children; many are graphic memoirs of former inmates or guards. The fact that nineteen books have been published since 2000 is an indicator that a consciousness of Alcatraz remains very much a part of American culture. Only 3 years after the prison opened Hollywood made a B-grade movie called *Alcatraz Island. The Last Gangster*, starring Edward G. Robinson and James Stewart, followed in the same year and until 1996 by fourteen more films.

In the popular mind the word *Alcatraz* conjures a dark image of an escape-proof "little iron curtain world of lost souls sitting in the shadow of the Golden Gate," reserved for America's most desperate, incorrigible criminals. That picture was deliberately created by the "New Dealers" in the 1930s in response to the nation's question, "What are you doing to protect us from rampant crime?" and fostered and embellished by Hollywood and tabloid newspapers.

Alcatraz is among a number of erstwhile prisons throughout the world, now tourist attractions, which appeal to our morbid fascination with crime and punishment. Each reflects what a society *was* and *how it changed*. As will be shown, Alcatraz is twice iconic: not only an intimidating former prison, but a symbol of freedom for Native Americans.

Alcatraz's meaning has changed several times, whether by political will, by social manipulation, or by the power of the people. That meaning is as complex as its colorful history, and the stylistic and functional diversity of its architecture is almost irrelevant. During 160 years of U.S. government occupation the island has been also a lighthouse station (its only continuous nonindigenous association), an artillery emplacement, a military stockade, a political symbol for Native Americans, and a national park and bird sanctuary.

Although it was America's version of Devil's Island for less than one-fifth of that time, it is the notorious federal penitentiary looming out of the fog on the "grim, tide-gnawed rock" that is an icon of American architecture.

THE YEARS WHEN LITTLE HAPPENED

Alcatraz is a waterless rocky island, 1½ miles offshore from San Francisco Bay's northern marina. Rising precipitously to 130 feet above sea level, it is about 19 acres in area and at its widest approximately 500 feet across. It was visited—but never occupied—by the indigenous Coastal Muwekma and

Costanoan people (aka Ohlone, "people of the west") who settled nearby grassy and wooded Angel Island about 2,000 years ago. Then, as now, Alcatraz was a rookery for many species of seabirds and thus a source of eggs. Some writers, basing their speculation on oral history, claim that the islet was believed to "harbor evil spirits, and used to isolate or ostracize tribal members who had violated a taboo," rather incongruously adding that it could have been a hiding place for Indians attempting to escape the Spaniard's California Mission system. Evil spirits and punishment are hardly compatible with voluntary flight and sanctuary, and such assertions may stem from a *post facto* construct related to the Europeans' consecutive military and civil prisons.

The first nonindigenous people to see Alcatraz were with the Spanish explorer Lieutenant Juan Manuel de Ayala when he sailed the packet boat *San Carlos* into San Francisco Bay on the night of August 5, 1775. They spent the next 6 weeks exploring the area. Making charts from a small boat, Ayala's pilot, José de Cañizares described an island "so arid and steep there was not even a boat harbor there: I named [it] *La Isla de los Alcatraces* because of their being so plentiful there." *Alcatraces* is an archaic Spanish word for a seabird—perhaps gannet, pelican, or cormorant. By 1826 the name was anglicized to Alcatraz.

After more than a decade of conflict with Spain, the Republic of Mexico was constituted in 1824 and laid claim to former Spanish territories including California. According to most sources, in April 1846 one Julian Workman, a naturalized resident of Los Angeles, petitioned California's Governor Pío de Jesus Pico IV for tenure of Alcatraz under a Mexican law that allowed the secession of coastal islands to approved Mexican citizens. Title was granted in June on condition that Workman build a lighthouse. He immediately transferred ownership to his son-in-law, one Francis Temple, just as the Mexican–American War reached the West Coast; before Temple could take possession of the island, American Naval forces seized California. The War was ended in February 1848 by the Treaty of Guadalupe Hidalgo, and because no lighthouse had been built under the land grant, the U.S. government rejected private ownership claims. Aware of its strategic significance, California's acting Military Governor John Charles Frémont personally paid Temple $5,000 for the unoccupied island on behalf of the government; it seems that his repeated applications for reimbursement were turned down.

FORTRESS ALCATRAZ

Gold was discovered in the Sierra Nevada foothills in January 1848. In the ensuing Gold Rush, San Francisco's population grew from about 450 in 1847 to an estimated 100,000 by the end of 1849. A little over one-third of the newcomers arrived by sea in the second half of 1849, at the rate of one thousand a week. With the vast mineral wealth and the inevitable mass migration

to the West Coast, the U.S. government needed to secure its citizens, its borders, and its resources; and in 1850 plans were put in hand for a lighthouse and a military installation on Alcatraz.

In 1847 only six trading vessels had entered San Francisco Bay. But from April to December 1849 the number of ships was about 550, emphasizing the urgent need for a lighthouse in the foggy harbor. In line with the passage through the Golden Gate, Alcatraz was a logical site, and its tower was the first in a chain of eight that the Baltimore firm of Gibbons and Kelly built along the northwestern coast of the United States. Although Congress appropriated funds in 1850, an "advance crew" did not begin the foundations until mid-December 1852. Construction of the white-painted two-story cottage with a 52-foot tower at its center began at the end of January 1853 and was completed 6 months later. Even when the lens for the light arrived the following October, "budget problems" delayed its commission. That finally happened on June 1, 1854. A fog bell—necessary because the light was not always visible—was added in 1856.

In 1850 an executive order from President Millard Fillmore reserved strategic lands—the old Presidio, Fort Mason, the Golden Gate's north wall, the Marin Headlands, Angel Island, Yerba Buena and Alcatraz—to protect the burgeoning city of San Francisco, especially in the threatening shadow of war with Spain. When Congress approved funding in 1852 a Board of Engineers for the Pacific Coast was appointed to oversee construction of a "triangle of defense" at Fort Point, Lime Point, and Alcatraz for the entrance to the Bay.

Alcatraz was given priority and in the following year First Lieutenant Zealous B. Tower (who eventually rose to be Brigadier General) began work. The fortress consisted of a number of "barbettes" (gun platforms), mostly facing the Golden Gate, that were quarried from the rock and protected by masonry breastworks. When its emplacements were completed in April 1855, the first permanent harbor defense of the West Coast fairly bristled with ordnance. The largest guns, of 15-inch bore, had a range of 3 miles. The steep cliffs around the island were blasted to make storming the defenses more difficult.

The sole access to the island was from a pier on the northeast side, defended by a casemate (bomb-proof enclosure) with eleven cannons. From the landing point the only way to the lighthouse, barracks, and service buildings on the highest ground was along a narrow road, heavily defended by a sally port near the dock. The massive fortified barracks at the summit of the island—aptly nicknamed "The Citadel"—was designed as a last line of defense by Second Lieutenant Frederic E. Prime. Enclosed by a dry moat, the plain 3-story brick building accommodated officers, non-commissioned officers (NCOs), and enlisted men, as well as service areas and storage spaces. Surrounded with rifle slots protected by iron shutters, its first level (the only part that survived a series of remodelings), formed a half-basement. The ground level—also with narrow windows that could serve as rifle slots—was reached across drawbridges at each end. The third level had slightly wider windows, and the roof

was surrounded with a parapet over which infantry could fire. It was completed in November 1859.

A month later Captain Joseph Stewart took command with the eighty-six strong Company H, Third U.S. Artillery. Alcatraz was replete with barbette batteries housing seventy-five large-caliber cannons ringing the island beneath the Citadel. The whole island was a fortification. During the Civil War, the defenses were reinforced with three more batteries—a total of 101 guns and nineteen howitzers. Immediately after the War, the ordnance was gradually augmented, and by 1868 the island boasted fifty unmounted and 103 mounted pieces. But none was ever fired in anger.

> As the initial exuberance at the end of the Civil War turned to a sober realization of the war's great cost, the country's political climate changed more and more to one of isolationism. . . . The Army's energies became centered on its role as a frontier constabulary, rather than as a force to be pitted against other modern military establishments.[1]

Then Alcatraz's military development suddenly ended. Being unrifled, most of her guns were considered too obsolete to defend the harbor and were removed. The Island began its metamorphosis to a prison.

FROM CANNONS TO CONVICTS

The first military prisoners—eleven men court-martialled for "infractions of Army Regulations"—arrived on Alcatraz with the original garrison in 1859. The Rock soon became a conveniently isolated prison to which other military posts sent their "problem" soldiers, until in August 1861 the Army designated it as the official stockade for the Department of the Pacific. Before long, the increasing number of inmates was further augmented by recaptured deserters and servicemen who had committed serious crimes. All were incarcerated in overcrowded conditions in the unsanitary basement of the sally port, where cells were shared with as many men as could fit in the space, sleeping head to toe on the floor, on wooden pallets and "vermin-breeding straw tick mattresses." The first room was located barely above the high tide mark, and the lack of fresh water and the absence of a latrine made the guardhouse "pestilential in the extreme."

Two years later convict laborers constructed a 20- by 50-foot temporary wooden cell block north of the prison. It was followed by several other structures nearby, constituting the "Lower Prison." In 1867 a brick cell block that provided a 6- by 3½-foot space for each man was built on top of the sally port. Until the end of the century, the Lower Prison housed an average of one hundred inmates. Then, partly to house prisoners taken in the Spanish–American War of 1898, many serving short sentences, the number increased by about five times in the first years of the twentieth century. In 1904 an

"Upper Prison"—a stockade enclosing three timber-framed two-story cell blocks—was built on the parade ground. Over the next few years prisoner work crews added a mess hall, kitchen, workshops, library, and a wash-house. The original Lower Prison, which had been almost burnt down in 1902, was refitted as workshops. That fire, and those that devastated San Francisco as a result of the April 1906 earthquake, prompted the administration to replace the timber buildings with masonry ones.

In March 1907 the last infantrymen left Alcatraz. Command passed to Major Reuben B. Turner of the Third and Fourth Companies of the U.S. Military Guard, and the island was redesignated "Pacific Branch, U.S. Disciplinary Barracks, Alcatraz." Demolition of the upper two stories of the old Citadel began late in 1908, the basement level and moat being retained as a starting point for the first permanent prison building. Designed by Turner and built by prisoner labor, the state-of-the-art reinforced concrete cell house—barges brought in all materials and building equipment—was completed in February 1912. It had central steam heating, skylights, and electricity, and its vast main space contained four blocks with a total of six hundred one-man cells, a dining hall and kitchen, a hospital (removing the risk of transferring inmates to the mainland for treatment), offices, and a recreation yard. Turner also built a simple rectangular two-story power plant. Eighteen months later a strange review of the development appeared in the *San Francisco Chronicle*, making the establishment sound a little like a resort:

> Standing in the center of the San Francisco Bay and commanding a full view of the Golden Gate, it is one of the beauty spots of the bay, its splendid, large, white stone buildings gleam brightly in the sunlight and make a conspicuous showing for many miles. As a prison it is ideal both as to location and buildings. Around the island erratic currents sweep, making it practically impossible for a prisoner to escape by swimming, could he elude the vigilant guards. The prison buildings are new, scrupulously clean and are light and airy, with modern plumbing in each cell, electric lights and comfortable beds. There are 200 shower baths for prisoners, a library, barber shop and all possible comforts—saving liberty.[2]

The utilitarian aesthetic of the cell house, with minimal quasi-classical detailing, was nothing to write home about. The concrete ground floor walls simulated coursed masonry; above them a simple molding carried shallow Tuscan pilasters, dividing a plain wall crowned with a low-profile cornice. The windows were simply unadorned rectangular holes. The plainness—it must be said, *uninformed* plainness—may have been an indicator of Turner's architectural education or artistic skill, or (less likely) an attempt to find that *architecture parlante* appropriate to prisons that so long had eluded architects. Certainly it demonstrated that visual considerations were not paramount.

The new prison building blocked the light from the original 50-foot lighthouse, which also had been damaged in the 1906 San Francisco earthquake.

The rather more ornate electricity-powered 84-foot reinforced concrete tower that replaced it was completed in December 1909.

Soon after the state-of-the-art military prison was completed, changes in penological philosophy (at least, in the military) were in the wind. The *San Francisco Chronicle* reported

> Saving for the most hardened offenders . . . Uncle Sam does not intend to keep his soldiers who have erred behind prison bars much longer. Deserters, men who have proved insubordinate, men who have in a thousand and one ways broken the military regulations so that courts martial have condemned them to imprisonment, are going to be given another chance to make good. They are going to be placed in disciplinary barracks where they will drill like soldiers and perform soldierly duties. Then when they show that they want to prove themselves fit to again wear the uniform they will be released, reassigned to regiments and given another chance to earn their honorable discharges. Incorrigibles and men who have committed grave crimes will be sent to Leavenworth.[3]

The average age of prisoners was 24, and most were serving short sentences for relatively minor offenses. Alcatraz was a minimum-security institution whose inmates attended "remedial education and vocational training" sessions. Many later returned to duty; some were given a dishonorable discharge. "With labor" varied according to a prisoners' offense and responsibility; some were assigned as domestic servants and even babysitters for officers' families; others crushed rock in the quarry on Alcatraz.

Because everything used on the island, including water, had to be brought by barge from the mainland, the cost of maintaining the military prison became prohibitive, especially as the Great Depression tightened its grip. The decision to close the facility in June 1934 coincided with another growing social need in America. There soon would be changes at Alcatraz.

A "DEVIL'S ISLAND" OF OUR VERY OWN

By the early 1930s the widespread poverty caused by the incipient Great Depression and the corruption generated by Prohibition (the Volstead Act had been in effect for 10 years) were sources of increasing organized crime in American cities, and lawlessness in rural areas. The era's notorious criminals—Al Capone, Bonnie Parker and Clyde Barrow, the Ma Barker gang and others—were kept in the public eye by newspapers and a plethora of lurid true-crime magazines like *True Detective*, *Police Gazette*, *Master Detective*, and *Police Story*. By the early 1940s an estimated two hundred fifty titles were in print. A recent commentator significantly noted that though there was "public fascination with psychopathic violence" these graphic accounts "invariably [ended] with more general invocations of the need for tough measures against criminals of all sorts." Encouraged by what the American public

read, a "cry went out to take back America's heartland," as another writer put it.

Moreover, the matter was taken up by politicians and bureaucrats. Anthropologist Joel Gazis-Sax writes that in 1933 Sanford Bates, director of the Bureau of Prisons, drew the nation's attention (as though it was necessary) to the "bold and ruthless depredations of a small group of desperate criminals" whose prominent exposure in the media undermined the public's trust in the Federal Prison System. Bates lamented the evil influence of these desperados on "the man who is a criminal by force of circumstances, the accidental offender, the feeble-minded, the under-privileged and the sorely tempted" simply because they were incarcerated in the same prisons. Attorney General Homer Cummings warned that the United States was "confronted with real warfare which an armed underground is waging upon organized society . . . a war that must be successfully fought if life and property are to be secure in our country."

On a national radio broadcast of October 12, 1933, Cummings emphasized that the worst offenders would be put out of reach in a new type of federal prison "on a precipitous island in San Francisco Bay, more than a mile from shore. The current is swift and escapes are practically impossible. . . . Here may be isolated the criminals of the vicious and irredeemable type." The following day *The New York Times* confirmed that the Bureau of Justice had taken over the former military prison on "rocky, inaccessible Alcatraz Island . . . for confinement of defiant and dangerous criminals." The well-chosen words covered it all: "rocky," "defiant" and "dangerous" fit the punishment to the crime; "inaccessible" reassured the public of security against the forces of evil. Many of Cummings' words were rhetorical, and many of his actions symbolic. Primarily, the establishment of the federal penitentiary on Alcatraz was a political move—after all, none of the Army's reasons for leaving had changed and maintaining a civilian prison would cost the American taxpayer no less. But if for a while it soothed a restive public, even by creating an illusion of security in the big cities, it was a worthwhile investment.

In the middle of 1934, after $263,000 had been spent on sophisticated physical and technological modifications to Turner's 1909–1912 cell house, *The New York Times* followed with, "Equipped with the latest devices to prevent escape . . . the 'Devil's Island' of the Government prison system is ready to receive incorrigible convicts." After a couple of weeks the newspaper reinforced the announcement with the evocative, verbose headline, "Alcatraz prison also a fortress; on its lonely rock it is as secure as man and nature are able to make it." And more than 60 years after its closure that is what the name "Alcatraz" normally conjures in the public mind.

English historian Michael Woodiwiss claims that "Alcatraz held unlimited potential for the writers of popular fact and fiction. It almost immediately became part of American folklore." Only 4 years after the penitentiary was opened Yip Harburg would include in the lyrics of "Lydia the tattooed lady,"

one of Groucho Marx's signature tunes in *At the Circus*: "For two bits she will do a mazurka in jazz, / With a view of Niagara that nobody has./ And on a clear day you can see Alcatraz./ You can learn a lot from Lydia!" The movie was internationally released, and when we consider that for comic effect Alcatraz is bracketed with such familiar references as the Battle of Waterloo, Lady Godiva, Niagara Falls, Picasso, and Nijinsky its instantly *international* iconic quality becomes obvious. Indeed, Woodiwiss' observation could be stated without qualification: "It almost immediately *became part of folklore.*"

THE WHAT-MAN OF WHERE?

Folklore inevitably embraces myths. And there is little doubt that the "official" secrecy that swathed the grim penitentiary—the press was forbidden to visit the island—and the popular appetite for the salacious combined to generate an Alcatraz mythology. Perhaps the best-known theme was in Thomas Eugene Gaddis' 1955 book, *Birdman of Alcatraz: The Story of Robert Stroud*, made into a movie by MGM in 1962. Nominated for four academy awards, the film was a huge success at the box office.

Hollywood has never let truth stand in the way of a good story, and the "taglines" read "Inside the rock called Alcatraz they tried to chain a volcano they called 'the birdman,'" and "Now the world will know the story of the most defiant man alive!" Because of it, the hitherto unknown Robert Franklin Stroud was probably Alcatraz' most famous prisoner. But he never had a single bird in the 17 years that he was there. Nor did he in any way resemble Burt Lancaster (who portrayed him in the film); far from a benign, bespectacled, bearded grandfatherly figure, Stroud was a gaunt, balding, hatchet-faced, thin-lipped man with a history of psychotic episodes.

In Alaska in 1909, when 18 years old, he shot a young bartender to death, seemingly over a mere $10. Convicted of manslaughter, he was sentenced to 12 years imprisonment in McNeil Island federal penitentiary. Soon after arriving there he stabbed (though not fatally) a fellow prisoner, and with a 6-month extension to his sentence, he was transferred to Leavenworth. Almost immediately he became a disciplinary problem. After several minor misdemeanors, on March 25, 1916, and in front of a thousand witnesses, Stroud in an aggressive outburst used a "shank" to stab to death a guard with whom he'd had ongoing conflicts. He was convicted of murder and sentenced to hang. Stroud's mother hired a lawyer to appeal the verdict. It stood, but his sentence was reduced to life imprisonment. At a second retrial, Stroud was again found guilty; this time, after more than 2 years of legal wrangles, he was resentenced to death. A third challenge was again unsuccessful, and the death sentence was upheld. Finally, in 1920 President Woodrow Wilson commuted it to life imprisonment without parole. Because of Stroud's erratic eruptions of violent behavior, he was permanently segregated.

During the 30 years spent in Leavenworth he studied birds. Starting with two sparrows that he found in the yard, later he requested a canary; and his collection grew eventually to hundreds, kept in wire cages stacked in two adjoining cells. Stroud bred and sold canaries, developing a lucrative business and attracting international attention from the bird-lovers' community. His research was published in two books, *Diseases of Canaries* (1933) and *Stroud's Digest on the Diseases of Birds* (1943). At first, prison officials encouraged Stroud's studies because of the publicity value for the prison. But soon there were problems. As one biographer notes:

> Stroud had become an administrative nightmare. The huge volume of mail and special requests that he burdened the staff with on a daily basis came to be al- most unbearable. The task of censoring his copious mail and filling his orders for bird feed, reading materials, and other research items could have justified hiring a full-time personal assistant. Leavenworth was severely overcrowded, yet he was allowed to maintain residence in two cells. . . . Stroud's birds and his research had at one time, but now his demands had become a bitter nuisance to the administration.[4]

In December 1942 he was transferred to Alcatraz where he spent the next 17 years, 6 years in segregation on the third tier of D Block, after which, because of his mental condition that gave rise to violent mood swings, he was moved to the prison hospital where he "endured the deepest lock-down of his imprisonment." In 1959 he was again transferred, this time to the Medical Center for Federal Prisoners in Springfield, Missouri. On November 21, 1963, he died of natural causes at the age of 73. Stroud had been incarcerated for 54 years, all but 10 of them in segregation. Although he may have been "the bird doctor of Leavenworth," he never was the Birdman of Alcatraz.

THE ROCK OF DESPAIR

The 60-year-old lawyer, civic leader, and banker James A. Johnston, Alca- traz's first warden, had formerly worked in the California Department of Cor- rections. One writer claims that despite his reputation as a humanitarian reformer, by the time he reached Alcatraz he had thoroughly embraced the theories of Frederick Winslow Taylor, known as the "father of scientific man- agement." Johnston's program—probably the most inflexible in the U.S. cor- rectional system and long anachronistic in penological terms—was designed so that "big men were to be made small." He created a penal purgatory, "the Rock of Despair." According to Joel Gaziz-Sax,

> It was impressed [on an inmate] that he was powerless. . . . The function of the case-hardened steel bars; of the labyrinth of catwalks and barbed wire crisscrossing the skies over the prisoners' heads; of the dank, brick dungeons

underfoot; of the empty isolation rooms; of the sacrosanct rule of silence; of the mirror sheen of the concrete floors; and of the guards who moved up and down the aisles [counting each man] was to evoke . . . awe of the penitentiary. The Rock was intended to be a place of ignominious anonymity and damnation for the prizes in the war on crime.[5]

In order to hold America's "most poisonous malefactors" considerable alterations were made to Turner's original reinforced concrete cell house. Robert Burge, one of America's foremost security experts, was commissioned as consultant under the joint guidance of Cummings, Bates, and Johnston. Beginning in April 1934, the soft strap-steel fronts and doors of 336 of the 600 cells (Blocks B and C) were replaced with tool-proof steel bars, fitted with remote locks that allowed guards to operate the doors row by row. None of the four three-tiered blocks within the cell house touched a perimeter wall. They were separated by corridors (later given such ironic nicknames as Times Square, Broadway, Park Avenue, and Michigan Avenue) with highly polished green concrete floors.

Alcatraz, with a total of approximately 1,545 inmates over 29 years, never reached its capacity as a civilian prison. The average population was about 260, less than 1% those held in federal facilities. The highest recorded occupancy was 302, and the lowest 222. Inmates were assigned a cell in B or C block. D Block contained thirty-six segregation cells and six solitary confinement cells. Apart from occasional emergency occupancy, A Block was utilized for materials storage. There was also a library and barbershop on the main floor of the cell house. Multilevel gun galleries at each end of the building allowed patrolling guards to carry weapons behind protective bars and wire mesh. Tool-proof steel bars with alloy steel cores secured all the windows. The old ducts and tunnels that honeycombed the island were concreted to make them "prisoner proof."

The administrative offices were located at the southern end of the cell house; a large space that doubled as a chapel and movie theater occupied the floor above them. The kitchen and mess hall were at the northern end. Remotely activated tear gas canisters—they were never discharged—were installed in the mess hall and main entrance, and metal detectors were located outside the dining hall and on the access paths to the workshops. A hospital above the mess hall had treatment, operating and X-ray rooms, a dental clinic, and several small wards (including a psychiatric unit), all staffed by U.S. Public Health Service employees. Shower rooms and clothing stores were located in the basement of the kitchen wing.

The recreation yard, a bleak concrete rectangle west of the kitchen was a little smaller than a football field, and enclosed by 20-foot high walls patrolled by armed officers. Plain concrete bleachers abutted the main building. A laundry and dry-cleaning plant and workshops were housed elsewhere on the site. An armory protected by tool-proof steel was constructed near the main entrance,

outside of but close to the cell building. Four tall guard towers were strategically positioned around the barbed-wire fence of the 7-acre prison compound. Searchlight towers and floodlights were also installed, as well as telephone and shortwave radio connections to the mainland.

Some employees were provided with rental accommodation. The first contingent numbered about seventy-four, about fifty of whom were correctional officers (some with families) handpicked by Warden Johnston from other institutions. He noted in his first report that the three-story former barracks—known as the "Sixty-four Building," it was next to the dock—had been converted into twenty-seven apartments for single men and a few families "to the end that we would have a sufficient number of custodial officers available . . . to meet any emergency." The rudimentary apartments had 12-foot ceilings, uneven floors, and steam radiators. The building also housed a post office and a canteen. On the other side of the parade ground there were newer three-bedroom apartments boasting stainless steel sinks, balconies, and "spectacular views of San Francisco." A large house was built for the warden adjacent to the cell house, and a duplex was provided for the captain and associate warden. Besides the correctional officers—about one third of whom lived on the mainland—there were twenty-five office staff, a "Religious, Welfare and Educational Director," health workers, and workshop foremen. Eventually, in addition to the prisoners, about three hundred civilians—men, women, and children—would be living on Alcatraz at any given time. They had their own bowling alley, soda fountain shop, and a convenience store. The prison boat made twelve return trips daily, so most shopping was done on the mainland.

The penitentiary was ready for occupation by mid-August 1934. The military had withdrawn about 6 weeks earlier, leaving behind thirty-two "hard case" prisoners—murderers, robbers, rapists, and homosexuals. By June 1935 the total number of civilian prisoners in Alcatraz stood at 242; there was one guard for every three, compared to an average ratio of one to seven in other penal institutions. The first cohorts came from Washington State's McNeil Island, and from the federal penitentiaries at Lewisburg, Atlanta, and Leavenworth. Federal prisons throughout the country had been encouraged to send their least redeemable inmates with "histories of unmanageable behavior" to The Rock. As one authority explains, prisoners were not directly sent to Alcatraz by the courts; rather, "they 'earned' their transfer . . . by attempting to escape, exhibiting unmanageable behavior, or . . . had been receiving special privileges." The "birdman" certainly fit the latter category. So did Al "Scarface" Capone.

AN ARISTOCRAT AMONG CRIMINALS—NO LONGER

Alphonsus Gabriel Capone, who in 1925 had "inherited" an organized crime empire—bootlegging, prostitution, and gambling—in Chicago, worth $100

million a year (about $1.2 billion at today's values), was among the first federal prisoners transferred to Alcatraz. Capone eluded the law through violence and murder, intimidation and bribery, until in October 1931, following investigation by IRS intelligence agents led by Elmer Iray, he was convicted of income tax evasion. After a failed appeal, in May 1932 Capone was sentenced to 11 years imprisonment in the federal prison in Atlanta, Georgia.

There, he bribed guards to obtain special privileges, such as unlimited visits and having uncensored reading materials and alcohol smuggled to him. And he continued to run his Chicago rackets through subordinates who had taken rooms in a hotel near the prison. But as a result Capone was transferred to Alcatraz where tight security and Warden Johnston ensured that he had no contact beyond the island. The swaggering crime boss was soon disabused of the view that life would be the same as in Atlanta.

On The Rock, despite several attempts to buy favor and flaunt his power, he was treated the same as any other inmate. Strange as the claim may seem, Capone was different from the "veterans of the penal system" who were part of the first transfer to Alcatraz. Unfamiliar with prison culture, he was continually harassed; threats—and actual attempts—on his life necessitated his protection by inmates paid by his declining crime syndicate. He made enemies among the prisoners, partly for his arrogance and partly because some "detested [him] because of his wealth, short sentence, and because his men had 'taken care of' some of their friends."

One historian notes, "Fearing for his life, [he] did not use the recreation yard; instead, he retreated to a basement shower room where he played his banjo." His jobs included work in the laundry and cleaning the showers and latrines, for which (it is said) he earned the sobriquet, "the wop with the mop." After 4½ years in Alcatraz his mental state began to deteriorate. He was diagnosed with irreversible syphilis, contracted decades earlier, that had reduced him to a "confused, babbling and docile" wreck. He completed his term in January 1939 and was transferred to the Terminal Island Federal Correctional Institution in California near Los Angeles, from which he was released in November. Al "Scarface" Capone died of heart failure at his Palm Island, Florida, estate in January 1947. He was 48.

THE "WORST OF THE WORST": LIFE IN ALCATRAZ

In most American prisons convicts shared a cell with at least one other inmate; in Alcatraz each had his own cell. Although in other accounts dimensions vary slightly, a description of a typical cell is best left to Alvin Karpis, "Public Enemy No. 1," who lived in one for 26 years—almost the entire life of the prison:

> It is eight feet by five and one-half feet with an eight-foot ceiling, on which is mounted a twenty-watt light bulb. The bunk is made up with two white [cotton]

sheets and a blanket as well as two more blankets folded military style across the foot of the bed. The bunk hangs by chains from the wall and folds up against the wall when necessary. The toilet is at the end of the bunk beside a small wash basin in the center of the back wall. Under the basin a heavy mesh screen a foot off the floor encloses a ventilator [into the service duct] eight inches wide and six inches high. Eighteen inches from the ceiling a shelf of one-inch plank, one foot wide, sits against the back wall. . . . On the shelf I find the following items: [a safety razor, an aluminum cup for drinking water, a second one with a cake of Williams shaving soap in it, a shaving brush, a highly polished metal mirror, a toothbrush, toothpowder, playmate soap, a comb, nail clippers, Stud smoking tobacco, a corncob pipe, a roll of toilet paper, brown shoe polish, a green celluloid eye shade, a whisk broom . . . , and the rule book.]. In the middle of the wall opposite the bed a steel table and seat fold against the wall when not in use. [Under] the long shelf are several clothes hooks.[6]

The steel-barred fronts of the spartan cells afforded no privacy; along "Broadway" especially, between B and C blocks, prisoners stared across the corridor into another cell. They were denied almost all contact with the outside world. The necessities of life—food, water, clothing, and medical care—were regarded as their only rights; anything else was a privilege. A few examples will suffice. Visits, all needing Warden Johnston's direct approval, were limited to one a month and had to be earned; none was allowed during the first 3 months of "quarantine status." Inmates could also earn access to the prison library—ten thousand books and carefully selected periodicals were available by the end of the first year—but no publications were allowed that gave a glimpse of what was happening in the world beyond Alcatraz. Receiving and sending letters was also a privilege, and all correspondence was censored and retyped by prison staff. Even work was regarded as a privilege that had to be earned by good conduct; without it, the prisoner was condemned to the excruciating boredom of regimented and inflexible routine. But whether working or not, day would pass into indistinguishable day. On weekdays, inmates spent at least 14 hours locked in their cells; the time outside the cells was for working or eating, always at exactly the same moment in exactly the same place.

Awakened at 6:30 A.M., they were allowed 25 minutes to tidy themselves and their cells and stand to be counted (in the course of a day, there were twelve scheduled counts). Then the cells were opened tier by tier, and the inmates marched single file and in silence to breakfast in the Mess Hall. Twenty minutes later they lined up for work details; anyone not "privileged" to work was locked in his cell and came out only for meals. The others worked from 8.20 until 11.35 A.M., with one 8-minute rest period. At noon, 20 minutes were allowed to eat lunch in the Mess Hall, after which all prisoners were "locked down" for a half-hour "break." Work resumed at 1:30 P.M. and continued until 4:10, with another 8-minute break. All prisoners ate the evening meal in the Mess Hall, and by 5.30 P.M. all were locked in their cells for the

night; "lights out" was at 9:30 P.M. That was today's schedule; it was yesterday's; it would be tomorrow's. Only when the weather was bad or the island was fogbound did the daily routine vary: then, because of anticipated escape attempts, inmates were confined to their cells except at mealtimes.

As other wardens succeeded Johnston, there was a little relief from this mind-numbing routine. Revised in 1956, the *Regulations for Inmates, U.S.P., Alcatraz* stated, "As a general rule, you will work eight hours a day, five days a week, with Saturdays, Sundays and Holidays devoted to recreation. Movies are shown twice each month [earlier it had been only once]. Exercise Yard activities include baseball, handball and various table games."

Many former inmates from Alcatraz's early years regarded Johnston's repressive rule of silence as their most unbearable punishment. It is reported that several were driven insane by it. It was derived from the "silent" system introduced in 1816 at Auburn Prison in Cayuga County, New York, where prisoners slept in tiny single-occupancy cells but worked together during the day, although in enforced absolute silence. Most northern and eastern state prisons followed the model after the Civil War, but in the early decades of the twentieth century it was no longer used in the United States.

That is, except at Alcatraz. Prisoners were allowed to converse only to ask someone to pass the salt, pepper, or sugar during meals; for 3 minutes during morning and afternoon work breaks on Monday through Friday; and for 30 minutes in the yard on Saturdays. Despite two unsuccessful (and punished) protests in 1936 and 1937 to have the policy revoked, it remained in force until later in 1937 when Johnston finally capitulated—one of only a few changes he ever made. He told the press that he abolished the rule "to ease the rigidity of discipline"; in return, he was praised for the "humanitarian gesture."

Of course other sounds broke the silence at Alcatraz, all on schedule. In time, their regularity may have made them blend in the environment: an "ear-shattering bell" awakened the inmates each morning; a shrill whistle signalled every phase of the daily routine; and doleful "foghorns at opposite ends of the island [blasted] every twenty seconds and every thirty seconds." But one sound must have remained unnerving: almost every night, the guards had target practice outside the prison wall and the noise of pistols, machine guns, rifles, and riot guns disturbed the prisoners; worse, guards intentionally left the bullet-riddled target dummies lying around until the next day.

"GETTING THE TREATMENT"

Privileges granted for good behavior were taken away for the slightest infraction of the rules. But there were far worse punishments for recalcitrants.

Because the outer blocks, A and D, had not been included in the 1934 upgrade at Alcatraz, for several years they were used only occasionally to temporarily isolate a few troublesome inmates. But following a disastrously

unsuccessful escape attempt in January 1939, the Bureau of Prisons provided funds to secure the forty-two-cell D Block for disciplining delinquent prisoners. Completed in 1941, it became known as the "Treatment Unit." Once segregated, an inmate lost contact with the rest of the prison population. Thirty-six refurbished isolation cells had steel-barred fronts and steel-lined floors, walls, and ceilings. Most were a little larger and (because they faced an outer wall) lighter than those in Blocks B and C; otherwise, they differed little. D Block inmates were not allowed to work and left their cells only for two showers and one visit to the recreation yard each week. All meals were eaten in the cells, and the sole concession was access to approved reading materials.

Dubbed "Black Holes" by prisoners, five of the remaining D Block cells on the bottom tier, the coldest place in the prison, were for solitary confinement. Reserved to punish serious breaches of prison rules, they contained only a sink, a toilet, and a weak light bulb controlled by the guards. A standard barred door stood 3 feet inside a solid steel outer door that excluded all natural light and most sound; of course, that arrangement made the room much smaller. The occupant was denied showers, time in the exercise yard, or books. One account describes how officers flicked lights on at 6:30 A.M. and passed one big lump of oatmeal and prunes soaked into bread through a slot inside the barred door. Then the officers flicked out the lights until the next meal. During the day there was nowhere except the steel floor to sit or lie down. Each night after a meager supper the inmate was handed bedding that he was forced to hand back 20 minutes after breakfast the following morning. According to one former inmate, if a prisoner's attitude did not improve "he remained in the hole—sometimes as long as nineteen consecutive days," the maximum time he could be confined in solitary. If he remained obdurate, guards removed him, fed him a full meal, allowed him to brush his teeth, and then returned him to the hole for 19 days more. It is difficult to imagine a worse existence. But the prison authorities managed to devise one: sensory deprivation.

The remaining "strip cell," also known as the "Oriental," was the most severe discipline. The amazing thing is that it was considered an acceptable way to treat a human being. It was a punishment that even the most case-hardened inmates of Alcatraz truly feared. Alvin Karpis was assigned to the "Oriental" on several occasions—an experience not easily forgotten. He recalled,

> The double doors block out all light even in the middle of the day. The walls and floors are steel, nothing else exists in the small cupboard-like space except a hole in the floor which is the toilet. A guard flushes it from outside the cell. Otherwise, nothing. No bed, no blanket, no book, no shelf, no sink. . . . Standing naked on the damp steel floor, I hear the doors lock behind me and realize that if I [raised both my arms] I would touch both walls and that I might walk about three steps before colliding against the [end] wall. I am supposed to receive one

subsistence meal a day. The bread and water diet has been replaced by a dixie cup of mush . . . [mashed] leftovers from the main line—beets, carrots, spinach . . . a sickly looking puke that is more liquid than solid. . . . Days seem like nights and nights seem like days.[7]

A mattress was provided at night and removed at dawn. Inmates were usually subject to this degree of punishment for only one or two days. That was enough.

ON THE OTHER HAND . . .

When later reflecting on their incarceration, some inmates actually spoke of two "positive" aspects of Alcatraz: single cells and the quality of the food. The first gave at least some degree of privacy and reduced the chance of being sexually violated. And who wouldn't appreciate better food? However, Warden Johnston's motives were hardly altruistic: apart from the fact that they already existed in the military cell house and cost less to convert, single cells further isolated the inmates. He also believed that good food would remove a major cause of the riots that frequently were experienced in other institutions. Under Johnston, prisoner "culinary workers," supervised by trained correctional officers, prepared three balanced meals a day (totalling 3,600 calories) from a 10-day cycle of menus devised by Public Health Service nutritionists. The food was served cafeteria-style from *bain-maries* at one end of the mess hall. Inmates held out their trays in silence to those serving the line, each of whom would give a measured portion of the food he was serving. Those who didn't want a particular part of the meal were not obliged to take it. But whatever they took, they had to eat or face disciplinary action. That meant there was no waste.

Probably under pressure from the Bureau of Prisons, the rigid program of the Johnston years was gradually relaxed, and by 1937 the "Rule of Silence" had been discontinued. By 1940 the mail restrictions were relaxed, and prisoners could correspond with a second relative. In 1945 the men could see one movie a month; a library with fiction, reference, and periodical sections had been organized, and there was a prison band. When Johnston retired in 1948 prisoners were already allowed to undertake approved hobbies in their cells and keep the necessary equipment with them, as well as their own books, drawing materials, writing paper, and educational material. They could even decorate their cell walls with pictures and religious objects.

Johnston was replaced by the "militant and uncompromising" Edwin Swope, whose "patronizing manner" undermined the morale of guards and prisoners alike. Swope was succeeded in 1955 by Paul J. Madigan, who had worked his way up through the prison service, and whose "listening skills endeared him to both personnel and inmates." The last warden of Alcatraz,

"liberal, relaxed" Texan Olin G. Blackwell was only 46 years old when he "inherited an aging, crumbling prison" in 1961 and introduced more generous reforms. One commentator writes that the latter two "helped change Alcatraz from the famous prison of 'punishment and not reformation' to one where prisoners could live, eat and relax, relatively unmolested by the . . . guards or tortured by the strict prison rules." Madigan installed radio headsets in the cells, tuned to light music and baseball stations, and at Christmas he provided cigars, chocolates, and a special dinner. Blackwell (among other things) had hot water piped to the cells, added new sports to the exercise yard, and extended the radio network to include news broadcasts and talk shows.

But for all that, Alcatraz was still Alcatraz. During the life of the penitentiary, eight prisoners were murdered by their fellows, five committed suicide, fifteen died of natural causes, and several went insane. Of a total of 1,545 prisoners who "did time" there, thirty-six tried to escape in fourteen attempts, the last of them in 1962. Twenty of the fugitives were recaptured, seven were shot and killed, two drowned, and five were never found, assumed by prison authorities to have perished in the icy waters of San Francisco Bay.

The 1962 incident, documented in J. Campbell Bruce's 1963 book *Escape from Alcatraz*, was popularized in a 1979 Paramount motion picture of the same name, starring Clint Eastwood. Leaving papier-mâché dummies in their cells, Frank Morris and brothers John and Clarence Anglin disappeared on the night of June 11, 1962 in a sophisticated escape. They planned for 11 months, and for over 6 they chipped away moisture-damaged concrete with improvised tools to gain access to a services duct behind Cell Block B. The escape route then led through a disused ventilator duct to the roof. Climbing down service pipes, they scaled a 12-foot fence; at the shore they inflated their life vests and raft made from stolen raincoats and launched into the Bay. Plywood paddles and fragments of the raft were found on Angel Island and although the official report (published by the FBI after several years) concluded that the escapees drowned, one historian was told by relatives of the Anglins that they had received postcards from South America. Frank Morris was never heard from again.

CLOSURE

Late in 1962, Attorney General Robert F. Kennedy ordered the closure of Alcatraz. The decision was taken principally for financial reasons: first, the marine atmosphere had caused severe deterioration of the aging concrete and steel structures; second, public concern was growing about pollution of San Francisco Bay by the island's sewage (together, the cost of repairs to the building fabric and the drainage system was estimated at $5 million); and third, the day-to-day operating cost—all food, fuel, supplies, and even water had

to be brought to Alcatraz by barge—was three times that of any other federal prison. The Bureau of Prisons regarded The Rock as "an administrative monstrosity."

But money wasn't the only problem. One historian cites a combination of less tangible issues: such as "the increase in assaults and general violence; the turnover of personnel, involving an increase in the number of inexperienced officers; a general decline in staff morale; public concerns about the location of the prison; and the rising tide of criticism by penologists." The author of *The Birdman of Alcatraz*, Thomas Gaddis, called the penitentiary "the federal prison with a name like the blare of a trombone, a black molar in the jawbone of the nation's prison system." Changes in penal philosophy were leaning toward rejecting "the spirit of retribution and [attempting] coolly to balance the needs of deterrent and detention with the possibilities of rehabilitation"—an approach for which Alcatraz had never made provision. From fall 1962 inmates were transferred to other establishments, including Atlanta, Leavenworth, and Terre Haute in Indiana. In March 1963 the twenty-seven remaining prisoners were relocated to a new maximum security prison near Marion, Illinois—"the new end of the line, a true heir to Alcatraz in its barbaric treatment of prisoners"—and 2 months later Alcatraz Island was transferred to the General Services Administration.

"WE HOLD THE ROCK!"

Alcatraz has a unique iconic meaning for Native Americans. Through the 1950s the U.S. Bureau of Indian Affairs undertook a massive but spectacularly unsuccessful Voluntary Relocation Program to persuade indigenous people to migrate from reservations to urban centers—a move that for many of them led to poverty and isolation. The federal government's termination policy of August 1953 (called "the ultimate forced assimilation policy") was intended to end the recognition of Indian nations, thus invalidating treaties made over a century earlier.

On March 9, 1964, after 5 years of frustrating inaction on the part of the 1964 Presidential Commission on the Disposition of Alcatraz Island, and in order to draw public attention to the problems of the Bay Area Indian community, five Sioux demanded title to The Rock under the terms of the 1868 Treaty of Fort Laramie. They remained on Alcatraz for only 4 hours, calling for it to become a site for an Indian university and cultural center, ecology and spiritual centers, and a museum.

The claim was reiterated on November 9, 1969, when at San Francisco's Pier 39 a college student Richard Oakes, a Mohawk, symbolically offered $24 in trade goods for Alcatraz Island—as much as Peter Minuit paid the Canarsee Indians for Manhattan in 1626. Calling themselves "Indians of All Tribes," Oakes and his supporters then chartered a boat, the *Monte Cristo*, and claimed

Alcatraz for the Indian people "by right of discovery." The next morning the Coast Guard peaceably removed them from the island.

Ten days later, about one hundred Native Americans—eighty students from the American Indian Studies Center at the University of California at Los Angeles (UCLA), some married couples, and six children—occupied Alcatraz. They set up headquarters in the former warden's house and used the cell house as living quarters. Within 3 weeks a council was elected, which drafted rules and established policies about elementary education, health, and child care. Tasks were assigned, and decisions were made by consensus; as time passed, a complex administrative infrastructure was developed to manage resources and undertake public and media relations. The Indians' essential demands had not changed since 1964, and their resolve was hardening. Their persistence eventually obliged the federal government to agree (at least ostensibly) to enter formal negotiations. But it was willing to yield nothing and wanted the occupiers off the island. Growing public support for them made forcible removal politically inadvisable.

Cracks began to appear in the Indian organization early in January 1970. Oakes' teenage step-daughter Yvonne died in a fall, and a few days later he and his family left Alcatraz. Indian college students returning to school were replaced by urban Indians and others from reservations. Moreover, non-Indians, including many people from the San Francisco hippie and drug culture moved to the island, blurring the focus of the occupation. A power struggle for political control led to the tribes' downfall as two competing groups, both of whom earlier had opposed Oakes, jockeyed for leadership. The changing population on the island, characterized by the "open use of drugs, fighting over authority, and general disarray of the leadership" became an increasing problem.

On December 4, 1970, the government shut off the island's electrical power supply. The backup generators were inoperative, food was spoiled, and fuel and water lines leaked. The fresh water supply barge was discontinued. Three days later fires destroyed several historic buildings. As the occupation extended into 1971 and problems multiplied, media and public support for the Native Americans was eroded. When early in June, FBI agents, federal marshals, and police removed six unarmed Indian men, five women, and four children from Alcatraz Island, the occupation that had lasted 19 months and 9 days was over.

The Indian occupation of Alcatraz has been identified as "perhaps the most significant event in the history of US-American Indian relations in the post-reservation era." For the Native American people, the brief and shining moment represented a new sense of pride, culture, and hope. The personal lives of many of them were dramatically changed as a result of the occupation, and it gave others a new hope. As Troy Johnson points out,

> The underlying goals of the Indians on Alcatraz were to awaken the American
> public to the reality of the plight of the first Americans and to assert the need

for Indian self-determination. As a result of [it], either directly or indirectly, ... Indian self-determination became the official US government policy. [While] the occupiers were on Alcatraz Island, President Nixon returned Blue Lake and 48,000 acres of land to the Taos Indians. Occupied lands near Davis California would become home to a Native American university. Alcatraz may have been lost, but the occupation gave birth to a political movement which continues. . . . [8]

One cannot avoid being aware of parallels between the Bureau of Prisons' treatment of the tried and convicted public enemies taken in the politically driven 1930s "war on crime," and the way in which since 2001 the U.S. administration has dealt with an estimated seventeen thousand "public enemies" held without trial, alleged enemy combatants in a "war on terror." Late in 2003, U.S. personnel at Afghanistan's Bagram airbase described the habitual use of sensory deprivation (just like that in D block at Alcatraz) as "torture lite." The then U.S. vice president stated that such torture is a legitimate means—"whatever it takes"—to break enemies' spirits.

At Guantanamo Bay hundreds of men were held, all without charge; some for years on end. Reuters reported in January 2007 that about 160 were locked alone for 22 hours a day in the 6- by 12-foot cells of a new "state-of-the-art" maximum security Camp 6. The fluorescent lights were never turned off, and "all they [had were] an inch-thin mattress, a steel platform to sleep, a steel sink and toilet and the *Koran*." The isolation suffered by convicted criminals in Alcatraz in the 1930s (when presumably we were less enlightened) was denounced by the courts as "cruel and unusual punishment." It rightly horrifies and outrages us to read of it. What happened to our commitment to the presumption of innocence and our respect for human rights in the intervening generations, if we treat in the same way men who have yet to be convicted of a crime?

NOTES

1. Haller, Stephen, et al., *Seacoast Fortifications Preservation Manual.* Golden Gate National Recreation Area, July 1999. www.nps.gov/goga/historyculture/alcatraz-fortifications.htm

2. Baily, C. H., "The Rock," *San Francisco Chronicle* (June 14, 1914), 5.

3. Baily.

4. "Robert Stroud: Birdman of Alcatraz." www.alcatrazhistory.com/rs4.htm

5. Gazis-Sax, Joel, "American Siberia: The Purpose of Alcatraz." www.notfrisco2.com/alcatraz/purpose.html

6. Karpis, Alvin (as told to Robert Livesey), *On the Rock: Twenty-Five Years in Alcatraz*. New York and Toronto, Canada: Beaufort, 1980.

7. Karpis.

8. Johnson, Troy, *The Occupation of Alcatraz Island: Indian Self-Determination and the Rise of INDIAN Activism*. Champaign: University of Illinois Press, 1996.

FURTHER READING

Babyak, Jolene. *Birdman. The Many Faces of Robert Stroud*. Berkeley, CA: Ariel Vamp Press, 1988.

Bennett, James V. *I Chose Prison*. New York: Knopf, 1970.

Beyeler, Ed and Susan Lamb. *Alcatraz—The Rock*. Flagstaff, AZ: Northland, 1988.

Bruce, J. Campbell. *Escape from Alcatraz*. New York: McGraw-Hill, 1963.

DeNevi, Don. *Alcatraz '46*. San Rafael, CA: Leswing, 1974.

DeNevi, Don. *Riddle of the Rock*. Buffalo, NY: Prometheus Books, 1991.

Esslinger, Michael. *Alcatraz—A Definitive History of the Penitentiary Years*. San Francisco: Ocean View, 2003.

Fuller, James. *Alcatraz Federal Penitentiary, 1934–1963*. San Francisco: Asteron, 1982.

Gaddis, Thomas E. *Birdman of Alcatraz: The Story of Robert Stroud*. New York: Random House, 1955.

Grassick, Mary K. *Alcatraz Island, Main Prison Building: Golden Gate National Recreation Area, San Francisco, California*. Harpers Ferry, WV: Media Services, National Park Service, 2005.

Gregory, George H. *Alcatraz Screw: My Years as a Guard in America's Most Notorious Prison*. Columbia: University of Missouri, 2002.

Heaney, Frank, and Guy Machado. *Inside the Walls of Alcatraz*. Palo Alto, CA: Bull, 1987.

Hurley, Donald J. *Alcatraz Island Memories*. Sonoma, CA: Fog Bell Enterprises, 1987.

Johnson, Troy R. *We Hold the Rock: The Indian Occupation of Alcatraz, 1969 to 1971*. San Francisco: Golden Gate National Parks Association, 1997.

Johnston, James A. *Alcatraz Prison and the Men Who Live There*. New York: Charles Scribner's Sons, 1949.

Johnston, James A. *Prison Life Is Different*. Boston: Houghton Mifflin, 1937.

Karpis, Alvin (as told to Robert Livesey). *On the Rock: Twenty-Five Years in Alcatraz*. New York, Toronto, Canada: Beaufort, 1980.

Madigan, Paul J. *Institution Rules and Regulations*. San Francisco: Golden Gate National Parks Association, 1983.

Martini, John A. *Fortress Alcatraz—Guardian of the Golden Gate*. Kailua, HI: Pacific Monograph, 1990.

McHugh, Paul. *Alcatraz: The Official Guide*. San Francisco: Golden Gate National Parks Conservancy, 2006.

Needham, Howard, and Ted Needham. *Alcatraz*. Millbrae, CA: Celestial Arts, 1976.

Odier, Pierre. *The Rock: A History of Alcatraz: The Fort/the Prison*. Eagle Rock, CA: L'Image Odier, 1982.

Oliver, Marilyn Tower. *Alcatraz Prison in American History.* Springfield, NJ: Enslow, 1998.

Quillen, Jim. *Alcatraz from Inside.* San Francisco: Golden Gate National Parks Association, 1991.

Stuller, Jay. *Alcatraz, the Prison.* San Francisco: Golden Gate National Parks Association, 1998.

Thompson, Leon. *Alcatraz Merry-go-Round.* Fiddletown, CA: Author, 1995.

Thompson, Leon. *Last Train to Alcatraz.* Fiddletown, CA: Author, 1988.

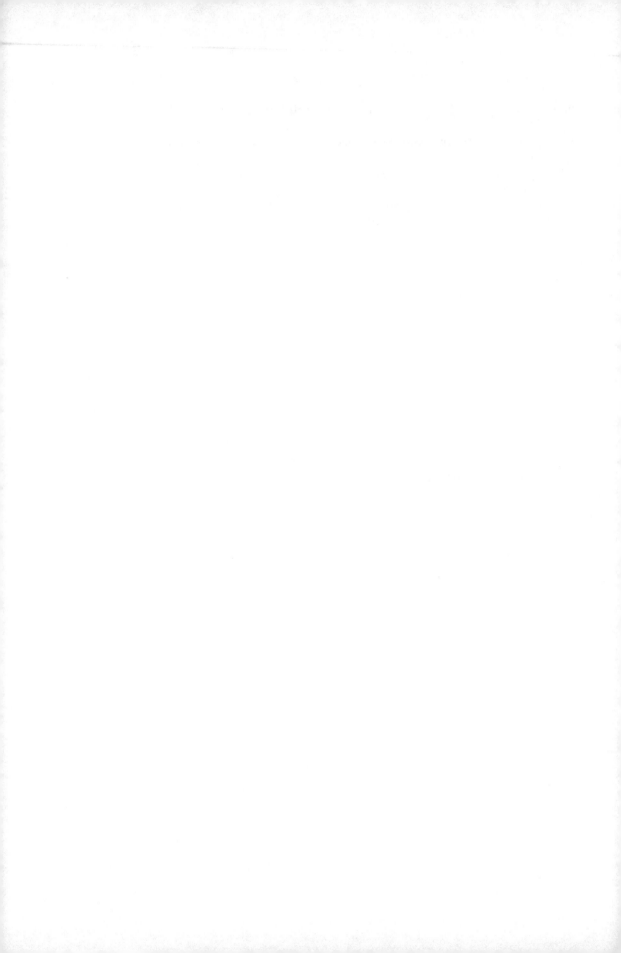

Brooklyn Bridge, New York City

"Do I have a bridge for you!?"

The publisher's note for Richard Haw's 2005 study, *The Brooklyn Bridge: A Cultural History* claims that the bridge is among "the world's most recognizable and beloved icons," adding that it has been endorsed (although failing to say by whom) as "a flawless symbol of municipal improvement and a prime emblem of American technological progress." Flawless? Perhaps not, but the rest of the claim is accurate enough.

Nevertheless, true iconic status is conferred by the ordinary people, not an elite. Almost since its opening the bridge has been a common element of popular culture—on magazines and postcards and in comic books, advertisements, films, television programs, and cartoons. Its image has embellished all kinds of tourist souvenirs, and collectibles that had little else to do with New York. It has even been the design motif for over two hundred fifty different silver spoons. However, when something becomes a part of our language, its claim to iconhood—if that is a word—is placed beyond challenge.

In the twenty-first century the expression "selling the Brooklyn Bridge" remains in use to describe an offer or promise that exploits gullibility. As Brooklyn author Gabriel Cohen observes, "The idea of illegally selling [the bridge] has become the ultimate example of the power of persuasion." In the 1937 Paramount film *Every Day's a Holiday*, Mae West plays Peaches O'Day who sells it and receives a bill of sale for "One bridge in good condition." That was art mimicking life. From as early as the 1880s, New York confidence tricksters paid for information about recently arrived passengers—"marks"—who might be parted easily from their money. The proximity to Ellis Island and the international fame of the bridge made it an ideal subject for scams. The notorious Gondorf brothers Charles and Fred (immortalized in *The Sting*) sold it many times. William McCloundy (aka "I.O.U." O'Brien) was sent to Sing Sing for the same trick in 1901. And on several occasions George C. Parker forged plausible "ownership" documents to take in eager buyers. By the 1920s newcomers had became more sophisticated and the deception no longer worked; besides, immigration officials distributed pamphlets explaining that New York's public buildings were not for sale.

BEFORE THE BRIDGE

Only 12 years after the Dutch founded New Amsterdam at the southern tip of Manhattan Island, a few crossed the East River to farm on the western edge of Long Island. In 1646, Breuckelen—named for a village near Utrecht in The Netherlands, it was the first municipality in what is now New York State—was established. When the British annexed the town 18 years later, the name was anglicized to Brooklyn.

Communication across the 500 yards of water was difficult. Cornelis Dircksen Hooglandt, a Long Island farmer, started the first regular ferry service around 1642. Apart from the introduction of government regulation, little

would change for almost 200 years. Crossing the fast-flowing, turbulent tidal inlet in a rowboat that carried a sail (when weather and tide were auspicious) was at worst dangerous, because of the busy marine traffic combined with floating ice, storms, or fog. At best, it was inconvenient and therefore costly; one early-nineteenth-century writer recalled waiting "from morning to night . . . in a northeast storm, before any boat ventured to cross to the city." Some winters saw the river freeze over and ferry services were cancelled for days at a time. As demand increased, the proliferating ferry services peppered the river with an increasing range of craft: oar-barges for pedestrians; spritsail boats for horse-drawn vehicles; and unstable, flat-hulled pirogues; there were even vessels powered by horses on treadmills.

The advent of steam ferries revolutionized the short journey. In 1813 Robert Fulton and William Cutting were granted a franchise, and Fulton introduced his steamboat *Nassau* in May 1814. Twin-hulled with a connecting deck, she could carry five hundred fifty passengers and a few wagons, and she was designed to cross and return without needing to put about. By 1839 all the steam ferries in service were owned by the New York and Brooklyn Ferry Company, and over the next quarter-century twenty-four vessels had been added to the service. By then Brooklyn's population had grown to about three hundred fifty thousand, and the ferries were carrying 41.4 million passengers annually, not without difficulties. New York printer Samuel W. Green wrote in 1883, "the transportation of the vast mass of humanity and freight . . . across the East River, like true love, does not always run smooth."[1] Of course, the story of the ferries is a saga in its own right, too long to be more than hinted at here.

OVER THE RAINBOW

It seems that the earliest proposal for a bridge between Manhattan and Brooklyn was made in 1800, when someone described as a "gentleman of acknowledged abilities and good sense" offered to build one in just 2 years. Bridge historian David McCullough identifies the gentleman as Thomas Pope, a New York carpenter and landscape gardener, whose "invention," as he saw it, [was] available in all sizes and suitable for any site. An 1800-foot span cantilever between Manhattan and Brooklyn, expectedly and unsuitably built entirely of timber, was to soar some two hundred feet over the water, like "a rainbow rising on the shore."[2] And all for $144,000! Details were explained in Pope's self-published book of 1811, verbosely titled, *A Treatise on Bridge Architecture; in which the Superior Advantages of the Flying Pendent Lever Bridge Are Fully Proved. With an Historical Account and Description of Different Bridges Erected in Various Parts of the World, from an Early Period, Down to the Present Times*. It is hardly surprising that he was not taken seriously. There was no shortage of suggestions—most of them flights of fancy—over

the next several decades. Republican Congressman James Stranahan later re-called that an anonymous "gentleman now residing in Brooklyn" had cham-pioned a "solid bulkhead pier of some five hundred feet in width from city to city, with a narrow opening for the flow of water [the velocity of the current would have been enormous] and the passage of vessels [the smashes against the piers would have been spectacular] in the center of the river, spanned by a draw-bridge." He dismissively commented that "there was not the slightest prospect that the General Government would ever consent." Someone even absurdly proposed a pontoon bridge—the temptation to remark that the idea was never floated is irresistible.

By midcentury it was clear that a permanent link was urgently necessary. McCullough cites one prophecy but does not name the prophet: "If there is to be a bridge it must take one grand flying leap from shore to shore over the masts of the ships. There can be no piers or drawbridge. There must be only one great arch all the way across." "New York and Brooklyn must be united," insisted *The New York Tribune* in 1849, giving voice to widespread public feeling. But nothing happened. The problem posed by building the founda-tions in the strong swirling currents of the tidal strait, "one of the busiest stretches of navigable salt water anywhere on earth" seemed insurmountable.

STANDING IN THE WINGS

John Augustus Roebling was born in Muhlhausen, Prussia (now Germany), in 1806, where he received his elementary and secondary education. At the Royal Polytechnic School in Berlin he studied architecture and engineering, bridge construction, hydraulics and languages, as well as philosophy under the famous Georg Hegel. Following his graduation with a degree in civil engi-neering in 1926, he served an obligatory 3 years working for the government, mostly on road building in Westphalia. In 1831, on Hegel's advice, he emi-grated to the United States, where he founded the utopian farming commu-nity of Germania (later Saxonburg) in Butler County, Pennsylvania, with his brother Karl and other refugees from ideological oppression.

When the agricultural venture failed Roebling returned to engineering, from 1837 working on several canal and railroad projects. One source has it that the "general idea of suspension bridges [was] a favorite one with him, ever since his college days, when it formed the subject of the graduating thesis." Applying his earlier studies, he completed the Allegheny Aqueduct in Pittsburgh in 1845 for the Pennsylvania Main Line Canal; over the next 3 years followed the Monongahela Bridge, Pittsburgh Bridge and four aqueducts—Delaware, Lackawaxen, High Falls, and Neversink—on the Delaware and Hudson Canal. Between 1851 and 1855 he built the 825-foot Niagara Suspension Bridge, connecting the New York Central and Canada's Great Western Railway.

Before he designed the great bridge across the East River, Roebling's greatest achievement was the Cincinnati-Covington (now John A. Roebling) bridge over the Ohio River, of 1856–1857; its 1,057-foot suspension span was then the longest in the world. Except for the foundations of the towers, all the design features and construction techniques that defined the Brooklyn Bridge had been developed by Roebling on its Cincinnati-Covington forerunner.

John Roebling's suspension structures used the low-carbon iron wire rope that he first patented in 1841–1842; indeed, it was integral to their success. Architectural historian Kenneth Frampton identifies this innovation as "one of the decisive breakthroughs in modern suspension bridge technology." Inspired by a German invention, Roebling's experiments were conducted on a "rope walk" behind his Saxonburg farm, where at first he employed his fellow villagers to make the rope by hand. The cables for his aqueducts were spun on-site, either compacted as parallel strands or twisted. A cable-wrapping device, also patented by Roebling in 1842, protected the iron from corrosion. By 1848 his factory (by then mechanized) was serving a growing market and he relocated it in Trenton, New Jersey.

There is a story, perhaps apocryphal, that on a winter's day in 1853, Roebling was on an East River ferry, trapped by floating ice between Manhattan and Brooklyn. The experience (it is said) prompted him to think about a bridge. In fact, he had been entertaining that idea since 1852, believing that the "locality [most] favorable to bridging" was Blackwells Island (since 1973, Roosevelt Island). According to the *Long Island Democrat*, that site had been mooted as early as October 1836. Anyway, it was not until June 1857 that Roebling wrote to the iron manufacturer Abram Stevens Hewitt, who supplied the wire for his rope works, contending that two bridges—one from Manhattan to Blackwells Island and another from the island to Long Island City—could be built for $600,000. Hewitt had the letter printed in the *New York Journal of Commerce*, and it excited great interest. A little later *Frank Leslie's New Family Magazine* would describe a suspension bridge of *three* 700-foot spans, the middle one crossing Blackwells Island. Nothing happened. Two years later, responding to would-be backers, Roebling proposed two 800-foot suspension spans linked over the island by a 500-foot cantilever, near the site of the present-day Queensboro Bridge. The estimated cost had doubled. Before any further progress could be made, the project was shelved because of economic depression. Then came the Civil War.

A BRIDGE WITH NO NAME

In 1865 a former army engineer, Colonel Julius Walker Adams of Brooklyn, exhibited the first "practical design" for an East River bridge—a suspension structure, using steel chains—at the annual fair of the American Institute of the City of New York for the Encouragement of Science and Invention.

In January 1867 his influential and wealthy friend William C. Kingsley, contractor and publisher of *The Brooklyn Daily Eagle*, having widely canvassed support for the design, pressed State Senator Henry Cruse Murphy to introduce a bill in the New York State Legislature to enable a private company to build Adams' bridge.

In April, thirty-eight prominent Brooklyn citizens formed the board of directors of the New York Bridge Company (a name allegedly chosen because they intended to build a bridge *to* New York). For 16 years the press would alternatively refer to the project as the East River Bridge, the Great Bridge, the Brooklyn Bridge, or even (as events transpired) the Roebling Bridge. The obverse of the commemorative medallion struck for its opening would bear the motto, "Two Cities As One," the reverse legend reading, "Souvenir of the Opening of the East River Bridge, May 24th 1883."

According to McCullough, the Bridge Company was granted "broad and ambiguous" powers, including authority to acquire land for the bridge and its approaches. The legislation called for a toll bridge yet mentioned nothing of an approved location or design. Optimistically, it set a completion date of January 1, 1870. Although the act had set up a private corporation, the City of New York was allowed to make a $1.5 million capital investment, and the City of Brooklyn $3 million; private stockholders would provide the remaining $500,000. The share price was fixed at $100; it is noteworthy that over 60 percent of the private funding came from Kingsley and those he represented.

Within a month Adams' proposal was replaced by Roebling's. The exact circumstances surrounding the Board of Directors' collective change of mind remain obscure. At its second meeting, on May 23, 1867, it elected Murphy president and, mainly as a result of Kingsley's lobbying, named John Augustus Roebling as chief engineer. Assisted by the gifted young Wilhelm Hildenbrand, engineer-in-charge of his drafting room, Roebling set about preparing detailed plans and choosing a site. Submitted in September, his report boasted:

> The completed work, when constructed in accordance with my designs, will not only be the greatest bridge in existence, but it will be the greatest engineering work of the continent, and of the age. . . . The great towers will serve as landmarks to the adjoining cities, and they will be entitled to be ranked as national monuments. As a great work of art, and as a successful specimen of advanced bridge engineering, this structure will forever testify to the energy, enterprise and wealth of that community which shall secure its erection.[3]

As the proposal firmed over the next year there were mounting rumblings of disgruntlement, disagreement, and disapproval from many quarters and for different motives. Roebling needed to silence his critics, including the New York Polytechnic Society (that convened lectures questioning the engineering validity of the structure), Mayor Martin Kalbfleisch of Brooklyn, and the publisher of *The New York Tribune* Horace Greeley (both of whom had

doubts about the span). More important, he needed to reassure potential investors. So when the design was complete, he asked that an independent Board of Consulting Engineers assess the design. McCullough notes that "he did not want their advice or opinions, only their sanction."

Roebling nominated seven of the nation's most reputable engineers. They were appointed in January 1869, with generous $1,000 honoraria (now worth about fifteen times that amount) paid by Kingsley. Under the chairmanship of the civil engineer and inventor Horatio Allen, the Board comprised William Jarvis McAlpine, president of the American Society of Civil Engineers, the architect Benjamin Henry Latrobe, John J. Serrell, J. Dutton Steele, and James Pugh Kirkwood. Adams, whose proposal had been displaced by Roebling's, and who (not unexpectedly) had pronounced the design unsound, was a canny inclusion. The Board's deliberations were no mere formality. After half a dozen meetings during which it examined the documents and virtually cross-examined Roebling, in March it unanimously agreed that his proposal was acceptable and achievable.

The U.S. government wanted to be sure that the bridge would not impede navigation, especially in giving access to the New York Navy Yard, so the project still needed the *imprimatur* of Congress. Chief of Army Engineers General A. A. Humphreys directed Major-Generals John Newton and Horatio Wright and Major W. R. King, all engineers, to examine the design independently of the civilian Board. In mid-April the soldiers, together with the Board, John Roebling, and his son Washington (of whom more is said below), several potential Brooklyn investors and a few others took a railroad tour to see Roebling's bridges at Pittsburgh, Cincinnati, and the Niagara Gorge. The military engineers recommended that the air draft—that is, clearance above the average high spring tide level—at center span of the East River bridge be increased by 5 feet to 135 feet, a recommendation that seems pedantic, given the vagaries of tides. Otherwise, "there was no doubt of the entire practicability of the structure nor of its stability." On June 21, 1869, the government advised the Bridge Company that it approved the design and location of the bridge. Subscriptions to capital stock were filled within 6 weeks.

"HARP AND ALTAR, OF THE FURY FUSED"

Straightforward physics underlie Roebling's design. The four main suspension cables, continuous from anchorage to anchorage, pass over the towers and hang in catenaries (the curve that cables naturally assume when suspended from two points) between them. That frees the towers from horizontal forces; acting in compression, they transmit the self-weight of the structure and any live loads to the foundations. The colossal anchorages resist the tensile forces in the main cables. The steel-framed bridge deck hangs from those cables on vertical "suspenders," and diagonal stays stabilize it against wind loads.

Roebling designed the bridge with a safety factor of six; that is, the ratio of the breaking stress of the structural components to the estimated maximum stress when they are in "ordinary use." Modern engineers and safety authorities are generally content with a safety factor of two. Then, he was attempting to achieve something that had never been done before. The total length of the bridge is just over 6,000 feet. Its 1,616-foot long main suspension span, with its center soaring 135 feet—about twelve stories—above the East River, passes at a height of 119 feet through two arches in each tower (in a masterpiece of understatement Roebling called those towers the "most conspicuous features") that rise close to either shore of the river. Above the waterline the towers are built of granite quarried in Maine; beneath it, they are of New York limestone. They stand upon almost incomprehensibly massive timber footings—caissons—that are in themselves an audacious wonder of engineering. Reaching a height of 276 feet—about twenty-five stories—above the river, for 15 years the towers, except for the spire of Trinity Church, were by far the tallest buildings in New York City. They have been called "gothic" (by others but never by John Roebling), a stylistic categorization that stretches the architectural lexicon. They have pointed arches, that's all; otherwise, their style may be described generously as "engineers' nondescript."

A 930-foot-long suspended "land span" at each end of the bridge returns its roadway to ground level. All three spans are supported by suspension cables. Swooping over the river, the cables—one at each edge and two at the central axis of the bridge—continue, via roller joints in saddles on the tops of the towers, to the rectangular masonry anchorages in Manhattan and Brooklyn. Each seven-story high anchorage is a third of an acre in area and weighs 60,000 tons; four 23-ton embedded anchor plates with 152 anchor bars secure the cables in each. Almost 16 inches in diameter, each main cable consists of nineteen strands made up of parallel pencil-thick steel wires—a total of almost 5,500 individual filaments in each cable. The strands are wrapped in soft wire. Roebling prophesied that steel was "the metal of the future"; by using it in a structural application, he anticipated other American architects by almost 20 years. Just then, engineers were leading the way to a new technology and a new aesthetic. Fifty years after Roebling chose steel, the Swiss architect Le Corbusier would point out that "the engineer, inspired by the law of economy and governed by mathematical calculation, puts us in accord with universal law. He achieves harmony."

The 85-foot wide bridge deck, made of spruce, is carried on a braced grid, with 33-inch deep steel principal trusses suspended from the main cables by 2-inch diameter wire ropes at 7½-foot centers. Six lines of trusses extend from one anchorage to the other. Diagonal stays of steel wire rope connect the tops of the towers to points at 15-foot centers along the deck's longitudinal edge beams, extending about 400 feet from the towers in each direction. The visual contrast of the (comparative) wire filigree and massive stone towers was best described by the poet Hart Crane as "harp and altar, of the fury fused" in *To Brooklyn Bridge*.[4]

To connect the elevated railroad systems of New York and Brooklyn, Roebling provided two cable-car tracks; between them and 18 feet above the deck, a pedestrian boardwalk (he gave it the grand title, "elevated promenade") afforded uninterrupted panoramic views. Flanking the tracks there were two-lane carriageways for horses and horse-drawn vehicles. Of course, roadway use has continually changed with changes in transportation modes; although the bridge now carries three lanes of automobiles in each direction—a daily total of more than two hundred thousand—it retains the exclusive pedestrian right-of-way.

A BRIDGE GROWS IN BROOKLYN

When attempting to analyze the Brooklyn Bridge's iconic quality, the 13-year-long construction process is as significant as the finished structure. The story begins in tragedy. On July 6, 1869, while John Roebling was locating the Brooklyn tower, a ferryboat collided with the slip on which he stood, crushing his right foot against the piling. The injured toes were immediately amputated—he refused anaesthetic—but (perhaps because he insisted upon hydrotherapy over conventional medical treatment) tetanus followed. He died on July 22, with his *magnum opus* hardly started.

Washington Augustus Roebling was just 32 years old when he succeeded his father as chief engineer of "the most prestigious [engineering project] of the continent and of the age." Certainly it was the most ambitious bridge that America had ever seen. Washington had worked off and on in the family business since graduating from Rensselaer Polytechnic Institute in 1857. When the Civil War erupted, he enlisted as a private in the 6th New York Artillery. Transferring to staff duty as an engineer in 1862, he designed suspension bridges over the Shenandoah and Rappahannock rivers. After three field promotions he resigned his colonel's commission and in January 1865 married Emily Warren of Cold Springs, New York. Rejoining the family company after demobilization, he assisted his father during the construction phase of the Cincinnati-Covington Bridge. When the Roeblings won the East River bridge commission Washington and Emily moved to an apartment in Brooklyn Heights. For much of the next year they traveled in Europe, where the young engineer consulted experts about the all-important foundation design.

The construction and placing of the bridge *caissons* (the French word for boxes) was a truly monumental undertaking. Constructing foundations in fast-flowing waters had always been problematical for bridge builders. For Westminster Bridge (1750) over the River Thames in London the Swiss engineer Charles Labelye had constructed enormous inverted timber caissons on shore; they were then floated into position and slowly sunk as masonry piers were built on them. A century later the Englishmen William Cubitt and John Wright developed Labelye's idea for a bridge over the Medway at Rochester. They created the first *pneumatic* caisson; after the water had been forced out

by compressed air, workmen could enter through airlocks and excavate in dry conditions.

In October 1869 the contract to build the caissons was won by Eckford Webb and George Bell's Greenpoint shipyard at Newton Creek, Brooklyn. The surveying and dredging work completed, laborers began clearing the Brooklyn Tower site on January 2, 1870. The 3,000-ton Brooklyn caisson, constructed from huge foot-square flitches of oak and yellow pine, was launched on March 19; measuring 168 by 102 feet (about the area of four basketball courts), it had, when completed, a 15-foot thick roof; 9-foot thick walls enclosed its chambers. The lower 3 feet were clad in boiler plate, inside and out. The joints were caulked with oakum, hot pitch was poured between the courses of the roof, and the entire outside was painted with marine varnish. There were holes in the roof for two access and two supply shafts and air, gas, and water pipes. In May six tugboats towed the gigantic structure to its final location 5 miles to the south of the shipyard, where finishing touches were added before it began to disappear forever beneath the East River.

On June 15 the first limestone blocks were laid atop the caisson; it took the weight of three courses of stone before it began to sink. For the next 14 months, ferryboat commuters would watch workmen swarming over the base of the Brooklyn tower; of course, they would see nothing of the hazardous underwater work. Compressed air was pumped into the caisson to prevent water from flowing in; then (mostly) impoverished Irish, German, or Italian immigrant laborers at first using hand tools (but later, even dynamite) excavated clay and boulders from the river bed. The atmosphere within the caisson was dank, and the temperature was at least 80° Fahrenheit. Roebling's master mechanic, E. Frank Farrington compared the horrific working conditions with Dante's inferno: "[inside the caisson] everything wore an unreal, weird appearance [with] the flaming lights, the deep shadows, the confusing noise of hammers, drills and chains, [and] the half-naked forms flitting about."[5] For this work the excavators were paid $2 a day. Over twenty-five hundred individuals worked in the Brooklyn caisson, and about one hundred a week quit, despite their desperate need for work. Although 260 men worked three shifts around the clock, weekly progress was measured in inches. On March 11, 1871, a stable stratum was reached about 45 feet below water level, and the caisson was filled with Rosendale natural cement.

The slightly larger Manhattan caisson—because it needed to go deeper its roof was 22 feet thick—was launched on May 8, 1871. For safety reasons its interior was fully lined with boiler plate (there had been a fire in the roof of the Brooklyn structure) and painted white better to reflect light for the workers. Once fitted out, it was towed to the site in October and by November settled on the river bed.

Apart from "normal" mishaps like fire, flood, and sometimes violent blowouts, the workmen faced an even greater peril. As the excavation deepened, air pressure in the workspaces had to be increased to as much as four

atmospheres. By May 1872 the Manhattan caisson reached firm sand at 78 feet, although it was still 30 feet short of bedrock. Roebling decided to go no deeper. At least three men died from caisson disease (decompression sickness or "the bends"). Andrew H. Smith, the Bridge Company's surgeon, reported a further 107 nonfatal cases of the agonizing condition; of those afflicted, one man in seven was paralyzed to some degree. Washington Roebling was himself among them. Early in the summer of 1872, suffering a second attack—the first had been in December 1870—he was carried out of the Manhattan caisson. By the year's end, he was partially paralyzed, hardly able to speak, deaf, and beginning to go blind.

EMILY WARREN ROEBLING: "SURROGATE CHIEF ENGINEER"

Fearing that he might not survive, and although it exhausted him, he spent almost 4 months dictating to Emily his detailed instructions for completing the superstructure. He taught her mathematics and physics—strength of materials, stress analysis, and catenary curve calculation—as well as "bridge specifications and the complexities of cable construction." One essayist asserts (with some justification) that "although her training was informal, Mrs. Roebling [was], without official position or title, surrogate chief engineer between 1872 and [the opening of the bridge] in 1883."

Indeed, her part in building the great bridge cannot be overstated. First, her husband was able to continue only because of the constant care, patience, strength, and understanding that she provided; as he later wrote: "At first I thought I would succumb [to my illness], but I had a strong tower to lean upon, my wife, a woman of infinite tact and wisest counsel." However, Emily was to him much more than a nurse and an inspiration. On her daily visits to the construction site, she answered questions from the staff and the contractors; she kept the records, took care of correspondence, lobbied, addressed meetings of engineers, represented Washington at social functions, and in 1882 successfully fended off attempts to replace him as chief engineer. And all before she was 40 years old!

One writer has called her the "public face of the Brooklyn Bridge." Another remarks that she was soon doing everything so competently that many believed that she *was* the chief engineer. McCullough notes that "it was common gossip that hers was the great mind behind the great work and that this, the most monumental engineering triumph of the age, was actually the doing of a woman." He adds that some of her contemporaries thought it "preposterous and calamitous" that she had crossed the social boundaries set for an affluent woman in the late Victorian era.

About a week before the bridge's official opening Emily was the first person to cross it, riding in a carriage and carrying a live rooster as a symbol of victory. McCullough writes, "From one end of the bridge to the other, the men . . .

stopped their work to cheer and lift their hats as she came riding by." At the subsequent ceremony New York congressman Abram S. Hewitt wordily declared,

> This bridge will ever be coupled with the thought of one, through the subtle alembic of whose brain, and by whose facile fingers, communication was maintained between the directing power of its construction and the obedient agencies of its execution. It is thus an everlasting monument to the self-sacrificing devotion of woman, and of her capacity for that higher education from which she has been too long debarred. The name of Mrs. Emily Warren Roebling will thus be inseparably associated with all that is admirable in human nature, and with all that is wonderful in the constructive world of art.[6]

"THE MAN IN THE WINDOW"

But to return to the building of the bridge. In 1873 Emily had taken her ailing husband for treatment at the famous spa gardens in Wiesbaden, Germany where they remained for 6 months. When they returned to the United States, it was to Roebling's family and business in Trenton. Then, in the middle of June 1877 they moved to a house in Columbia Heights, Brooklyn, within sight of the bridge. Although increasingly debilitated, Washington Roebling wanted to retain control of the project. From his third-floor back bedroom, "the man in the window" watched through field glasses every step in the construction and dispatched Emily with instructions for the assistant engineers. Of course, the work had continued while the Roeblings were away. Besides Hildenbrand, the assistant engineers associated with the project—all in their thirties when the work began—during its entire history were Francis Collingwood Jr., Charles Cyril Martin, George McNulty, William H. Paine, and Sam Probasco.

The Brooklyn tower was topped in June 1875. The Brooklyn anchorage, started in February 1873, was completed in the following October; the Manhattan anchorage, commenced in October 1871, was finished in July 1876, at the same time as the Manhattan tower. A month later the four structures were linked by a single ¾-inch diameter wire rope. On August 25, to mark the achievement and prove the strength of that rope, E. Frank Farrington made the dizzying 22-minute crossing from Brooklyn to Manhattan on a jury-rigged boatswain's chair, as "cannon roared, and the myriads of spectators swung their hats and cheered with wild excitement, while all the steam-whistles on land and water shrieked their uttermost discordance." But it would be about 7 more years before the great bridge was finished.

There had been administrative changes during the Roeblings' absence. Prompted by the perceived tardiness of the project and cost blowout, voices had been raised against the New York Bridge Company, claiming that it was

"influenced by political and other complications." And there was talk of profiteering—a charge that an audit proved to be unfounded. As James Stranahan put it, "I doubt whether any public work was ever conducted with greater economy or a more sacred regard to the general good. There never was a dollar of jobbery in it, from beginning to end." However, the original legislation was amended in June 1874 to allow the municipal governments of New York and Brooklyn to gain majority ownership of the bridge. The new Board of Directors successfully pushed for further enactments that would eliminate the private Bridge Company altogether and allow the work to be completed as a joint municipal project by Trustees acting for the two cities. There was a hiatus in the winter of 1875–1876, because of lack of funds, and another in the following September when several warehousemen unsuccessfully petitioned the United States Circuit Court to halt the work because the bridge was "an illegal structure interfering with navigation."

Those matters were resolved. And just as the Roeblings returned to Brooklyn the task of spinning the main cables began. Of course, the four were fabricated together. Each comprised nineteen "strands" made up of bundles of 278 one-eighth-inch diameter steel wires that had been soaked in linseed oil and dried, laid parallel, and wrapped in soft wire by John Roebling's patented process. There were nearly fifty-five hundred wires in each 16-inch thick cable. All the spinning, wire by wire, necessarily was done *in situ* by men poised above the river on "buggies" or "cradles"—call them what we might, they were little more than insubstantial platforms carried on "traveler ropes"; other ropes supported a 4-foot-wide footbridge for the workers. Hundreds of coils of continuous wire were unwound from huge spools in a shed near the Brooklyn anchorage, and a wheel fixed to a traveler rope carried them one at a time over the 10-minute crossing. It's hard to imagine how all this daredevilry would have looked from 200 feet below—men walking in the air—or how the emerging lacy web may have caught the imagination of a public that had watched the growth of the ponderous towers for 7 years.

The complicated, onerous work took until the middle of October 1878. Roebling's specifications for the cable wire were based on performance, rather than on the type of steel to be used. The lowest tender came from his family's company—Washington had sold his shares to resolve any conflict of interest—for wire made by the new Bessemer conversion process. John Buell notes that lack of detailed knowledge of that technique allowed "a certain individual with a financial interest in one of the other bidders" to question its suitability. The contract therefore went to the lowest bidder for crucible-cast steel (the highest grade, used in cutlery and toolmaking). Two years into the cable spinning phase, it was discovered that J. Lloyd Haigh of New York was supplying wire made of Bessemer steel. Roebling decided not to replace the affected strands—after all, the calculated safety factor was very high—but Haigh was forced to increase by 250 the number of wires in each of them. He was imprisoned for fraud.

Beginning in January 1881, suspenders of wire rope, clamped to the cables by wrought iron, were fixed to carry the substantial prefabricated steel substructure of the deck. When the roadway was completed the diagonal stays from the towers were secured.

The bridge approaches that had been started in August 1877 were completed in July 1882. A month later, the firm of Jones and Benner won a contract for building the viaduct and a cast iron and glass station at the Brooklyn Terminal; the Pittsburgh Bridge Company carried out similar work at the New York Terminal. The bridge railway, with cable cars operated from a powerhouse between Main and Prospect Streets in Brooklyn, commenced service 4 months after the bridge's official opening. The elevated promenade between the tracks was illuminated at night by seventy electric arc lamps supplied by the Weston Electric Light Company of Newark, New Jersey. The steel components of the bridge were protected with two coats of mineral-based red paint, colored with hematite (iron oxide) mined near Rawlins, Wyoming.

Because of its revolutionary structural system and construction details were unfamiliar to traditional contractors, the bridge was built for the most part by men directly employed by the New York Bridge Company (or later by the Trustees). Many of them were recent immigrants, and almost all remain anonymous. Materials were purchased mainly by contract. Work was directed by Washington or Emily Roebling or their team of assistant engineers. Some sources put the size of the work force at six hundred at any one time; others give a total of twenty-six hundred over the 13 years of construction. Although records are at best inconsistent, it is believed that about thirty men died on the project: as noted, at least three died of caisson disease, and some of the worst accidents happened during the cable rigging when several men were killed by falls or by falling equipment. It is ironic that only those workers who died have been named.

During the last 6 years of the project, there were "several disheartening work stoppages caused by lack of funds or lack of steel." Perhaps it was to be expected that the final stages of such an attenuated undertaking would be fraught with growing criticism and heightened dissension, on any number of grounds. Well before the roadway was built, the budget had blown out. Some engineers and architects not involved with the project—one historian dubs them "kerbstone superintendents"—raised technical and aesthetic objections to the design; envy cannot be discounted as their motive. Opportunistic landowners inflated acquisition prices for properties at the bridge approaches and rapacious subcontractors inflated their rates. And when Roebling, with great foresight, introduced steel trusses to strengthen the roadway, *The New York Times* criticized his "stupidity," warning that the extra weight would overload the structure. Naturally, such public doomsaying (albeit unsupported by calculations) created fears among the bridge's potential users. In summer 1882 Roebling was obliged to prove the safety of his design to a bedside inquisition of Trustees, and his dismissal as chief engineer was narrowly

averted. One writer observed that "the emotional pain caused by ignorant criticism, fraudulent contractors, the virulent opposition of the press, and interference by trustees with neither ability nor vision hurt him far more" than his physical affliction.[7]

"THE CROWNING GLORY OF AN AGE"

Brooklyn's schools and businesses closed at noon on May 24, 1883—"The People's Day"—for the formal opening ceremonies. One newspaper reported that Manhattan was in a less festive mood. U.S. President Chester Arthur and New York Governor Grover Cleveland attended the event with their entourages. Escorted from Fifth Avenue to the Manhattan tower by the Seventh Regiment of the National Guard of the State and a military band, and accompanied by New York's Mayor Franklin Edson and city officials they walked across the Great East River Bridge elevated promenade. At the center of the span the New York members of the party were replaced by their Brooklyn equivalents. Cannons saluted from Fort Greene, the harbor forts, the Brooklyn Navy Yard, and five naval vessels gathered for the occasion; whistles blew, and the bells of Trinity Church rang out.

At two in the afternoon more than fourteen thousand invitees and myriad others gathered around a bunting-draped podium at the Brooklyn railway terminal to watch William Kingsley, then vice president of the Trustees, formally present the "the crowning glory of an age memorable for great industrial achievements" to Edson and Mayor Seth Low of Brooklyn. They responded with speeches and Trustees Richard S. Storrs (for Brooklyn) and Abram Hewitt (for New York) also made speeches. After five o'clock, with the official program concluded, more than one hundred fifty thousand people crossed the great bridge; public celebrations continued into the evening with an extravagant, hour-long fireworks display. Just before midnight the carriageways were opened to vehicles, and eighteen hundred made the crossing.

What of Washington and Emily Roebling on that great day? The ceremonies concluded, and the dignitaries were driven to the engineer's Columbia Heights house to congratulate him. Although he could walk Washington had been unable to attend the opening. *The New York Times* reported:

> From the back study on the second floor of his house [he] had watched through his telescope the procession . . . until the Brooklyn tower was reached. Then he returned to his dark chamber to gain a few minutes' rest. . . . Mrs. Roebling also had returned from the bridge immediately after [the formalities] and was not feeling very well. . . . However, she regained sufficient strength afterward to receive at her husband's side and accept her share of the honors of the bridge.

John Roebling first had costed his East River Bridge at $3 million. By 1867 that estimate had increased to $7 million; 5 years later Washington Roebling

revised it to $9.5 million. With the purchase of land, the figure grew to $13.2 million in 1875, still far short of the $15.2 million incurred by the time that the bridge opened. One source estimated the final cost at $17.2 million (based on the unskilled wage index, today that figure would be about $2.2 *billion*). Bridge Trustee Stranahan explained that the escalation was caused by changes in the interests of safety and convenience, ordered by either the government or the Trustees. Noting that the bridge was "not that contemplated in [the original] estimate," but "higher, wider, and composed of stronger material," he insisted that the changes were needed "to make the bridge what it should be," whatever that meant.

Washington Roebling resigned as chief engineer on June 30, 1883, and his chief assistant, Charles Cyril Martin, was appointed in his place.

Between 1886 and 1896 the City of Brooklyn annexed surrounding towns, and in 1898 its residents voted by a narrow margin to form Greater New York with Manhattan, Queens, the Bronx, and Richmond (later Staten Island). In January 1915 the name of the bridge was officially changed from "New York and Brooklyn Bridge" to "Brooklyn Bridge," although that had been determined long since by popular usage. The U.S. government designated the bridge a national historic landmark in January 1964; it was listed on the National Register of Historic Places in October 1966, and as a New York City landmark in August 1967. The American Society of Civil Engineers named it a National Historic Engineering Landmark in 1972. Nevertheless, it remains only a "potential" entry for UNESCO's World Heritage list. Neither does official recognition make it an icon of American architecture or engineering.

THE EIGHTH WONDER OF THE WORLD

Why the *eighth* wonder? Simply because an arbitrary seven "wonders of the world" had been identified since classical antiquity. The idea first occurs in Herodotus' *The History* in the fifth century B.C. About 200 years later the chief librarian of the Alexandria Mouseion, one Callimachus of Cyrene wrote *A Collection of Wonders Around the World* (since lost), and a century after that Antipater of Sidon and Philon of Byzantium named the seven, probably as a "must-see" list for tourists. Somewhat revised, it appeared in its present form in the Middle Ages, when only the pyramids at Gizeh remained standing: also included were the "hanging gardens" of Babylon (probably confused with Nineveh), Phideas' statue of the Olympian Zeus, the Artemision of Ephesus, Mausolus' Tomb at Halicarnassus, the Colossus of Rhodes, and the walls of Babylon (later cast aside in favor of the Pharos at Alexandria). The point to be made is that from its inception the list was in flux, so we must not be surprised if modern lists also have been revised.

The publisher of Haw's *The Brooklyn Bridge: A Cultural History* asserts that the bridge is "hailed by some as the Eighth Wonder of the World." But only some. There were modern contenders for the title before the Brooklyn Bridge; for example, the Victoria Bridge, Montréal of 1860. And since 1883 many others have been feted as the eighth wonder, among them the West Baden Springs Hotel, Indiana (1902), the Panama Canal (1914), the Houston Astrodome (1965), Sydney Opera House (1973—even an opera, *The Eighth Wonder*, was written about it), and the weird and wonderful Palm Islands of Dubai, still under construction. Were every one legitimate, candidates by now would be staking claims as the several hundredth "wonder." One source names the Victoria Bridge as "widely referred to as the eighth wonder of the *modern* world." That qualification betrays a trend: besides "wonders of the *modern* world," now there are lists of "*modern* wonders of the *western hemisphere*." As their ambit narrows such lists become less significant, especially in an age of accelerating technological change. Therefore, what yesterday was exalted to stand with the seven, today is supplanted, just like in the ancient world. The promotion of a work to the rank of wonder often is merely promotion, and it may be challenged by "Says whom?"

Inclusion even on a list of "modern suspension bridge wonders of the world," based on longest, highest, or biggest is not an indication of iconic status. There are sixty-five such bridges with longer spans than the Brooklyn Bridge. The longest to date—6,529 feet—is the Akashi-Kaikyo Bridge across the Akashi Straits in Japan. Although discontinued for political reasons in October 2006, the proposed Strait of Messina Bridge, linking the Italian mainland with Sicily, would have had a main span seven-and-a-half times that of the Brooklyn Bridge.

Roebling's bridge did not seize the popular imagination simply because it was big. What is "big" depends wholly upon the frame of reference within which it stands. In 1943 Oscar Hammerstein II wrote a song about an 1880s cowboy returning from Kansas City to the Oklahoma Territory. He reports, "They went an' built a skyscraper seven stories high—about as high as a buildin' orta grow!" In truth, that sentiment could have been expressed by his urbane cousin from New York City or Brooklyn, the first and third largest cities in the United States. The bridge was of brobdignagian scale in what was then at the most a five- or six-story cityscape. Because tall buildings are now commonplace—New York has more than eighty that exceed 600 feet—it is difficult for us to appreciate the wonder that those colossal granite towers generated in the tens of thousands of people who daily commuted across the East River. As it came into being over almost 14 years the bridge created a sense of anticipation and perhaps even of ownership within those who moved in its growing and familiar shadow. In the popular mind, of itself it assumed iconhood.

Drawing upon Alan Trachtenberg's *The Incorporation of America*, in which he examined the evolution in the late nineteenth century of the American

corporation and the "emergence of a changed, more tightly structured society," Jennifer Pricola wrote in 2002, "The Brooklyn Bridge lies at the point where these processes intersect." Identifying it as icon—more correctly, a metaphor—of industrial and corporate America, she added "the success of a suspension bridge relies on the inherent tension of its structure, and in the case of the 'Great Bridge,' everyday conflict and myriad obstacles prolonged and burdened the work, adding to its emblematic power. [In the same way] tensions bind America; its society stands on—and gains strength from—the incorporation of conflicting interests and ideologies."[8]

As it reflected those social tensions, the bridge also exposed aesthetic tensions, certainly in America but also in most of the Western world. Appearing in *Harper's Weekly* just 2 days after the official opening, a critique by architect Montgomery Schuyler dismissed Roebling's design as "architectural barbarism," guilty of "a woeful lack of expression." He lamented that some "future archaeologist, looking from one of these towers upon the solitude of a mastless river and a dispeopled land, may have no other means of reconstructing our civilization than that which is furnished him by the tower on which he stands." Commenting with Ruskinian dogmatism, "this . . . ought to be a question with every man who builds a structure which is meant to outlast him," he wryly added, "The work which is most likely to become our most durable monument, and to convey some knowledge of us to the most remote posterity, is a work of bare utility; not a shrine, not a fortress, not a palace, but a bridge."[9]

Schuyler cannot be blamed for failing to understand that he was witnessing a major change of direction: given impetus by the Industrial Revolution, the engineer was about to eclipse the architect. The greatest and most innovative structures, for a time, would be built without benefit of or even advice from architects. In the case of the bridge, style is not an issue: it is a harbinger of a new design approach in which the essence of the structure is clearly expressed in the form. The clumsy moldings and the tentative, archeologically incorrect "gothic" elements may be a slight nod toward contemporary fashion. One historian writes that Schuyler's review was simply sour grapes, but that it recognized the bridge "for the icon it [would] become—an icon built without architectural input and for which [an architect] can take no credit."

In fairness, it must be noted that Schuyler's views mellowed as Western architectural thought evolved. In *Architectural Record* of March 1909, after congratulating himself for "the first attempt . . . made in this country at an aesthetic consideration of an important engineering work," he admitted that what one demands in such a work [as the bridge] is "the adaptation of form to function." He added that in the case of the bridge, "the successes are all won by letting the structure 'do itself,' so to speak, the failures all incurred by forcing it to do something else. Even to-day . . . there is no finer thing in its kind to be seen than the gossamer structure of the metal, the airy fabric that swings between the towers."

His changed position is reflected by later writers. Analyzing a claim that the bridge was "offered as an example that negotiated a position midway between tradition and novelty, the stable and the exploratory," Trachtenberg asserts that it is significant because it "embodies two styles of building: the masonry is traditional, while the steel is something new. To be recognized as architecture, structural stone must be carved into a familiar shape, while the steel, unburdened with precedents, could take whatever shape its function demanded."

The Brooklyn Bridge is a multilayered icon, confirmed by its place in the heart of the people of Brooklyn and Manhattan, even when it was still in course of construction; by its reflection of changes in corporate structure and the rise of industry; by its heralding of a new dawn of engineering as art; and by its anticipation of a new architectural aesthetic. Another layer was added in the 1920s, when through their diverse media, a group of New York thinkers and artists including the poet Hart Crane, the painter Joseph Stella, and the essayist Lewis Mumford countered the pessimistic view of America expressed in T.S. Eliot's 1922 epic poem, *The Wasteland*.

For the bridge's centenary, on May 24, 1983, Paul Goldberger wrote an appreciation, "Brooklyn Bridge at 100, embodies the spirit of an age" in *The New York Times*:

> The Brooklyn Bridge . . . stands for many things—for movement, for thrust, for the triumph of man over nature and, ultimately, for a city that prized these qualities over all other things. . . . So much more than a roadway [the bridge] was, by itself, the tallest and grandest manmade thing in the city. [Its] Gothic towers of granite were New York's first skyscrapers, for in 1883 they stood high above everything else on the skyline; its roadway provided a spectacular panorama of the city that could be obtained nowhere else. To see the city and the river from the Brooklyn Bridge was like flying.
>
> But the genius of John Roebling's design goes beyond even this. The bridge is an object of startling beauty. . . . What makes it magic is the way the towers, the cables and the roadway all play off against one another. The towers stand like great, majestic gateways to Manhattan and Brooklyn. The cables offer a gentle counterpoint, so delicate that they look like harp strings, and though they are, in fact, made of heavy strands of steel bound together, they make us feel that if we plucked them they would respond with beautiful music. And the roadway lifts in a gentle curve, animating the entire composition.

NOTES

1. Green, Samuel W., *The Complete History of the New York and Brooklyn Bridge: From Its Conception in 1866 to Its Completion in 1883*. New York: S.W. Green's Son, 1883.

2. McCullough, David G., *The Great Bridge: The Epic Story of the Building of the Brooklyn Bridge*. New York: Simon & Schuster, 1983, 24.

3. McCullough, chapter 1 and widely elsewhere.

4. First published in Hart Crane, *The Bridge: A Poem*. New York: H. Liveright, ca.1930.

5. Deborah Nevins, "1869–1883–1983," in Brooklyn Museum, eds. *The Great East River Bridge 1883–1983*. New York: The Museum; Abrams, 1983.

6. ASCE. "History and Heritage of Civil Engineering: Emily Roebling." www .asce.org/history/bio_roebling_e.swf

7. Keller, Allan, "The Great Brooklyn Bridge," *American History Illustrated* (April, 1973), 10.

8. Pricola, Jennifer, "American Icon." http://xroads.virginia.edu/~MA03/pricola/ bridge/intro.html

9. Schuyler, Montgomery, "The Bridge as Monument," *Harper's Weekly* (May 26, 1883). See also Schuyler, "Our Four Big Bridges," *Architectural Record* 25(March 1909), 147–160.

FURTHER READING

Brooklyn Museum, ed. *The Great East River Bridge 1883-1983*. New York: The Museum; Abrams, 1983.

Crane, Hart. *The Bridge: A Poem*. New York: H. Liveright, ca.1930

Haw, Richard. *The Brooklyn Bridge: A Cultural History*. New Brunswick, N.J.: Rutgers University Press, 2005.

Latimer, Margaret, Brooke Hindle and Melvin Kranzberg, eds. *Bridge to the Future: A Centennial Celebration of the Brooklyn Bridge*. New York: New York Academy of Sciences, 1984.

Lopate, Phillip, and Burhan Dogancay. *Bridge of Dreams: The Rebirth of the Brooklyn Bridge*. New York: Hudson Hills, 1999.

McCullough, David G. *The Great Bridge: The Epic Story of the Building of the Brooklyn Bridge*. New York: Simon & Schuster, 1982.

Roebling, John A. *Report to the President and Directors of the New York Bridge Company on the Proposed East River Bridge*. Brooklyn, N.Y.: The Daily Eagle, 1867.

Roebling, Karl. *The Age of Individuality: America's Kinship with the Brooklyn Bridge*. Fern Park: Paragon Press, 1983.

Schuyler, Hamilton. *The Roeblings: A Century of Engineers, Bridge-Builders and Industrialists; The Story of Three Generations of an Illustrious Family, 1831–1931*. New York: AMS Press, 1972.

Shapiro, Mary J. *A Picture History of the Brooklyn Bridge: With 167 Prints and Photographs*. New York: Dover, 1983.

Trachtenberg, Alan. *Brooklyn Bridge: Fact and Symbol*. Chicago: University of Chicago Press, 1979.

Vogel, Robert M. *Building Brooklyn Bridge: The Design and Construction, 1867–1883*. Washington, D.C.: National Museum of American History, Smithsonian Institution, 1983.

Weigold, Marilyn E. *Silent Builder: Emily Warren Roebling and the Brooklyn Bridge.* Port Washington, NY: Associated Faculty Press, 1984.

INTERNET SOURCES

Brooklyn Bridge website. www.endex.com/gf/buildings/bbridge/bbridge.html
Pricola, Jennifer. "American Icon: Incorporating Tensions in the Brooklyn Bridge." http://xroads.virginia.edu/~MA03/pricola/bridge/print.html

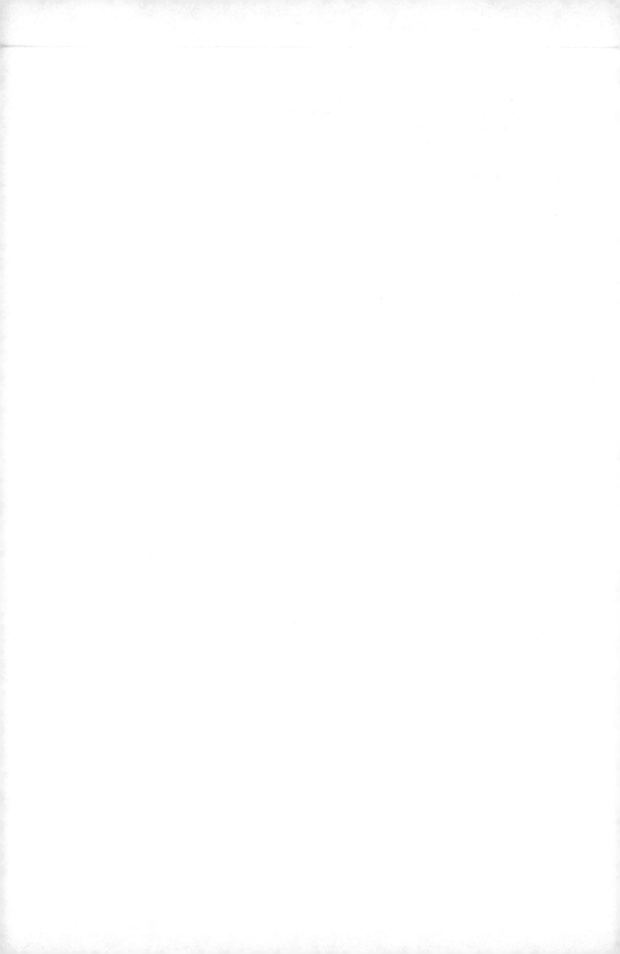

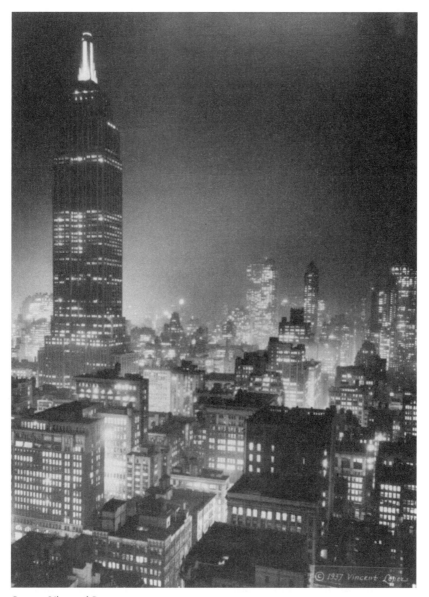

Courtesy Library of Congress

Empire State Building, New York City

"The strangest story ever conceived by man"

James Sanders' *Celluloid Skyline*, a book about Hollywood's vision of Manhattan, reveals filmmaker Merian Cooper's inspiration for the climax of the movie *King Kong*: "One afternoon in February 1930 . . . [he] glanced up just as the setting sun glistened off the wings of a plane . . . near the New York Life Insurance Building." Cooper later wrote that when he imagined "a giant gorilla on top of the building [he] thought . . . , if I can get the gorilla logically on top of the mightiest building in the world and then have him shot down by the most modern of weapons . . . then no matter how great he was in size that gorilla was doomed by civilization."[1] While the film was in production, the Chrysler Building soared past the Life Insurance Building, and in 1931 the Empire State Building became the tallest in the world. Cooper twice made changes to his scenario in response to this "race to the sky." When *King Kong* was released in March 1933 with the tagline "The strangest story ever conceived by man," the gigantic primate was seen by the world climbing the Empire State, then only 2 years old. The movie's breathtaking climax did much to establish the towering structure as an American icon quite early in its history, and since then the motion picture industry has done much to affirm that.

Sometimes a Hollywood producer makes a "discovery" and an actor has appeared in a leading role in his or her very first movie, without having to climb the arduous ladder from bit player to star. That, in a sense, is what happened with the Empire State Building. And although it was momentarily eclipsed by the upstart One World Trade Center (WTC), it reprised the role with great success in 2005, in color and with very convincing special effects. In Dino De Laurentiis' 1976 remake of *King Kong*, the final showdown between giant ape and (in that case) jet aircraft took place atop the WTC—a change that recognized that the Twin Towers had won (at least temporarily) the title of the world's tallest buildings. But in Peter Jackson's nostalgic re-remake Kong was back on his original perch, snatching biplanes from the air. The Empire State's propagandists observe that "a building with this much character can't seem to keep itself out of the movies." But it seems that its prominence in films has more to do with its size than its character. Those people who count such things tell us that almost twelve thousand movies have been set in New York City; to avoid showing the Empire State Building is analogous with a director asking a 7-foot tall extra to mingle inconspicuously in a crowd scene.

However, the soaring office tower has had more than "walk-on, walk-off" roles in around ninety movies—certainly too many to examine in any detail here—usually as a location for a least some of the action. Memorable among them was the "legendary tearjerker" *An Affair to Remember* (1957)—perhaps because it starred Cary Grant and Deborah Kerr—about star-crossed lovers who agree, after spending 6 months apart, to confirm their enduring love by meeting at the top of the Empire State Building. The film was the inspiration

for TriStar Pictures' romantic comedy *Sleepless in Seattle*, variously described by critics as "shallow, contrived and ineptly directed" and "predictable, manipulative, and completely satisfying," which (naturally) appealed widely to the same kind of audience. It also included a climactic meeting at the top of the Empire State. Is there nothing new under the sun?

In a rather different vein, Twentieth Century-Fox's 1996 "big, dumb, glossy blockbuster" *Independence Day*, with a $71 million budget, spectacular special effects and the insipid tagline, "We've always believed we weren't alone. Pretty soon, we'll wish we were," evoked the sci-fi movies of 50 years earlier. In it, the Empire State Building is obliterated in an alien attack that reduced most of New York City to ashes. One reviewer quipped that the movie was "like an advertisement for more defense spending."

And now for something *completely* different. The Empire State Building was the sole star of *Empire*, filmed by Andy Warhol in July 1964. Despite the medium, it could hardly be classified as popular culture; indeed, the fact that it was added to the National Film Registry in the Library of Congress in recognition of its "cultural, historical and aesthetic significance" suggests that some regard it as high art. The grainy black-and-white silent film comprised one continuous, 8-hour-and-5-minute shot of the building at night. In 2006–2007 the New York Museum of Modern Art screened a 2-hour, 24-minute excerpt; then, who would know?

As late as 2007, the long-running BBC-TV sci-fi series *Doctor Who* included an episode titled "Daleks in Manhattan" in which the ubiquitous Time Lord confronted his old enemies in the recently completed Empire State Building, where they were modifying the mast to achieve their evil ends. There were plausible re-creations (or evocations) of the Art Deco interiors. In 1966 the building had been featured—albeit briefly—in another *Doctor Who* six-part adventure, "The Chase," in which William Hartnell played the original Doctor in black and white.

In 1955, the American Society of Civil Engineers named the Empire State Building as one of the "seven modern wonders of the western hemisphere," and on the occasion of its Golden Jubilee in 1981 it was, not without reason, designated an official New York City landmark.

As part of its 150th anniversary celebrations in 2007, the American Institute of Architects (AIA) polled over eighteen hundred people about "America's favorite architecture." The foremost popular choice was "the most iconic building in the United States—the Empire State Building." Commenting upon the list, R. K. Stewart, then president of the AIA, observed, "When you ask people to select their favorites, they don't choose buildings or designs that are the most advanced or scientific—they choose buildings that hold a place in their hearts and minds." Every year, nearly four million visitors pay $18 each to take in the vista from the skyscraper's eighty-sixth floor observation deck.

THE TALL BUILDING HISTORICALLY CONSIDERED

William Starrett, a principal of the contracting firm that built the Empire State and many other tall buildings, claimed in 1928 that the skyscraper was "the most distinctively American thing in the world."

> It is all American and all ours in its conception, all important in our metropolitan life; and it has been conceived, developed and established all within the lifetime of men who are, in many cases, still active in the great calling. . . . For the skyscraper, to be a skyscraper, must be constructed on a skeleton frame, now almost universally of steel, but with the signal characteristic of having columns in the outside walls, thus rendering the exterior we see simply a continuous curtain of masonry penetrated by windows. . . . We use these skyscrapers and accept them as a matter of course, yet as each new one rears its head, towering among its neighbors, our sense of pride and appreciation is quickened anew, and the metropolis, large or small, wherein it is built, takes it as its very own, and uncomplainingly endures the rattle and roar of its riveting hammers, and the noises and the inconvenience of traffic which it brings. And this is because we recognize it as another of our distinctive triumphs, another token of our solid and material growth.[2]

Capitalism sired the skyscraper. From the late nineteenth century, because of spiralling real estate values in America's major urban centers, there was a need to optimize land use. Chicago in particular was a focus of change, and the devastating October 1871 fire was a catalyst. Subsequent renewal of the central business district—The Loop—called for the fusion of existing knowledge and emerging technology to create a new building type: the tall office block. Load-bearing construction was uneconomical for such a use; the structural need for walls to be thickest at the lowest levels wasted prime rentable space at high cost. The drawbacks weren't only financial but environmental as well; as Starrett explained, "Masonry structures of ten stories and more demanded lower walls of such fortress-like thickness and sparse window vents that the ground-floor space, most valuable of all, was devoured and the sunlight all but excluded."

Once, Americans variously used the word *skyscraper* to describe a high-flying bird, a fly ball in baseball or even a tall hat. In 1883 an *American Architect and Building News* article applied it to building, declaring that public buildings should always have something in their vicinity that soared above all around, the form of "sky-scraper gives that peculiar refined, independent, self-contained, daring, bold, heaven-reaching, erratic, piratic, Quixotic, American thought." It prophetically (and jingoistically) added that "American constructive and engineering skill" could build such a building strong enough to resist any gale. Indeed, the building type was, as Starrett affirmed a half-century later, an American invention in which (at least to the admiring eyes of European architects) those distinctively New Worldly qualities were

perceived. Nevertheless, Europe eagerly adopted the form and the name (except the Germans and the Dutch, who spoke more pedantically of "*cloud-scrapers*").

Although tall buildings were nothing new, the skyscraper had no architectural precedent. Egypt's Great Pyramid at Gizeh (ca. 2570 B.C.) was 481 feet high. Neither were the multistory buildings innovative: the 300-foot Ziggurat of Marduk—the biblical Tower of Babel—built in Babylon about 800 years later had seven stories. But these ancient buildings *defined* space, rather than *enclosing* it. The great Roman public baths and basilicas and the later Christian cathedrals throughout Europe, though they enclosed stupendous volumes, were essentially single-story buildings. There were a few historical examples of multistory space-enclosing buildings, such as the second century A.D. residential tenements in Ostia, Italy, but their practicality was limited, mainly by inconvenience of access to the upper levels.

The new building form can be related to new materials. As early as 1849 the New York inventor and architect James Bogardus had built the four-story Laing stores, in which the upper floors, roofs, and even the relatively thin external walls ("curtain walls" that served as nonstructural environmental screens) were supported by cast-iron frames. The building was assembled in about 2 months. Three decades later, the Chicago architect William Le Baron Jenney employed a similar structural system for his seven-story so-called first Leiter Building in the windy city.

But iron presented difficulties. Although much lighter than masonry construction of equivalent strength, it failed structurally at quite low temperatures; that risk could be reduced by encasing structural members in fire resistant material. However, though perfectly adequate in compression, cast- and wrought-iron had little tensile strength, so that iron beams were limited to relatively short spans, necessitating forests of columns, which in turn diminished the flexibility of space deployment, especially in commercial buildings. After about 1865 consistent quality steel was economically produced in large quantities by the Siemens-Martin open-hearth method; because of its high tensile strength a steel frame was lighter still. Jenney's ten-story Home Insurance Building in Chicago (1884–1885) was the first to make use of full steel skeleton construction, and by the 1890s the "typical" skyscraper had a riveted steel frame that carried all the loads—self-weight, imposed dead loads, live loads, and wind loads—within an enclosing curtain wall.

In multistory buildings, a mechanical vertical transportation system was essential. Elisha Graves Otis installed the first passenger elevator in a New York department store in 1857; by 1873 over two thousand commercial buildings throughout the United States had steam-powered Otis systems (steam-powered *goods* lifts had been used in Britain since 1835). But steam elevators, that were slow and needed very large spaces to accommodate the vast drums around which their cables were wound, were not well suited to skyscrapers, even those of moderate height—say, up to twenty stories.

Otis and other manufacturers responded with hydraulic elevators; occupying much less space, they could travel at up to 700 feet a minute—nearly three times the speed of the fastest steam elevators. In 1880 the German Werner von Siemens employed an electric motor on a rack-and-pinion elevator, and 7 years later in Baltimore an electric version was developed that moved the cage by winding the cable on a revolving drum. The first Otis "direct-connected geared electric elevator" was used in the Demarest Building in New York in 1889.

NEW YORK, NEW YORK

Of course, in New York, the skyscraper had evolved in much the same way as elsewhere. As hard as it is to imagine now, before about 1880 Manhattan's general skyline was only a few stories high. The rare soaring exceptions were the 281-foot neo-Gothic spire of Richard Upjohn's Episcopal Trinity Church, completed in 1846, and Richard Morris Hunt's 18-story, 250-foot *New York Tribune* building of 1873–1875. Generally, successive office buildings would increase from only seven or eight stories in the 1870s to eighteen or more in the 1890s. Although an intervening economic depression dampened commercial building activity, two very tall structures, both longer term projects, were completed in the 1880s: the Brooklyn Bridge, with its 276-foot towers, was opened in 1883 and the 301-foot Statue of Liberty was dedicated 3 years later.

Commercial developments began to catch up. In 1883–1884 Norris G. Starkweather built the eleven-story, cast iron-framed Potter Building with its ornate terracotta façades; 5 years later Bradford Lee Gilbert's 130-foot Tower Building, also of eleven stories and the first in New York with a steel skeleton frame, was finished. Its close contemporary, the twenty-story, 309-foot *New York World* Building (aka the Pulitzer Building) by George B. Post was the first office tower taller than Trinity spire; it also was steel-framed, although the external walls had a partly structural function.

In 1892 the New York Building Law first regulated skeleton construction, and steel-framed skyscrapers proliferated before the turn of the century; examples include Robert Henderson Robertson's 292-foot American Tract Society Building (1894–1895) and his thirty-story, 391-foot Park Row Building (1896–1899). The 612-foot Singer Building (completed 1908) by Ernest Flagg seized the "world's tallest building" record from Ulm Cathedral, Germany; dubbed a cathedral of commerce and industry, it was the first secular building to hold the title. The following year it was surpassed by LeBrun and Sons' 700-foot Metropolitan Life Insurance Building and then in 1913 by Cass Gilbert's 792-foot Neo-Gothic Woolworth Building, that held the record until 1930.

Most New York office towers were monolithic prisms, rising directly from the edges of their sites. Flagg, an erstwhile critic of high rise, had advocated height limitations and restrictive zoning, as demonstrated in the Singer Building's set-back design, so that "we should soon have a city of towers

instead of a city of dismal ravines." Such views contributed to the Building Zone Resolution adopted by New York City in July 1916; a major catalyst to the legislation was the completion a year earlier of Ernest R. Graham's thirty-six-story Equitable Life Assurance Building, which "caused resentment due to its massive scale . . . and for blocking sunlight from the street." Among other things, the Resolution covered issues of health, fire safety, and compatible land use. More significantly in the present context it controlled the height and setbacks of tall buildings, assuring that adequate light and air reached adjoining properties and streets.

A QUESTION OF STYLE

The accelerating advances in technology made it (some might say) relatively easy to resolve the pragmatic aspects of the skyscraper. But what of an appropriate aesthetic for a new building type? In March 1896 the Chicago architect Louis Sullivan challenged,

> Offices are necessary for the transaction of business; the invention and perfection of the high-speed elevators make vertical travel . . . , once tedious and painful, now easy and comfortable; development of steel manufacture has shown the way to safe, rigid, economical constructions rising to a great height; continued growth of population in the great cities, consequent congestion of centers and rise in value of ground, stimulate an increase in number of stories. . . . Thus has come about the form of lofty construction called the "modern office building. . . ."
>
> Problem: How shall we impart to this sterile pile, this crude, harsh, brutal agglomeration . . . the graciousness of those higher forms of sensibility and culture. . . ? How shall we proclaim from the dizzy height of this strange, weird, modern housetop the peaceful evangel of sentiment, of beauty, the cult of a higher life?[3]

He had long since concluded that the tall building should incorporate a base (the floors that allowed public access), a shaft (a number of identical floors for offices), and a capital (a well-defined cornice terminating the composition). That was not to say that it should plunder history, but despite his denials, comparison with a classical column is inevitable. His Wainwright Building in St. Louis, Missouri (with Dankmar Adler, 1890–1891) probably best demonstrated his newly derived aesthetic.

The theories of the French architect Eugène Emmanuel Viollet-le-Duc (1814–1879) reached America just as architects were grappling with this issue. Until then, architecture had been a retrospective art; after all, the ways and means of building—indeed, the uses of buildings—had not changed significantly for centuries. At best, architects designed according to an appropriate stylistic precedent: for example, perhaps Gothic for churches, Greek for cultural institutions, or Renaissance for government buildings. At worst,

styles were selected or hybridized from an historical smorgasbord. In any case, as far as it was possible, archaeological detail (to a greater or less degree) masked the skyscraper's innovative structural system. The building form of the new "metallurgical architecture," Viollet insisted, should express the materials and methods that it employed. Yet it took some time for the tall building to shake free from the chains of historicism. Well into the twentieth century architects continued to select inappropriate styles as precedents; that is true of all the New York buildings already cited. The mind-set is betrayed in the 260 entries in the 1922 *Chicago Tribune* competition for "the most beautiful office building in the world"; European designers employed a new aesthetic, American designers did not.

A major influence on the surface appearance—inside and out—of New York skyscrapers was the 1925 Paris *Exposition Internationale des Arts Décoratifs et Industriels Moderne*, that gave rise to the jazzy "Art Deco" style. Someone has described it as "modernism with the plainness taken off." It may be that its decorative qualities, though owing nothing to historical sources, made it more acceptable than the austerity of socialistic (God forbid! Even communistic) European Modernism of those postwar years; besides, much of the New Architecture was rooted in Germany. That country had been deliberately sidelined by the organizers of the 1925 Paris show. And the United States declined to have a pavilion, ostensibly on the grounds of having insufficient original designs to exhibit (exposition rules excluded copies and imitations of old styles). For all that, the show, which ran from April to October, was well attended by interested Americans: architects, designers, and laymen alike.

Anyway, Art Deco, because it had no relevance to building *process* was little more than appliqué—young people now would call it "bling"—that, though often expensive, had no deep relationship with the underlying (and often quite pragmatic) architecture. Earliest New York examples include the offices and showrooms of the Cheney Silk Company (1925), decorated by the French metalworking company Ferrobrandt, and the fifty-six-story Chanin Building of 1927–1929, by Sloan and Robertson, embellished by architect Jacques L. Delamarre and sculptor René Chambellan.

In 1926 construction began on the Chrysler Building, in which the lavish application of Art Deco was stretched to the limits of taste. Many corporations built skyscrapers for their promotional value, and one writer extravagantly claims that automobile magnate Walter P. Chrysler wanted his building to be decorated with "hubcaps, mudguards, and hood ornaments, just like his cars, hoping that such a distinctive building would make his car company a household name." He also wanted it to be the world's tallest building.

AND THE WINNER IS . . .

From late in the nineteenth century 180 office blocks of at least twenty stories were built in Manhattan. Until 1929 the tallest—in fact, the tallest in the

world—was the 792-foot, fifty-five-story Woolworth Building on Broadway. After that, the "race for the sky" was between the Bank of Manhattan Trust Company at 40 Wall Street (since 1996, the Trump Building) and Chrysler's tower on the corner of 42nd and Lexington Avenue.

The "cold and nondescript" Manhattan Trust building, designed by H. Craig Severance with associate Yasuo Matsui and consulting architects Shreve and Lamb, was completed in April 1929; at 927 feet (2 feet above the planned height disclosed by Chrysler) it won the world title—at least, momentarily. Its rival, designed by architect William van Alen, was intended be crowned with a dome. But the architect covertly had obtained permission to add the stainless steel spire that is now recognized as the building's most distinctive feature; its components were preassembled inside the upper floors, and it was fixed in just an hour-and-a-half on October 23, 1929, bringing the height to 1,048 feet. Triumph was short lived. The Empire State Building won the race a few months later. As historian Mark Kingwell colorfully puts it, "The Chrysler and the Manhattan Company buildings had gone head to head, neck and neck down the stretch. Now, it was as if a powerful novel breed of animal had rounded the curve behind them and, with a burst of powerful strides, beaten them soundly, going away."[4]

Described by one of its architects as "the product . . . not of pure inspiration but of a symposium of owner, banker, builder, architect, engineer, and real-estate man," the Empire State Building was the outcome of a courageous real estate speculation by a company formed in 1929, the year of the Wall Street crash. The principal investors were the multimillionaire John Jacob Raskob, former CEO of General Motors; industrialists Pierre Samuel du Pont and his cousin Coleman, both of E. I. du Pont de Nemours and Company; Louis G. Kaufman, president of the Chatham and Phoenix Bank; and Republican politician Ellis P. Earl.

Raskob, the prime mover of the project, was a self-made financial genius. In 1901 Pierre du Pont had hired him as a stenographer on an annual salary of $1,000; within a decade he had become assistant treasurer of the vast DuPont corporation and in 1914 was promoted to treasurer. From 1915, advised by Kaufman, he invested the company's profits from World War I munitions in General Motors stock, eventually securing almost half of the automobile company. In 1918 he became vice-president of finance of DuPont and General Motors.

Although a Republican, in 1926 Raskob contributed to the campaign to reelect as mayor of New York Democrat Alfred E. ("Al") Smith, "a colorful, charismatic product of the lower East Side." Both men were successes from poor Irish Catholic families, and their working relationship cemented a friendship. In 1928, against the best advice of the politician's aides, Raskob was appointed as campaign manager in Smith's unsuccessful contest with Herbert Hoover for the U.S. presidency. Paradoxically, a Republican millionaire was thus chairman of the Democratic National Committee. When he launched the Empire State Corporation Raskob offered Smith the position of

president at an annual salary of $50,000. It was a canny public relations move, as one historian observes: "[they] had suffered side by side through bruising attacks on their religion and patriotism; now that Smith had returned to private life, Raskob was there with what he needed most—a job. Smith, like the building itself, was 'up from the city streets,' and he had a magnetism of legendary proportions: he would serve as front man and mascot for the [Empire State] project."[5]

The paradox of that project was that it became a reality just when "almost everything else was coming apart and tumbling earthward." The Empire State venture was made public in August 1929; land had been purchased, architects commissioned, documentation prepared, contracts let, and a company office set up at 200 Madison Avenue. Then at the end of October came the cataclysmic crash of the New York Stock Exchange; after a brief recovery in 1930, that fall would generate the Great Depression that spread internationally for most of the decade. But to discontinue the project would have inflicted monumental losses on his coinvestors and especially on Raskob. Having committed themselves they had no choice but to grit their financial teeth, take their chances on an economic turnaround and carry on with their plans. In December Smith announced that they had taken a loan of $27.5 million from the Metropolitan Life Insurance Company. One commentator observes that the building was a "stalwart symbol of optimism"—perhaps *bravado* is a better word. Kingwell eloquently writes that the Empire State Building's

> unlikely birth in the middle of the 1929 crash; its defiant optimism steered by Al Smith and . . . Raskob, those quintessential self-made men; the astonishing assembly line of steel and stone that made it the fastest megaproject the world had seen; its gathering of workers from all nations and trades—all this combines to make [it] the ultimate dream building.[6]

It has been claimed that the name was chosen "as part of a public relations and morale boost" in those dark days. Some sources ascribe New York's appellation as the Empire State to George Washington, who in December 1784 called it "the seat of the Empire." Between 1785 and 1790 New York City was indeed the first seat of the U.S. government.

THE LIGHTHOUSE OF MANHATTAN

For much of the nineteenth century the Empire State Building's Fifth Avenue site was farmland, later transformed into a desirable address for New York's urban aristocracy. The block between 33rd and 34th Streets became the location of two mansions on expansive sites: the northern half was occupied by Caroline Astor, while her nephew, William Waldorf Astor built a house on the southern half. In 1893, "in order to spite his aunt," he replaced his

residence with the Waldorf Hotel, designed by the highly productive turn-of-the-twentieth-century architect Henry Janeway Hardenbergh. Four years later Caroline fought back by replacing her own home with the Astoria Hotel, also by Hardenbergh. The hotels combined to create the Waldorf-Astoria, a gathering place for the "four hundred," the cream of New York Society. In 1928, the complex was sold to Bethlehem Engineering Corporation, and the establishment was later "reincarnated" as a forty-seven-story Art Deco pile on Park Avenue.

The Empire State Corporation acquired the Fifth Avenue property, as well as adjoining lots that brought the total area to about 2 acres, for a little over $16.2 million dollars. When space in the Empire State Building was eventually offered for lease in the 1930s, much would be made of the site's history—it must be said, apparently to little effect. Journalist Frances Low wrote in *American Heritage* in 1968 that oversize press announcements trumpeted William Astor's 1827 purchase of the land and "burbled on about the 'perpetual prestige' of the address." Some advertisements included photographs of the Astor mansions, Astor weddings, or of the Waldorf-Astoria Hotel to attract tenants to "the world's most distinguished address."

The Corporation commissioned the architectural firm of Shreve and Lamb to design its building. Richmond H. Shreve was widely acknowledged for his expertise in dealing with logistical issues, and William F. Lamb was a talented designer. At first they were asked to create a fifty-story, 650-foot high office block but that program was to undergo several revisions—some sources say as many as fifteen. There is a persistent story that at a briefing meeting Raskob took from his desk drawer a thick "jumbo" pencil (the kind still available as novelties) standing it on end, he asked Lamb, "Bill, how high can you make it so that it won't fall down?" The proposal was changed to an eighty-six story, 1,050-foot tower, crowned with an observation platform, giving the Empire State nine more rentable floors than the Chrysler Building. But that would make it only 4 feet higher than its rival. According to one writer, Raskob was "worried that Walter Chrysler would pull a trick like hiding a rod in the spire and then sticking it up at the last minute." Believing the 4-foot margin to be inadequate, he asserted that "this building needs a hat." Further changes to the design in December 1929 increased the Empire State to 102 floors and a height of 1,472 feet, including an ambitious 220-foot stainless steel mooring mast for dirigibles like the pioneering German *Graf Zeppelin*.

"THE LOONIEST BUILDING SCHEME SINCE THE TOWER OF BABEL"

In the 1930s newspapers across the United States published promotional photographs of the American airship *Los Angeles* docking at the Empire State Building. It never happened. All the images were "photographic

composites"—a polite way of saying "fakes." Yet for a short time a mooring mast was seriously proposed. The romantic idea was that transatlantic travelers could disembark at the very heart of New York. The eighty-sixth floor would house airline offices and passenger lounges and facilities; the actual anchorage would be at the 106th level. The building frame was braced to resist the 50-ton pull of a moored dirigible—*Graf Zeppelin*, for example, was 776 feet long and 110 feet high—and some of the winch equipment was installed. Little thought was given to the practicalities, especially the major objection that the unpredictably fluctuating air currents over Manhattan would make it virtually impossible to securely moor the huge vessels. The Corporation's lawyers nevertheless drafted documents to argue that "owners of neighboring buildings could not sustain a claim of trespass when they found dirigibles overhead." Moreover,

> Raskob and Smith were inviting the unwieldy craft to come in low and slow, over hazards such as the menacing Chrysler Building spire, and somehow tie up without use of a ground crew. Then, too, if the crew released ballast to maintain pitch control, a torrent of water would cascade onto the streets below. And once secured, a dirigible could be tethered only at the nose, with no ground lines to keep it steady.[7]

Even if such difficulties could have been overcome, passengers would have to disembark nearly a quarter mile in the air, and find their way down a swinging gangway to a narrow open platform near the top of the mast. They then would have to negotiate two steep ladders inside the mast to reach the elevators. That was hardly a dignified arrival for people affluent enough in those Depression days to spend $5,000 for a one-way ticket. The chief of Germany's *Zeppelin Gesellschaft*, Hugo Eckener, himself an experienced airship pilot, had strong misgivings about the proposal. The early support, even enthusiasm, of the American press soon gave place to a more cautious approach; one paper hyperbolically criticized, "the proposal . . . hangs on the highly dubious contention that the saving of an hour's time to thirty or forty travelers is of more importance than the assured safety of thousands of citizens on the streets below."

It took only one nearly disastrous attempt to moor a small U.S. Navy nonrigid airship—a "blimp"—to prove the point. On September 16, 1931, the docking procedure succeeded for just 3 minutes. The craft was almost upended by unpredictable eddies, and its spilled water ballast drenched pedestrians blocks away. Two weeks later a Goodyear blimp delivered a bundle of newspapers to the mast by rope. After that, the proposal was abandoned—a decision tragically validated in May 1937 by the fiery destruction of the *Hindenburg*. The question may be asked, "What would have happened if the hydrogen-filled *Hindenburg* had exploded over midtown Manhattan instead of at Lakehurst, New Jersey?" The observation decks would remain just observation decks, and the mast later formed the base of a television tower.

"THE PARAGON OF EFFICIENT BUILDING CONSTRUCTION"

The client's brief was succinct enough: "a fixed budget, no space more than 28 feet from window to [central] corridor, as many stories of such space as possible, an exterior of limestone, and completion by 1 May 1931." The potential outcome was largely constrained by New York's strict zoning regulations, which mandated that from the thirtieth floor up the building could not exceed a quarter of the ground lot in area. In the event, the architects were more generous to their neighbors and to the New Yorkers who moved on the canyon floor below. Working in association with the structural engineers H. G. Balcom and Associates, Shreve and Lamb (joined some time in 1929 by Arthur L. Harmon) produced a steel-framed tower whose five-story base covered the whole site. Rising uninterrupted from a 60-foot setback at the sixth floor to the eighty-sixth floor, it was faced with silver-gray Indiana limestone and granite, and its verticality was emphasized by continuous chrome-nickel steel mullions.

Typically, the tower floors had a central core—elevators, stairs, toilets, service shafts, and corridors—surrounded on four sides by a 28-foot deep perimeter of office space. As one critic comments, the configuration had "the so-called skyscraper advantages of more windows and minimized interior darkness. Although there would be less rentable space, the tower footage was considered prestige space that would command good prices." The structural system was hardly innovative: its 210 closely spaced steel columns produced a robust frame with a high degree of structural redundancy—that is, there were many alternate paths by which the building loads were transmitted to the foundation. The disadvantage was that this forest of columns restricted flexibility in the layout of offices, reducing market appeal for prospective lessees.

The Otis Company installed seven banks of elevators with a total of fifty-eight cars for passengers and eight for goods and services. Each bank (they varied in size) was dedicated to a number of levels; to expedite movement, those carrying passengers to upper floors would bypass the lower ones. They were designed to travel at 1,200 feet per minute, although when the building was progressing, changes to New York codes restricted speeds to just over half that. A month after the Empire State was opened, the code was again revised to allow faster movement.

The design aesthetic was unremarkable, and the building was either ignored or criticized by the *aficionados* of the sterile European modernism—the so-called international style—then incipient in North America. But apart from Raskob's metaphor of the "jumbo" pencil, there seems to have been no client–architect discussion of the building's style. Efficiency, not aesthetics, had been stressed. Noting architectural historian Edward Wolner's comment that the "Empire State . . . was modernistic, not modernist. It was deliberately less pure, more flamboyant and populist than European theory allowed," it can be

claimed justifiably that the building's artistic qualities are relatively inconsequential, because much of its significance lies in the fact that the design, in William Starrett's words, was "magnificently adapted to speed in construction." And speed *was* of the essence.

The contract was let to the Starrett Brothers construction company—the firm's name changed to Starrett Brothers and Eken in 1930—who were probably New York City's major builders of skyscrapers through the 1920s. They had a disarmingly honest approach to tendering; when the clients asked how much equipment they had on hand, Paul Starrett replied, "Not a blankety blank [*sic*] thing. Not even a pick and shovel," before explaining, "This building . . . is going to represent unusual problems. Ordinary building equipment won't be worth a damn on it. We'll buy new stuff, fitted for the job, and at the end sell it and credit you with the difference. . . . It costs less than renting second-hand stuff, and it's more efficient."

In 1928 his brother William wrote more politely and poetically of the difficulties of the heroic task in *Skyscrapers and the Men Who Build Them*:

> Foundations are planned away down in the earth alongside the towering skyscrapers already built. Water, quicksand, rock and slimy clays bar our path to bedrock. Traffic rumbles in the crowded high-ways high above us and the subways, gas and water mains, electric conduits and delicate telephone and signal communications demand that they not be disturbed lest the nerve system of a great city be deranged. . . . The obtaining of materials near and far and the administration of all those thousands of operations that go to make up the whole, are the major functions of the skyscraper builder. Knowledge of transportation and traffic must be brought to bear that the building may be built from trucks standing in the busy thoroughfares, for here is no ample storage space, but only a meager handful of material needing constant replenishment—hour to hour existence. Yet it all runs smoothly and on time in accordance with a carefully prepared schedule; the service of supply . . . , the logistics of building, and these men are the soldiers of a great creative effort."[8]

To meet the almost impossibly tight schedule set for them the contractors had to adhere to a meticulously detailed program devised by the chief engineer, Andrew J. Eken. The critical path schedules were said to have been worked out to the minute. Coordinating over sixty different trades, those schedules were complicated by the downtown location, because there was nowhere to hold materials awaiting use. The Empire State was the first commercial project to employ the "fast-track" technique, in which construction began before design details were finalized—in this case, to win the race for the tallest building.

Of course, the first phase of construction was the demolition of the Waldorf-Astoria Hotel, beginning on October 1, 1929. Some sources claim that seven hundred workers removed 16,000 truckloads of debris that were loaded into barges and dumped into the Atlantic Ocean, "five miles beyond Sandy Hook."

Even before demolition was complete, excavation for the new building started. From January 22, 1930, two shifts, each of three hundred men working day and night, dug 55 feet below ground to construct footings in the gray Manhattan bedrock.

"SKY BOYS"—THE HIGH STEEL WORKERS

Work began on the building's skeleton just under 2 months later. Rolled steel columns and beams manufactured in Pittsburgh were transported to a supply yard in New Jersey, to be taken by truck to the site. They were marked with their location in the frame and the number of the electrically driven derrick that would hoist them for fixing at their final location. It is said that often the whole process took only 80 hours. The frame rose an average rate of four-and-a-half floors a week. William Starrett justifiably boasted, "The first column was set on April 7, 1930 and twenty-five weeks later over 57,000 tons of steel had been topped out . . . 87 stories above the sub-basement level, twelve days ahead of schedule."

This unprecedented feat was achieved by a well-organized workforce of three hundred skilled high steel workers—the "sky boys." They came from different backgrounds; some had been sailors, accustomed to the lofty rigging of ships (a generic term for men who work on tall building frames is still "rigger"). But most of those on the Empire State Building were Caughnawaga Mohawks from an Indian reserve on the St. Lawrence near Montreal, Canada. The photographer Lewis Wickes Hine was commissioned to document the construction of the Empire State Building. His heart-stopping images show steelworkers—known as "sky boys"—walking on beams or sitting astride them, "riding the ball," climbing on guy wires, even relaxed, eating their lunches or clowning around between heaven and earth, without hard hats or any of the safety gear mandated by modern laws. According to Low, the popular press lauded these "poet builders . . . who ride the ball to the 90th floor or higher, and defy death to the staccato chattering of a pneumatic riveting-hammer." "Fitting-up gangs" secured the prefabricated steel sections to hoisting cables, and "raising gangs" rode them to their place, where they were built into the frame by "riveting gangs." When the steelwork was at its busiest, thirty-eight riveting gangs were employed. They worked in teams of four: the "heater" raised the rivets to red-heat in a forge, picked them up with 3-foot tongs and lobbed them one by one to the "catcher," who caught them in a can. Also using tongs, he placed them, still red-hot, into predrilled holes in the structural joint. The "bucker-up" supported the rivet while the "gun-man" secured it with a compressed-air hammer.

Of necessity, the rest of the building work was also efficiently organized. Low writes, "Other crews in the construction process swarmed in [an appropriate verb] on the heels of the steel setters." The various suppliers of materials,

machinery, or equipment synchronized delivery with installation. Materials arrived on-site in trucks that drove into the ground floor—at the peak of activity, that meant almost five hundred deliveries every day. They were immediately unloaded into any of twenty rail cars (each one, pushed by workers, held about eight wheelbarrows full) that was raised to the designated floor on a purpose-built temporary elevator, and transported on tracks to the location where the material was "deposited at the workers' very elbows." Movement of the ten million bricks used in the building was handled in a similar way. Delivery trucks dumped their loads down a chute to a hopper in the basement; as they were needed, bricks were dropped from the hopper into railway carts and taken to their location. The building's masonry skin was fixed by mid-November 1930; all the stonework except for few ornamental details at the lower levels was set in 16 weeks. Low wrote,

> Stairways rose through the skeleton; then came the electric cables and various kinds of piping, the building's veins and arteries. The lower floors were plastered before the roof was made tight. The overlapping schedule was working well, and, with the omnipresent pressure for speed, it all gave, in the [*New York*] *Times*'s felicitous phrase, the impression of "a chase up into the sky."

More time was saved by organizing the lunch breaks. Low states that "When the noon whistle blew, five mobile cafeterias began shuttling up and down [on the 3rd, 9th, 24th, 47th, and 64th floors of the] scaffolding. For forty cents—and with no time lost—a man could sit on a girder and gulp down two sandwiches, coffee or milk, and pie." The provision meant that the men had more time to eat, and the contractors had a more productive workforce. Fewer than one in seven of the workmen left the site at lunch times. A temporary reticulation system provided drinking water throughout the site.

Starrett Brothers and Eken executed the contract for the Empire State "with a level of organization and detail that was unequalled . . . as the paragon of efficient building construction and a record for speed of construction that remains unmatched." The building was finished ahead of schedule on April 11, 1931—only a year and 45 days after it had begun. That was achieved by an average workforce of twenty-five hundred. During spring and summer 1930, when site activity reached its peak, thirty-four hundred workers—nineteen hundred on the principal contractor's payroll, and fifteen hundred employed by sixty-seven subcontractors—saw the building rise more than a story every day. Altogether, they worked 7 million carefully monitored man-hours, including Sundays and public holidays. According to *The New York-Daily News*, fourteen men died in accidents in the course of building; although of little consolation for their families, the project had an impressive safety record, because as a rule of thumb, the expected number of construction deaths was then one worker per floor.

On May 1, 1931, in "almost a holiday atmosphere" New York City officially dedicated the skyscraper. With Governor Franklin D. Roosevelt and

Mayor "Jimmy" Walker watching, Al Smith, his wife, and two grandchildren cut the ribbon to the main entrance of the Empire State Building. A congratulatory message from President Herbert Hoover was read at the opening ceremonies on the observation deck: "This achievement justifies pride of accomplishment in everyone who has had any part in its conception and construction and it must long remain one of the outstanding glories of a great city." By touching a golden telegraph key in the White House, he turned on the building's lights. The CBS and NBC networks broadcast the proceedings, and the highest telegraph station in the world transmitted and received telegrams. *The New York Times* hailed the Empire State as "Building in excelsis"; other newspapers were just as effusive about this "poetry in steel" and "the tallest arrow in Manhattan's quiver."

THE "EMPTY STATE BUILDING"

There can be no question that the building opened at the wrong time. Optimistically conceived during a real estate boom, the venture's financial success was shattered by the Wall Street crash; construction of the skyscraper had proceeded "against all logic." But because of Depression prices, it cost only $24.7 million—half the notional budget and well below the contractor's estimated $43 million.

Despite its well-publicized renown as the world's tallest office building, the owners were hard pressed to find tenants for the 2.1 million square feet of office space. Witty New Yorkers coined the epithets "Empty State Building," "the 102-Story Blunder" and "Smith's Folly." To exacerbate the impact of the Depression, the Fifth Avenue address, classy as it may have been, was too far from the central business district. Even after *King Kong* made it more famous in 1933, only a quarter of the building was leased; 6 months later there were still fifty-six vacant floors. To create an illusion of higher occupancy, lights were kept burning at night on the empty floors. Following World War II, New York commerce found its center of gravity in the Rockefeller Center, a 22-acre, nineteen buildings complex on 48th and 51st Streets, between Fifth and Seventh Avenues.

The Empire State now has over eight hundred small tenancies supporting nine thousand employees in what are decidedly unfashionable offices. Kingwell characterizes it as "a kind of urban time machine filled with diamond merchants, insurance companies and private investigators, among many, many others." The rents are around 77% of Midtown Manhattan averages. He writes,

> In business terms, the Empire State Building may be the most famous white elephant on the planet. . . . It has never succeeded in its ostensible function as an office building. . . . Vacancy rates have recently climbed again, from a low of 1.7 percent in 2000 to more than 18 percent. . . . The small offices and antiquated

infrastructure are part of the deterrent, despite projected upgrades; but so is a continuing feud between the two companies that control the building. . . , which complicates leasing arrangements.[9]

On the other hand, he admits that "Nostalgic love of the building seems to fend off any association beyond a name with American empire, taking the old building on its merits as an icon of capitalism, technology, and the modern," and wistfully adds, "The Empire State was meant, without irony, as a concrete expression of the American Dream, the optimism in technology and perseverance that can conquer all challenges . . . this was an illusion born of romance and sadness."

Perhaps the most lyrical response to the Empire State Building was that of the blind and deaf author Helen Keller, following a 1932 visit to the Observation Deck:

> I was pleasantly surprised to find [it] so poetical. From everyone except my blind friend I had received an impression of sordid materialism—the piling up of one steel honeycomb upon another with no real purpose but to satisfy the American craving for the superlative in everything. . . . Well, I see in the Empire Building something else—passionate skill, arduous and fearless idealism. The tallest building is a victory of imagination. Instead of crouching close to earth like a beast, the spirit of man soars to higher regions, and from this new point of vantage he looks upon the impossible with fortified courage and dreams yet more magnificent enterprises.
>
> What did I "see and hear" from the Empire Tower? As I stood there 'twixt earth and sky, I saw a romantic structure wrought by human brains and hands. . . . I saw it stand erect and serene in the midst of storm and the tumult of elemental commotion. I heard the hammer of Thor ring when the shaft began to rise upward. I saw the unconquerable steel, the flash of testing flames, the sword-like rivets. I heard the steam drills of pandemonium. I saw countless skilled workers welding together that mighty symmetry. I looked upon the marvel of frail, yet indomitable hands that lifted the tower to its dominating height. Let cynics and supersensitive souls say what they will about American materialism and machine civilization. Beneath the surface are poetry, mysticism and inspiration that the Empire Building somehow symbolizes. In that giant shaft I see a groping toward beauty and spiritual vision. I am one of those who see and yet believe.[10]

The Architects

Canadian Richmond Harold Shreve (1877–1946) graduated in architecture from Cornell University in 1902, and after a brief teaching career joined the New York Beaux-Arts firm of Carrère and Hastings in 1906. He was at various times president of the American Institute of Architects, chair of the International Congress of Architects, president of the New York Building Congress, governor

of the Real Estate Board of New York, and a member of the Board of Design of the 1939 World's Fair. William Frederick Lamb (1883–1952) studied architecture at Columbia University and L'Ecole des Beaux-Arts, Paris. On graduating in 1911, he also joined Carrère and Hastings. Carrère died in 1911, and following Hastings' retirement the practice became known in 1920 as Carrère and Hastings, Shreve and Lamb, but 4 years later the latter two established a new practice, with Shreve as the administrative force in the firm and Lamb as the principal designer. Arthur Loomis Harmon (1878–1958) studied at the Art Institute of Chicago, before graduating from the Columbia University School of Architecture in 1901. After working in several New York architectural offices, including McKim, Mead, and White, he established his own practice in 1913. He joined Shreve and Lamb as a partner in 1929, after the Empire State building had started, and shared the design development work with Lamb.

Despite the Depression, the firm produced a number of tall buildings before World War II, including (among others) Carew Tower, Cincinnati, Ohio (1929); R.J. Reynolds Tobacco Co. Building, Salem, North Carolinda (1929); and in New York City: Lefcourt National Building (1929); 500 Fifth Avenue (1930–1931); 99 John Deco Lofts (1933). The practice flourished in the postwar years, even after the death of the founders. Perhaps its best-known building from that phase was the Deutsche Bank (opened in 1974 as Bankers Trust Plaza) that had to be demolished as a result of damage sustained from the collapse of the Twin Towers on 9/11.

The Structural Engineer

Homer Gage Balcom (1870–1938), the "man who made the Empire State Building stand," after receiving a civil engineering degree from Cornell University, was employed by the Berlin Iron Bridge Co. in Connecticut. When the firm was subsumed by the American Bridge Co. in 1900, he became design engineer and within 3 years was responsible for design of its New York City and Pittsburgh commissions. In 1905 he joined New York architects Reed and Stem, designers of Grand Central Terminal, and 3 years later formed an engineering partnership with Wilton J. Darrow.

When Darrow retired in 1916 the practice was renamed H. G. Balcom and Associates; it (and especially Balcom) had already earned an international reputation for structural steel design. During the Great World War I, he voluntarily served as chief structural engineer at the Emergency Fleet Corporation Yard, Hog Island, Pennsylvania. Besides the Empire State Building, Balcom's important New York skyscrapers were the Park-Lexington Building (1923), 230 Park Avenue (1929), the new Waldorf-Astoria Hotel (1931), the Bank of New York Building (1931), and the GE Building, 30 Rockefeller Plaza (1933).

The Contractors

Starrett Brothers and Eken was the construction division of the Starrett Corporation. The Starretts had long been associated with leading building and architectural firms in New York and Chicago. Paul Starrett (1866–1957) began his professional career in Daniel H. Burnham's office in 1887. In 1897 he joined the George A. Fuller Co., America's largest construction firm, working in Baltimore and Washington; the following year he moved to their New York office. He became a chief of construction and served as president from 1905 until 1922. William Aiken Starrett (1877–1932) received a civil engineering degree from the University of Michigan, and joined the Fuller Co. in 1898. From 1901 until 1913 he joined his brothers Theodore and Ralph as vice president of the Thompson-Starrett Construction Co., before becoming a partner in the architectural firm of Starrett and van Vleck. He returned to the Fuller Co. in 1919 as a vice president but left with his brother Paul to found Starrett Brothers in 1922.

After working as an engineer on both coasts and overseas, Andrew J. Eken (1882–1965) became a vice president of the Fuller Co. in New York and then president the Canadian office. He joined Starrett Brothers in 1929; the name of the firm was changed to Starrett Brothers and Eken in the following year. "Starrett Brothers became known for undertaking large-scale and complex construction projects executed with efficiency and speed." Besides the Empire State, they were responsible for other Manhattan landmarks, including the Pennsylvania Railroad Station, and buildings for the New York Life Insurance Co., the Manhattan Company, McGraw-Hill, Fuller (the Flatiron Building), the Plaza, the Commodore and Biltmore hotels, as well as hotels in other U.S. cities and the Lincoln Memorial in Washington, D.C.

During the Depression, Starrett Brothers and Eken undertook large-scale housing projects, including Hillside Houses in the Bronx, and Williamsburg Houses in Brooklyn, and Parkchester in the Bronx.

NOTES

1. Sanders, James, *Celluloid Skyline. New York and the Movies.* New York: Knopf, 2003. www.moviediva.com/MD_root/reviewpages/MDKingKong.htm

2. Starrett, William A., *Skyscrapers and the Men Who Build Them.* New York: Charles Scribner's Sons, 1928, 1.

3. Sullivan, Louis H., "The Tall Office Building Artistically Considered," *Lippincott's Magazine* (March 1896), 403–409; widely republished later.

4. Kingwell, Mark, *Nearest Thing to Heaven: The Empire State Building and American Dreams.* New Haven, CT; London: Yale University Press, 2006, 11.

5. Low, Frances, "A Chase up into the Sky," *American Heritage Magazine* 19 (October 1968). www.americanheritage.com/articles/magazine/ah/1968/6/1968_6_14.shtml

6. Kingwell, "New York's Lighthouse," *New York Times* (April 23, 2006).

7. Reingold, Lester A., "Airships and the Empire State Building—Fact and Fiction," *Air and Space Smithsonian* (July 2000).

8. Starrett, *Skyscrapers and the Men Who Build Them.*

9. Kingwell, "New York's Lighthouse."

10. Keller, Helen, *The New York Times Magazine* (January 1932), cited in Alexander Klein, *Empire City: A Treasury of New York.* New York: Rinehart, 1955, 76.

FURTHER READING

Architectural Forum. 52(June 1930) through 55(July 1931). [Empire State Building, a series of 12 (mostly technical) articles]

Doherty, Craig A., and Katherine M. Doherty. *The Empire State Building, Featuring the Photographs of Lewis W. Hine.* Woodbridge, CT: Blackbirch, 1998.

Empire State: A History, May 1, 1931. New York: Empire State Inc., 1931. [Commemorative booklet of opening]

Finan, Christopher M. *Alfred E. Smith: The Happy Warrior.* New York: Hill and Wang, 2002.

Goldman, Jonathan. *The Empire State Building Book.* New York: St. Martin's, 1980.

Hine, Lewis Wickes. *Men at Work: Photographic Studies of Modern Men and Machines.* New York: Macmillan, 1932. Republished in an unabridged, enlarged edition New York: Dover, 1977.

James, Theodore, Jr. *The Empire State Building.* New York: Harper and Row, 1975.

Kingwell, Mark. *Nearest Thing to Heaven: The Empire State Building and American Dreams.* New Haven, CT; London: Yale University Press, 2006.

Nakamura, Toshino, ed. "Empire State Building, 1931." *A+U* (April 1987).

O'Connor, Richard. *The First Hurrah: A Biography of Alfred E. Smith.* New York: Putnam, 1970.

Pacelle, Mitchell. *Empire: A Tale of Obsession, Betrayal, and the Battle for an American Icon.* New York: Wiley, 2001.

Rasenberger, Jim. *High Steel: The Daring Men Who Built the World's Greatest Skyline.* New York: HarperCollins, 2004.

Robins, Anthony W. *Empire State Building* (LP-2000). New York: City of New York, 1981. New York City Landmarks Preservation Commission Designation Report.

Shreve, Richmond Harold. "The Economic Design of Office Buildings." *Architectural Record*, 67(March 1930), 341–359.

Tauranac, John. *The Empire State Building: The Making of a Landmark.* New York: Scribner, 1995.

Walsh, James J. "John J. Raskob." *Studies: An Irish Quarterly Review of Letters, Philosophy and Science,* 17(1928).

Willis, Carol, ed. *Building the Empire State.* New York: W.W. Norton in association with the Skyscraper Museum, 1998.

INTERNET SOURCES

Empire State Building official Internet site. www.esbnyc.com

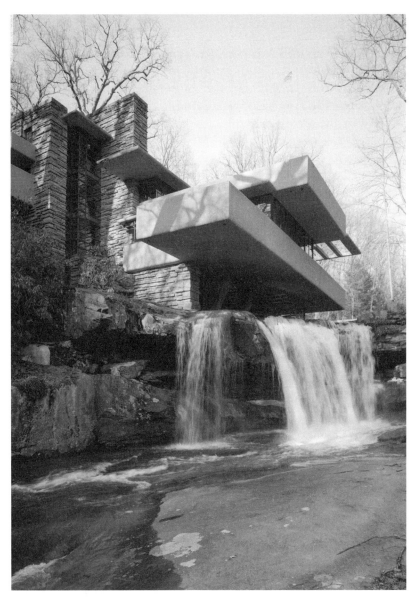

Courtesy Library of Congress

Fallingwater, Bear Run, Pennsylvania

The most beautiful house . . . of any century?

On a hillside beside PA Route 381, about 70 miles from Pittsburgh between the villages of Mill Run and Ohiopyle in southwestern Pennsylvania, and surrounded by woodland, is one of the most famous houses in the world. Fallingwater, suspended over a waterfall on the clear, swift-flowing Bear Run, was created by the architect Frank Lloyd Wright as a weekend retreat for Philadelphia retailer Edgar Kaufman and his wife Liliane; it has been an American icon since its completion in 1937.

Opened to the public in 1964, despite its remoteness, it has been the destination of about four million people, making it the twentieth most visited house in America. Many architecture critics have hailed it as Wright's greatest work—not an easy decision to make —and in 1991 the American Institute of Architects (AIA) voted it the best work *ever* produced by an American architect. Others have gone further: when naming the house Commonwealth of Pennsylvania Treasure 2000, Janet Klein, chair of Pennsylvania's Historical and Museum Commission, called it "a magnificent work that has inspired people of all ages around the world . . . considered by experts to be the 'top building of the 20th century.' " It continues to capture the hearts of the American public. Placed thirty-ninth in the AIA's 2007 survey of the nation's favorite architecture, after the White House, Biltmore Estate, and Monticello, it was the fourth most popular house. Lynda Waggoner, who manages it for the Western Pennsylvania Conservancy (WPC), says "[Fallingwater] is taught in every Art History 101 class."

Why is it iconic? R. Jay Gangewere wrote in 1999:

> Created in the midst of the Great Depression, the woodland retreat over the waterfall had a fast track into the American psyche. It was a personal escape into nature, produced at a time when Hollywood was creating escapist fantasies of its own about avoiding economic hardship. Millions of Americans, including unemployed workers in western Pennsylvania, could dream about life in a private retreat created by the most famous architect in America.[1]

Former Wright apprentice Robert Miller Green observed:

> A couple of years ago the American Institute of Architects published a paper which rated the one hundred "Most Influential Buildings in the History of the World." . . . Every great building in the world was on this list. [Fallingwater] was rated ahead of the Taj Mahal, The Parthenon, the great Gothic churches of France, Westminster Cathedral, the best buildings of the Renaissance, all the finest buildings which have been constructed since, as the building which has had the most influence upon architecture. It was as if, now that Frank Lloyd Wright had set the limits so high, nothing could now be forbidden the creative architect. And, people wanting to live in houses no longer had to be content with the box house that most reside in, that there was something different and better available. Frank Lloyd Wright had made that possible![2]

Public awareness of Fallingwater was immediately manipulated by the wealthy, well-connected, and marketing-savvy Kaufman, who was aware that

"a merchant could rely on no more effective advertising than a glamorous lifestyle." About a month after the owners moved in, the *St Louis Post-Dispatch* ran a piece, "A House that Straddles a Waterfall." New York's Museum of Modern Art (MoMA) mounted a photographic exhibition from January to March 1938—it is said to have affected Ayn Rand as she was writing *The Fountainhead*. MoMA board member Henry R. Luce, an evangelist of modernism, was also owner and editor-in-chief of *Time* magazine, and on February 21 its color cover featured a portrait of Wright seated in front of a large perspective drawing of Fallingwater. By then Lewis Mumford already had reviewed the house in *The New Yorker*. In the first 2 months of 1938 the building was also featured in *Architectural Forum* (owned by Luce), in Pittsburgh's *Bulletin Index*, in Pennsylvania's *We the People*, and in the national periodicals *Town and Country* and *Art Digest*. It was first published outside the United States in the Argentinean journal *Nuestra Arquitectura* in the following October.

Since then, besides appearing in every general book about twentieth-century architecture, Fallingwater has been, internationally, the subject of more than 120 dedicated books and monographs and articles in many languages. Its iconic status is inextricably linked with that of its designer.

FRANK LLOYD WRIGHT: ARCHITECT AND ICON

Frank Lloyd Wright is certainly the twentieth century's most famous architect. He once said, "Having a good start, not only do I fully intend to be the greatest architect who has yet lived, but . . . to be the greatest architect who will ever live." Following his death in April 1959 the *AIA Journal* observed, "His place in history is secure. His continuing influence is assured. [America's] architectural achievements would be unthinkable without him. He has been a teacher to us all." A few years earlier an affectionate caricature of the architect had appeared in an episode of Al Capp's internationally syndicated comic strip, "Li'l Abner." That he was recognizable in such a popular cultural medium proves that he was then (and remains) a truly iconic figure, and not just in the United States. In his later life he was showered with American and international honorary degrees, awards, and tribute, including the Gold Medals of the Royal Institute of British Architects in 1941 and, belatedly, of the AIA in 1949.

Wright held himself in high regard. "Early in life I had to choose between honest arrogance and hypocritical humility," he said. "I chose the former and have seen no occasion to change." Anecdotes about his egotism—many apocryphal—abound. One example will suffice. Wright, who flaunted his own "Welshness," in 1956 visited the Welsh coastal village of Portmeirion, bursting with wildly eclectic architecture built over decades by Bertram Clough Williams-Ellis. After subjecting Wright to what someone has called "an excruciating display of and recitation about" his own long career, Williams-Ellis

asked for Wright's opinion of his work. The American drily observed, "It can truly be said that we are both doing God's work. You're doing it your way. I'm doing it his way."

In a 74-year career Wright produced nearly 1,150 designs for all types of buildings; more than 530 of them were realized. He also designed furniture and furnishings, light fittings, stained and art glass, dinnerware, and graphic work; he wrote several books and countless articles, most of them polemical and many of them seminal works on modern architecture. And he proposed Broadacre City, a way to decentralize urban America, "the culmination of [his] ideas on a new architecture for a new democracy." Documentary film-maker Ken Burns described Wright's life as "a rollercoaster of stunning success and fame, vilification and exile, public humiliation, scandal, and devastating personal tragedy. He was controversial, notorious, provocative, and above all unpredictable—an epitome of excess in an age of propriety."[3]

Frank Lincoln Wright ("Lloyd" was a later substitution in deference to his mother's family) was born in June 1867 at Richland Center, Wisconsin, the son of music teacher William Cary Wright and Anna Lloyd-Jones Wright, also a teacher. When he was about age 9, his mother gave him the "Froebel gifts," geometric wooden blocks designed by Friedrich Froebel, the German creator of kindergarten. Wright claimed that they greatly influenced his architecture; his father played Bach, which Wright identified as the source of his sense of harmony. An elementary education in Wisconsin and Massachusetts (he never completed high school) preceded three terms of civil engineering studies at the University of Wisconsin. In 1887–1888 he worked in architect Joseph Lyman Silsbee's Chicago office, followed by 6 more years in the firm of Dankmar Adler and Louis Sullivan, where he eventually became chief draftsman, responsible for residential commissions.

In 1889 Wright married Catherine "Kitty" Tobin. With $5,000 borrowed from Sullivan, he bought land in Oak Park (now a Chicago suburb) and built his first home. But while employed by Adler and Sullivan he undertook a number of private—so-called bootlegged—commissions and was dismissed for "moonlighting." In 1893 he started his own practice in Oak Park and Chicago, and over the next 8 years or so he built about fifty residences. Published in the *Ladies Home Journal* of February 1901, his "Home in a Prairie Town" demonstrated a "modern architecture for a democratic American society." Culminating with the Frederick Robie house in Chicago, by about 1909 he had refined this "Prairie" type: frugally ornamented long, low buildings, their horizontality accentuated by low-pitched roofs with broad eaves and bands of windows. With their distinctive central fireplaces and especially the open floor plans that eliminated traditional box-like rooms, Wright's houses would revolutionize middle-class domestic architecture, first in the American Midwest, and eventually throughout the world.

In 1910 the Berlin publisher Ernst Wasmuth produced a sumptuous folio, *Ausgeführte Bauten und Entwürfe [Buildings and Designs] von Frank Lloyd*

Wright. A more modest version soon followed. Wright was still a parochial architect in the United States, and these volumes opened his work to an admiring international audience and significantly influenced the development of European Modernism. H. P. Berlage, regarded as the father of Dutch modern architecture, hailed him as the "most talented" of American architects. When the Wasmuth publications appeared Wright was in Europe.

In September 1909 he had caused a scandal in Chicago when he deserted Kitty, his wife of 20 years and their six children, to run off with Mamah Borthwick Cheney, the wife of a former client. The abrupt closure of his studio stranded his staff, as well as those clients whose commissions were incomplete. Because of financial "complexities," none of his employees would take over the practice; but Wright finally convinced Herman Von Holst to do so. After their escape Mamah worked at Leipzig University, while Wright lived at Fiesole near Florence, preparing drawings for Wasmuth. From time to time they met in Berlin, and after her work was finished she joined him in Italy. Presenting themselves as married, they traveled to Bavaria, Vienna, Paris, and London before returning to Chicago in 1911, only to be met with social and professional ostracism. Catherine denied him a divorce.

Leaving her and his children in the Oak Park house, Wright attempted to reestablish his practice in Spring Green, Wisconsin. On 200 acres of family-owned land he began to build a house which he named "Taliesin," after the sixth-century Welsh bard. The press preferred to call it a "love bungalow," and Mamah moved in shortly after Christmas 1911, while it was still incomplete. Around then only few of Wright's designs were realized; until 1914 there were some houses, but most commissions were for insignificant works. One major project, the Midway Gardens restaurant and beer garden on Chicago's South Side, led to his frequent absences from Taliesin in 1913 and 1914. In mid-August 1914, while Wright was in Chicago, Mamah dismissed a servant, Julian Carlton. A few hours later the man returned to the house and set one wing on fire; as the occupants ran out he used an axe to murder Mamah, her children Martha and John, three employees, and the teenage son of another; two others were injured. Wright was devastated and buried himself in what work he had.

Since 1913 he had been negotiating the commission for a new Imperial Hotel in Tokyo, "a project that literally consumed his emotional and physical energies." Well, almost all his energies. When the contract was signed in 1916 he went to Japan, accompanied by the sculptor Miriam Noel, whom he had met after she had written to him offering sympathy a few months following the Taliesin calamity. In summer 1915 he had asked her to move into Taliesin.

Until 1922 Wright spent about two-thirds of his time in Tokyo, completing the hotel that would famously survive the Kanto earthquake that destroyed most of the city in September 1923. In those years he undertook other commissions in Japan and built several houses in Los Angeles and elsewhere in the

United States. In November 1922 Catherine finally agreed to a divorce, and a year later, having lived together for 8 years, Wright and Miriam, by then a morphine addict, married at Spring Green. It didn't last. They quarreled a great deal, and she left Wright in April 1924.

In November 1924 Wright met the Serbian dancer Olga Ivanovna (Olgivanna) Milanoff; 33 years his junior, she was the estranged wife of a Russian architect, Vlademar Hinzenberg. Three months later Wright invited her and her 8-year-old daughter Svetlana to move into Taliesin. She divorced Hinzenberg, and at the end of 1925 she and Wright had a daughter, Iovanna, although they didn't marry until August 1928. Happiness was elusive: for years they fought for custody of Svetlana and immigration charges initiated by Hinzenberg, as well as other accusations made by the mentally unbalanced Miriam, with whom an acrimonious 3-year divorce was emotionally and financially ruinous for Wright. Miriam died in 1930.

Wright had rebuilt the parts of his house destroyed in 1914; there was another fire in April 1925, and he rebuilt again. But throughout the 1920s, for the reasons outlined, his architectural commissions were few. By 1927 he was deep in debt. The Bank of Wisconsin foreclosed on Taliesin, and Wright was evicted. Owing nearly $500,000, he was forced to auction his collection of valuable Japanese prints and offer his beloved house for sale. His old friend and client Darwin Martin rallied others to form Wright Inc., which assumed ownership of Taliesin and managed Wright's finances. But with the onset of the Great Depression commissions all but disappeared and money problems deepened. Attempting to keep his name before the public, Wright turned to lecturing, writing books, and articles and mounting "The Show," a national (and later international) traveling exhibition of his oeuvre. He also published the inspiring (if not altogether honest) *An Autobiography*. But the small income derived from all this self-promotion was hardly enough to maintain the run-down Taliesin, and plagiarizing didactic notions outlined to them by the visionary Dutch architect Hendrik Theodor Wijdeveld, in 1932 Wright and Olgivanna established a design school—the Taliesin Fellowship.

Reconstruction at Spring Green began in April. Under the motto, "first the buildings, then the creative work," the students—known as "apprentices"— were set to plastering and painting walls, digging ditches and growing food. For "washing dishes, caring for their own rooms . . . kitchenizing and philosophizing in voluntary cooperation in an atmosphere of natural loveliness they are helping to make eventually habitable," in the first year each *actually paid* Wright $675 for what he described as "education" and keep.

> . . . Wright was sixty-five when the Taliesin Fellowship commenced. Although there was a seed of underlying altruism, the school had been started principally to raise money. Wright sought other teachers in music and painting but they would not come unless he could pay them. By his own admission he was . . . incapable of working with anyone whose ideas differed from his own. Thus his

"curriculum" was architecture and Wright was the solitary master of the apprentices. Any diversity resulted from some apprentices already having training outside architecture: the crafts, painting, civil engineering, music and sculpture.[4]

Wright and Olgivanna ruled at Taliesin. Ayn Rand observed during a visit that at mealtimes the couple sat with their family and occasional guests at "high table" on a dais in the dining room, eating gourmet food while the apprentices were served fried eggs.

It seems that the wider architectural community then regarded Wright as a spent force—"yesterday's news" and out of touch with the times. After all, he had built only a couple of houses since 1920 and had turned his attention to self-publicity, income generation in a world of professional famine and idealistic speculation: his autobiography, the Taliesin Fellowship, and developing his "Broadacre City."

Then he met Edgar J. Kaufmann Senior, and his renaissance began.

EDGAR JONAS KAUFMANN SR., "MERCHANT PRINCE"

Wright was commissioned to design Fallingwater by Pittsburgh's "merchant prince," Edgar Jonas Kaufmann Senior. Kaufmann's Jewish father Morris had emigrated to America from Viernheim in Hessen, Germany, in 1870 with three brothers—Jacob, Isaac, and Henry—when he was only 12 years old. With their $1,500 capital, the following year Jacob and Isaac established an off-the-rack clothing store in a tiny room on Carson Street, Pittsburgh, selling mostly to workers from the nearby Jones and Laughlin steel mill.

They prospered, and in 1877 the business was relocated at Smithfield Street and Diamond Alley (now Forbes Avenue) in downtown Pittsburgh. A decade later "Kaufmann's Grand Depot," boasting itself to be "America's largest outfitting establishment," had expanded to Fifth Avenue. The two younger brothers, Morris and Henry eventually joined the business; Jacob died in 1905. Through competitive pricing and wide choices the store attracted a broad socioeconomic cross-section of clientele to its "ornate, midtown shopping palaces stuffed to the brim with all the goods a lady or gentleman would want." In 1910, when the "The Big Store" had 11 acres of floor space and twenty-five hundred employees, Edgar was invited to run the business.

He was the second of Morris and Betty Kaufmann's four children, born in November 1885. He was educated at Pittsburgh's Shady Side Academy—then private boys' school—and following a year at Yale University School of Engineering, he turned to a highly successful career in the family business. To gain retailing experience he worked for Marshall Field's in Chicago, *Les Galeries Lafayette* in Paris, Karstadt in Hamburg, and for a store in Connellsville, Pennsylvania. In June 1909, perhaps for business reasons, he married his uncle Isaac's daughter Lillian (later changed to Liliane). Their wedding was in

New York because marriage between first cousins, while permitted by Jewish law, was illegal in Pennsylvania.

By 1913 Morris had bought out Henry's interest in the business; Edgar had acquired Isaac's, making him the major shareholder. Under his management annual net sales rose to $30 million by 1920, and he was soon recognized as the "most brilliant retailer in the family." He has been described as "a most charismatic man, fond of social life, genuinely interested in the lives of his employees. Handsome, fit, he possessed a captivating gaze. . . . A philanthropist and patron of the arts, he also loved the outdoors, and especially enjoyed horseback riding, fishing and hiking."[5] The other side of Edgar Kaufmann was a tough bargainer who got what he wanted.

In 1918 he organized six other Pittsburgh department store owners to found the Research Bureau for Retail Training. Collaborating with the Carnegie Institute of Technology (now Carnegie Mellon University) and the University of Pittsburgh; it provided professional education for retail managers and salespeople and conducted research into the retail sector. From 1929 he chaired its executive committee, until 2 years before his death in 1955.

Kaufmann's first architect was the Beaux-Arts-trained Benno Janssen. In partnership with Franklin Abbott in 1913 Janssen enlarged "The Big Store" into an eleven-story stylistically indeterminate monolith. In 1922 he designed the Kaufmanns' house, "La Tourelle" in Fox Chapel about 6 miles northeast of downtown Pittsburgh—a rambling amalgam of historical revivalist forms. Then in 1925 Kaufmann commissioned Janssen and his partner William York Cocken to undertake a major remodeling of his store's main floor. Opened on May 1, 1930, the "art-deco masterpiece," which "set the store apart from all others in Pittsburgh," was replete with black glass, bronze finishes, terrazzo floors, new elevators, and a series of ten 15- by 8-foot murals by New York artist Boardman Robinson, unfolding the history of commerce. In 1933 Liliane established the glamorous Vendome Shops (named for the Place Vendôme in Paris), up-market boutiques on the store's underperforming eleventh floor, in which "she sought to offer sophisticated customers [an] interesting and tasteful selection of quality goods"—at a price.

The 1920s renovation to his store marks Kaufmann's first engagement with modern (more accurately, *moderne*) architecture. What circumstances moved him to commission the aging (and some said, passé) Frank Lloyd Wright to design a weekend retreat in the forest?

IN HARMONY WITH NATURE

Speaking of the house in a May 1953 NBC television interview with Hugh Downs—the transcript has been widely published since—Wright said,

> There in a beautiful forest was a solid, high rock ledge rising beside a waterfall, and the natural thing seemed to be to cantilever the house from that rock bank

over the falling water. . . . Then came (of course) Mr. Kaufmann's love for the beautiful site. He loved the site where the house was built and liked to listen to the waterfall. So that was a prime motive in the design. I think that you can hear the waterfall when you look at the design. At least it is there, and he lives intimately with the thing he loves.

As noted, early in his career Kaufmann had worked at Connellsville in Fayette County, southwestern Pennsylvania. Then, its population of over twenty-two thousand was supported by a thriving coal and coke industry. Local workers, and others from farther afield, often retreated to the leafy mountains on their days off. One could imagine that Kaufmann was among them. What would become the Bear Run Nature Reserve lies on the west slope of Laurel Ridge, facing the dramatic gorge of the Youghiogheny River in Pennsylvania's Allegheny Mountains. Its 5,000 acres is covered in forests of white oak, black oak, red oak, birch, tulip, maple, hickory, butternut, apple, and wild black cherry— in fact, more than five hundred species of evergreen and deciduous trees—rising from the dark, rich soil. The WPC recently published an idyllic description of Bear Run, the clear stream that passes directly under Fallingwater and flows through this demi-paradise:

Depending upon water level, you will hear either its roar or gurgle long before you approach the first of [its] four bridges. . . . [It] flows through a gauntlet of rhododendron, winds its way through old hemlock and over rock formations that at times produce a spectacular array of rapids and waterfalls. Tumbling over moss-covered rocks, dodging lichen-encrusted boulders, and pouring a smooth, even flow across sandy, leaf-littered terraces, [it] relentlessly . . . descends more than 1,500 feet to the Youghiougheny River.[6]

The Baltimore and Ohio Railroad made a twice-a-day whistle stop just where Bear Run reached the river, providing a focus for the small industry that dotted the area. And because the place was accessible, in 1890 a group of Pittsburgh Freemasons bought about 135 acres upstream from the station and built the Masonic Country Club, a members' weekend retreat. Five years later they bought another 1,500 acres. But the venture was not successful, and the property changed hands three times between 1906 and 1909, when it was acquired by the Syria Improvement Association (also a Pittsburgh Masonic group), and renamed the Syria Country Club; it comprised a large clubhouse, a dance pavilion, six cottages, and assorted buildings along the streamside road.

Kaufmann may have heard from one of his store detectives, Charles Filson, a Mason, that the property was available. He leased it in 1916 and established Kaufmann's Summer Club as a vacation site for his store's women employees, where they could enjoy "tennis, swimming, volleyball, hiking, hayrides, picnicking, sunbathing, singing, theatre and 'quiet' reading" well away from industrially polluted Pittsburgh. In 1921 the club renewed its 5-year lease, and in May 1926 the store employees' group, The Kaufmann

Beneficial and Protective Association, bought the property. Kaufmann held the mortgage, but the camp lost its appeal and fell into disuse during the Depression, so he took over the title in July 1933.

In 1921 he and Liliane had built their first summer retreat—a rustic wooden cabin made by Aladdin Readi-Cut Homes, "without electricity, indoor plumbing, or heat, except from a woodstove" about 500 yards southeast of the site of the future Wright house. It was nicknamed "Hangover" because it stood on the edge of a cliff. The Kaufmanns would spend a couple of weeks at a time there in the summers, although they went there year-round to fish, hike, swim, or just read.

Edgar Kaufmann actively promoted Modernist art and design. The 1913 touring New York Armory International Exhibition of Modern Art was shown in Kaufmann's Pittsburgh store. He had met German modernists during his European travels and knew the architect Joseph Urban and the furniture designer Paul T. Frankl, both Viennese émigrés. From the 1920s his store held exhibitions and organized lectures and undertook "an innovative series of special programs [that identified it] with technological and scientific progress." For example, after the influential Paris *Exposition Internationale des Arts Décoratifs et Industriels Modernes* of 1925, Kaufmann's presented its own Industrial Arts exhibition; and in 1928, following Charles Lindbergh's solo Atlantic flight, the store mounted an aircraft exhibit, drawing fifty thousand visitors in a single week.

Kaufmann, "irresistibly drawn to Wright's charming personality and mesmerizing sermons about buildings," probably chose the architect to design his summer house simply because he had seen his work and liked what he saw. It has been suggested that the merchant approached Wright in late summer 1934 after becoming aware of his mid-1920s unrealized proposal for a planetarium and "automobile objective" (Wright's words for a parking garage) for Gordon Strong on Sugarloaf Mountain in Maryland. In *Fallingwater Rising: Frank Lloyd Wright, E.J. Kaufmann, and America's Most Extraordinary House* Franklin Toker asserts that the merchant had been corresponding with Wright from the beginning of the year, "and probably before." He comments that it is hard to comprehend "what Kaufmann's support did to launch Wright on one of the great comebacks in art history. . . . Kaufmann did not create Fallingwater, but it speaks volumes for his courage and shrewdness that when Fate gave him a chance to sponsor an architectural wonder, he seized it."[7]

For a long time the conventional wisdom held that Edgar and Liliane Kaufmann's first contact with Wright was through their only child, also Edgar. On returning to the United States in 1934—he had been studying painting in Vienna and Florence—the 24-year-old gained an apprenticeship in the Taliesin Fellowship in October through a deal struck between his father and Wright. But after only 6 months he left to become a manager in the family business; it has been suggested that Junior was dismissed for what Wright called a lack of "circumspection." Toker believes that it was only after his father's death in

1955 that he started to present himself as the most important element in the Kaufmann equation. It worked. At (his) death in 1989, *The New York Times* wrote: "More than anyone else except, of course, Frank Lloyd Wright, Edgar Kaufmann Jr. was responsible for Fallingwater." But as Gill summarizes, "Junior was into his own mythmaking as the man who brought . . . Wright to the attention of the senior Kaufmann. Junior, an artist and architect with no future but later a curator at the Museum of Modern Art . . . was many things, but he was not midwife to Fallingwater."[8]

Anyway, in December 1934 Wright visited the Bear Run site with Taliesin apprentice Bob Mosher to supervise the mapping of its natural features. A few weeks later he wrote to the Kaufmanns, "The visit to the waterfall in the woods stays with me, and a domicile has taken vague shape in my mind to the music of the stream." The details of the site survey—carefully plotted contours and the exact location of each boulder and tree—arrived at Taliesin from Pittsburgh in April 1935; surveyors use different scales from architects, and all had to be replotted to the normal scale of building plans.

"THE SINGLE MOST CELEBRATED ACT OF ARCHITECTURAL CREATIVITY EVER"—REALLY?

Many writers, drawing upon apprentice Edgar Tafel's account of subsequent events, claim that Wright did nothing with the commission for 9 months and then drew complete plans for the house in a couple of hours. In the face of reasonable refutations (like that offered by Toker in 2003) this romantic myth of the genesis of Fallingwater continues—maybe because it *is* romantic. As late as June 2005 Hugh Pearman, the London *Sunday Times* architectural critic wrote:

> Wright sat down, got out his coloured pencils and—in two hours flat or as much as three by some accounts—*designed the house, in its entirety, down to the smallest detail*. As he drew it, he talked, describing it. It was all in his head. Wright placed the house on a great rock right on top of the waterfall. He named it, and signed it. *This astonishing feat of speed-design is the single most celebrated act of architectural creativity ever. It really happened*: several people witnessed it.[9] [emphases added]

Three months earlier Ken Burns had told the same story when delivering the Nancy Hanks Lecture on Arts and Public Policy in New York.[10] The gist is as follows.

On Sunday, September 22, 1935, Kaufmann Senior telephoned Wright from 140 miles away: he was on his way to see the designs for his house. Mosher later recalled, "Fees for the sketches of the new house were determined and presentation was scheduled for September 1935." Burns said, "Though

Wright had as yet committed absolutely nothing to paper, he remained completely calm"; with a filmmaker's dramatic flair he continued:

> The communal work at the fellowship came to a halt and a hush descended on the cavernous drafting studio as word went out among the students that Wright had begun, at last, to draw. For more than two hours, anxious apprentices handed him pencil after pencil, quieted those acolytes who walked in unaware of the unfolding drama, and watched transfixed as the Great Master summoned up, in a remarkable moment of architectural alchemy, the design he had obviously been thinking about for some time.
>
> "He draws the first floor plan," Edgar Tafel said, "and he draws a second floor plan and he shows how the balconies are, and Mr. Wright says, 'And we'll have a bridge across, so that E.J. and Liliane . . . can walk out from the bedroom and have a picnic up above.'" The apprentices are amazed as Wright then quickly draws . . . a "section through the building," then a huge elevation, twice the normal size of preliminary drawings. "And he's putting the trees in," Tafel exclaimed, "he knows where every damn tree is."
>
> A few minutes later, a secretary announced that Kaufmann had arrived. Wright dramatically ushered him in. "Welcome, E.J.," he said expansively, "we've been waiting for you."

Burns concluded, "Wright named the home he had designed for Kaufmann Falling Water. It would of course eventually become the most famous modern house in the world —and he had drawn it all in less than three hours." Burns inferred from the story, as have others, that design and drawing are synonymous. That is not so. In the practice of architecture there are great differences between preliminary design, design development, and drawing—especially presentation drawing. The instant design scenario is unreasonable; and as Judge Judy says, "If it's not reasonable, it's not true." It does not fit with the actions of a cash-strapped architect without another commission on his horizon. Indeed, the only phrase in Burns' version that resonates is "the design *he had obviously been thinking about for some time*." Tafel, then a 23-year old sorcerer's apprentice with a rose-colored view of Wright, may be excused his awe at the genius-at-work illusion.

Toker's "best guess" was that Wright had privately worked on the design and was so intimately familiar with its smallest details that they existed in his mind as "virtual drawings," so to speak. It was a simple matter to put them on paper, with no seeming effort. Gangwere had reached the same conclusion 4 years earlier. So had Wright's biographer Meryle Secrest, who in 1992 had described Fallingwater as "the fruit of a mature creativity and a deeply felt aesthetic."

Although Victor Cusack, a later member of the Fellowship, was not present, he passed on Mosher's version of events in defense of his idol Wright. It is only fair to include his comments:

> Toker's absurd speculation . . . is ridiculous on the face of it and to no purpose. When sketches were presented to his client, Kaufmann had no idea when they

might have been drawn. Nor were the sketches a dramatic "parlor trick." Only plans and a front elevation were presented to Kaufmann to which Mosher and Tafel added a section and side elevations during lunch.[11]

According to Mosher, when Kaufmann saw the house located not *near* his family's favorite picnic spot but *over* it he told Wright that was not what he had expected. The architect replied that he wanted his client to live with the waterfall, not just to look at it. Kaufmann unreservedly accepted the plans, and although subsequent drawings (naturally) included more detail, the basic design changed little. There is a persistent but unsubstantiated myth that Frank Lloyd Wright named the house Fallingwater (*FaLLingWater*) to incorporate his initials. Work on the house began in April 1936.

A WORK OF ART BEYOND ANY ORDINARY MEASURE OF EXCELLENCE

Architecture, of course, can be heard as well as seen. In a talk to the Taliesin Fellowship in May 1955, Wright called Fallingwater "one of the great blessings to be experienced here on earth," explaining that because "nothing yet ever equalled the coordination, sympathetic expression of the great principle of repose where . . . all the elements of structure are combined so quietly that really you listen not to any noise whatsoever although the music of the stream is there . . . you listen to Fallingwater the way you listen to the quiet country."

Donald Hoffmann observes that Wright "appreciated the powerful sound of the falls, the vitality of the young forest, the dramatic rock ledges and boulders [as] elements to be interwoven with the serenely soaring spaces of his structure." He continues,

> But [he] understood that people were creatures of nature, hence an architecture which conformed to nature would conform to what was basic in people. . . . Although all of Fallingwater is opened by broad bands of windows, people inside are sheltered as in a deep cave, secure in the sense of hill behind them. Their attention is directed toward the outside by low ceilings; no lordly hall sets the tone but, instead, the luminous textures of the woodland, rhythmically enframed. . . . Sociability and privacy are both available, as are the comforts of home and the adventures of the seasons.[12]

Fallingwater beggars all attempts at description, whether in prose, poetry, or even images. Echoing the Pottsville sandstone ledges around the waterfall, its four levels—they have been described as concrete "trays"—step back into the wooded hillside as they rise. Wright perceived the engineering principle of the cantilever in the rock outcroppings and even in the rhododendron bushes; thus Fallingwater's concrete cantilevers echo those in the landscape, while complementing the verticality of the waterfall itself. Although it stands high above Bear Run, the house's horizontality—Wright's "line of domesticity"—is

achieved primarily by the terraces (almost the same in area as the inside of the house) and flat roof. It is further emphasized by low ceilings and full height window-walls that provide spatial continuity between interior and exterior. Visual counterbalance is provided by a four-story sandstone chimney, laid in roughly dressed shallow courses whose "irregularities [mirror] the randomness of nature as opposed to man-made precision."

Architectural historian Spiro Kostof, in explaining how Wright "[sent] out free-floating platforms audaciously over a small waterfall and [anchored] them in the natural rock," comments that "something of the prairie house is here still." That is hardly surprising; Wright insisted that throughout his long career he never saw the need to revise the philosophy so clearly expressed in his 1905 essay, "In the Cause of Architecture." Put simply, he believed that a house was "a single living space and everything about it grew from a plan that expressed the owner's individuality. . . . Openness was achieved by exploiting technology [that is, by using central heating]. . . . Through sensitive use of materials, the spaces became a whole whose external masses, expressing what was within, existed in harmony with each other and the earth itself." So, although coming 30 years after his "prairie houses" and employing constructional materials and techniques different from theirs, in its essence Fallingwater was connected closely to them. In his Unity Chapel in Oak Park, Illinois, Wright had pioneered the architectural use of reinforced concrete as early as 1904. In 1938, emphasizing "for the first time in my practice, where residence work is concerned," he insisted that the material "was actually needed to construct the cantilever system of this extension of the cliff."

In harmony with the natural stone walls, chimney, and floors, Wright adopted contemporary and synthetic materials (including steel-framed windows) for what has been described as a "futuristic house of tomorrow"—a philosophical paradox, which we have no space to discuss here. Fallingwater also incorporated a kitchen with a table and counters covered with plastic laminate; it also had an AGA cooker, Cherokee-red linoleum floors, and pale-yellow steel cabinets. The walls and floors of the bathrooms were cork-paneled, and the fluorescent lighting was also "innovative and modern."

Carried on four stone stub walls, the lowest occupied level (although there is a cellar), was almost entirely taken up with a south-facing living space, flanked by terraces on the east and west. Inside and out, the floor was paved with random-shaped, slightly uneven sandstone flags; inside, it was waxed to a high gloss ("for cleanliness"), evoking the wet rocks in the stream. Kaufmann suggested that the hearthstone—the great boulder that had been his "favorite spot for lying in the sun and listening to the falls"—not be leveled. Wright agreed, and it erupts through the floor; unwaxed, the "heart" of the room—indeed of the whole house. It has been observed that the hearth had always been more than a psychological center for Wright; in the open plans of his houses, although they were usually centrally heated, it was a physical center that expressed "otherwise intangible values and ideals about family and

family life" and with the kitchen formed a central core around which the house was built. That was doubly paradoxical, considering the repeated and dramatic disruptions to his own family life; and the parlous state of Edgar and Liliane Kaufmann's marriage, described variously as "troubled," "complex," and "hollow." As someone has said, "It is a stretch to think that a house created by the libidinous Wright for the libidinous Kaufmann could reflect the strengthened American family of the 1930's, but icons need not be true: they only have to look true."

Steps from the east terrace led down to a 4½-foot deep plunge pool. The west terrace soared over the boulders flanking the waterfall. Inside the living room another stair led under the house, finishing just above the surface of the water. Access to the kitchen was in the diagonally opposite corner, beyond the hearth. The joinery was fashioned from North Carolina black walnut, and the window frames were painted Cherokee red—a favorite of Wright's.

Drawing upon the natural colors of the rocks and trees on the woodland site and (as always) the building materials Wright, in keeping with his deep belief in organic and integrated architecture, employed a limited palette of color lifted with accents in bright furnishings, "like wildflowers or birds outside." Liliane Kaufmann took a particular interest in the interiors. The WPC notes that her "sensibilities and attention to detail . . . brought elegance to a mountain retreat." In June 1937 she began choosing elegant furnishing fabrics, under Wright's jealous eye. Reviewing samples, he wrote to her in June 1937 that he found "the red color too heavy but the grey and white good" but otherwise imposed his opinion with uncharacteristic gentleness:

> [I] have the feeling that something less strident in pattern, (in fact no pattern at all), some coarse texture of the weaving—blue or yellow or warm grey with a bright thread woven into it, would be more in our thesis—"the nature of materials" and better for the house itself. . . . Because the environment is so rich and lively the detail of the furnishings can be merely tributary . . . the furniture units and pillows should run the gamut of color— in variety—from mercury red to cream or tan color, blue-green, yellow in between. But I am afraid of more pattern as we have already put so much design into the thing.[13]

He custom designed no less than 169 pieces of freestanding and built-in furniture for Fallingwater. Much of it—tables, chairs, stools, desks, and even lamps—was manufactured by the Gillen Woodworking Co. of Milwaukee and employed marine-quality plywood (because of the dampness of the site) veneered with black walnut. Always anxious to retain control, he called that attention to detail "client-proofing." But Edgar and Liliane added hundreds of items from their extensive eclectic collection: antique and contemporary; American, Asian and European; paintings, furniture, sculpture and *objets d'art*.

As to the "nonpublic" parts of the house: the master bedroom on the second level opened onto an expansive south-facing terrace twice its area,

cantilevered over Bear Run. There was also a dressing room and a guest room, each with its own smaller terrace, and three bathrooms. The third level—more than half of it is a south-facing terrace—was occupied by another bedroom (a "bed space"), a study, and a bathroom. Those are the bald facts. They cannot convey any idea of the complex and subtle spatial relationships—level to level and inside to outside—of this unique house. But the subtlety, if people search for it, goes deeper. A recent visitor, pointing out that "as opposed to visual elements that occupy space, auditory experiences occupy time and move forward in a linear manner," observed that the location of Fallingwater made the house into "a commentary on the passage of time."

The Kaufmanns moved into their summer house in November 1937. The original budget of $40,000 would have seemed extortionate at a time when an average four-bedroom brick house could be built for one-tenth of that amount. But the difficulty of finding skilled labor, the access problems associated with the remote site and its terrain and not least the "endless wrangling between a determined Wright and an equally willful Kaufmann" inflated the final cost (according to some sources) to $155,000, equivalent to about $2.2 million today." Other sources place the estimate at $30,000 and the final cost at an undefined figure "over $70,000."

Whatever it cost, the house was worth every penny!

A "GENTLE NOD TO THE INTERNATIONAL STYLE"—NOT!

In 2007 the AIA inaccurately characterized Fallingwater as "Wright's gentle nod to the International style." But none of the gestures that Wright made to European Modernism—and they were often repeated—could be called a gentle nod. Quite the contrary. As Joseph Connors points out, the house was Wright's "polemic response to modernism" that sprang from "ideas and imagery that flowed in such profusion from his pen and pencil in the years around 1900."

What *was* his attitude to Modernism? He fired his first salvo against it as early as 1928, in a review of the English translation of Le Corbusier's manifesto, *Vers une Architecture*. And when Wright's "Show" traveled in Europe in 1931 he accused the Modernists "in the land of the Danube and the Rhine" of denying their personalities and surrendering their individual freedom in the quest for internationalism—something that he refused to do. Although he admitted that their pragmatic architecture may have satisfied social and material needs, he accused them of forsaking human spirituality and promised: "What you have seen from my hand is not yet finished." He wrote in *An Autobiography*, published a year later, "I find myself standing now against . . . the so-called international style."

In February to March 1932, New York's Museum of Modern Art mounted the International Exhibition of Modern Architecture. The show introduced

the work of Walter Gropius, Ludwig Mies van der Rohe, Le Corbusier, J.J.P. Oud, and other European modernists to the American public. Overlooking the philosophical and artistic differences between them (which were as significant as the similarities), the curators Philip Johnson and Henry-Russell Hitchcock lumped those architects together and conjured the myth of an "International Style." Under the patriotic title "Of thee I sing" Wright reviewed the exhibition in Buckminster Fuller's *Shelter Magazine*. He asked whether "any aesthetic formula forced upon [America] can do more than stultify [the] reasonable hope for a life of the soul?" and pronounced in cumbersome prose and political confusion,

> A creative architecture for America can only mean an architecture for the individual. The community interest in the United States is not communism or communistic as the internationalists' formula for a "style" presents itself. Its language aside, communistic the proposition is. . . . We are sickened by capitalistic centralization but not so sick [that] we need confess impotence by embracing a communistic exterior discipline in architecture to kill finally what spontaneous life we have left. . . .

Wright never recanted. After World War II, in the draft of a letter to Wijdeveld (never sent) he complained that America, which in the 1930s had become the home of many European architects fleeing Hitler's Germany, was "overfilled with Leftwing Modernists." Naming many of them, he wrote, "The breach between myself and these men has widened; their apostasy has only served to betray the cause of an organic architecture in the nature of materials which I believe to be the architecture of Democracy." He believed that their "leftwing" architecture was—paradoxically—"distinctly Nazi."

Wright scholar Donald Leslie Johnson has remarked that besides Fallingwater, several of Wright's works of the 1930s—Ocotillo Camp, the Johnson Wax administration building, the Rose Pauson house, and Taliesin West—are "among the most important architectural works of the century, each remarkably and naturally different." He added that comparison is inevitable. Although Wright excepted the German Pavilion at the Barcelona World's Fair (1929) and the Edith Farnsworth house in Plano, IL (1945–1951), both by Mies, he believed that the white boxes of the "predatory internationalists" were "naive, puerile, conceptually sterile, and unnecessarily repetitive."

Someone has written that Wright perceived European Modernism as a "threat to his significance as an influential architectural force" because "a new generation of modernist architects was taking over that regarded [him] as a traditionalist and a has-been." Wright had never, in neither life nor art, been traditionalist. And Fallingwater proved that he was no has-been. Anyway, the question also must be asked, "What significance?" After all, he had built little for a decade.

Some architecture critics have suggested that Wright embraced the foreign style. In 1986 Paul Goldberger wrote in *The New York Times* that with

Fallingwater Wright "cast his net wider, integrating European modernism and his own love of nature and of structural daring, and pulled it all together into a brilliantly resolved totality." About a decade later Hugh Pearman claimed that the house blended "Wright's broad-brimmed Arts and Crafts-influenced Americanism with the white horizontality of the European modernism he professed to despise." Yet another writer contends that

> Fallingwater shared some aspects with the modern style of architecture. The flat, horizontal bands that created floating and overlapping planes in space is the most obvious similarity. . . . His use of concrete bears a similarity to the contemporary International Style but Wright used it in a more complex manner. . . . The open interior plan of Fallingwater is reminiscent of the 'free plan' used by International Style architects.[14]

There was little wonder in any of that. Many of the characteristics of twentieth-century European architecture (especially in houses)—open plans designed to fit the occupants' lifestyle, ranges of windows, horizontality, straightforward expression of materials—had all *originated* with Wright. Europeans had adopted (at best, or worse, simply copied) those elements from him in the first place, elements that he had initiated and refined before 1910. In the Bear Run house Wright saw no need to change his architectural philosophy; he was simply responding to new materials. His architecture was unique. So was Fallingwater in any way a response to international Modernism? No. What does it owe to international Modernism? Nothing—not even a "gentle nod." On the contrary, as Richard Lacayo wrote in *Time*, "the European Modernists . . . owed a lot to his rethinking of architectural space, a debt they generally acknowledged."

A FALLING FALLINGWATER

A 1937 article in *St. Louis Dispatch* article painted a romantic picture:

> Walking over the ground with his client, Wright said: "You love this waterfall, don't you? Then why build your house miles away, so you will have to walk to it? Why not live intimately with it, where you can see and hear it and feel it with you all the time?" Had Edgar Kaufmann been the sort of man who couldn't understand that idea, he would have contested the point. . . . As it was, he objected only that this would be an impossible engineering feat. "Nature cantilevered those boulders out over the fall," the architect answered. "I can cantilever the house over the boulders."[15]

But from the very beginning, Fallingwater was falling down. The lower concrete terrace, jutting 15 feet over the stream, immediately sagged. That was caused by the failure to provide enough steel reinforcing in the cantilevered

inverted T-beams that supported the slab, "despite strong admonitions to do so." Some have attributed Wright's reluctance to his "lifelong aversion to being told what to do." That is a little unfair; for structural advice (as all architects do) he depended on a civil engineer—in Wright's case, Mendel Glickman of Milwaukee. Moreover, the innovative design stretched conventional builders and—perhaps most significantly of all—Wright was not often on site and his instructions were sent from Taliesin by surface mail. In such circumstances mistakes were inevitable. In Wright's absence Metzger-Richardson, the Pittsburgh firm that supplied the steel, urged Kaufmann and his contractor Walter J. Hall, to double the amount of reinforcing in the beams. They did as he suggested. Wright, who thought—incorrectly, as it happened—that the extra steel would do no more than increase the load on the beams, was irate. At the end of August, he wrote to Kaufmann:

> My dear E.J.: If you are paying to have the concrete engineering done down there is no use whatever in our doing it here. I am willing you should take it over but I am not willing to be insulted. . . . I don't know what kind of architect you are familiar with but it apparently isn't the kind I think I am. You seem not to know how to treat a decent one. I have put so much more into this house than you or any other client has a right to expect that if I haven't your confidence—to hell with the whole thing.

The client, who could be relied upon to give as good as he got, wittily replied by return mail:

> Dear Mr. Wright: If you have been paid to do the concrete engineering up there is no use whatever of our doing it down here. I am not willing to take it over as you suggest nor am I willing to be insulted. . . . I don't know what kind of clients you are familiar with but apparently they are not the kind I think I am. You seem not to know how to treat a decent one. I have put so much confidence and enthusiasm behind this whole project in my limited way, to help the fulfillment of your efforts that if I do not have your confidence in the matter—to hell with the whole thing.
>
> P.S. Now don't you think that we should stop writing letters and that you owe it to the situation to come to Pittsburgh and clear it up by getting the facts?[16]

As soon as the formwork was stripped, even with the extra steel the living room terrace sagged 1½ inches. Cracks opened in the parapet walls of the bedroom terrace. Some of the deflection was due to the engineer's failure to allow for the weight of the concrete when it was still wet, but most resulted from inadequate reinforcement. Metzger-Richardson wanted to fix permanent steel bracing in the creek bed, but Wright dug his heels in. "I have assured you, time and again, that the structure is sound," he told Kaufmann in January 1937. Kaufmann sided with him, and the bracing was not deployed. But as the years passed, the problem became worse.

Kaufmann recorded the deflection periodically until 1955. He and his son had agreed that Fallingwater should someday be placed in public ownership, and it was entrusted to the WPC in 1963. Only a couple of measurements were taken in the 40 years after Kaufmann Senior's death, so in 1995 the WPC commissioned the structural engineers Robert Silman Associates to conduct a thorough survey. They discovered that the lower terrace had deflected up to 7 inches in the southwest corner; and, if left, it was in danger of complete collapse. Analysis of the entire structure revealed that the main cantilever beams were failing under their own weight and that of the lower terrace; they were also supporting the weight of the upper terrace, transmitted through the mullions of the living room windows. The solution was to posttension three of the four beams.

In 2001 the Conservancy, with private, corporate and government funding, launched an $11.5 million project to preserve Fallingwater and its site. The work included the major structural repairs described, restoring wooden furniture and steel window- and door frames, installing an on-site sewage treatment plant system, undertaking extensive landscaping, and waterproofing the terraces and the built-up flat roofs. Kaufmann Senior had described Fallingwater as "a seven-bucket building." Measures were taken to reduce dampness and mold inside the house, caused by its unique location above a waterfall in a humid forest—for that reason its owner had jokingly named it "Rising Mildew." The structural repairs were completed in March 2002.

Despite the sometimes uncomfortable client–architect relationship, Wright was given other commissions at Bear Run—that is always a clear sign of client satisfaction—and E.J. and the tetchy old designer remained firm friends. The only *realized* project was a separate guest wing further up the hillside, reached by a path with a stepped vaulted canopy. It was built in 1938–1939; an addition followed 10 years later. Wright also designed a gate lodge and a "farm unit" for Fallingwater in 1940 and an addition to the house in 1947.

In 1935 Wright's Broadacre City model was displayed in Kaufmann's department store. During the 1940s Kaufmann "drew Wright into his urban renewal plans for Pittsburgh. As a civic leader [he] envisioned a rebuilt downtown core and . . . he advanced the work of the new agencies to create a 'Pittsburgh Renaissance.'" But nothing was built, "despite the time, energy and money spent on them."

Early in the 1950s Edgar and Liliane separated, and in September 1952 she died at Fallingwater from an overdose of sleeping pills. Just about then Wright was designing the pyramidal Rhododendron Chapel at Bear Run for her and Edgar Junior, and "Boulder House" in Palm Springs, for her. Neither was ever built. Edgar Senior married the publicist Grace Stoops in September 1954. He died at Palm Springs in April 1955. An obituary in *The Jewish Criterion* celebrated his philanthropy: "Look about you and you will see imperishable proof of Mr. Kaufmann's regard for the warmer, gentler side of life. Brilliant merchant he was, but that is not how his name will be cherished wherever

people gather to laugh or relax or cry. As the tiller of the soil who brought it to blossom and fruit—that is how Edgar Kaufman inscribed his name on memory's ageless tablets." There was no mention of Fallingwater.

Edgar Junior said of his parents' woodland retreat, "It has served well as a house, yet has always been more than that, a work of art beyond any ordinary measure of excellence. Itself an ever-flowing source of exhilaration, it is set on the waterfall of Bear Run, spouting nature's endless energy and grace."

NOTES

1. Gangewere, R. Jay, "Merchant Prince and Master Builder," *Inside Carnegie* (March-April 1999), 1.

2. Green, Robert Miller, "Frank Lloyd Wright: Architecture. Design, Style." www.modusmodern.com/robertgreen/fallingh20a.asp

3. Burns, Ken, "The Master Builder," *Vanity Fair*, 459(November 1998), 302–318.

4. Langmead, Donald, and Donald Leslie Johnson, *Architectural Excursions: Frank Lloyd Wright, Holland and Europe*. Westport, CT: Greenwood, 2000, 154.

5. "The Family." www.paconserve.org/fallingwater/family/edgar_sr.htm

6. "The Significance of a Stream in the Overall Scheme." *Conserve*, 19(Spring 2007). www.paconserve.org/e-conserve/spring-07/stream.htm

7. Toker, Franklin, *Fallingwater Rising: Frank Lloyd Wright, E.J. Kaufmann, and America's Most Extraordinary House*. New York: Knopf, 2003.

8. Gill, Leonard, "The Wright Stuff—Mr Kaufmann Builds His Dream House," *Memphis Flyer* (November 7, 2003). www.franklintoker.com/reviews.html

9. Pearman, Hugh, "How Many Wrights Make a Wrong?" *Sunday Times Magazine* (June 12, 2005), 1–2.

10. For a transcription of Burns' lecture see www.artsusa.org/events/2005/hanks/transcript.asp#ken

11. Cusack, Victor, "A View from a Former Apprentice," *Taliesin Fellows Newsletter* (October 2003), 5.

12. Hoffmann, Donald, *Frank Lloyd Wright's Fallingwater: The House and Its History*. New York: Dover, 1993, introduction.

13. Wright to Liliane Kaufmann, June 1937. www.wpconline.org/fallingwater/building/chronology.htm

14. Cueto, Ruben, "Fallingwater: Uniqueness and Innovations." www.rubencueto.com/Site/Writings8.html

15. Puezel, Max, "A House that Straddles a Waterfall," *St. Louis Post-Dispatch Sunday Magazine* (March 21, 1937), 1.

16. The exchange is reported in Gangewere, "Merchant Prince and Master Builder."

FURTHER READING

Boulton, Alexander O. *Frank Lloyd Wright: Architect: An Illustrated Biography*. New York: Rizzoli, 1993.

Cannon, Patrick F. *Hometown Architect: The Complete Buildings of Frank Lloyd Wright in Oak Park and River Forest, Illinois*. San Francisco: Pomegranate, 2006.

Cleary, Richard L. *Merchant Prince and Master Builder: Edgar J. Kaufmann and Frank Lloyd Wright*. Pittsburgh, PA: Carnegie Museum; Seattle: University of Washington, 1999.

Futagawa, Yukio, and Bruce Brooks Pfeiffer. *Frank Lloyd Wright: Fallingwater*. Tokyo, Japan: A.D.A. Edita, 2003.

Gill, Brendan. *Many Masks: A Life of Frank Lloyd Wright*. New York: Putnam's Sons, 1987.

Hoffmann, Donald. *Frank Lloyd Wright's Fallingwater: The House and Its History*. New York: Dover, 1993.

Kaufmann, Edgar, Jr. *Fallingwater, a Frank Lloyd Wright Country House*. New York: Abbeville, 1986.

Langmead, Donald, and Donald Leslie Johnson. *Architectural Excursions: Frank Lloyd Wright, Holland and Europe*. Westport, CT: Greenwood, 2000.

Lemly, Brad. "How a High-Tech Fix Kept Frank Lloyd Wright's Masterpiece from Tumbling Down." *This Old House* (January-February 2003).

McCarter, Robert. *Fallingwater: Frank Lloyd Wright*. London: Phaidon, 1994.

Menocal, Narciso G., ed. *Fallingwater and Pittsburgh*. Carbondale: Southern Illinois University Press, 2000.

Secrest, Meryle. *Frank Lloyd Wright: A Biography*. New York: Knopf, 1992.

Stoller, Ezra. *Frank Lloyd Wright's Fallingwater*. New York: Princeton Architectural Press, 1999.

Toker, Franklin. *Fallingwater Rising: Frank Lloyd Wright, E.J. Kaufmann, and America's Most Extraordinary House*. New York: Knopf, 2003.

Waggoner, Lynda S. *Fallingwater: Frank Lloyd Wright's Romance with Nature*. New York: Fallingwater, Western Pennsylvania Conservancy; Universe, 1996.

Weintraub, Alan, Alan Hess, and John Zukowsky. *Frank Lloyd Wright: Mid-Century Modern*. New York: Rizzoli, 2007.

Weiss, Norman, et al. "Fallingwater (part 1): Materials—Conservation Efforts at Frank Lloyd Wright's Masterpiece." *APT Bulletin*, 32(no. 4, 2001), 44–55. See also Pamela Jerome et al., (part 2), *APT Bulletin*, 37(no. 2–3, 2006), 3-11.

Wright, Frank Lloyd. *An American Architecture*. San Francisco: Pomegranate, 2006. Edited by Edgar Kaufmann Jr.

Wright, Frank Lloyd. *Writings and Buildings*. New York: Horizon, 1960. Selected by Edgar Kaufmann Jr. and Ben Raeburn.

Golden Gate Bridge, San Francisco, California

"The biggest thing of its kind"

The Golden Gate Bridge, internationally recognized as "an icon of striking grace and beauty," spans the mile-wide opening into San Francisco Bay from the Pacific Ocean and connects San Francisco and the Marin County headlands, near the town of Sausalito. Joseph Baermann Strauss, the chief engineer, aspired to construct "the biggest thing of its kind that a man could build." Randal Brandt writes that it

> continues to astound and inspire. Some believe its soaring grace and sublime elegance enhance the beauty of its site as few man-made structures do. Considered an Art Deco sculpture and a symphony in steel, the bridge has always inspired artists, poets, writers, and filmmakers. It has also become a symbol for communication, for the portal to the Pacific . . . and for San Francisco.[1]

It was a brilliant response to what many saw as a plethora of insoluble problems. Its towers were the tallest, its main suspension cables the thickest, and its submarine foundation the largest ever built. One of its piers stands in 100 feet of open sea, assailed by 7½ knot currents, and its roadway soars across a canyon swept by 75 mph winds. For 27 years, with a center span of 4,200 feet and a total length of nearly 9,000 feet, it was the world's longest suspension bridge until New York City's Verrazano Narrows Bridge—60 feet longer—was opened in November 1964. In July 1981 the record passed to the Humber Bridge in England; in 1998 the Great Belt East Bridge in Denmark, with a main span of 5,328 feet; and Japan's Akashi-Kaikyo Bridge, with a span of 6,532 feet, were completed.

Yet biggest is not necessarily best. Now over 70 years old, the Golden Gate Bridge, in terms of its structural design and its aesthetic appeal, remains among the world's most stunning examples of bridge engineering. *Frommer's Travel Guide* calls it "possibly the most beautiful, certainly the most photographed, bridge in the world. With its gracefully swung single span, spidery bracing cables and zooming twin towers, [it] looks more like a work of abstract art than one of the twentieth century's greatest practical engineering feats." Over 10 million tourists visit it each year.

Prestigious awards began the year after it was completed and keep coming. In 1938 the American Institute of Steel Construction hailed the bridge as "the most beautiful steel bridge built in the United States last year." In 1984 the American Society of Civil Engineers (ASCE) named it a National Historic Civil Engineering Landmark and 10 years later counted it among seven wonders of the modern world. Three months earlier the Society of American Registered Architects—for the first time honoring a structure other than a building—had given it a Distinguished Building Award in recognition of "enduring excellence in design" and its "impact on the city, design, economic value, cultural statement, engineering accomplishment and contribution to the overall furtherance of the region." In March 1999 CONEXPO-CON/AGG, a construction industry trade show, awarded it second position (after

the Channel Tunnel joining France and England) in the Top 10 Construction Achievements of the Twentieth Century. That was small beer compared to the ASCE's May 2001 accolade: a Monument of the *Millennium*. In 2007 a popular survey of America's favorite architecture, conducted by the American Institute of Architects (AIA), placed the bridge in fifth position.

Thanks largely to the pervasiveness of the American film industry, the bridge was established internationally as a popular icon even before it was completed. In pretelevision days most cinemas began their programs with newsreels; the nation and the world saw what was happening in San Francisco. Feature films also showed the bridge; among the first was *Stranded*, (according to *Time*) an "eminently unimportant little fabrication" released in 1935 whose unlikely hero was "*the* foreman" of the Golden Gate building team. In 1936 RKO released *Night Waitress* that used background scenes of workers on the bridge (Anthony Quinn had a bit part), and First National Pictures released *China Clipper*, a "thinly disguised fictionalized story" of Pan-Am Airways in which the flying boat is seen above the unfinished bridge. Many more appearances were to follow.

FINDING THE GOLDEN GATE

In June 1542 the Portuguese-born Juan Rodríguez Cabrillo embarked upon the first European exploration of North America's Pacific Coast, possibly reaching as far north as what is now Oregon. Sailing on the *San Salvador* from Navidad, New Spain (now Mexico), on a quest for gold and a connection between the Pacific and the Atlantic oceans, he failed to sight San Francisco Bay. Sixty years later another Portuguese, Sebastian Vizcaíno, led an ill-fated fleet—the *San Diego*, *Santo Tomás*, and *Tres Reyes*—which in December 1602 discovered a bay that he named after the Count of Monte Rey. In 1769 Gaspar de Portolá, governor of Baja California, led an overland expedition to locate Vizcaíno's find and in October discovered San Francisco Bay.

It was not until the night of August 5, 1775, that Lieutenant Juan Manuel de Ayala sailed the Spanish naval vessel *San Carlos* from the Pacific through the 3-mile "hidden strait which navigators had passed by for two centuries [with] a gap barely a mile wide at the narrows" into San Francisco Bay. The following morning he named the place for the little willow trees (*saucelitos*) on its shores, and for 6 weeks he mapped the Bay. The survey completed, as the *San Carlos* sailed outward on the tide she was caught in the currents between the cliffs and her rudder was damaged as she was driven onto rocks near Point Cavallo on the north shore. The experience was prophetic of the difficulties that would confront the builders of the Golden Gate Bridge 150 years later. But we anticipate.

In March 1776 a small expedition under Lieutenant Colonel Juan Bautista de Anza Bezerra Nieto determined potential sites for *El Presidio Real de San*

Francisco (The Presidio) and the *Mission San Francisco de Asis*, and 6 months later Lieutenant José Joaquin Moraga built the military outpost. Padre Junípero Serra and others from the third Spanish Franciscan mission in a chain extending from San Diego began Christianizing the local Indians and at Yerba Buena Cove settlers from Monterey founded the tiny community that would become the city of San Francisco.

After a decade of conflict Mexico won its independence from Spain in 1821. Three years later the Mexican Republic was founded, and California remained its remote northern province for 24 years. Then in 1845, hearing of America's annexation of Texas, Californians grew "suspicious of the intentions of the growing number of American settlers"; the settlers, for their part, were afraid that the Mexicans would oust them. Lieutenant John Charles Frémont of the U.S. Army Topographical Engineers increased tensions during his third exploration of Alta California; early in March 1846 he built a log fort near Monterey and raised the American flag. Two months later the United States' "quest for new territory and its ambition to stretch coast to coast" prompted it to declare war on Mexico. War-time events in California and Frémont's belligerence are not germane to this essay; suffice it to say that due in part to his imprudence, the Americans took California by force when a political solution was close at hand. The Treaty of Guadalupe Hidalgo ended the war in February 1848. It was Frémont who named the entrance to San Francisco Bay. Believing that one day it would be commercially important, in 1846 he pronounced, "To this gate I gave the name of *Chrysopylae*, or Golden Gate; for the same reasons that the harbor of Byzantium [now Istanbul] was called *Chrysoceras* or Golden Horn."

MEANWHILE, ACROSS THE WATER . . .

In June 1841 William Richardson, an English-born Mexican citizen, took possession of a 19,500-acre peninsula—he named it *Rancho Sausalito*—on the north side of the Golden Gate, that had been granted to him in 1838; it represented about 6 percent of present-day Marin County. It had a safe anchorage—Whaler's Cove—and abundant fresh water springs. Richardson's "fortunes waxed and waned": he sold water and supplies to visiting ships, established a regular "tank boat" service to transport passengers and water from his springs at Sausalito, raised cattle, dealt in otter pelts, and traded along the northern coast. Following the American conquest, he was made captain and collector of the Port of San Francisco.

On January 24, 1848, James Marshall found gold at Sutter's Mill, 50 miles northeast of Sacramento, setting off the Gold Rush. San Francisco's population mushroomed from under five hundred in 1847 to around one hundred thousand by the end of 1849. California attained statehood in 1850.

Despite Richardson's expectations of untold wealth, during the Gold Rush his land was squatted on, his herds were rustled, and his harbor was

supplanted by a new port at Yerba Buena. More business disasters followed, and early in 1856, "ailing and in financial straits," he filed for bankruptcy. When he died in April "the shambles of [his] debt-ridden former *rancho* [in Marin County] were gobbled up by ambitious entrepreneurs." Local railroads were built by 1864, and on May 10, 1869, the Central Pacific and Union Pacific railroads met at Promontory Summit, Utah, forming a transcontinental link. Throughout the rest of the nineteenth century San Francisco's metropolitan area underwent major growth; by the 1880s, the population would reach 274,000.

The post–Gold Rush boom showed speculators the potential rise of land values in Marin County, were it more accessible to San Francisco. In 1868 a group of nineteen San Francisco businessmen formed the Sausalito Land and Ferry Company. Some of them saw Sausalito's potential as a permanent town and land was surveyed, and roads constructed; a ferry service to San Francisco was inaugurated on May 10; the side-wheeler *Princess* made five round trips daily. In 1871 the Company contracted with the newly incorporated North Pacific Coast Railroad to extend its narrow-gauge line to Sausalito, to connect via ferry to San Francisco. From a pier at Sausalito, the line followed the shore of the bay and by 1875 served Marin County as far as Tomales; by 1886 it was extended through San Anselmo to Cazadero in Sonoma County's timber lands. Although it was established to transport lumber to San Francisco, its existence gave better access to Sonoma and Marin Counties, pushing up real estate values. The oil-fuelled wooden-hull side-wheeler *Sausalito*, launched in 1894, and *Cazadero* and *Tamalpais* were typical of the earlier ferries crossing the Gate. Many others were built. Until the declining service was discontinued at the end of February 1941 they carried freight cars as well as passengers.

Early in the twentieth century, San Francisco's population, at "an all-time high and rising" (by more than 20 percent between 1910 and 1920), was congesting the urban space limited by geography. But the *rate* of growth was declining. Los Angeles, the city's southern rival with plenty of land, was prospering. Historian Kevin Starr observes, "San Franciscans were beginning to realize that there was a vast northern and interior empire that had to be integrated into [their] economy and transportation and travel network" if they were to survive.[2] But the sparsely populated counties across the Golden Gate could be reached only by ferry. When beaches, amusement parks, and other diversions across the Bay became popular attractions, on Sunday nights Sausalito was choked with traffic, as cars queued up to return to San Francisco. Certainly a bridge to Marin County would relieve many of the city's problems.

A BRIDGE—TOO FAR?

There is a compelling and amusing story about the first mention of a bridge. In 1853, bankrupted by an abortive attempt to corner the rice market, the

San Francisco entrepreneur Joshua Norton had sought refuge in insanity. On August 18, 1869, he "decreed" in the *Oakland Daily News*:

> Now, therefore, we, Norton, *Dei Gratia*, Emperor of the United States and pro-
> tector of Mexico, do order and direct, first, that Oakland shall be the coast
> termination of the Central Pacific Railroad; secondly, that a suspension bridge
> be constructed from the improvements lately ordered by our royal decree at
> Oakland Point to Yerba Buena [San Francisco], from hence to the mountain
> range of Saucilleto [*sic*], and hence to the Farallones, to be of sufficient strength
> and size for a railroad; and thirdly, the Central Pacific Railroad Company are
> charged with the carrying out of this work, for purposes that will thereafter ap-
> pear. *Whereof fail not under pain of death.* [emphasis added]

The noted engineering academic Henry Petroski opines that Norton, in proposing a bridge that would have combined the San Francisco, Oakland Bay, and the Golden Gate Bridges, was relaying the ideas of contemporary engineers: ideas that were ahead of their time. Whatever its source, the notion was held up to ridicule; nevertheless, crazy or not Norton "saw the future in linking the growing city of San Francisco [to] the wide open lands of Marin County . . . and the 'Redwood Empire.'" In 1872 a bridge was again proposed by Charles Crocker, cofounder of the Central Pacific Railroad; naturally, he wanted to build a structure that would carry his trains into San Francisco. Nothing came of it.

The issue was resurrected in July 1916. James Wilkins, a journalist trained in structural engineering, used a *San Francisco Call Bulletin* editorial to assert that it was possible "to bridge San Francisco Bay at various points." He added, "But at only one point can such an enterprise be of universal advantage—at the water gap, the Golden Gate, giving a continuous dry-shod passage around the entire circuit of our inland sea." Wilkins realized that the development of Marin was dependent upon its relationship to San Francisco.

> [He] lived across the Bay but worked in San Francisco [and] he could no longer
> tolerate the delayed time it took a ferryboat to cross . . . when an automobile
> could transport a man 20 miles in a half an hour. He pointed out that more than
> 200,000 people lived in the Northern Counties with no direct access to San
> Francisco, and decried the inconvenience and delay that travelers from the north
> had to endure. Wilkins estimated the costs for the bridge at about $10 million
> by comparing his plans to the costs of other bridges of that type.[3]

For 10 years San Francisco's chief engineer, Michael M. O'Shaughnessy, had been rebuilding the urban infrastructure—a sewerage system, firefighting mains, aqueducts, and a cable-car network—destroyed by the 1906 earthquake. In 1919, perhaps rising to Wilkins' challenge, and certainly mindful of the urgency of expansion, O'Shaughnessy canvassed engineers nationwide about the feasibility and cost of bridging the Golden Gate. The choice of site

held no appeal for pragmatists: some said that the span was too great; others that the fogs, high winds, and turbulent ocean currents presented insurmountable problems; and still others said that the bridge would be too close to the notorious San Andreas Fault, just 7 miles to the west, and the Hayward Fault, about 10 miles to the east. Moreover, it was claimed that it would cost too much—some predicted $100 million.

On June 28, 1921, the Chicago engineer Joseph Baermann Strauss presented O'Shaughnessy with preliminary designs for a bridge with an estimated cost of $27 million. As an undergraduate at the University of Cincinnati, Strauss had been enthralled by John A. Roebling's Cincinnati-Covington suspension bridge, then about 25 years old. It awoke in him a passion for bridges, and his senior thesis proposed an "outside-the-square" railroad to bridge the 60-mile-wide Bering Straits. His realized output, though important, was much less spectacular. Following his graduation in 1892, he worked as a draftsman for the New Jersey Steel and Iron Company and lectured at his alma mater before moving to the Lassig Bridge and Iron Works in Chicago. In 1899 he was engaged as principal assistant in the office of Chicago engineer Ralph Modjeski, where he developed his "pattern" design for a counterweighted drawbridge. Falling out with Modjeski in 1902, he formed Strauss Engineering Corporation and 2 years later changed its name to Strauss Bascule Bridge Company; almost all the four hundred structures that his firm built throughout the world were drawbridges, many of which were "downright ugly."

The critics were unkind to Strauss' initial cantilever-cum-suspension design for the Golden Gate Bridge. One described it as "an upside down rat trap"; another called it a "hybrid monstrosity with little but functionality to recommend it." Although he admits that there was some doubt over how much credit for the elegant final design is deserved by Strauss, Petroski acknowledged in that he was at least "the entrepreneurial driving force behind its construction."[4] Starr agrees: Strauss was "an archetypal American kind of personality, who comes to fruition mythically in the Wizard of Oz behind the curtain . . . the man who is constantly dreaming dreams and promoting big projects."[5] More of that later.

In 1922 O'Shaughnessy and Strauss, with Edward Rainey, secretary to San Francisco's Mayor James Rolph Jr., proposed forming a special bridge tax district. On January 13, 1923, a meeting of representatives from twenty-one affected counties at Santa Rosa in Sonoma County formed the Association of Bridging the Gate and soon drafted the *Golden Gate Bridge and Highway District Act*. Passed by the State Legislature on May 25, it gave counties the right to organize as a bridge district that could borrow money, issue bonds, construct a bridge, and collect tolls. The proposal met with strenuous resistance from "well-financed special interest groups," collectively dubbed the "Old Guard." Their antagonism would be sustained until construction began. Strauss would call his fight for the bridge "a thirteen years' war . . . a long and torturous march."

Many engineers doubted that a bridge could be built in such a "notoriously violent" environment, scoffing that "Strauss will never build his bridge, no one can bridge the Golden Gate because of insurmountable difficulties which are apparent to all who give thought to the idea." The San Francisco Board of Supervisors, doubtless with an eye on reelection, worried about taxpayers' reaction to being saddled with some of the cost. The conservationist Sierra Club believed that the bridge would spoil the beauty of the Bay (ironically, the Bay Area chapter's Internet site now carries the bridge as its banner). Shipping agents, expectedly taking a short-term view, feared that constructing the bridge would slow their trade.

And ferry companies, especially the influential Southern Pacific Railroad's lucrative Golden Gate Ferries, anticipated that their profits would be eroded. They launched a belligerent—and temporarily very successful—campaign against the bridge, using the main (and specious) argument that "the 30-minute ferry ride across the strait was a time for people to mingle and receive a break in their day." But as congestion worsened, that relaxing trip was transformed into an "over-stuffed journey that left riders annoyed and frustrated."

There was other resistance, too. The U.S. War Department feared that if it were bombed in a conflict—although in 1923 none was on the horizon—the bridge could collapse and block the harbor. Because it controlled any construction works that could affect shipping and seaward defenses anywhere in the United States (and because it owned the coastal land on both sides of the Golden Gate), the Department had to authorize the bridge project. In May 1924 Colonel Herbert Deakyne conducted a hearing to consider the financial feasibility and strategic implications of the joint San Francisco-Marin County application to build the bridge. Just before Christmas, in what has been described as "an atmosphere of overwhelming support" for the project, the secretary of war signed a provisional permit, pending the submission of more detailed plans.

Since 1922 and on his own initiative, Strauss had energetically lobbied civic organizations and addressed public meetings throughout Northern California. In the face of the concerted propaganda described, not all residents were comfortable with the proposed bridge. Although its potential benefits—increased property values, tourism revenues, and economic development—were undeniable, some had been convinced that the expensive project might also inflate property taxes. In the event, out of twenty-one counties that had shown initial interest, only San Francisco, Marin, Sonoma, Del Norte, and parts of Mendocino and Napa joined the Bridge and Highway District. The others withdrew in 1926. When the San Francisco Board of Supervisors opposed Strauss' plans (it has been claimed that) he hired a political fixer named Harry H. "Doc" Meyers to bribe Board member Warren Shannon, "who would come to the Strauss offices and be given a sealed envelope with a $100 bill inside, which he either kept for himself or distributed to the necessary supervisors to bring them on board." The outcome was that "magically, San Francisco's resistance evaporated." Despite being "damned by a thousand

hostile sneers," on December 4, 1928, the District was established. Its board of seven directors from San Francisco, two from Marin and one from each of the other participating counties first convened on January 23, 1929.

Eleven engineering firms submitted proposals for the Golden Gate Bridge. When the board began to lean to other more experienced tenderers, Strauss showed that he was prepared to do "all that it takes" to secure the contract. He agreed to engage two of his rivals as consultants, to almost halve his fee, and even to discard his own initial design. But he was adamant that he should be recognized as the designer and builder of the Golden Gate Bridge. On August 15, 1929, he was appointed chief engineer; Leon S. Moisseiff, Othmar Hermann Ammann, and Charles Derleth, Jr. were named consulting engineers.

About a year later the War Department issued its final permit for a suspension bridge with a vertical midspan clearance of 220 feet. On August 27, 1930, 2 months behind schedule, Strauss submitted his final plans to the District board.

The Hoover administration provided no funding for the bridge; neither was the State of California willing to finance it. The San Francisco–Oakland Bay Bridge, which was also then being promoted, "had already received the limited funds available." Money would have to be raised locally. In October 1929 Wall Street crashed, and within months the United States began slipping into the Great Depression. It was hardly the psychological moment to ask the electorate to bankroll a major construction project, and opponents of the District's proposed $35 million bond were not hard to find. The Southern Pacific Railroad mounted another legal challenge, and advertising campaigns condemned the timing of a bond issue during the Depression as economically reckless. In those circumstances it is the more remarkable that on November 4, 1930, over three-quarters of the eligible voters, convinced that the bridge represented employment opportunities, approved the issue. They were prepared to offer their houses, commercial properties, and farms as collateral.

In the straitened climate, banks would not accept the bonds. In fall 1932 Strauss approached the visionary Amadeo P. Giannini, founder of the Bank of America. When Strauss and the directors confronted Giannini with their problem, he is said to have responded, "We need the bridge. We'll take the bonds." He bought $6 million worth, and in November contracts totaling almost $24 million were awarded.

"WITH A LITTLE HELP FROM MY FRIENDS [?]"

The inscription on Frederick W. Schweigardt's statue of Strauss at the San Francisco end of the bridge hails him as "the man who built the bridge," and attests—not without hubris—"here . . . is the eternal rainbow that he conceived and set to form, a promise indeed that the race of man shall endure unto the ages." Because he was obsessed with getting the credit, Strauss

underemphasized the crucial roles played by mathematician Charles Alton Ellis and engineer Leon Moisseiff, who together solved the Golden Gate Bridge's complicated practical problems. Moisseiff had developed a new theory of suspension bridge design, but it was Ellis' job to apply that theory in practice.

Ellis graduated from Wesleyan University in June 1900, and after working in various capacities for the American Bridge Company he was appointed assistant professor of civil engineering at the University of Michigan in 1908. Following a brief engagement (1912–1914) as design engineer for the Dominion Bridge Company, he joined the University of Illinois as professor of structural and bridge engineering. He received his C.E. degree in 1921—the year in which Strauss offered him the post of vice president in charge of development and design of the Golden Gate Bridge. Strauss found in Ellis the credible engineering expert that he needed, and as often as he could, he name-dropped his colleague's qualifications in business meetings. There is little question that Ellis' mathematical analysis of the Golden Gate towers, published in January 1934, was the "outstanding achievement of his professional career."

Through him, Strauss recruited Moisseiff to his board of consultants. When asked to evaluate Strauss' design, Moisseiff tactfully focused on the cost, which he pronounced as "about correct and may be exceeded by not more than $2,000,000." Strauss, acutely conscious of time and finance pressures, was persuaded by Moisseiff to abandon his original design in favor of a pure suspension bridge, which would use less steel and be faster to build. In March 1930 Ellis began the preliminary design and estimate, completing the work in just 4 months; it was endorsed by the three consulting engineers, and the Bridge District board accepted it in August. On the other hand, Strauss' own belated report of March 1931 was not favorably received, and when Ellis declined to comment on it Strauss concluded—unjustifiably—that Ellis was trying to undermine him with the directors.

Besides writing the specifications which underlay the ten separate construction contracts, Ellis communicated by telegram from his Chicago office with Moisseiff in New York, consulting over "the thousands of detail calculations involving suspension ropes, decks, floor beams, highway track, cables, towers, and more." The careful, time-consuming work annoyed Strauss, who (it seems clear) did not really appreciate the complexity of the task. In October 1931 he urged Ellis to finish. When the mathematician insisted that he needed more time, Strauss instructed him to take an immediate vacation, which he began early in December. Three days before he was due to return to work he received a letter of dismissal from Strauss, stating that the bridge design was "nothing unusual and did not require all the time, study, and expense which [Ellis] thought necessary for it." He was replaced by Clifford Paine, Strauss Engineering Corporation's managing engineer.

> Ellis was shocked. He had poured his entire being into the bridge for three years. . . . Harsher realities soon set in [and he] had trouble finding steady work

during the Great Depression. . . . Forced into semi-retirement, Ellis revisited the computations [for the towers]. . . . Investing about 70 hours per week, he executed a complete review of the numbers in five months, working unpaid.[6]

Moisseiff, however, was convinced that the original calculations had been correct and convinced that the towers would stand, the bridge's consulting engineers gave permission for the work to commence. When the bridge opened in 1937 many people—Strauss, his assistants, consultants, District directors, and others—shared the credit for it. But although the bridge design was "almost single-handedly his own," Ellis was not mentioned; all record of him had been stricken from the bridge documentation. The first time he was publically acknowledged as the bridge's designer was in an obituary published late in 1949, and it was not until May 10, 2007 that, after several writers had proved his authorship, the District admitted that "the record clearly demonstrates that Charles Ellis] deserves significant credit for the suspension bridge design we see and cherish today."

Strauss' other "helper" was Irving Foster Morrow, then a relatively obscure San Francisco architect. Architectural historian Alan Temko asserts that "Strauss hired him . . . because he thought he could master him." He and his architect wife Gertrude Comfort Morrow designed the streetlamps, railings, pedestrian walkways, and the crisply modeled faces and details of the towers, classified by some critics as "a stylized geometry in the Art Deco style." Temko explains that, because the chief engineer "had the stupidest ideas of what a bridge could look like," Morrow, who seems to have had the ability, persuaded Strauss "to see the drama of the bridge" and managed to turn the open spaces "in the original architectural treatment into . . . giant portals framing the sky. And he [incorporated his] signature vertical fluting . . . so that the bridge catches the light and changes with the sun. . . . [In that way he] had turned it into a sculpture."[7]

The Morrows also chose the distinctive International Orange paint for which the bridge is famous. As early as 1919 Irving had poetically observed that the Golden Gate was "caressed by breezes from the blue bay throughout the long golden afternoon, but perhaps it is loveliest at the cool end of the day when, for a few breathless moments, faint afterglows transfigure the gray line of hills." Although other paint colors were proposed—aluminum, gray, or (as seriously suggested by the Navy) yellow and black stripes—the Morrows believed that orange would harmonize with that spectacular landscape and would be more visible in the sea fog for which the Bay Area is notorious. Moreover, they offered practical justification for using it: "Incidental to its color is the fact that this paint is extremely durable under adverse exposure conditions. It is made of basic lead chromate . . . and [remains] bright and free from fading for a long time." For the next 27 years, only touch-up would be required. In April 1936 Strauss also accepted Morrow's recommendations for a lighting design—usually the province of electrical engineers—for the bridge.

"I BEEN AN IRONWORKER ALL MY LIFE."

Complete with marching bands, groundbreaking ceremonies, "the like of which for pageantry and enthusiastic support of the citizenry had never before been witnessed in the bay region," were held on February 26, 1933, at the Presidio's Crissy Field. Representatives of all the western states took part, and President Herbert Hoover announced the occasion on a national radio broadcast from Washington, D.C. But in fact the ground had already been broken. On January 5 the first workers had begun excavations for the twelve-story high concrete anchorage structures, designed to resist twice the pull of the main cables. They were completed in February 1936.

The Golden Gate Bridge rose above the Bay in the years when unemployment in America stood at 25 percent. As the country began to sink into the Great Depression, membership in labor unions continued to decline; in the preceding years the union movement had failed to organize the large number of workers in the major growth industries. But just as the bridge was started the tide changed, partly due to the F. D. Roosevelt administration's pro-union stance and the *National Industrial Recovery Act* of 1933. The bridge contractors were obliged to hire labor through Local 377 of the Bridge, Structural and Ornamental Iron Workers Union. It is no longer known how many men worked on the project; as the Bridge District later pointed out, it was built by ten different primary contractors and their subcontractors who were no longer in business. The District did not have their employment records.

There were then few steel workers living in San Francisco. As word spread that jobs were available, desperate itinerants bought addresses and Social Security numbers from San Franciscans so that they could meet residence qualifications for employment. Overnight, cowboys, clerks, and cab drivers miraculously became high steel men. The son of one such worker recalls that when an individual was asked, "Have you ever been an ironworker?" he'd reply, "Yeah, I was born an ironworker. I been an ironworker all my life." One source notes that union wages ranged between $4 and $11 a day; workers clocked in when they reached their work locations, and the climb to get there—sometimes taking up to 40 minutes—was on their own time. Despite the obvious risks, employment on the bridge was very desirable, and there "was always somebody waiting at the base of the tower for someone to fall off so they'd get a job."

In 1932, to the great annoyance of the Bridge District board, Strauss went missing for 6 months. It remains unclear where he was: some sources say he was in the Adirondacks, recovering from a nervous breakdown; others that he was "recuperating" on a Panama Canal cruise. He finally wired from New York to say he promised to "return to San Francisco by leisurely stages." In the interim, he had left May, his wife of 37 years, to marry a much younger widow, Ethelyn Hewitt. Back in San Francisco, he withdrew to his apartment on Nob Hill and oversaw the construction at a distance, visiting the bridge only occasionally over the next two years.

In the first half of 1933 the concrete pier under the north tower was built on the Marin County coast. That was relatively straightforward. But the south pier was founded on the sea-bed, "full in the face of the . . . sometimes raging Pacific," over 350 yards from shore. The enormous engineering problem was solved by building a fender—a great sheath to facilitate construction of the pier and to protect it from the sweep of heavy seas. One contemporary account calls it a "marvel of construction"; with 40-foot-thick concrete walls, and enclosing an elliptical area 300 feet long and 155 wide. It extended 100 feet below, and reached 15 feet above the average high water mark. When it was complete, seawater was pumped out while the concrete pier was poured. The south pier and both approach trestles were completed by December 1934.

The 745-foot steel towers, composed of massive 42-inch square, 35-foot high prefabricated "cells" were in made in New Jersey, Maryland, and Pennsylvania by the McClintic-Marshall Corporation, a subsidiary of Bethlehem Steel. They were shipped to storage yards in Alameda from East Coast seaports through the Panama Canal before being taken by barge across the Bay to the construction site. The steelworkers were amazed at the way that they could be stood temporarily in place without a single rivet. Teams of riggers and riveting gangs assembled them. A "heater" made each rivet red-hot in a forge and used tongs to toss it to a "catcher," who caught it in a funnel shaped can and placed it, still red-hot, into a predrilled hole in the structural joint; a "bucker-up" located it while a "gunman" flattened it with a compressed-air hammer. The north tower began to rise on the Marin shore in November 1933 and took 11 months to finish; the south tower was started in January 1935 and completed by the end of June. Then workers built catwalks and started spinning the cables.

The Golden Gate was spanned using loom-type spinning carriages devised by John A. Roebling's Sons, builders of the Brooklyn Bridge. The New Jersey firm was contracted to spin the two main cables on site. Begun in October 1935, the cables were completed in March 1936—almost 8 months ahead of schedule. Just over 3 feet in diameter, each consisted of 27,572 galvanized steel parallel wires of pencil thickness, compressed into sixty-one 452-wire strands and wrapped in steel wire. Passing over steel saddles at the tops of the towers, they were secured in the massive anchorages. Within each anchorage a device called a strand shoe was used to secure the "dead wire" while a spinning wheel pulled a "live wire" across the bridge. Once it reached the opposite anchorage, the live wire was secured, and the wheel returned with another loop of wire to repeat the process. Thus, strand by strand at 650 feet a minute, the cables were spun from side to side—1,000 miles of wire placed in every 8-hour shift. Steel clamps around the main cables anchored the vertical suspension cables supporting the steel frame of the road deck, which was completed by November 1936. Commenced in the following January, the flexible 7-inch thick *in situ* concrete road was finished by April 1937.

"THE HALFWAY TO HELL CLUB"

There were no fatal accidents on the Golden Gate Bridge site until October 21, 1936, when a worker named Kermit Moore was crushed by a falling beam. By then, twenty-four men had died on the San Francisco–Oakland Bay Bridge—only one third of the one-life-per-million-dollars statistic that California's Industrial Accident Commission seems to have thought acceptable.

Believing that any workplace could be a safe environment, Strauss insisted upon rigorous safety practices. Medical staff were on call at a field hospital near the Corporation's Fort Point site office. It has been suggested, cynically, that he acted out of concern for his image—efficiency was paramount. But whatever his motive, he acted. Russell Cone, the bridge's resident engineer, monitored a matrix of safety procedures. Because of danger from falling rivets, workers wore "hard-boiled hats" made from steamed canvas, glue, and black paint that had been developed by the Sausalito-based safety equipment manufacturer, E. D. Bullard. Although the Golden Gate project was not the first on which hard hats and safety lines were mandatory, it was the first to sanction failure to use them with the threat of dismissal. There were other safety measures too. All riveters were required to wear respirators, and provisions were made so hands could be kept clean to prevent hand to mouth infection. Because steel components needed to be sandblasted before painting, Bullard's company also designed a "sand-blast respirator helmet." Workers were supplied with antiglare goggles and antisunburn cream. "Drinking alcohol or stunting—at any height"—also meant immediate sacking. Indeed, "special diets were prescribed for high steel workers to counteract dizziness. Men with hangovers were required to drink down a cure of sauerkraut juice." And because of the confined space within prefabricated cells, the painters were regularly checked for lead poisoning. As a result of tests on the Marin Tower the base of the paint on the splices of the San Francisco Tower was changed from red lead to iron oxide.

Strauss believed that "men performing without fear would work faster and more surely, thereby trimming costly days off the length of the job." So in June 1936, when progress was delayed, he invested over $130,000 in "the most expensive, elaborate safety device ever conceived for a major construction site"—a huge manila rope net of 6-inch-square mesh hung hanging down about 60 feet under the part of the structure where the men were working. Manufactured by the J. L. Stuart Company, it was secured to outriggers and cantilevered 10 feet beyond the bridge either side and 15 feet past the length of the road deck framing. As Strauss predicted steelworkers, now feeling more secure on the sometimes slippery beams, built the bridge floor in a little under 5 months. The net also saved the lives of nineteen men, who styled themselves the "Half-Way-to-Hell Club." One writer comments that it became such a morale-booster that workers had to be restrained from jumping into it on purpose. But the best-laid plans. . . .

On the morning of February 16, 1937, an eleven-man crew was stripping concrete formwork near the north tower when a trolley wheel casting broke. Their mobile scaffold gave way and slipped from the bridge. Momentarily it teetered before falling with its occupants into the net, which ripped under the 5-ton load. One worker managed to grab a beam and was rescued. The others and two men who already were working in the net plunged 220 feet into the icy waters of the Bay. Only two survived. Of course, accusations flew, including many directed at Strauss. But a very prompt inquest conducted by the San Francisco coroner, Dr. T. B. W. Leland, laid no blame. When the bridge opened 3 months later, a San Francisco newspaper, observed that "in the midst of the gaiety many paused in their merrymaking to stand silently before the temporary wooden memorial honoring the men who died in the construction of the bridge."

"OPEN UP THAT GOLDEN GATE!"

Although the lyric from the song *California, Here I Come!*, popularized by Al Jolson, had nothing to do with the bridge—it was written and recorded in 1924—the two have been become popularly associated ever since the great span was opened to pedestrian traffic on Thursday May 27, 1937. A few days later *Time Magazine* diffidently reported, "They opened another bridge in California last week." On the ground the scene on "Pedestrian Day" was different and excited. Most schools, offices, and stores were closed for the day; those that remained open were run by a skeleton staff. From early in the morning crowds—an estimated eighteen thousand people—gathered at either end of the bridge, anxious to cross and glad to pay the five cents to do it. At the stroke of six o'clock, "foghorns gave great blasts, the toll gates opened and the earliest and eagerest arrivals—most of them high school students— ran or walked out onto the bridge."

By evening, an estimated two hundred thousand had crossed. Donald Bryan from San Francisco Junior College was the first person to cross the entire span. Had the *Guinness Book of Records* existed, many eccentric citizens would have found their way into it, and as "firsts," would still be there: a first roller-skater, a first stilt walker, a boy who walked backwards, a tap dancer, a tuba player, a man pushing a pill box with his nose, and even a woman determined to be the first to cross with her tongue out!

Strauss made a speech. It was reported that, "His hands trembling, Strauss spoke in a low voice: 'This bridge needs neither praise, eulogy nor encomium. It speaks for itself. We who have labored long are grateful. What Nature rent asunder long ago, man has joined today. . . .'" He then recited the poem he had written, which begins "At last the mighty task is done;/ Resplendent in the western sun/ The Bridge looms mountain high;/ Its titan piers grip ocean floor,/ Its great steel arms link shore with shore,/ Its towers pierce the sky."

The joyous occasion introduced a week-long Golden Gate Bridge Fiesta, with a nightly pageant at Crissy Field, fireworks, parades, tournaments, and all sorts of entertainment. The following day the Golden Gate Bridge was opened to vehicles when President Franklin D. Roosevelt pressed a telegraph key in the White House, flashing a green light to announce the event to the world and "sending 100 skyrockets aloft in San Francisco." Then

> car horns, sirens, bells, whistles, cannon and other sounds of celebration filled the air around the bridge. Approximately 400 Navy biplanes from three aircraft carriers thundered overhead, a parade of official cars, flags flying, crossed the span, and a huge fleet of 19 battleships and heavy cruisers, plus three carriers and hundreds of other ships, sailed beneath the bridge into San Francisco Bay.

By the end of the day, 32,300 vehicles and 19,350 pedestrians had paid tolls and crossed the bridge.

"PLANNING FOR THE BIG ONE . . . "

As noted, some doomsayers had expressed early doubts about the bridge's stability in earthquakes. Bailey Willis, a geology professor at Stanford, was so convinced that the south tower's rock foundation was seismically unstable that he actually engaged in a fist fight over the question. *Time Magazine* reported in June 1937 that Willis' opinion was "overwhelmed by numbers," remarking that only a major earthquake could settle the question. In 1929 Charles Ellis confidently had told the National Academy of Sciences that in an earthquake the safest place in San Francisco would be in a hammock slung between the towers of the bridge. Strauss' team believed that their bridge could survive a recurrence of the 1906 earthquake, with a hurricane thrown in.

On the evening of October 17, 1989, the Golden Gate Bridge was put to the test when the Bay Area was devastated by the 15-second Loma Pieta earthquake. Measuring 7.1 on the Richter scale, with an epicenter 56 miles south of San Francisco, it was the worst quake since 1906; for weeks, hundreds of aftershocks followed. The bridge was undamaged. Nevertheless, for safety's sake the Bridge District immediately undertook a "vulnerability study." In 1990 its consultant, T. Y. Lin International, reported that an earthquake of a Richter magnitude between 7.0 and 8.0 with an epicenter near the bridge would cause enough damage to force extended but temporary closure, while a stronger quake would create "a substantial risk of . . . collapse of the San Francisco and Marin approach viaducts and the Fort Point arch, and extensive damage to the remaining bridge structures, including the main suspension bridge."

The District understood that retrofitting the bridge was much less costly than replacing it—at the time, an estimated $128 million compared to $1.4

billion. But it was not until 1996 that a three-phase construction strategy—to withstand an 8.3 earthquake—was in place. The first phase addressed the Marin approach viaduct. The second retrofitted the San Francisco approach viaduct, the southern anchorage housing, Fort Point arch, and two southern pylons; in April 2007 it received the ASCE's Outstanding Civil Engineering Achievement. Phase 3, scheduled for completion in 2009, was to modify the main suspension bridge and the northern anchorage housing. By 2000, the estimated cost had grown to $297 million, and to $405 million by April 2006. The Bridge District reassured the public that the work was "far enough along that the Bridge no longer faces the potential for collapse [but] until the entire retrofit is completed, the risk of significant damage to the main suspension bridge remains."

"BEAUTY THAT TAKES LIVES BECOMES UGLINESS"

In celebrating such an icon as the Golden Gate Bridge, it seems morbid to turn to the subject of suicide. But the two *are* associated in the public mind. Journalist Tom McNichol wrote in 1991:

> California is also home to the most powerful suicide magnet in the Western world, the Golden Gate Bridge. . . . [Its symbolic power] is a strong draw, located about as far West as one can go, in a city Jack Kerouac once described as possessing an "end-of-land sadness." Aesthetics also seems to play a role in Golden Gate suicides. Five times as many people have committed suicide from the Golden Gate as from the comparatively frumpy Oakland Bay Bridge.[8]

Recognizing the possibility of suicides, the diminutive Strauss had designed 5-foot-6-inch high railings (about 6 inches taller than he was). He boasted in the *Call-Bulletin* that the bridge was "practically suicide-proof" because the guard rails were "so constructed that any persons on the pedestrian walk could not get a handhold to climb over them." He also asserted that the "telephone and patrol systems will operate so efficiently that anyone acting suspiciously would be immediately surrounded" before rashly claiming, "Suicide from the bridge is neither possible nor probable."

But as Edward Guthmann explained in *The San Francisco Chronicle* in October 2005, "By the time the bridge opened . . . Strauss' promise had evaporated. It's unclear when the plans were modified, but at some point architect Irving Morrow [reduced the guardrails] to four feet, and in doing so created a stage for decades of self-slaughter."[9] Between 1937 and 2005 there had been 1,218 *reported* suicides. The first leap was made fewer than 3 months after the bridge opened, and average of nineteen followed each year. In 1977, there were forty. It seems that the problem is increasing: the *Chronicle* reported that at least thirty-four people had jumped in 2006, adding that the bodies of four

others seen jumping had not been recovered and that seventy attempted suicides—twenty more than the annual average—had been restrained.

Three-quarters of the jumpers were men. Eighty-seven percent came from the Bay Area, overturning the myth that most victims travel to San Francisco to carry out their tragic intention. Richard H. Seiden, professor of behavioral science at UC Berkeley, in a 1978 study of over five hundred people who were prevented from jumping, identified five causes of the bridge's "mystical allure": accessibility; finality; "suicide contagion," often spread by media coverage; the attraction of "seeing for the last time something that is truly beautiful"; and "joining the herd."

As early as 1948 the Golden Gate Bridge and Highway District briefly entertained (but rejected) the idea of building high fences and electrified guardrails to act as suicide barriers. Electric fences again were considered 3 years later but dismissed because of the hazard to bridge workers. In 1953, despite an informed claim that adding 3 feet to railing heights—at a cost of only $200,000—would not affect the bridge's stability; nothing was done. The following year the District experimented with barbed-wire fencing, but once more the issue of workers' safety (and of course workers' compensation) put to rest that idea.

In 1970, following the *coincidental* antisuicide effect of a 9-foot "litter-proofing" chain link fence—is a falling bottle more important than a falling person?—above Fort Point, the District commissioned San Francisco architects Anshen and Allen to design suicide barriers, only to reject all eighteen of the alternatives that they suggested. The preferred solution never reached even a final design stage, in part (according to one of the architects) because the District wanted them "to agree that if someone was able to scale the barrier and commit suicide, the architects rather than the district would be held liable in lawsuits." Late in 1973 plans were announced for a $1 million barrier. *The New York Times* reported that "public opinion was strongly opposed . . . objecting that it would be ugly, ruin the view, or be ineffective on the basis that people would simply kill themselves elsewhere." That view was demolished by Seiden's study: only about 6 percent of his subjects had tried later to commit suicide in some other way. In 1998 the Bridge board considered a 7-foot high "Z-clip" barrier, originally designed as a livestock fence. Although the cost would have been under $3.5 million, once again the design was rejected.

Guthmann's article launched a seven-part *Chronicle* series, "Lethal Beauty." Together with Jenni Olson's January 2005 film, *The Joy of Life*, which dealt in part with the history of the Golden Gate Bridge as a suicide landmark, and the imminent release of Eric Steel's controversial documentary movie *The Bridge*, which secretly shot several actual death leaps, the essays were pivotal in renewing debate about a suicide barrier and moving the District's directors—after their earlier futile gestures—to address the crucial issue.

In May 2007 the Oakland engineering/architectural firm DMJM Harris undertook a $1.78 million Golden Gate Bridge Suicide Deterrent System

Study for the District. Because any barrier must prevent suicides without endangering the bridge structure in high winds the smallest design details needed to be resolved. The first phase of the study, scheduled for completion in spring 2007, was to report on wind tunnel testing of "generic suicide deterrent concepts"; the second, to be finished by spring 2008, would "take the . . . generic concepts that passed the wind test and develop potential alternatives for further evaluation" in engineering and environmental contexts. The District seems to be more conscious of the latter: "The Bridge, which is eligible for inclusion in the National Register of Historic Places, is afforded protection under both state and federal historic preservation laws"; so any alternative systems "must satisfy applicable state and federal requirements regarding projects that impact historic resources."

If present trends continue, seventy more people will die before the District even decides what kind of suicide barrier it should build. The question is, "What should be done when faced with a choice between life and beauty?" In August 2005 Dr. Mel Blaustein, chair of the Psychiatric Foundation of Northern California's Golden Gate Bridge Task Force, wrote that the "Golden Gate Bridge with its 4-foot railing is clearly a lethal solution to temporary problems." Before telling the tragic story of how

> Mary Zablotny's 18-year-old son, . . . a senior at the French American School in San Francisco, with . . . no psychiatric history and an expected enrollment in Reed College, suicided on February 1. In her testimony before the bridge board of directors [his mother] said, "I'm an artist, and aesthetics are important to me. But beauty that takes lives becomes ugliness."

STAR OF THE SILVER SCREEN

The New York Times travel writer James Martin claimed in 1990, "San Francisco's biggest movie star is undoubtedly the Golden Gate Bridge." It was inevitable that directors would use the distinctive monument as an "establishment shot" just as the Eiffel Tower has become visually synonymous with Paris, and the Statue of Liberty with New York. Except for its hilly streets, San Francisco has little else. Martin continues, ". . . there you are, dwarfed by one of the world's most beautiful man-made achievements: the Golden Gate Bridge. With its magnificent setting, burnt-orange color and Moderne towers, the 52-year-old span has appeared in countless films."[10]

Well, hardly *countless*, but in a good many. And mostly in the background. For example, in some of the *Star Trek* cult movies Starfleet Command Headquarters, the Star Fleet Academy, and the chambers of the Federation Council are located (albeit with geographical license and probably annoyingly for San Franciscans) at various sites around the bridge. In a few films it has been integral to the plot, or at least provided a platform (in some cases literally) for the

action. For example, the climax of *A View to a Kill* (1985) sees the indefatigable Agent 007 grappling at the top of the bridge with the insane Max Zorin, who plans to corner the microchip market by destroying Silicon Valley.

James explains that in the movies "the bridge is a metaphor for man's achievements over nature and, in the visual language of the cinema, that metaphor has often been twisted around to remind us that there are forces far greater than man." Thus, while in Stanley Kramer's 1959 adaptation of Nevil Shute's novel *On the Beach* it survives a nuclear war that devastates the northern hemisphere and eventually destroys humanity, it does not fare so well in other disaster movies. For example, it is destroyed by a giant six-tentacled—perhaps the studio's low budget could not stretch to eight—octopus in Columbia Studios' 1955 *It Came from Beneath the Sea*; in *Superman: The Movie* (1978) the man of steel saves the roadway from collapse when the evil villain Lex Luthor nukes the San Andreas fault; and in the second most unlikely scenario of all, in *The Core* (2003) solar microwaves melt the suspension cables (but somehow not the automobiles on the bridge), and hundreds of people are plunged into the boiling sea. But the audience's credulity is stretched to snapping point when at the noisy climax of *X-Men: The Last Stand* (2006) computer-generated images allow the villains to relocate the structure to reach Alcatraz.

Naturally, The Golden Gate Bridge has appeared in several television series set in San Francisco. The earliest was the soap opera, *Love Is a Many Splendored Thing* (1967–1973) in which it was included in the opening sequence of each episode. The opening title of *Monk*, first aired in 2002, is against a fixed aerial shot of the bridge, which (frustratingly) doesn't quite fit on a normal aspect format TV screen. Other shows include the ABC sitcom *Full House* (1987–1995); the Fox production of *Sliders* (1995–1997); *Nash Bridges* (1996–2001); *Charmed* (began 1998); *Half and Half* (began 2002); and The Disney Channel's *That's So Raven* (began 2003). Also in the sphere of entertainment, the bridge features in video games and video music clips, as well as on album covers.

Fiction writers have also embraced the bridge. It has a major role in George R. Stewart's frequently reprinted sci-fi novel *Earth Abides*, first published in 1949, and of course most of Alistair MacLean's thriller *The Golden Gate* (1976) is set on it. Some minor works have unlikely plots: Mike Dolinsky's *Golden Gate Caper* (1976) revolves around an attempt to steal the bridge; *Modesty Blaise: The Night of Morningstar* (1982) by Peter O'Donnell, has the comic-book heroine foiling a plot to destroy it. Archivist Randal Brandt has produced a bibliography of almost fifteen hundred mystery, detective, and crime fiction titles whose plots, or parts of them, are set in the Bay Area; many illustrate the bridge on their dust jackets.

The Golden Gate Bridge is an international icon at the popular level, but it also enjoys a place in the realm of high art. Interviewed in the 2004 PBS TV-movie, *Golden Gate Bridge* the historian Kevin Starr, observing that "great

works of art encode within themselves messages that are at once transcendent and enigmatic, mysterious," asked, "What does the Parthenon mean? What does Beethoven's Ninth mean? What does Hamlet mean?"

> The Golden Gate Bridge means many things. It means the victory of San Francisco over its environment. It means San Francisco remains competitive. It means that people can cross the channel more easily. But it also means something else. It celebrates in a mysterious way man's creativity and the joy and wonder of being on this planet.

Someone writing in a totally different context once said, "The light that shines the farthest abroad, is the light that shines the brightest at home." And though the bridge, universally recognizable and admired, belongs in one sense to the whole world, it belongs especially to residents of the San Francisco Bay area, who

> feel this bridge as an entity and have a section for it. They admire its living grace, and its magnificent setting. They respond to its many moods—its warm and vibrant glow in the early sun, its seeming play with, or disdain of, incoming fog, its retiring shadowy form before the sunset, its lovely appearance in its lights at night. To its familiars it appears as the "Keeper of the Golden Gate."[11]

NOTES

1. Lowell, Waverly, and Linda Vida, "Bridging the Bay: Bridging the Campus." www.lib.berkeley.edu/news_events/bridge/gate_6.html

2. Halpern, Dan, "A Serviceable Icon," *Architect Magazine* (October 1, 2007). www.architectmagazine.com

3. Beyer, Sandra, "The Bridge That Couldn't Be Built." http://content.grin.com/data/4/22383.pdf

4. Petroski, Henry, "Art and Iron and Steel," *American Scientist*, 90(July-August 2002), 313.

5. Hartlaub, Peter, "Steel, Concrete and Poetry: The Making of a Bay Area Landmark," *San Francisco Chronicle* (May 1, 2004). www.sfgate.com/cgi-bin/

6. "Golden Gate Bridge" [PBS]. www.pbs.org/wgbh/amex/goldengate/peopleevents/p_ellis.html

7. "Golden Gate Bridge" [PBS]. www.pbs.org/wgbh/amex/goldengate/filmmore/pt.html

8. McNichol, Tom, "Choosing Death," *Los Angeles Times* (October 13, 1991), 25.

9. Lifson, Thomas, "Saving People from Themselves," *American Thinker* (October 30, 2005). www.americanthinker.com

10. Martin, James A., "Golden Gate, Silver Screen," *New York Times* (January 7, 1990),.

11. Anon., Cited John Bernard McGloin, *San Francisco, the Story of a City.* San Rafael, CA: Presidio Press, 1978.

FURTHER READING

Adams, Charles Francis. *Heroes of the Golden Gate.* Palo Alto, CA: Pacific Books, 1987.

Brown, Allen. *Golden Gate: Biography of a Bridge.* Garden City, NY: Doubleday, 1965.

Burgin, Victor. "The Bridge." *Creative Camera* (April 1984), 1334–1345.

Cassady, Stephen. *Spanning the Gate: The Golden Gate Bridge.* Mill Valley, CA: Squarebooks, 1986.

Cowan, Sam K., ed. *Gold Book: Official Guide and Directory, Golden Gate Bridge Fiesta.* San Francisco: Franklin Johnson, 1937. See also Angelo J. Rossi, et al. *Official Program: Golden Gate Bridge Fiesta, San Francisco May 27 to June 2, 1937.* San Francisco: Golden Gate Bridge and Highway District, 1937.

Crosbie, Michael J. "The Background of the Bridges: Two Famed Spans Raced for Records in the Depths of the Depression." *AIA Journal,* 74(March 1985), 150–157.

Dillon, Richard H. *High Steel: Building the Bridges across San Francisco Bay.* Berkeley, CA: Celestial Arts, 1998.

Fincher, Jack. "The 'Impossible' Bridge that Spans the Golden Gate." *Smithsonian,* 13(July 1982), 98–107.

Friend, Tad. "Jumpers. The Fatal Grandeur of the Golden Gate Bridge." *New Yorker* (October 13, 2003).

Guthmann, Edward. "Lethal Beauty. The Allure: Beauty and an Easy Route to Death Have Long Made the Golden Gate Bridge a Magnet for Suicides." *The San Francisco Chronicle* (October 30, 2005). See also the following six editions of the newspaper.

Horton, Tom. *Superspan: The Golden Gate Bridge.* San Francisco: Chronicle Books, 1983.

Lewis, Karen R., comp. *Building the Golden Gate Bridge: A Directory to Historical Sources.* San Francisco: Labor Archives and Research Center, San Francisco State University, 1989.

McGloin, John Bernard. *San Francisco, the Story of a City.* San Rafael, CA: Presidio Press, 1978. See especially chapter, "Symphonies in Steel: Bay Bridge and the Golden Gate."

Meiners, William. "Credit where Credit was due: Charles Ellis, a Purdue Civil Engineering Professor from 1934 to 1946, is Finally Being Recognized as the True Designer of the Golden Gate Bridge." *Purdue Engineering Extrapolations* (Summer 2001), 6–11.

Morrow, Irving F. "Beauty Marks G.G. Bridge Design: Some Notes on Architecture of Structure." *Architect and Engineer,* 138(March 1937), 21–24.

Petroski, Henry. "Art and Iron and Steel." *American Scientist*, 90(July–August 2002), 313 ff.

Schock, Jim. *The Bridge, a Celebration: the Golden Gate Bridge*. Mill Valley, CA: Golden Gate International, 1997.

Strauss, Joseph Baermann. "Here's Your Bridge, Mr. O'Shaughnessy." *Saturday Evening Post* (May 29, 1937), 20, 90, 92–94.

Strauss, Joseph Baermann. *The Golden Gate Bridge: Report of the Chief Engineer to the Board of Directors of the Golden Gate Bridge and Highway District, California*. San Francisco: Golden Gate Bridge and Highway District, 1938. Reprinted 1987.

Wilson, Neill Compton. *Here is the Golden Gate: Its History, Its Romance and Its Derring-do*. New York: Morrow, 1962.

Zee, John van der. *The Gate: The True Story of the Design and Construction of the Golden Gate Bridge*. New York: Simon & Schuster, 1986.

Zee, John van der, and Russ Cone. "The Case of the Missing Engineering." *Image: The Magazine of Northern California* (May 31, 1992), 6–11.

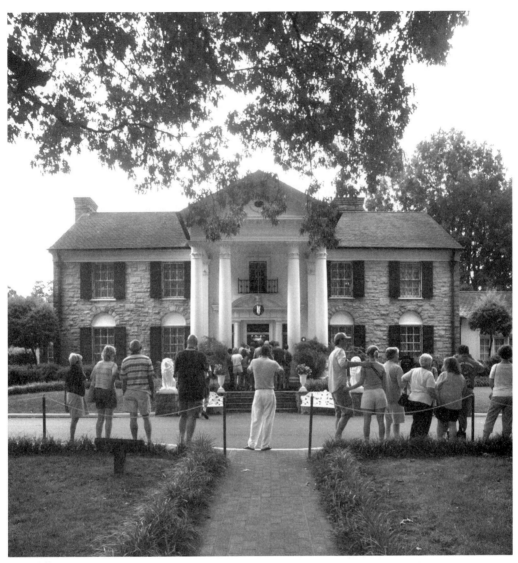

Graceland Mansion, Memphis, Tennessee

"Love me, love my house."

Elvis Presley's remarkable career began in 1954. Many musicologists and social historians place him among the most culturally significant figures of twentieth century America, if not of the entire world. The Elvis Presley International Fan Club Registry lists ninety-five member groups in North and South America, western Europe and Australasia, but another source identifies over three hundred fifty, including some in eastern Europe, India, Sri Lanka, Hong Kong, The Philippines, and Japan. Yet another claimed in 2007 that there are over five hundred active official Elvis Presley fan clubs in the United States and forty-five other countries. Elvis is still known internationally by his first name alone. It has been observed that his carefully constructed image as a "hillbilly rube, notorious rock 'n' roll rebel, American movie idol, and international superstar" eclipsed the reality of his persona, and since his death in August 1977 at age 42 that image has stretched to legendary proportions, so that Elvis has continued as a twenty-first-century American cultural icon.

In the popular mind there is absolute fusion between the performer Elvis Presley and Graceland Mansion, his home for 20 years (1957–1977). The house is an icon because its owner is one. Media studies expert Gilbert Rodman writes in *Elvis after Elvis* that Graceland is "so widely recognized, so famous for being famous, as to have become effectively invisible: though signs about Graceland are familiar sights on the U.S. cultural terrain, what we typically see in such signs is not Graceland, but Elvis." He explains that the house "gave Elvis something no other U.S. celebrity of the twentieth century had; a permanent place to call 'home' that was as well known as its celebrity resident."

> It gave his stardom a stable, highly visible, physical anchor in the real world . . . which has been linked in the public eye with Elvis and his stardom from the day he bought it . . . until the day he died there . . . and beyond. . . . Elvis was associated with a very specific site on the map (i.e., not just a region or a city, but an actual street address) in a way that no other star ever was—or has been since—with the longstanding connection between these icons working to transform the private, domestic space of Elvis's home into a publicly visible site of pilgrimage and congregation.[1]

ELVIS THE PELVIS

Elvis Aron (Aaron) Presley was born on January 8, 1935, in the depths of the Great Depression, to Vernon Elvis Presley and his wife Gladys (nee Smith). His identical twin brother, Jesse Garon, was stillborn. The family lived in a 450-square foot self-built shack in East Tupelo, Mississippi, about 80 miles southeast of Memphis; the two-room building had no indoor plumbing, and the Presleys could not afford electricity. When Elvis was age 3 his father was jailed for 8 months on a forgery charge; unable to repay money owed on the house, Gladys was evicted and moved in with her husband's family. In the first

of sixteen relocations, and over the next nineteen years the Presleys would live mostly in rented public housing (the longest stay was for 3 years), boarding houses, and even shanties.

When he was age 10 or so, Elvis began to sing at the Pentecostal First Assembly of God church in Tupelo, at school, and on a Saturday talent show sponsored by the local radio station. He was given his first guitar for his eleventh birthday. Chasing opportunities for employment, Vernon Presley moved his wife and son from time to time, eventually arriving in Memphis in 1948. They stayed in boarding houses until fall 1949, when they moved to Lauderdale Courts, a large public housing project at the north end of the city. During his years at Humes High School Elvis and four other boys from Lauderdale Courts formed a band. Upon leaving high school in July 1953 he worked at M. B. Parker Machinists, although he already was reaching for a musical career.

During that summer he paid the Memphis Recording Service a few dollars to record two songs ("My Happiness" and "That's When Your Heartaches Begin"), and the following January he made a second recording. In the spring his auditions for the Songfellows, an amateur gospel quartet, and a professional band were unsuccessful. But in late June, the Memphis Recording Service invited him to come to the studio. After listening to a number of songs, the music producer Sam Phillips set Elvis up with Scotty Moore and Bill Black, who styled themselves the Starlite Wranglers, and on July 5 the three young men—Moore was 4 years older than Elvis and Black was then age 28—went to the now-famous Sun Studio so that Phillips could "hear them on tape." The session was less than exciting until, during a break in recording, Elvis began toying with "That's all Right," a 1946 blues number. That very week Phillips arranged for the song to be played on a popular Memphis radio show. Public reaction was immediate and overwhelmingly positive, and the disc jockey replayed it several times that night. When the record was released 2 weeks later there were already six thousand local orders for it.

Elvis made his first major public appearance with the Blue Moon Boys—Moore, Black, and D. J. Montana—at Memphis's Overton Park outdoor theater on July 30. Sun Studio released his second record in late September, and Phillips arranged a guest appearance to a "polite, but somewhat tepid, reception" on the *Grand Ole Opry* on October 2. Two weeks later a rival program, *Louisiana Hayride*, broadcast a guest appearance to twenty-eight states, and the band was signed to a 1-year contract on the show. Elvis and the Blue Moon Boys became virtually full-time professional entertainers. Besides their weekly spots on *Louisiana Hayride*, for the next year they toured almost continually, beginning with civic clubs and school functions in Arkansas and Mississippi and eventually performing almost every night. In November and December, they played in Houston, Texas and appeared elsewhere in Texas and Missouri in January 1955. Presley sang for the first time at Memphis's Ellis Auditorium on February 6, and a week or so later the Blue Moon Boys

were booked as part of a Hank Snow/Jamboree Attractions package tour that began in Roswell, New Mexico.

In March Elvis went to New York City to audition (albeit unsuccessfully) for *Arthur Godfrey's Talent Scouts*, a weekly CBS network program that had recently migrated from radio to television. Another 3-week, twenty-city tour with Jamboree Attractions began on May 1, and through the late summer and fall Elvis was touring again. According to one oft-quoted source, audiences were astounded by the "ferocity of his performance; Elvis caused a great commotion wherever he went, with girls screaming and fainting and chasing after him throughout the South."

From mid-1954 Sam Phillips had set about promoting Presley's records. At first the young singer was dismissed as a mere regional sensation, but by summer 1955 many major record labels—and others—were showing interest in his work. In August Vernon and Gladys signed a contract (still under 21, Elvis could not sign for himself) appointing the musical impresario "Colonel" Tom Parker (born Andreas Cornelis van Kuijk) as "special adviser to Elvis Presley." Country music historian Colin Estcott writes,

> Elvis was already starting to show signs of breaking out of the country market when his [Sun Records] contract was sold to [RCA Victor] in November 1955, a deal masterminded by his new manager. . . . Parker persuaded RCA to pay an unprecedentedly high $35,000 for . . . a singer of virtually untested appeal outside the country market. RCA . . . was able to catapult him into the national marketplace via television and concentrated promotion. By the end of March 1956, his first RCA single became both a figurehead for rock and roll and a lightning rod for all those who despised it. In his dress, his stage moves, and his few stage-managed interviews, he projected an image that was at once threatening and vulnerable.[2]

By the end of 1956 Elvis had become "a national and international phenomenon." In that year, his first two RCA albums were both million sellers. In April he signed a 7-year contract with Paramount Pictures, making his movie debut in the Civil War drama *Love me Tender*. Reviewer Hal Erickson notes, "Naturally, Elvis is afforded plenty of opportunities to sing: the scene in which he launches into an anachronistic hip-swivelling performance at a county fair is one of the high points of mid-1950s kitsch." By the time that the movie was released in November, Elvis had appeared often on the small screen; indeed, he made eleven national television appearances in 1956. Between January and March he was a guest on six episodes of CBS's *Dorsey Brothers Stage Show*. Then in June forty million viewers saw him on Milton Berle's *Texaco Star Theatre*, when his gyrating hips earned him the nickname "Elvis the Pelvis."

Newspaper reviews most often labelled these television "guest spots" as "lewd," "nasty," or "appalling." One critic wrote, "Presley is mostly nightmare. On-stage his gyrations, his nose-wiping, his leers are vulgar." Some

journalists compared his act to a striptease. John Crosby of *The New York Herald Tribune* condemned Elvis as "unspeakably untalented and vulgar," and Jack Gould declared in *The New York Times* that he had "no discernible singing ability." The critiques moved parents, the Parent-Teacher Association, and many conservative religious groups to condemn Elvis and his music by identifying both with increasing juvenile delinquency. Certainly, as one writer points out, he "outraged adults, mesmerized the teenagers of the new youth generation, and . . . brought shock, outrage, and nationwide controversy." But he soon became "the leader of the cultural revolution sweeping across the country."

Elvis' appearance on *The Steve Allen Show* in July attracted an audience that challenged the extremely popular *Ed Sullivan Show*, then considered unbeatable in the ratings war. Sullivan had publicly declared that he would not have Presley as a guest. But business being business, he relented. On September 9 over 80 percent of America's viewing audience watched the first of three appearances for which Sullivan paid Elvis $50,000—a deal that created national headlines. According to Ron Simon, curator of the Museum of Television and Radio, "The sexual energy of Presley's first appearance . . . jolted the staid . . . conformism of Sullivan's audience. By his third and final appearance, Elvis was shot only from the waist up."

Whatever. When compared to the on- and offstage behavior of some later rock bands, or the obscene lyrics and foul language of recent performers, Elvis was mild indeed—and a *real* musician. Estcott asserts that he was "indisputably the most influential performer in the history of rock and roll" and acknowledges that though he amalgamated country music with rhythm and blues, he also "embraced black and white gospel, mainstream popular music, light opera, and more." Jody Cook, in a summary of Presley's career in the National Historic Landmark Nomination of Graceland, adds,

> Presley's roots in the Deep South, his love of all kinds of music, and his extraordinary talent as a gifted musician were key elements in the birth of the new music eventually known as rock 'n' roll, a gumbo of southern musical styles. His unique contribution was to unite and fuse all kinds of musical influences—gospel, country, blues, honky-tonk, rhythm and blues, and popular—in the creation of a new American music. From romantic, sentimental ballads and religious songs to blistering rock 'n' roll, Elvis Presley could make any kind of song his own.[3]

Although the media dubbed him "the king of rock and roll"—later, simply "The King"—Elvis believed that the title properly belonged to Antoine Dominique "Fats" Domino.

On the strength of their gifted son's meteoric success, in 1956 the Presleys purchased a modest ranch-style house on Audubon Drive, east Memphis. A year later Elvis would buy Graceland.

MOVIES, MILITARY, AND MARRIAGE

Elvis made two movies in 1957. *Loving You*, described by one critic as "a streamlined and sanitized retake" of his own life story, was released in July. It was followed in November by the black-and-white *Jailhouse Rock*, of which one reviewer wrote, "seldom would Elvis be so well showcased in the future." But "showcasing" was the whole point: the films were vehicles for his songs, and lucrative soundtrack albums were also produced. Presley was drafted into the U.S. Army in December 1957, when the Cold War was at its height. Before his induction, he filmed and recorded the soundtrack of *King Creole*, a musical adaptation of Harold Robbins' novel *A Stone for Danny Fisher*, that some critics believed to be "probably" his best movie.

In March 1958 he entered Fort Hood, Texas, for 6 months basic training. Soon after, Gladys Presley, suffering from acute hepatitis, was hospitalized in Memphis; Elvis was granted compassionate leave to visit her in mid-August, shortly before she died of a heart attack. He was very deeply attached to his mother, and the loss was a "devastating experience" for him.

About a month later, he was assigned to the 32nd Tank Battalion of the Third Armored Division and shipped out to Friedberg, West Germany. He was promoted to sergeant in January 1960 before being discharged early in March. The previous November at Weisbaden, Germany, Elvis had met and fallen in love with 14-year-old Priscilla Ann Beaulieu (he was 24), the stepdaughter of a U.S. Air Force captain. Gossip about their relationship has been well aired and no doubt well distorted; besides, it is none of our business. Suffice it to say that following a Christmas 1962 visit to Graceland, Priscilla moved into the house in early 1963 and completed her senior high school year in Memphis. Elvis later told his friend, British journalist Derek Johnson, "After a lengthy infatuation with Priscilla, I have now found true love with her. Parker has been on at me for some months to get married because it would be good for my image, and that's been one of the few things I've ever agreed with him." On May 1, 1967, Priscilla and Elvis married in Las Vegas. The following February their only child, Lisa Marie, was born.

ELVIS IS BACK

Despite fears that his prolonged absence in the army would dent his popularity, "great anticipation and large crowds" had greeted Elvis' return to the United States. Two months after his discharge from the military, he began work on his fifth Paramount film, *GI Blues*, the first of nine to be produced by Hal Wallis. Featuring ten new songs, the soundtrack album—in terms of weeks on the Billboard charts, Elvis' most successful to date—had been recorded a month earlier. On May 8 ABC's *The Frank Sinatra Timex Special*, called *Welcome Home, Elvis*, went to air and attracted two-thirds of the national television audience. That was ironic, because only 3 years earlier

Sinatra had accused rock and roll of "[smelling] phony and false." Ol' Blue Eyes had vitriolically added, "It is sung, played and written for the most part by cretinous goons [read, 'Elvis'] and by means of its almost imbecilic reiterations, and sly, lewd, in plain fact, dirty lyrics . . . it manages to be the martial music of every sideburned delinquent [read, 'Elvis'] on the face of the earth." Presley was paid $125,000 for singing just one song on Sinatra's show.

He returned to moviemaking in 1960, at first taking serious roles. Twentieth Century Fox's *Flaming Star* was critically praised as "a western starring young Presley in a surprisingly well-cast role. . . . This lean frontier drama . . . offers one of his most impressive performances." But Fox followed with *Wild in the Country*, whose script "looked good on paper but when it came time to produce it, things came apart more than they came together." It seems that Elvis fans were not interested in his dramatic skills. They wanted his music. When both films flopped at the box office (which is after all what counts), in 1961 Paramount returned him to a "vehicle tailored to his singing talents:" Wallis' *Blue Hawaii*, filmed partly on location on Oahu and Kauai in the spring of 1961. It was his top-grossing film to date, and the soundtrack album was on the Billboard chart for 79 weeks, 20 of them at the top; more than two million copies were sold. Throughout the 1960s Presley made no fewer than twenty-seven formula movies for various studios—Paramount, Twentieth Century Fox, MGM, Allied Artists, and Universal among them. But despite being "frothy and inconsequential" they succeeded at the box office, and most of his albums of the decade were of their soundtracks. But by the late 1960s his career was in trouble. Because they had displaced live appearances, the movies and the accompanying soundtracks "had almost destroyed his reputation." In 11 years he had given only two concerts, both in 1961: one for charities in the Memphis area and the other on March 25, when he starred in a benefit concert in Honolulu to raise funds for the USS *Arizona* Memorial at Pearl Harbor.

Then in June 1968 he recorded a show for NBC "that did much to restore his credibility." The Singer Sewing Machine Company at first proposed a Christmas television special, *Singer Presents Elvis*, but Presley indicated that he wanted to do a show that he wanted to "proclaim, through his music, who he really was" and that he was able to sing all kinds of American music. The production was retitled *Elvis—The '68 Comeback Special*; aired in December and attracting a staggering 42 percent of the national television audience, the "astonishing triumph" gave NBC its biggest overall ratings victory of the year and won critical acclamation. It ushered in the third phase of Presley's career.

VIVA LAS VEGAS!—AND ELSEWHERE

In the first 2 months of 1969 Elvis recorded at American Sound Studios in Memphis his first studio albums of other than a soundtrack or gospel music: *From Elvis in Memphis* and *Back in Memphis*. In March he returned to Universal Studios to make his last acted film, the "box-office bomb" *Change of Habit*.

One critic wrote, "convincing yourself that Elvis Presley is a doctor at a free New York City medical clinic is like trying to imagine Arnold Schwarzenegger as a rabbi."

On July 31 Presley launched a now-legendary, month-long series of concerts—usually two shows a night—at the International Hotel (later the Hilton) in Las Vegas. The sophisticated production that, like the 1968 NBC special, ran the whole gamut of American music, incorporated a rock and roll band, an orchestra, and two backing quartets—the black female Sweet Inspirations and the white male Imperials. It broke attendance records for Las Vegas shows and received outstanding critical reviews. Elvis returned for more sold-out shows at the International in August and September 1970, with even larger audiences. Including his final appearances in December 1976 he would entertain an estimated 2.5 million people at the venue. In fall 1970 he began a concert tour of Detroit, Michigan, Miami, Florida, Mobile, Alabama, Phoenix, Arizona, St. Louis, Missouri, and Tampa, Florida setting a pattern for the next several years and giving over one thousand concerts. Although he never appeared live outside the United States, his January 14, 1973, show at the Honolulu International Center Arena was watched live via satellite by as many as 1.5 *billion* viewers in forty countries.

Elvis and Priscilla separated in February 1972, agreeing to share custody of Lisa Marie. They divorced in October 1973. Soon after, Elvis was hospitalized in Memphis with serious health problems including pneumonia, pleurisy, hepatitis, and prescription drug dependency. Although they recurred over the next 3 or 4 years, he maintained his rigorous schedule of Las Vegas engagements and concert tours, giving his last live performance at the Market Square Arena, Indianapolis, Indiana, on June 26, 1977.

Elvis Presley died alone in his bathroom at Graceland on the morning of August 16, 1977. He was only 42 years old. Although one medical report gave the cause as "heart attack," conjecture persists. Elvis' biographer Peter Guralnick comments that "drug use was heavily implicated in this unanticipated death of a middle-aged man with no known history of heart disease," explaining that three independent reports stated "a strong belief" that the primary cause of death was the use of multiple medications. One analysis showed the presence of "fourteen drugs in Elvis' system, ten in significant quantity. Codeine appeared at ten times the therapeutic level, methaqualone . . . in an arguably toxic amount, three other drugs appeared to be on the borderline of toxicity" and concluded that "the combined effect of the central nervous system depressants and the codeine had to be given heavy consideration."[4]

Fans transformed Elvis' death into a "populist event of unique scale and significance." Tens of thousands of them flocked to Memphis until his funeral was over, almost paralyzing traffic in the city. Some of the more passionate among them entered a state of denial, and for years to come there would be frequent reports of "Elvis sightings." Indeed, they continue still. But a Gallup poll in 1997—20 years after his death—revealed that only 4 percent of

Americans believed that Elvis was alive; 93 percent were convinced that he was dead, but the remainder was uncertain. The same poll found that almost half of Americans—mostly baby boomers—still considered themselves Elvis fans. He lived on, but only in America's collective memory.

THE SINGER, NOT THE SONG

Soon after Elvis' death, American music critic Dave Marsh wrote,

> If any individual of our time can be said to have changed the world, Elvis Presley is the one. In his wake, more than music is different. Nothing and no one looks or sounds the same. His music was the most liberating event of our era because it taught us new possibilities of feeling and perception, new modes of action and appearance, and because it reminded us not only of his greatness but also of our own potential. But it's just as unquestionable that the kind of rock and roll we have—a music of dreams and visions, not just facts and figures or even songs and singers—was shaped by him in its most fundamental features.[5]

In January 2004 the Recording Industry Association of America (RIAA) officially recognized Elvis as the number one solo recording artist in U.S. history, having won more of its awards than anyone else in the world. His album sales exceeded 120 million, among them ninety-seven Gold, fifty-five Platinum, and twenty-five Multi-Platinum releases. He also had fifty-one Gold, twenty-seven Platinum, and seven Multi-Platinum singles—more than any artist or group in history. One writer notes that besides these "extra-ordinary sales achievements, Presley's first Gold single 'Hard-Headed Woman' was the first certified Gold rock and roll record—a landmark in the history of American music."

In January 1971 the U.S. Junior Chamber of Commerce honored Elvis as one of Ten Outstanding Young Men of 1970. In summer 1971 the City of Memphis renamed the section of Highway 51 South in front of Graceland to Elvis Presley Boulevard. He also received, at the age of 36, the Lifetime Achievement Award of the National Academy of Recording Arts and Sciences (NARAS), an honor that acknowledged "creative contributions of outstanding artistic significance to the field of recording." The citation read in part that it was for "his artistic creativity and his influence in the field of recorded music upon a generation of performers and listeners whose lives and musical horizons have been enriched and expanded by his unique contributions."

Elvis remains the only performer to be inducted into three music Halls of Fame: Rock and Roll (in 1986, the inaugural year), Country (in 1998), and Gospel (in 2001). In 1984, he received the W. C. Handy Award from the Blues Foundation and the Academy of Country Music's inaugural Golden Hat Award; 3 years later he was the first posthumous recipient of the American Music Awards' Award of Merit. Presley was nominated for fourteen

Grammies, the recording industry's most prestigious annual tribute, presented by NARAS. He won three, all for his recordings of gospel music, the first in 1967 for Best Sacred Performance of "How Great Thou art." But then, he had often claimed that gospel was his favorite music.

According to the National Historic Landmark Nomination of Graceland,

> Before Elvis . . . the music business primarily revolved around songs, not singers, and sales of sheet music drove the business. But [he] broke the hold that Tin Pan Alley had on the industry—it changed course, and the new focus was the singer, not the song. . . . His unique talent and style propelled the reinvention of America in the 1950s and 1960s on the home front and internationally, and assured the breakdown of traditional barriers of race, class, region, and gender that had defined and maintained the social order for generations.

GRACELAND: LIFE BEFORE ELVIS

Graceland Mansion crowns a hill beside Elvis Presley Boulevard (formerly Highway 51 South), at Whitehaven, about 10 miles south of downtown Memphis. In 1939 Ruth Brown Moore, the socialite granddaughter of Memphis publisher Stephen C. Toof, and her husband, urology professor Dr. Thomas D. Moore, built the mansion and outbuildings on land owned by her family since the mid-1890s. Ruth had indirectly inherited one-third of the 480-acre farm from her aunt Grace and named it Graceland in her honor. The Moores commissioned local architects Furbringer and Erhman (see sidebar), to design the thirteen-room house to flaunt the musical talents of their teenage daughter, Ruth Marie, who later became a harpist with the Memphis Symphony Orchestra. The local press confided that Mrs. Moore had said that the house had been designed "with an eye for future musicales and space was essential . . . not only for seating purposes, but for tone volume" and explained, "the rooms along the entire front of the house, which she called 'the dining room, reception hall, drawing room, and solarium' could be opened up to seat five hundred people for a musical event."

It seems fitting that a house that (it might be said) was born of music would later become the home of Elvis Presley. Elvis expressed that he was pleased that music played a major role in the lives of the Moore family, and on his first inspection of the property he sat down and began playing Mrs. Moore's piano, although it was in need of tuning.

A pin oak–lined driveway curves up the hill from the road to the west front of the two-story mansion, which follows no architectural rules. Standing in a grove almost in the middle of the property, the gable-roofed house with double-hung small-paned windows is a stylistic mishmash, parodying the antebellum mansions of the Old South. Categorized by some writers as "Greek," "Classical," or "Georgian," Graceland is in none of those styles—unless it is

George VI, who reigned 1937 to 1952. The principal façade's main feature is a pseudo-classical portico with paired giant nearly-but-not-quite Corinthian columns. The portico is flanked by two bays of incongruently rusticated Tishomingo, Mississippi, limestone. Beneath it, a central door is surrounded by uninformed quasi-Tuscan detail: an ill-proportioned entablature crowned with a broken segmental pediment supported by very plain engaged columns, and all framed by giant pilasters of the same indeterminate order as the front columns. The rear wall of the central pavilion and those of the single-story south wing are stuccoed brick. Robert Schmertz, a Pittsburgh architect and songwriter, once described houses with this kind of pretentious frontality as "Queen Anne front and Mary Ann behind."

The layout was originally cruciform, entered through a spacious central hall leading to an ascending stairway in the northeast corner. "Tall, wide, elliptical-arched openings" between them allowed the hall, the living room (on its south side), the dining room (on its north), and the parlor to be opened, as noted, to form a 75-foot long reception space across the entire west front. The internal plaster moldings and details were "classical." Besides that, said the realtor's advertisements, "a big kitchen, pantry, butler's pantry, utility room, one bedroom and a bath and a half [were] on the ground floor. Upstairs [were] four bedrooms and three baths." The basement contained a timber-paneled den and a playroom. The house stood on almost 14 acres of "beautifully wooded and planted land" with magnolias, sycamores, sweet gums, and willows.

WHERE ELVIS LIVES

In May 1956 the Presleys had moved into the first home that they owned, bought with money from Elvis' first movie deal—a pale green timber-frame ranch-style house with black shutters, brick trim, and a gray tile roof at 1034 Audubon Drive in an upper-middle-class Memphis neighborhood, It may have been the fulfillment of a dream, but life there became difficult soon enough. Art historian Karal Ann Marling writes,

> When Elvis was home [the fans] came by the hundreds, at all hours of the day and night. Vernon never had to mow the lawn. The girls plucked it out, blade by blade, for their scrapbooks. They tiptoed up the driveway when nobody was looking and pressed their ears to the green siding, hoping to hear a snatch of "Hound Dog" through the walls. Elvis put up a fence, a low brick wall with wrought-iron spikes on top. But the fence didn't keep anybody out. . . . Vendors sold hot dogs and popcorn on the street. The city posted [No parking, loitering or standing] signs.
>
> The fans ignored the signs. When Elvis wasn't home, they yoo-hooed out by the fence until Mrs. Presley came down to visit. Could she rub Elvis's Cadillac with this Kleenex, please? Would she take this paper cup and dip some Elvis

water out of the swimming pool? Could we stand in the carport if we're real quiet? The family treated the invaders with grave country courtesy. When Elvis came home for the Fourth of July in 1956, there were Elfans in the carport and the driveway, fans out by the fence, fans cruising down the street, honking and waving and taking pictures. Fans in the bushes with their noses flattened against the windows. . . .

The hillbillies had taken over Audubon Drive. The neighbors were beside themselves . . . [6]

After her divorce in 1952, Ruth Moore had allowed a local Disciples of Christ congregation to meet in her house until they could build a church on the adjoining land. In mid-March 1957, returning from visiting Elvis on the set of *Loving You* in Hollywood, Vernon and Gladys began searching for a larger house at a more private location. They soon called their son to tell him they had found a likely place. He was instantly taken with Graceland—the church had moved and there was vacant possession—and 9 days later he closed a deal with Ruth Moore. He paid $102,500 for the property, topping an offer from the Memphis YMCA by about $65,000. He paid half in cash; Mrs. Moore accepted the Audubon Drive house as the balance. One writer notes that Graceland had been vacant when Elvis first saw it and he had no problem with the church being next door; Mrs. Cobb (formerly Ruth Marie Moore) recalled that as one reason why her mother chose him as the buyer over other offers. Another reason that cannot be discounted, of course, was the inflated price that he offered.

At the end of March Elvis began a personal appearance tour. In his absence painters started redecorating the house interiors and began work on a 6-foot masonry wall along the road; the rest of the boundary was fenced. The contractors expected to finish in 3 weeks, and the Presleys planned to move in on April 15. But issues over nonunion labor halted progress, so that Vernon, Gladys, and Elvis' paternal grandmother, Minnie May, took possession a month late. The singer was in Hollywood, filming *Jailhouse Rock*.

Graceland's décor went through many changes over the 20 years that Elvis Presley lived there, in response to his shifting aesthetic preferences (the word *taste* sticks in the throat). Marling comparts the successive interior schemes as follows: the Elvis and Gladys Phase or "purple with clouds" period (1957–mid-60s—actually, dark blue walls and a deep red carpet); Elvis's Swingin' Bachelor Phase (1964–68—red drapes and white carpets à la *Viva Las Vegas*); the Domestic Phase (1967–72, during which Elvis added touches of light blue to the first floor rooms); and the Red Phase (1973–77); in 1974, Elvis and his girlfriend Linda Thompson redecorated in blood-red shag and velveteen. The press unkindly dubbed the latter the "antebellum bordello red period." Marling adds another: "the Posthumous Phase" (1981–82), noting that "before being opened to the public, Graceland [was] tastefully refurbished in cobalt blue and white." That was the work of Priscilla Presley.

THE ELVIS AND GLADYS PHASE

Some obsessive fans insist that though he was assisted by Gladys and the interior decorator George Golden, "the King had final say in all work done on his castle" during the first phase of Graceland renovations. That is inconsonant with Golden's own recollection, who claimed in 1993 that Elvis' parents invited bids from him and his two female rivals—there were then only three decorators in Memphis. As the selected tenderer, he remembered being allowed free rein to decorate Graceland any way he saw fit. Golden "avoided turning Graceland into the last word in interior decoration, circa 1957"; rather

> he opted for a hodgepodge of styles, ranging from contemporary suburban ranch house to something best characterized as Late Fifties Lush Life. The latter . . . was most visible in Graceland's dining and living rooms, two lavish (if small-ish) chambers awash in chandeliers, gold-on-white trim and swagged draperies. In their 1987 book *Elvis World* . . . Jane and Michael Stern [assert], "You have seen this place before, but not in the real world [but] in the movies . . . it says "rich person's home."
>
> Elvis told Golden that he wanted "the darkest blue there is for my room with a mirror that will cover one side of the room. I probably will have a black bedroom suite, trimmed in white leather with a white rug." What he actually got was "adorned with pink, flowered bedspreads, red telephone and a stuffed hound dog—more like a teenage girl's boudoir than sleeping quarters for the King of Rock n' Roll. Elvis also wanted stars and clouds painted on the entrance hall ceiling; for the downstairs reception rooms he ordered purple walls and white corduroy drapes. Gladys preferred the lighter colors and that's what Gladys got."[7]

Outside, Elvis' changes were just as uninhibited—the gauche opulence of a *nouveau riche*, and a young one at that. At night, he had the mansion floodlit with blue and gold. It was approached along a driveway "strung with blue lights like an airport runway," through purpose-made double wrought iron gates in the pink Alabama fieldstone wall. Closed, the gates simulated sheet music, decorated with musical notes and stylized rock guitarists. A large sunken stone–paved patio surrounded a new swimming pool—kidney-shaped, of course—at the southwest corner of the house. The Moore's four-car garage was extended to house Presley's ten vehicles. In August 1957 he imported two white marble lions (unmatched) to flank the approach to the front door. "Design coordination" does not spring readily to mind when evaluating the 1957 renovations to Graceland.

ELVIS'S SWINGIN' BACHELOR PHASE

Presley initiated several projects in the 1960s. Besides minor works, he enclosed a patio between the swimming pool and Graceland's single-story south

wing, creating an approximately 80- by 16-foot room joined to the house by a covered link. It originally housed an expansive slot car racetrack but was later remodeled as a trophy room for Elvis's awards and other memorabilia.

He also converted another patio on the east side of the mansion into a 14- by 40-foot den. Tour guides later dubbed this the Jungle Room, because of its ultra-lurid kitsch furnishings—green shag carpets on the floors and ceilings, wood paneling on the walls, and a mixed bag of pseudo-Polynesian furniture with wooden arms carved in animal and totem figures and upholstered in *faux* fur. Bernard Grenadier, a local designer and builder (some sources generously call him an architect), later completed a stone wall with a waterfall for the room. He also remodeled and furnished the master bedroom and bathroom.

FROM A MEDITATION GARDEN TO A MECCA

Probably most significant among Grenadier's additions was the Meditation Garden near the pool area south of the mansion. His son recalled, "In 1966, Elvis hired my father to design and build a meditation area. [It] was dedicated to the memory of Elvis' mother. . . . This would be a place that Elvis would go to be alone in his thoughts about his mother and his twin brother, who was stillborn, without having to leave Graceland." The Garden has been described as "a smallish open-air sanctuary beset [yes, *beset*] with Italian marble statues and an ornate fountain that features underwater lights and fourteen different sprays." The NPS provides a little more detail: "It includes a circular pool containing circular fountain jets, and a semi-circular pergola of Ionic columns on the south side of the pool, with fountains. A stepped brick wall with four arched openings containing stained-glass panels curves to follow the pergola and encloses the . . . south end."

Three days after he died, Presley's body was interred at Forest Hill Midtown Cemetery in Memphis. As a consequence of a macabre attempt 10 days later to steal the body, on October 2 Elvis and his mother were reburied side by side in the Meditation Garden; the marble monument from the Forest Hill family plot was relocated. Vernon Presley died on June 26, 1979, and was buried next to his son; Minnie May Presley followed in 1980. Opened to the public in 1978 the garden has become a Mecca for Elvis pilgrims, especially on the anniversaries of Elvis' death. Commenting that the response to celebrities "often expresses itself in ritual patterns reminiscent of the veneration of saints," Stephen R. Reimer writes,

> Up to 50,000 visitors descend on Memphis every year for the week [before] the anniversary of Elvis Presley's death. . . . Officials at Elvis Enterprises call this "Elvis International Tribute Week," while the locals call it "Death Week." [The night before] there is an elaborate candlelight vigil at the gravesite within the

Memorial Gardens . . . during which the pilgrims carrying candles file past Elvis's grave while Elvis songs are played over loud speakers. [They] come to pay their respects, to give thanks to Elvis for helping them, and to leave a gift at his grave. . . .

For Elvis . . . there is the sacred place of Graceland (both his house and his gravesite), sacred times (. . . "Death Week"), where offerings are left (flowers and teddy bears), relics are displayed and traded (including hair and toenails [and] collectibles), and the story of his life is retold as a legend which may bear little resemblance to historical truth. . . . This legend becomes a sort of divine truth which is not subject to verification or falsification; it cannot be contradicted by mere facts. The "scandalmongers" . . . say that he died a fat pill-popping has-been, but true believers know the truth and must preserve the sacred memory of Elvis against those who speak scandal.[8]

THE RED PHASE

The last time that the house was redecorated for Elvis was in 1974, in "a fit of gaudiness" on the part of Bill Eubanks of McCormick-Eubanks Interior Design, with input from Elvis and beauty queen Linda Thompson, his live-in girlfriend since mid-1972. She would remain at Graceland for about 3½ years.

Mirrors were added to the walls along the stairs to the basement, and the whole entire east wall of the living room, including the fireplace. The opening between the living room and the music room in the south wing was fitted with a sturdily framed stained glass wall. The sidelights of a central doorless opening featured stylized peacocks; matching colors were used in the transom. At the same time the sidelights and transom of Graceland's front door were also "enhanced" with stained glass. Eubanks designed a television room in the southwest corner of the basement. Its walls, ceiling, fireplace, and bar were fully mirrored, visually destroying the shape of the space. The south wall had three built-in television sets—one for each network in those pre-cable days—as well as a stereo sound system, and cabinets for Presley's record collection; the blue-and-yellow graphic on the west wall echoed the "taking care of business in a flash" personal logo that Elvis adopted in the 1970s. The poolroom in the northwest corner of the basement had walls and ceiling covered in hundreds of yards of pleated red paisley cotton. What the guidebooks call a "Tiffany-style" stained glass light—although Louis Tiffany would spin in his grave—illuminated the pool table. There were red Louis XV reproduction chairs in the corners of the room and busily patterned overstuffed sofas and cushions, leaving not a single spot for the eye to rest.

Eventually boasting twenty-three rooms, while in Elvis' ownership Graceland grew in area from just over 10,000 square feet to 17,500 square feet. Media studies expert Mark Crispin Miller writes that eventually "Elvis carefully

tended his little world with such costly cosmetic touches, living as the retired spectator of his own things. He would spend hours in his bedroom, watching his property on closed-circuit television." He suggests that Elvis may have "wanted to bedeck himself into oblivion; his career was a long process of accretion, at home and onstage. Shortly before he died, he started carpeting the ceilings."[9]

Although lengthy, the following summation by architectural historian Camille Wells is invaluable:

> The look of [Graceland's] interior at any one time is difficult to grasp—changes occurred often—but generalizations are possible. For each component . . . Elvis retained conventional room designations with their customary formal or casual qualities. Furthermore, every phase of interior treatment shares richly colored assemblages of thick carpet, costly fabrics, large-scale furniture, complicated lamps, and novelty accents. . . . Elvis's rise to fame and fortune was dizzyingly swift, at times overwhelming. Along the way, he snatched what he could learn about wealthy living from lavishly appointed theaters and auditoriums, luxury car and tour-bus interiors, Hollywood sets, and Las Vegas suites. Then he brought it all back to the house he proudly owned. As one analyst put it, Graceland is how a poor boy lives rich.
>
> Although Elvis discovered soon and under piteous circumstances that chilly-eyed observers thought his house was in staggeringly bad taste, he continued to decorate Graceland as he pleased—adding a new defiant edge and a willingness to embrace the outrageous. His choices also manifest an evolving sense of Graceland as a haven—even a fortress—rather than a showplace. . . . This muffling of Graceland is only the most obvious expression of the isolation and embattlement that accompanied his unparalleled stardom and threatened at last to engulf him.[10]

"ELVIS HAS LEFT THE BUILDING"

Elvis' will named his father as executor and trustee; the beneficiaries were Vernon, Lisa Marie, and Minnie Mae Presley. Vernon was authorized to provide funds to other family members if needed. As noted, he died in 1979 and Minnie Mae in 1980, so Elvis' daughter soon became the sole heir. Her inheritance was to be held in trust until her 25th birthday, and Vernon's will in turn appointed three cotrustees—her mother Priscilla, Elvis' accountant Joseph Hanks (who retired in 1990), and the National Bank of Commerce in Memphis.

Although Elvis Presley's estate dwindled to about $5 million, its cash flow problems were exacerbated by the cost of Graceland's maintenance and taxes, running into half a million dollars a year. Priscilla spent $500,000 restoring the house, replacing the garish red color scheme with blue, gold, and white. In late 1981 the executors engaged Kansas City investment adviser Jack Soden

to facilitate opening the mansion to the public. Tours began in June 1982; there were over three hundred thousand visitors in the first year; by the turn of the century that number would double (since then it has peaked at seven hundred thousand), and the estate would be worth $200 million.

In 1983 Elvis Presley Enterprises (EPE) acquired the suburban shopping center—an "unsightly blemish of tacky Elvis souvenir shops"—across the street from Graceland, began policing the sales of items not licensed by the Presley Estate, and began a makeover. When all the existing leases had expired, by about 1987 EPE began major renovations, purchasing the property, rebadged as Graceland Plaza in 1993.

When the original trust was dissolved on February 1, 1993, the Elvis Presley Trust was established, with Lisa Marie and the Bank as cotrustees, to manage the estate; she was president and chair of the Board. Her mother assumed an advisory position. As the enterprise continued to grow, so did the attractions. In fall 1997 Graceland bought Graceland Crossing, an independently owned shopping center just north of Graceland Plaza. The next major development was the purchase and makeover in 1999 of a nearby hotel. Renamed Heartbreak Hotel, it has 128 rooms and several appropriately garish suites—the Graceland, the Hollywood, the Gold and Platinum, and the Burning Love—decorated in appropriately bad taste.

On November 7, 1991, Graceland was placed on the National Register of Historic Places; on March 27, 2006 it was designated a National Historical Landmark. The NPS claims that before the site opened to the public, tourism in Memphis was minimal; now Graceland's annual contribution to the local economy is estimated at $300 to $400 million. "A major part of that impact is that most Graceland visitors come from outside the city. Further benefiting the city is the intense worldwide publicity that Graceland and the Elvis Presley phenomenon continually bring to Memphis." EPE employs about 350 people part-time and full-time over the whole year, and up to 450 in the summer season.

In August 2005 Robert Sillerman of the entertainment company CKX, Inc. paid EPE $114 million for an 85 percent interest in Graceland, including its physical and intellectual properties. Lisa Marie Presley retained the remainder and (with Priscilla as adviser) continued to be involved. Lisa is the sole owner of the house itself, its original grounds, and her father's costumes, wardrobe, awards, furniture, automobiles, and so on. She has made it all permanently available for tours of Graceland and for use in all of EPE's operations, which include "worldwide licensing of Elvis-related products and ventures, the development of Elvis-related music, film, video, television and stage productions, the ongoing development of EPE's Internet presence, the management of significant music publishing assets and more."

In February 2006 Sillerman announced a 3-year project to overhaul the tourist complex and build a 500-room convention hotel, a high-tech museum, and a visitor center "as large as a football field." Travel writer Suzaan Laing remarks that the expanded Graceland, no longer a mansion but a theme park,

and "a mixture of solemnity and Disneyfication . . . is overwhelmed by the cult and the commerce that supports it."[11]

GRACELAND IN POPULAR CULTURE

It is almost superfluous to write about how Elvis Presley—and by unavoidable connection, Graceland—has been exploited in popular culture. Most critiques label Graceland Mansion and its contents, *super*-kitsch; therefore it is not surprising that the populist mementos it generates are also kitsch. The word *kitsch* (from the German *verkitschen* = to make cheap) describes "something that appeals to popular or lowbrow taste and is often of poor quality." Another dictionary, actually citing Elvis-shaped cookie jars as an example, defines it as the " 'low-art' artefacts of everyday life."

In a July 2003 *Ladies Home Journal* interview, Presley's former wife Priscilla spoke of "Elvis's 'guys', his tight, macho entourage who have been pedalling scandal and stolen objects for years" conducting a lively trade in Elvis souvenirs. She complained, "I'm more upset about the pictures. I took pictures all the time and had left many photos in a drawer in our bedroom when I moved out. Some I had cut in half, torn and thrown in the trash. They're on the market now. You can see where someone put them back together. They were stolen and sold." As a proverb from the most ancient Jewish literature says, "Wherever the victim lies the vultures gather to feast."

Some scavenging crosses the boundaries of the bizarre and morbid. It was reported in 1999 that Athens, Georgia, sculptor Joni Mabe owns one of Elvis Presley's toenail clippings, that she "discovered buried among the long fibers of the shag-pile carpet of the Jungle Room." She had incorporated the little treasure as the centerpiece of a "tribute installation sculpture" titled *The Elvis Room*, together with Elvis "whisky decanters, collectors' plates, costumes, lamps, clocks, watches, bedspreads, pillows, ashtrays, bedroom slippers, towels, knives, cologne, worn shoestrings, and generous vials of the King's sweat."

It seems that people need reminders of where they have been or of what they have seen that are more tangible than memories. A few years ago, an Australian tourist found a marble chip on the Athenian Acropolis, hardly bigger than a matchbook; its surface was scored by several parallel chisel marks. She kept it as a souvenir. Had every visitor done that, the Acropolis would have quickly shrunk within a few decades. Far removed from such "pieces of the true cross," most of the EPE-endorsed souvenir trafficking at Graceland is in specially manufactured memorabilia. Otherwise, presenting the same temptations as the Acropolis (which has about 15 percent fewer visitors), the mansion would soon disappear. In the case of most of the architectural icons discussed in this book, the myriad visitors who are attracted to them, for whatever reason, become the (easy) target market for souvenir purveyors. According to Laing,

> The [Graceland] visitor's centre . . . has the layout and atmosphere of a casino. Hundreds of people of every description [queue] expectantly to take the shuttle bus that starts the [tour] . . . bearded men in "Elvis Lives" t-shirts, women in tight sweatpants with baby prams. . . . The souvenir shops around Graceland again objectify Elvis. Lovers of kitsch can go to town here—clocks of Elvis with swinging hips, Elvis Christmas lights, cookbooks (*All cooked up*, *Are you hungry tonight?*), plates, playing cards, clothes, jewelry.

As noted, EPE secured a monopoly of the Elvis Presley memorabilia bonanza. Retail outlets at the Plaza and Graceland Crossing include Good Rockin' Tonight, selling "Elvis CDs, DVDs, videotapes, books, and more," including Follow that Dream label exclusive releases; a clothing store called Elvis Threads offering t-shirts, jackets, hats, accessories, and "other Elvis-themed apparel"; and Elvis Kids with "many special gifts for the youngest Elvis fans." There is even Gallery Elvis selling "upscale art pieces and collectibles," whatever they might be. Although the rock star and his mansion have become syncretized, there is also a range of "Where Elvis Lives" items (note, "*lives*," not "*lived*"), with specific Graceland connotations. Visitors may choose from candles, clothing, cookie tins, mugs, plates, pink Cadillac metal signs, cross-stitch sampler kits, teddy bears, automobile license plates, car window shades, wallpaper friezes, guidebooks (even a pop-up edition), tour videos, wind chimes, belt buckles, stained glass panels, and miniature replicas of the mansion. Not all are labeled "made in U.S.A."

A graphic designer (pseudonym, Evil Amy) cynically describes her descent into the kitsch of Graceland when she arrived in Memphis a couple of hours early for a "Platinum Tour Package."

> Before [it] began, I went to a souvenir shop half a block from Graceland. Never let it be said that tourists don't love kitsch . . . If modern technology can put an Elvis face or signature on it, modern technology will license the rights to do so. Some of the more noteworthy items include ViewMaster reels, potholders bearing a recipe for fried peanut butter and banana sandwiches, a [BBQ] spice mixture known as "The Elvis Blend," and special edition dolls which look a lot like creepy little dwarves dressed in Elvis garb. Slightly disappointed in the lack of actual velvet Elvi (the plural of Elvis), I purchase an Elvis Christmas ornament whose hips swing back and forth. . . . As I leave the store, I notice a plexiglass guitar case in the . . . window. Patrons are invited to write a note to Elvis and slip it through a slit in the case.

She boasts, "I survived my Graceland TKO (Total Kitsch Overload). I have lived to tell the tale and have not yet covered my home in olive green shag, but beware citizens: should you visit Graceland, you just may be overtaken by kitsch."[12] But as Czech writer Milan Kundera said, "No matter how much we scorn it, kitsch is an integral part of the human condition."

A search on *eBay* in May 2008—over 30 years after his death—yielded almost nine thousand Elvis items. One off-site merchant extends the list to

embrace, *inter alia*, drink coasters; books (mostly picture books); cigarette lighters; denim bikini clip purses; diamante necklaces, rings, and pendants; fancy dress costumes (complete with Elvis wig); handbags; lunch boxes; medallions; a customized *Monopoly* game; pink computer mouse mats; purses; refrigerator magnets; "retro" and "jumbo" sunglasses; talking wall clocks; t-shirts (with a choice of legends including "The King is back," "Love me tender," or "Vagas [*sic*] rock star"; umbrellas; and wristwatches. And there is more—much, much more.

Paul Simon's 1986 song "Graceland" seems to represent the house as a destination akin to the Celestial City of John Bunyan's *Pilgrim's Progress*: "I'm going to Graceland,/ Poorboys and Pilgrims with families/ And we are going to Graceland . . . Maybe I've a reason to believe/ We all will be received/ In Graceland." Five years later, some of the lyrics of Marc Cohn's song "Walking in Memphis" had a similar metaphysical dimension: "Saw the ghost of Elvis on Union Avenue/ Followed him up to the gates of Graceland / Then I watched him walk right through / Now security they did not see him/ They just hovered 'round his tomb / But there's a pretty little thing/ Waiting for the King/ Down in the Jungle Room." In David Winkler's 1998 movie partly shot on location in the house, *Finding Graceland*, the hero, driving to Memphis, picks up a hitchhiker in a pink jacket who tells him he's Elvis Presley who wants to reach Graceland in time for the anniversary of his faked death. One reviewer remarks, "At times, it feels like *The Greatest Story Ever Told, Part II*." Perhaps these are linked to the apotheosis of Elvis Presley.

A few years ago, American journalist David Pulizzi asked in an unpublished essay, "What is Elvis now, [so far] into his odd post-life existence?" He answered,

> To [his now-aging fans] he remains a divine eminence. If anything, his recordings and movies have assumed an even greater poignancy since his death. They are precious reminders that the world was once a better place and they call forth an age when the fans themselves were young and carefree. Gathered in Memphis each year, . . . [they] the fans comport themselves as if they were teenagers, as if all the world was unadulterated innocence and fun. Some twisted and wholly idealized conception of Elvis resides at the center of that world. [So many] years after his death, the fans still *believe* in Elvis . . . in his essential goodness and in the majesty and transformative power of his music. And because of that unshakable faith and their willful disregard for any unpleasant facts that might taint the flawless image that they hold of Elvis in their collective consciousness, [they] are scorned and ridiculed by people the world over who just don't get Elvis and probably never will.[13]

He concluded, "Of course even in life—at least the life that we knew—Elvis was an idealized version of himself. And no one took a more active role in the creation of the Elvis myth than Elvis himself."

Furbringer and Ehrman, Architects of Graceland

Had Elvis Presley never bought it, Graceland would have remained an obscure suburban house—not very well designed, at that—created by obscure provincial architects.

Max Furbringer (1879–1957) studied architecture at Washington University and the Beaux-Arts Society of New York. He worked first in his native St. Louis, then in Buffalo and New York City; around 1908, he moved to Memphis, where he joined forces with local architect Walk C. Jones, Sr. (1874–1964). As a boy, Jones had worked in the office of architect Mathias H. Baldwin and (according to historian Judith Johnson) he also had been articled to Burke, Weathers, Shaw, Alsup and Hain.

Among the better-known works of the "successful" Jones and Furbringer collaboration were the Shrine Building; Temple Children of Israel synagogue (1915); the seven-story North Memphis Savings Bank (ca. 1920, said to be the first steel-framed building in the city); the C.R. Boyce residence (1919–1921, now the Junior League Community Resource Center); the University of Tennessee Medical Units (now the Health Science Center); the Hotel Claridge (1924); and several elementary schools in and around Memphis. Both men were active in community and professional affairs, at different times chairing the City Planning Commission (Furbringer for 10 years) and serving on the Housing Authority. Furbringer wrote the local building code and was a member of the City Board of Adjustment—a sort of planning appeals committee. None of these roles called for artistic creativity.

Jones' Yale-educated son, also Walk, joined the firm in 1931when he was 27 years old. The effect of the change can only be guessed at, but the Jones–Furbringer partnership was dissolved 4 years later, when the Joneses formed a new firm. Furbringer took Merrill G. Ehrman as a partner, and in 1938 they made preliminary designs for Graceland. Karal Marling writes, although not altogether accurately,

> Furbringer had been a leading Memphis architect since the turn of the century and a specialist in gracious homes for the well-off. Before World War I, he had a hand in designing some of the earliest Colonial Revival houses in the city, using a working vocabulary of giant porticoes and dark shutters set against brick or stone. . . . a Southern Revival, which, in homes by Furbringer, echoed the great antebellum mansions of Memphis.

Little is known of the later practice. After Furbringer's death, Ehrman undertook a much larger commission. Johnson writes,

> Modernism arrived at the Mid South Fairgrounds when the Mid-South Fair Association and the City of Memphis and Shelby County

governments decided to build The Mid-South Coliseum . . . at East Park-way and Southern Avenue. . . . In the late 1950s they commissioned a plan . . . which called for a large multipurpose building to be constructed to serve various community needs including an ice-skating rink. The firm of Merrill Ehrman and Max Furbringer designed the Mid-South Coli-seum, a $4,250,000 finally building erected in 1963 and 1964 [eventual cost, $4.7 million]. However, Max Furbringer had passed away in 1957 leaving Merrill Ehrman to design this local example of Luigi Nervi's fa-mous Coliseum [*sic*]. The Coliseum is arguably the first local facility to be designed for integration, as there are no separate facilities labeled black or white. It was also the site of integrated events including concerts, revivals and political rallies.

NOTES

1. Rodman, Gilbert B., *Elvis after Elvis: The Posthumous Career of a Living Legend*. New York: Routledge, 1996, 99.

2. Estcott, Colin, "Elvis Presley." www.countrymusichalloffame.com/site/inductees.aspx?cid=155

3. National Historic Landmark Nomination: Graceland. www.nps.gov/nhl/designations/samples/tn/Graceland.pdf

4. Guralnick, Peter, *Careless Love: The Unmaking of Elvis Presley*. Boston: Little, Brown, 1999, 651–652.

5. Marsh, Dave, "How Great Thou Art, Elvis in the Promised Land." *Rolling Stone* (September 22, 1977), 58.

6. Marling, Karal Ann, *Graceland: Going Home with Elvis*. Cambridge, MA: Harvard University Press, 1996.

7. Webb, Dewey, "The King and I . . . ," *Phoenix New Times* (July 28, 1993).

8. Reimer, Stephen, "The Cult of Celebrity: St. Elvis is still in the Building," *Edmonton Journal* (May 15, 2004). www.expressnews.ualberta.ca/article.cfin?id=5984

9. Miller, Mark Crispin, *Boxed in: The Culture of TV*. Evanston, IL: North-western University Press, 1988, 192.

10. Wells, Camille, "[Review]: *Graceland: Going Home with Elvis* . . . " *Journal of the Society of Architectural Historians*, 57(June 1998), 214–216.

11. Laing, Suzaan, "The Kitsch and Cult of Memphis." www.bootsnall.com/articles/06-12/

12. "Lifestyles of the Kitsch and Famous." http://evilamy.com/content/writing_kitsch.html

13. Pulizzi, David, "Finding Elvis" (August 2002). http://davidpulizzi.com/articles/elvis.html

FURTHER READING

Brixey, Ken, and Twyla Dixon. *Elvis at Graceland*. Memphis, TN: Cypress, 1983.

Chadwick, Vernon, ed. *In Search of Elvis—Music, Race, Art, Religion*. Boulder, CO: Westview, 1997.

Doll, Susan. *Understanding Elvis, Southern Roots vs. Star Image*. New York: Garland, 1998.

Dundy, Elaine. *Elvis and Gladys: The Genesis of the King*. London: Weidenfeld and Nicolson, 1985.

Gillette, Jane Brown. "Elvis Lives; Architects (1939): Max Furbringer and Merrill Ehrman." *Historic Preservation*, 44(May-June 1992), 46–53, 93–96.

Green, Margo Hoven, et al., comps. *Graceland*. Buchanan, MI: Trio, 1994.

Guralnick, Peter. *Careless Love: The Unmaking of Elvis Presley*. Boston: Little, Brown, 1999.

Guralnick, Peter, and Charles Hirshberg. *Elvis Then and Now*. New York: Gruner + Jahr USA, 2002.

Guralnick, Peter, and Ernst Jorgensen. *Elvis Day by Day*. New York: Ballantine Books, 1999.

Marling, Karal Ann. "Elvis Presley's Graceland, or the aesthetic of rock 'n' roll heaven." *American Art*, 7(Autumn, 1993), 72–105.

Marling, Karal Ann. *Graceland: Going Home with Elvis*. Cambridge, MA: Harvard University Press, 1996. See also review by Camille Wells, *Journal. Society of Architectural Historians*, 57(June 1998), 214.

Mason, Bobbie Ann. *Elvis Presley*. New York: Penguin Putnam, 2003.

Rodman, Gilbert B. *Elvis after Elvis: The Posthumous Career of a Living Legend*. New York: Routledge, 1996.

Rooks, Nancy B. *Inside Graceland: Elvis' Maid Remembers*. Philadelphia: Xlibris, 2005.

Tracy, Kathleen. *Elvis Presley: A Biography*. Westport, CT: Greenwood, 2007.

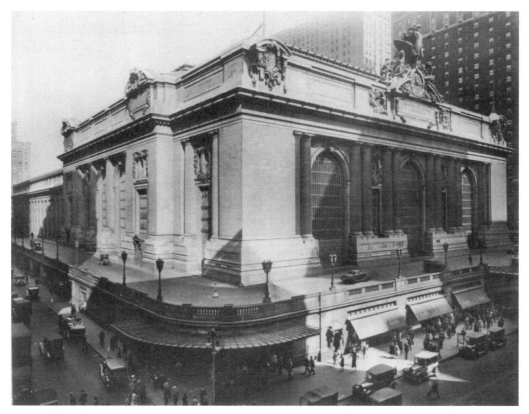

Courtesy Library of Congress

Grand Central Terminal, New York City

Once, twice, three times an icon

When Grand Central Terminal was rededicated in October 1998, one writer commented, "If the city [of New York] could be characterized by one building, it would be Grand Central." Not wishing to go quite as far, the National Geographic television channel, in an Internet promotion for its 2006 production, *Inside Grand Central*, called the Terminal "one of the most dramatic and enduring symbols of New York City," claiming,

> An architectural and technological marvel built almost a century ago, it has triumphed over the car and jet-age, corporate greed, the wrecking ball, even the city's indifference. . . . Facing different challenges today, this magnificent train station is reinventing itself for the future. . . . The Beaux-Arts building, completed in 1913, [was] the epicenter of midtown Manhattan with a "Grand Central District" of office buildings and hotels built around it. . . .
>
> Threat and survival would become themes of Grand Central in the coming decades. The onslaught of the car and jet as alternative forms of travel in the 1950s, the desire to erect a skyscraper over [it] in the 1960s, the fiscal neglect of cash-strapped New York City in the 1970s, and the growth of [its] homeless population in the 1980s each could have destroyed Grand Central, but it emerged stronger after each trial. . . . Today, the terminal is as vibrant and alive as ever.[1]

Grand Central Terminal deserves iconic status for three reasons. First, it was from its inception, a symbol of corporate capitalism and the power of the railroads—as architecture critic Wolf von Eckardt hailed it as "the statement of an era, a monument to the triumph of the railroads in forging an empire out of a wilderness and creating a wealth of museum treasures, public libraries and handsome buildings."[2] Second, promoted nationally and internationally in the populist media it has been for decades a critical transport hub, an icon of adventure or even of escape, a staging post to "the world beyond"; and third, since the end of the 1990s it has come to represent the social value that such architectural landmarks from the past holds for the future, a reminder of the imperative need to preserve our built heritage. When the restored building was opened in 1989, postmodernist architect Robert Stern wrote in *The New York Times* that as "a gracious gateway to one of the world's great cities," Grand Central Terminal was a "powerful symbol of American power, pride and know-how [whose] architects mined the architectural past to create a convincing expression of the belief that the goals of capitalism are not inimical to the enhancement of the public realm."

In 2007 the American Institute of Architects (AIA) invited almost two thousand people across the country to name their favorite buildings. On the resulting list of 150, Grand Central Terminal was afforded thirteenth place; the AIA dismissively commented only that it was "among the most important New York City landmarks for more than 100 years." But the building that sociologist Kurt Schlichting called "New York's secular cathedral "represents the 'Age of Energy' more than any other." Between 1865 and the

World War I New York witnessed the construction of the Brooklyn Bridge (completed 1883) as well as its first elevated railroad (1874), its first subway, the Interborough Rapid Transit Company (1904), and skyscrapers like the Park Row Building (1899), the Flatiron Building (1902), The Times Tower (1905), and many others. None of these architectural and engineering wonders had as much effect upon the metropolis as the Grand Central Terminal did.

Although its larger contemporary, Pennsylvania Station—wantonly demolished in the 1960s—served mostly America's East Coast, Grand Central was the terminal of the transcontinental railroads—a gateway indeed, and the gate was double-hinged. But according to Whitney Warren, one of its designers, *gateway*, suggesting a "passive orifice," was a deficient term; rather, he saw the Terminal as a "great reciprocating engine for pumping a huge flow of pedestrians through a whole series of valves and conduits into connecting systems—trains, subways, taxis, trolleys and elevated trains. . . . " He might have added "and beyond." Through Grand Central there passed many from Europe, traveling further westward across America to a new life on the prairies or the Pacific Coast; through it there also passed many others traveling eastward in search of adventure beyond 42nd Street, and even beyond the United States, back in the Old World.

Despite the fact that many Americans have never visited New York City, Grand Central is known throughout the nation. It has been woven into the plots of fiction, including for example, Leo Szilard's fantasy, *Report on Grand Central Terminal* (1949) and J. D. Salinger's 1951 classic, *The Catcher in the Rye*, as well as Sue McVeigh's *Grand Central Murder* (1939); Arthur J. Roth's *The Grand Central Murders* (1964), and the breathless 1977 thriller *A Stranger Is Watching* by Mary Higgins Clark. Like wines and Rubens' paintings, some *are* better than others. Perhaps more significantly, the Terminal has become familiar in America and internationally through that most pervasive expression of popular culture, the movie.

One source lists thirty-five films shot in part on location in Grand Central; there are others. The building's earliest screen appearance seems to have been in a 16-minute comedy, *Mr. Jones Has a Card Party*, made in 1909 by the great D. W. Griffiths, while the Terminal was under construction. Another short film, *The Breakdown*, followed in 1912. Thirty years later MGM released a B-grade film version of McVeigh's *Grand Central Murder*. Simply because it is part of New York City, Grand Central Terminal has been and continues to be incidental to the plot in many acted movies. It was also integral to the action in many films, among them Vincente Minnelli's 1945 wartime drama *The Clock*, Alfred Hitchcock's classic *North by Northwest* (1959, filmed at night in the building), a 1982 adaptation of *A Stranger Is Watching*, Francis Ford Coppola's *Cotton Club* (1984), *Midnight Run* (1988), and the bloody climax—what else?—of Brian de Palma's *Carlito's Way* in 1993, based on an Edwin Torres novel.

Documentary films such as *Koyaanisqatsi* (1982), *Chronos* (1985), and *Baraka* (1992) have also included it. Foreign filmmakers have shot footage there: Italian filmmakers used it in *Fuga dal Bronx* (*Escape from the Bronx*, 1983), and it featured in the East German short documentary *Großer Bahnhof* (*Grand Station*, 1990). It also had a prominent place in Karan Johar's controversial but critically hailed Bollywood drama, *Kabhi alvida na kehna* (*Never Say Goodbye*, 2006). But the relevant scenes, described in the script as taking place at Grand Central, were actually filmed in Philadelphia's 30th Street Station. That can be put down to artistic license; after all, it *was* Bollywood.

Perhaps its most stunning use as a location was in Terry Gilliam's poignant award-winning fantasy, *The Fisher King*, of 1991. To film the scene, the production company was given use of the Terminal for two nights from 11 o'clock until the commuter service commenced at 6:10 the next morning. Gilliam choreographed one thousand extras as commuters, briefly and romantically transformed into waltzers spinning around the concourse. He later explained,

> The waltz is the only thing that I would claim total credit for because it wasn't in the script. . . . A scene takes place at Grand Central Station, so I was there watching the rush hour develop, watching the swarm begin. It started slowly, then the tempo increased and I thought, "My god, wouldn't it be wonderful if all these thousands of people suddenly just paired up and began to waltz?" And the producers foolishly enough said, "What a good idea!" Bingo, it's in the film.[3]

The result was the movie's most memorable sequence.

Hollywood has also devised a fictitious Grand Central Terminal and a virtual one—the mark of digital technology. Released in 1978, *Superman, the Movie* included scenes in arch-villain Luthor's luxuriously appointed but entirely imaginary New York headquarters, "an amusing, baroque reproduction of [Grand Central] depicted as having an abandoned section underground" but actually built on a soundstage at Pinewood Studios in London. In 2005 Dreamworks, producers of the animated feature *Madagascar*, digitally recreated the Terminal, inside and out.

To employ a cliché, the building also found its way into America's living rooms. From 1937 through 1953 the NBC Radio Blue Network broadcast *Grand Central Station*, a drama series produced and directed by Himan Brown and written by Mary Brinker Post and others. Gerald Nachman nostalgically wrote:

> A tingle passed through you at the sound of trains roaring into Grand Central Station—or, as it was announced over the show's coast-to-coast loud speaker, "Gran-n-n-n-nd Cen-n-n-n-tral Station-n-n-n," with its pulsating opening: "As a bullet seeks its target, shining rails in every part of our great country are aimed at Grand Central Station, heart of the nation's greatest city. Drawn by the magnetic force of the fantastic metropolis, day and night great trains rush toward

the Hudson River, sweep down its eastern bank for 140 miles, flash briefly by the long row of tenement houses south of 125th Street, dive with a roar into the two-and-a-half mile tunnel which burrows beneath the glitter and swank of Park Avenue, and then. . . . Grand Central Station! Crossroads of a million private lives! Gigantic stage on which are played a thousand dramas daily."[4]

Of course, when radio was overtaken by television the Terminal was featured—although it was not always accurately identified—in dramatic series, *Saturday Night Live* (as a backdrop), reality shows, and even animated cartoons. Inevitably, with the juggernaut advance of electronic technology, it now appears as a "virtual" location in video games, including *Spiderman: The Movie* and *True Crime: New York City* among others. All these transient and comparatively trivial impingements on the public consciousness create an awareness of the building, making it an icon in the sense that it is recognized by millions who have never seen it "in the flesh," so to speak.

Perhaps most important, Grand Central Terminal's survival of a near-death experience in 1978 and its careful restoration over the next 20 years made it into another kind of icon—internationally, it is acknowledged as "a successful urban project that gave new life to an historic building which otherwise would have been discarded and destroyed."

MOVING THROUGH MANHATTAN

John Mason founded the New York and Harlem Railroad—the earliest to serve New York City—in 1831. At first a street railway whose horse-drawn cars with metal wheels ran on metal track, by 1834 it had its own two-track right-of-way connecting its depot at Madison Square on Fourth Avenue (later Park Avenue) and 85th Street; within another 4 years it had extended its commuter service to Harlem, which was then an affluent semirural suburb in northern Manhattan.

In 1845, at around the same time that the rival Hudson River Railroad also reached the capital, the New York State Legislature licenced northward extension to Albany. By 1850 the two services, together with the New York and New Haven Railroad, had constructed a variety of terminals, depots, freight houses, and passenger stations throughout the city. Horse-drawn extensions were amalgamated with steam-powered lines to form an unsystematic network of railways. Traffic increased as the population grew, paradoxically causing conflicts with New Yorkers who, while on the one hand demanding a transport service, understandably complained of the danger to pedestrians and horse-drawn traffic at grade-level crossings, the nuisance of noise, dirt, and fire (wood-burning locomotives threw off sparks) and the decline of real estate values along the rights-of-way. It seems that the railroads couldn't win. But they were a necessary evil.

In December 1854 the New York City Common Council banned steam locomotives south of 42nd Street; taking effect about 18 months later, the ordinance obliged the railroads to uncouple rolling stock and tow it to Madison Square with horses. It effectively obliged them to relocate their terminals further north, where they would need turntables, worksheds, coaling stations, and other provision for their operations—in short, a new depot.

CORNELIUS VANDERBILT AND GRAND CENTRAL DEPOT

In 1810, at the age of 16, the poor but canny Cornelius Vanderbilt had bought a small two-masted sailboat and established a commuter service between Manhattan and Staten Island. During the War of 1812 he won a government contract to deliver supplies to defense posts around New York Bay; with the income from that, his regular ferry business, and the servicing of farms along the Hudson River he was able to buy two more boats for coastal trade. Often dressing in a full naval uniform, he was nicknamed "Commodore," an epithet that he seems to have relished. In 1818 he entered the employ of Thomas Gibbons, a New Jersey steamship operator, ferrying passengers, mail, and freight between New Brunswick and Manhattan and applied himself to learning all he could about the business.

By 1828 he had saved $35,000—enough to start his own steamship company, which over the next decade became the dominant line on the Hudson, with over one hundred vessels plying between Manhattan and Albany; he is reputed to have employed more men than any other business in the country. When his rivals combined to buy him out, Vanderbilt turned to serving Long Island and Boston. Then, after a couple of ventures into international shipping, he decided (according to an anonymous biographer) that "the wave of the future was in another direction—building a railroad empire." During the Civil War he leased or sold most of his vessels to the Union government.

By then he was worth around $40 million and began to acquire railroads: the New York and Harlem in 1862 and 1863 and the flagging Hudson River, which he intended to consolidate with the Harlem a year later. In 1867 he bought the New York Central Railroad, merged it with the Hudson River, and then leased the Harlem to the newly formed New York Central and Hudson River Railroad. Together with the independent New Haven Railroad, all Vanderbilt's railroads ran steam trains into Manhattan. In May 1869 the State of New York permitted him to build a new depot that he promised would "rival the celebrated European ones." The proposed site, on Fourth Avenue between 42nd and 44th Streets was already occupied by railroad buildings; Vanderbilt bought up adjacent land, bounded by 42nd and 48th Streets and Lexington and Madison Avenues. The foundation stone of Grand Central Depot was laid on September 12, 1869, and the whole project was completed by October 1871.

Designed in the incongruous, grandiose but nevertheless fashionable French Second Empire style by architect John B. Snook and engineer Isaac C. Buckhout, the depot was (as one critic observed) "awkwardly up-to-the-minute, more cowtown than continental." Others claimed that it was already obsolescent. The red brick station building enclosed two sides of a 90-foot-high train shed with a glass-arched roof—at that time the largest interior space in America. In fact the train shed was the best part, but as another critic fruitily observed, it was "ignored in favor of meritricious confection." The basement of the main building housed four restaurants (two for both genders, and two for gentlemen only); a police station, a billiard room, and four shops. Waiting rooms, ticket and telegraph offices, dressing rooms, and newspaper stands occupied the ground floor. For some reason there were separate facilities for each line: the New York, New Haven and Hartford Railroad was located in the front part of the level, while the other lines—the New York Central and Hudson River Railroad and the New York and Harlem Railroad—had space on the New Street side. Because each maintained its own operations, traffic flow within the depot was confusing and time-consuming. Marshaling yards extended several city blocks to the north.

The self-made magnate added the Lake Shore and Michigan Southern Railroad to his empire in 1873, enabling him to provide the first rail connection between Chicago and New York, following the Erie Canal, the only flat path through the Appalachian Mountains.

Obviously, increased rail traffic made crossing Manhattan more dangerous for pedestrian and horse-drawn vehicles, and between 1873 and 1875, in exchange for a wider, four-track right of way, New York Central and Hudson River railroad invested millions of dollars to take its lines north of 50th Street below grade, partly in an open cutting, partly in a tunnel. That made life safer—albeit no more peaceful—for Upper East Side residents; nevertheless, "many people complained about the congestion, noise, smoke, and heat generated by the trains coming into the Park Avenue tunnel system."

WEALTH FROM THE AIR

As passenger numbers swelled, Grand Central Depot became inadequate, and quite quickly at that. By the 1890s, what "was glorious in 1871 had become . . . 'the worst station in New York,'" overtaxed by almost five hundred trains a day. Expansion and renovation was urgently necessary, and in 1898 the railroad expanded its three-story building into a six-story artificial stone and stucco-encrusted pile in the Renaissance style, designed by architect Bradford Lee Gilbert, a "driving force in the growing railroad industry." Even after the alterations, movement through Grand Central Depot was chaotic, largely because of the inordinate complexity of its administration and organization, which remained unchanged.

In 1900 William J. Wilgus, New York Central's chief engineer for Construction and Maintenance of Way collaborated with the Philadelphia architect Samuel Huckel, Jr. to remedy the problem. Most significant, to serve the increasing number of long-distance travelers and commuters they replaced the three separate waiting rooms with The Grand Rotunda, a single 200- by 100-foot space covered by 50-foot high roof formed by a series of barrel vaults. *The New York Times* reported on October 18 that the room, with its up-to-date appointments—armchairs, open fireplaces, rocking chairs, and writing desks—and "improvements of a modern type" was complete "after many delays and postponements." Attributed to Huckel, the rotunda (which was in fact rectangular) "was situated between 42nd Street and the concourse to serve as a transitional staging area for the crowds before they encountered the gates. Being entered through spacious vestibules and approaches from all four sides and having a marble staircase on the east end, the rotunda gathered passengers into a large, centralized enclosure before discharging them into the concourse and the space of the shed." One historian notes that

> the crowd entering the monumental space of the rotunda was also homogenized by class. An architectural description states that "an immigrant's waiting room is provided in the basement of the building with an approach from Forty-second Street, thus entirely relieving the main waiting room of this class of passengers." The immigrants were also provided with a separate underground tunnel that connected their waiting room to the concourse. In this way, they were invisible to the other passengers until shortly before they boarded the trains.[5]

In 1899 Wilgus had first proposed—in vain—to electrify New York Central's lines in and near New York. Even when a grand jury found, 2 years later, that the railroad had been criminally negligent in allowing the heat and smoke in the tunnels to harm its passengers' health, nothing was done to revive his idea. Then, on January 8, 1902, there was a horrific rear-end collision caused by poor visibility in the smoke-filled Park Avenue Tunnel; seventeen passengers died and thirty-eight others were injured. A week later the railroad announced its intentions to improve the tunnel and to expand Grand Central Terminal.

By the end of the year, Wilgus, by then a vice president of the company, had plans in hand to demolish the existing station and build an electrified underground system, with an upper level for long distance trains and a lower one for suburban commuter trains, and to construct an entirely new Terminal at 42nd Street. Moreover, he contended, employing electric locomotion would allow the Park Avenue rail yards to be covered, creating extremely valuable real estate in a "network of streets and buildings above them." Thus, he said, "from the air would be taken wealth." His proposal dealt with all the major problems confronting the railroad. On March 19, 1903, Wilgus put his visionary scheme before its president, William K. Vanderbilt. Later that year

New York State legislated to exclude "steam operation" from the Park Avenue Improvement after July 1908.

Once Wilgus' report was accepted, four architectural firms were invited to submit design proposals for Grand Central Terminal. The railroad board's choice of participants at first seems puzzling. Two of the competitors were—so to speak—"high-flyers": McKim, Mead, and White of New York, just then "the largest and most important architecture office in America, if not in the world," and Daniel H. Burnham and Company of Chicago, internationally renowned for the 1893 Columbian Exposition. Burnham and Charles Follen McKim were at that time members of the prestigious McMillan Commission, responsible for the development of Washington, D.C.

The other firms were not in the same league: one was Samuel Huckel, Jr., who after completing the 1900 renovation of Grand Central Depot had returned to Philadelphia to form a partnership with Frank R. Watson and specialize in designing churches. The second was the firm of Reed & Stem of St. Paul, Minnesota, who won the competition. They had a great deal of experience in railroad architecture and had already undertaken work for New York Central. Not insignificantly, Reed's sister was Mrs. William Wilgus, a fact that one might cynically expect may have played some role in the selection. The *ostensible* if somewhat flimsy reason given for Reed & Stem's success was that their scheme "called for an elevated driveway around the Terminal." Anyway, Reed went to New York in 1901 to commence preliminary work on Grand Central.

But more irregularities were to follow. According to the Terminal's "official" history, having won the lucrative commission, "Reed & Stem could not have been ready for the end run that was about to occur." After the competition had formally closed, New York-based architects Warren & Wetmore submitted a proposal. The Paris-educated Whitney Warren was a cousin of the railroad's president. In February 1904 Warren & Wetmore agreed to collaborate with Reed & Stem on the Terminal. It might be asked, what choice was there? The New York firm was responsible for the "broad outlines of design and the general aesthetic treatment" of the terminal; Reed & Stem took charge of the execution—the "engineer-architect" aspects—of the contracts. Reed was made executive head of the ponderously titled firm, New York Central and Hudson River Railroad Company Architects, an office he held until his death in November 1911, 15 months before Grand Central was officially opened. Architectural historian G. E. Kidder Smith summarized the professional tangle: "According to Carl Condit, William K. Vanderbilt more or less forced his cousin Whitney Warren [and his partner] Charles D. Wetmore, onto the Reed & Stem design team, and when Reed died in 1911, Warren & Wetmore took over and considerably altered the original plans, moreover taking credit "as sole architects of the terminal" (Stem, adds Condit, sued for damages and collected $400,000)."[6]

Although demolition of the old depot and excavation for the new had started, the plans for the Terminal were not submitted to the appropriate

authorities until December 23, 1904, 6 months later. The overall scheme was to provide an innovative efficient circulation system between streets, trains, subways, and the "El"—so-called Terminal City, the core of a "city within a city" that linked the great transport node with the changing needs of adjacent commercial and residential buildings. It began to take form between 1913 and 1917 as the Yale Club, the Biltmore Hotel, and two office buildings were constructed on railroad property across Vanderbilt Avenue. Throughout the 1920s, skyscrapers appeared on East 42nd Street, and apartment blocks began to rise on Park Avenue "air rights" tracts. Warehouses were replaced by the towering Chanin and Lincoln buildings and the seventy-seven story Chrysler Building, the second tallest skyscraper in the world. The Hotel Commodore (now the New York Grand Hyatt) opened on Lexington Avenue in 1919, and the Eastern Offices Building (aka the Graybar Building); each had a direct passageway connection to Grand Central's Main Concourse.

Added in the 1920s, a viaduct surrounding the station linked Park Avenue North and South. Terminal City also included the Roosevelt Hotel, the Biltmore Hotel (now the Bank of America), and the New York Central Building (now the Helmsley Building), straddling Park Avenue. Because the station was envisioned as the centerpiece of Terminal City, the original proposal included, to be constructed later, a thirty-story office tower rising directly above the concourse, "whose four corners actually were designed to support it." Despite later schemes, outlined below, that tower was never built. Early alternative façade designs for this never-realized building reflected the architectural style of terminal itself, notably, a Beaux-Arts proposal that was probably the work of Warren & Wetmore. Later proposals, driven by economic rationalism "to expand its functional and financial contribution," called for the demolition of the terminal.

WHAT ABOUT THE ARCHITECTURE?

It seems that the design of the terminal building did not "firm up" until the end of 1910; before that, the architects were probably preoccupied with the project's largely unseen but complex railroad and engineering elements. Certainly, the configuration of the main concourse remained undecided as late as September 1909; then, an "artist's impression" published in *The New York Times Magazine* showed a vaulted space with a vast central circular dome supported on pendentives—nothing like the concourse as built. It was not until January 14, 1911, that the newspaper announced that "fifty-five elaborate drawings" for the main section of the terminal had been filed with city authorities. They showed a building, parts of which were up to eight stories high. The paper confided that "architecturally, as well as in size, the building will be one of the most imposing in the city. . . . The façade will be of brick, granite, and limestone, with massive Corinthian columns and large allegorical

figures carved in stone above the bays on the Forty-second Street side." If that description was accurate, it is possible that even then the façade design (at least) was open to change.

Fitch and Waite commented in 1974 that "stylistically, the Grand Central Terminal was notable for its consistency and . . . remarkable for its sobriety and simplicity. The idiom [it employed] was that of the *École des Beaux Arts* in Paris and was characterized by rationality in plan but flamboyance in elevation and ornament."[7]

The Beaux-Arts style was born in France's *Académie Royale d'Architecture* that was founded (together with the *Académie Royale de Peinture et Sculpture*) in 1648. Louis XIV's chief minister Cardinal Jules Mazarin was given a huge budget and a brief to make France "best nation" in the arts. The academies were reorganized by Jean Baptiste Colbert after 1661; and following the Revolution, Napoléon III made them independent from state control, to become *L'École Nationale Supérieure des Beaux-Arts* in 1863. The pedagogy that replaced hands-on training with ateliers and theoretical lectures squeezed the essential virtue out of the arts, and regurgitation of professorial proclamations ensured professional success; virtuosity was discouraged; and in the case of architecture, eventually idealized design was divorced from the realities of actual construction. There would be no major changes to that system until students rebelled in 1968.

David Garrard Lowe, president of New York's francophile Beaux-Arts Alliance, explained in 1998 that the *École*'s professors' endorsement of classical Greek and Roman models extended to Italian and French Renaissance architecture, because it was logical that "the proportion and forms of the classical were the eternal norms of architectural design." Yet (he said) the *École* "never advocated copying the structures of the past. . . . If in aesthetic theory [it] looked back to the classical for inspiration, on its practical side it boldly embraced the future, accepting every new material and technique of construction."[8]

Beaux-Arts architecture had five main characteristics: eclecticism (the versatility and flexibility to work in any number of historical styles or a combination of them); symmetrical floor plans and elevations; a hierarchy of spaces, descending from ostentatious public rooms to utilitarian ancillary ones; a profusion of meticulously designed and archeologically accurate details; and the use of polychromy. For all its formality and ostentation it was generally user-friendly, and no matter how large they were, buildings were easy to navigate.

Although many European architects chose to study at their own national academies (mostly modeled on the *École*, anyway) the Paris school attracted architecture students from the United States, where there was no home-grown institution. Richard Morris Hunt was the first in 1846, followed about 20 years later by McKim and then a dozen or so more. Promoted by these men and patronized by the captains of commerce and industry, the Beaux-Arts fashion in architecture flourished in America between 1885 and 1920. It was

given tremendous impetus by Chicago's World's Columbian Exposition in 1893. Daniel Burnham oversaw the general design of the pavilions; the fourteen main buildings surrounding landscape designer Frederick Law Olmsted's waterway system were in the Beaux-Arts manner, which became the preferred style for government buildings, court houses, and museums—and of course railroad terminals. Throughout the Gilded Age it held irresistible appeal to the *nouveau riche* as they built their mansions. The Columbian Exposition also encouraged America's City Beautiful movement, characterized by symmetry and vistas terminated by monuments.

American Beaux-Arts declined toward the middle of the twentieth century. The great Chicago architect Louis Sullivan, who had studied at *L'École*, would assert that the preeminence of its forms at the Columbian Exposition had set American architectural thought back 40 years. And in his seminal 1908 *Architectural Record* essay, "In the cause of architecture," Sullivan's protégé Frank Lloyd Wright disparagingly wrote:

> Our aesthetics are dyspeptic from incontinent indulgence in "Frenchite" pastry. We crave ornament for the sake of ornament; cover up our faults of design with ornamental sensualities that were a long time ago sensuous ornament. We will do well to distrust this unwholesome and unholy craving and look to the simple line . . . the old structural forms which up to the present time have spelled "architecture" are decayed. Their life went from them long ago. . . .

Yet as late as 1998 David Garrard Lowe asserted that Beaux-Arts exponents "found New York a city of sooty brownstone and left it one of bright marble, furnished it with palaces and galleries, caravansaries [now, there's a romantic synonym for 'railroad terminals'] and public monuments." Of course, that included Warren & Wetmore's contribution to Grand Central Terminal.

THE MAIN CONCOURSE: HEART OF THE TERMINAL

Even while Grand Central was in the course of construction, several professional journals, including the British *Town Planning Review*, acknowledged it as the greatest railway terminal in the world. At its center and masterfully articulated to all its parts, the Main Concourse—275 feet long by 120 feet wide and rising to a 125-foot high arched ceiling—was the largest space by far and the building's showpiece. It gave access to the "long distance" platforms at a slightly lower level. The "suburban" concourse, beneath the main one, was much shallower, parts of it roofed with Guastavino vaults of interlocking terracotta tiles; the suburban platforms were at the lowest level. Pedestrian traffic between all these spaces was via ramps, rather than stairs. One contemporary description notes that the building was "replete with amenities for the traveler—commercial establishments, a police station, changing rooms, private offices [at the concourse's four corners] and apartments."

Warren & Wetmore's architecture—inside and out—was cosmetic, merely surface dressing for Reed & Stem's brilliant circulation plan. That is best demonstrated by considering the Main Concourse, which was reached directly from Manhattan's streets by entrances and the eastern and western ends, and on the south through the impressive waiting room (now known as Vanderbilt Hall). Journalist Jeffrey Hart claims that "no one can pass through this space without experiencing the presence of a powerful architectural will, a will analogous to that of the men who built the great railroads."

The Concourse walls were faced with simulated Caen stone (a fine-grained, light-colored limestone quarried in Normandy, France). The dadoes and dressings were of cream-colored marble imported from northeast Italy. The floor was paved with Tennessee pink marble. The architects originally intended to have a marble bifurcated stairs at each end—reputedly modeled on the Paris Opera House's grand staircase but sadly missing the mark and turning out rather plainer—"sweeping up" from the Main Concourse level to the east and west entrances. For whatever reason, only the west one was built, compromising the Beaux-Arts symmetry. In daytime, the vast space was naturally lit by three 60-foot high arched windows at the ends and large clerestory lunettes along each side. At night illumination was provided by gold-plated chandeliers—some weighed more than a ton—and thousands of points of light in the ceiling.

The Concourse's most striking element was the mural painted on the low elliptical vault of the ceiling. That vault, too, was surface dressing—merely plaster supported on a steel frame. The artist was the Frenchman Paul César Helleu, better known for his portraits, and the theme was the Mediterranean night sky with twenty-five hundred stars painted in gold on cerulean ground; each star was lit with a 40-watt bulb (they have since been replaced with fiber optics). Soon after the Terminal opened, one commuter noticed that the section of the zodiac shown in the mural was in fact reversed. One explanation among the many offered for the aberration is that Helleu based his composition on a medieval manuscript, made when cartographers traditionally portrayed the heavens as they would have been seen from outside the "celestial sphere." When the plaster ceiling began to disintegrate in the late 1930s the original painting was replaced.

GATEWAY TO THE CITY

Of course, the Terminal's exterior was as equally as grand as the interior. The limestone-clad south façade, oriented toward 42nd Street and the "better" part of early-twentieth-century New York, is said to have been envisioned as a "gateway to the city." One writer, reiterating an often-repeated very early report in *The New York Times*, called it "a Roman triumphal arch . . . its pairs of Corinthian columns flanking three enormous arched windows." Well,

the description is accurate in places. The orders *were* Corinthian, of a sort; but the coupled columns were not fully detached from the walls behind them and are more accurately described as deep pilasters; those at the end were not *quite* a pair. All stood, not with their bases on the ground, but upon an inordinately high plinth. Generally, the squat proportion of the composition was unlike any triumphal arch from antiquity. An attic story above the cornice, terminated by escutcheons, only added to the incongruity. So, in true Beaux-Arts manner, Warren & Wetmore profusely used "meticulously designed details" with little thought for—or perhaps little knowledge of—correct architectural grammar. In Umberto Eco's insightful thriller *The Name of the Rose* it is said of the demented monk Salvatore that he "spoke all languages, and no language . . . and yet, one way or another, I did understand what Salvatore meant, and so did the others." The analogy with Warren & Wetmore's architecture is clear.

The center of Grand Central's inventive south façade was crowned by the 50-foot high, 60-foot wide sculptural group, *Transportation*, carved from 1,500 tons of Indiana limestone and set in place a year and a half after the terminal was opened. The French sculptor Jules-Felix Coutan shipped his quarter-size plaster models from his Paris studio to New York, where sculptor John Donnelly made the final version from separate stones. William Bradley and Son of Long Island completed the work in 6 weeks. In the center of the grouping stands Mercury, god of commerce, travel, speed, and the messenger of the gods, flanked on his right by Hercules (symbolizing strength) and on his left by Minerva, goddess of wisdom. Behind them is an American eagle with outspread wings. The trio surmounts an enormous clock in Tiffany glass—13 feet in diameter, surrounded with cornucopias, symbolizing abundance.

The construction of Grand Central Terminal took almost 10 years—from June 1903 to February 1913. The attenuation of the work is accounted for by the need to maintain uninterrupted railroad services on a site that was already in use, at a time when traffic volume was rapidly increasing—halfway through the project sixty-five thousand passengers were passing through the station every day. On Sunday, February 2, 1913, the terminal, although unfinished, was formally opened to the public. The next day *The New York Times* reported:

> More than 150,000 persons . . . visited the new Grand Central Terminal between midnight yesterday when the doors were opened to the public, and at 7 o'clock last night . . . was made up principally of people from Manhattan, Brooklyn and the Bronx. Hundreds of people remained in the great concourse through the early morning hours, and from 8 o'clock yesterday morning until 5 in the afternoon the main floor of the concourse and the galleries were packed with the visitors. . . . It was a curious, good-natured throng, and reached its height at 4 o'clock, when the great structure was so crowded that persons found difficulty in moving. . . . The great throng . . . was lavish in praise.

BY THE SKIN OF ITS TEETH

In 1947 more than 65 million people passed through Grand Central Terminal—equivalent to 40 percent of the nation's population. But even then the role of railroads in America's long-distance transportation system was waning rapidly, displaced by intercity airplane services, highways, and automobiles. That decline would accelerate in the 1950s. New York Central Railroad sought ways to optimize its considerable real estate assets in midtown Manhattan, and the Chairman Robert Young attempted to increase revenues by redeveloping the property around Grand Central Terminal. He invited developers William Zeckendorf and Erwin Wolfson separately to present schemes for commercial buildings either above the Terminal or directly north of it. In 1954 Zeckendorf suggested replacing Grand Central with an 80-story, 4.8 million square-foot office tower, 500 feet taller than the Empire State Building, and architect I. M. Pei created a pinched-cylinder design in "the form of a glass cylinder with a wasp waist." Thankfully, the plan was abandoned.

A year later Wolfson unsuccessfully proposed a tower to replace the original six-story office building immediately north of the Terminal. But in 1958 his revised plan was accepted, and the fifty-nine story Pan American Airlines Building (now the MetLife Building), designed by Emery Roth & Sons in association with Walter Gropius and Pietro Belluschi, came into being. Architectural critic Carter Horsley calls it "a marvel of robust engineering and circulation in its interconnections with the terminal . . . a paradigm of well-planned, impressive and very efficient public spaces" while lamenting that "its immense bulk and height . . . completely dominates and overshadows the former New York Central Building . . . designed by Warren & Wetmore as part of the 'Terminal City' complex." The "mute, massive, overscaled octagonal slab" is still widely held to be the most hated skyscraper in the city, and the one that "New Yorkers would most like to see demolished."

Around the same time as the Pan Am tower was completed in 1963, one of New York City's finest older buildings—Pennsylvania Station, the monumental 1910 Beaux-Arts masterpiece of architects McKim, Mead and White—was leveled to make way for an office building and the "fourth incarnation" of the Madison Square Garden sports arena and entertainment.

"Penn Station," as it was popularly known, was the paragon of American railroad architecture, a quintessential Beaux-Arts building wedded to modern technology. At the end of the nineteenth century, the Pennsylvania Railroad dominated U.S. rail transport, moving more passengers and freight than any other railroad and servicing about twenty thousand stations. In 1902 the renowned New York Beaux-Arts architects McKim, Mead, and White were commissioned to design its new York terminal; it was built from 1904 to 1910 at a cost of $100 million, and its first year of operation over 10 million passengers were carried though it in 112,000 trains. Like Grand Central, its usage peaked toward the end of World War II, after which intercity travel

began to change as the automobile and inexpensive air travel took precedence over the train.

Covert plans to bulldoze Penn Station were being hatched as early as 1961. The company stood on the brink of financial failure, and the four city blocks occupied by the station had grown too valuable not to sell. In 1962 the owners of Madison Square Garden purchased air rights, and despite public outcry in October 1963 they began to demolish the building in what someone called an act of "economically driven barbarism." Many suggestions were offered about saving the beloved station but greed blocked the ear of those who could act. Now, the underground section is all that remains. In "Farewell to Penn Station" of October 1963 *The New York Times* editorialized, "We want and deserve tin-can architecture in a tinhorn culture. And we will probably be judged not by the monuments we build but by those we have destroyed."

A first positive outcome of the loss of Penn Station was the founding in 1965 of the New York Landmarks Preservation Commission (LPC), and the enacting of the rigorous Landmarks Preservation Law "in response to New Yorkers' growing concern that important physical elements of the City's history were being lost despite the fact that these buildings could be reused." There was also a heightened national awareness of such a need. Thankfully, those actions led to the salvation of Grand Central Terminal, and it now stands as an icon of values greater than material wealth. In August 1967 the LPC declared Grand Central Terminal a designated historic building and the surrounding block a historic area, giving it the full protection of the law.

The following February New York Central railroad, facing bankruptcy, merged with the Pennsylvania Railroad to form the Pennsylvania and New York Central Transportation Company (aka Penn Central). The new conglomerate, hardly in better financial shape than its predecessors, almost immediately leased Grand Central Terminal to UGP Properties, Inc. and despite the LPC designation contracted with the developer to construct above the heritage building a fifty-five-story office tower, designed by Marcel Breuer and Herbert Beckhard. The design involved demolition of the Main Waiting Room and part of the Main Concourse. According to one writer, "the façade would have been preserved, but rendered virtually invisible." The plan caused a huge controversy in the American architectural press and (more significantly) also faced wide popular resistance, a rage that would be maintained until 1978.

When the LPC disallowed the scheme, asserting that the proposal was inappropriate and that "the design seemed an aesthetic joke, one that reduced the terminal to the status of a curiosity," Breuer and his clients tendered what Horsley calls a "Machiavellian alternative," which would have preserved the Concourse but demolished the façade. In August 1969 the Commission rejected that scheme also and ruled that in "each case the original building would be so overshadowed by the new construction that its historical character would be lost."

The City of New York offered to compensate the owners and developers by transferring the air rights to eight alternative sites nearby. However, the companies sued the City for $8 million in the State Supreme Court, claiming that the LPC could not prevent them from building lawfully on the site, and that the city's designation of the terminal as historical had "constituted a 'taking' of their property" for which they should be compensated. The court found that the Landmark Preservation Law was "unconstitutional as applied to the Terminal," but when it declined to rule on the "taking" question, the plaintiffs took their case to the U.S. Supreme Court. On June 26, 1978—the first time that it had ruled on a case involving historic preservation—the Supreme Court found in favor of New York City. Six months later the National Register of Historic Places named Grand Central Terminal a National Historic Landmark.

One of the clearest voices that had been raised in defense of the Terminal had been that of Jacqueline Kennedy Onassis on behalf of New York's Municipal Art Society:

> Is it not cruel to let our city die by degrees, stripped of all her proud monuments, until there will be nothing left of all her history and beauty to inspire our children? If they are not inspired by the past of our city, where will they find the strength to fight for her future? Americans care about their past, but for short term gain they ignore it and tear down everything that matters. Maybe . . . this is the time to take a stand, to reverse the tide, so that we won't all end up in a uniform world of steel and glass boxes.

When in 1970 Penn Central Transportation Company filed for bankruptcy—until then, the biggest corporate bankruptcy in American history—title to the Terminal passed to American Premier Underwriters (APU), an interest that in turn was subsumed the Cincinnati-based American Financial Group (AFG).

The Metro-North Commuter Railroad Division of the the New York Metropolitan Transportation Authority (MTA) assumed operation of the Terminal in 1983. The building was disintegrating, the result of decades of neglect: the copper roof, that had made no provision for expansion and contraction, was leaking; masonry was spalling; structural steel was rusting. There were also cosmetic problems: surfaces were begrimed and stained and "commercial intrusions" blocked out natural light.

An urgent maintenance and capital improvements program first addressed the leaking roof and skylights, but Metro-North needed a long-term strategy. In 1988 it commissioned, under the leadership of the eminently successful preservation architects Beyer Blinder Belle of New York, a team of experts that included Chicago-based architects Harry Weese and Associates (as consultants) and New York engineers STV/Seelye Stevenson Value and Knecht. By April 1990 a $425 million Master Plan, developed in cooperation with the nonprofit Grand Central Partnership, comprising neighboring property

owners, and with the LPC, was ready. Following a public hearing, it was "adopted in concept" by the MTA. By 1992 $160 million had been spent on structural repairs, upgraded services, and improvements to the Main Concourse; the restored 12,000-square foot former Main Waiting Room was converted into an exhibition and special events space and renamed Vanderbilt Hall.

In March 1994 MTA signed a 280-year lease with AFG, which was transferred to Midtown TDR Ventures, LLC when it bought the station in December 2006. Although this financial wheeling and dealing has little to do with any architectural consideration of Grand Central Terminal, the lease allowed MTA to sign a contract with GCT Venture Inc.—a partnership of developer LaSalle Partners of Chicago and retail specialist Williams Jackson Ewing of Baltimore—to implement a comprehensive "revitalization" program based on the Master Plan. The intention was to increase revenues from the building by restoring it to its glory days. That would involve removing the *laissez-faire* accretions of 80 years, renovating the large public spaces, building a new north entrance, and improving retail functions with an upgraded food court and mall, which would be expanded by 50 percent to about 130,000 square feet. The total cost, originally estimated at $175 million, was about $250 million; it was jointly met by a bond issue (paid off by rents from retailers and restaurants), the Grand Central Partnership, Metro-North's own capital budget, and "significant funds" from the federal government.

Construction began in 1996 with the cleaning of the "sky ceiling" of the Main Concourse and culminated on October 1, 1998, with a rededication—who knows to whom?—of Grand Central Terminal before an audience of five thousand people. Michael Allen reported in *The New York Daily News*, "The technology in the terminal is new. Escalators have been added to link the lower and the main levels. Air conditioning has been added, along with new systems for sprinklers, electricity, lights, plumbing and safety. There are new train operation facilities, including indicator boards, the stationmaster's office and a customer service area."

A few days before the reopening, architectural critic Paul Goldberger, hailing "a triumphant moment in the modern history of New York," wrote in *The New Yorker*,

> The real brilliance of the [Grand Central Terminal]—for all its architectural glory—is the way in which it confirms the virtues of the urban ensemble. Grand Central was conceived as the monumental center of a single composition, with hotels and streets and towers and subways arrayed around it. When it opened … it was New York's clearest embodiment of the essential urban idea—that different kinds of buildings work together to make a whole that is far greater than any of its parts. . . . Now that Grand Central no longer functions as a place for long-distance arrivals and departures, it is more like a town square. Its clarity and its serenity, as well as its majesty, belong to everyone, and not, as they

once did, primarily to those coming to board the Twentieth Century Limited. A transcendent experience is there for the taking, even if you're only walking through.[9]

Architecture critic Walt Lockley's on-line evaluation of Grand Central Terminal is quirky but affectionate and incisive, affirming the view of its architect, Whitney Warren,

In the middle of the Grand Central Terminal there's a big nothing—two big nothings actually, two matching nothings, one volumetric nothing suspended in mid-air, and another flat-surface nothing spread out on the pavement. Together those two nothings make Grand Central Terminal possible. All this much *nothing* in the hyperdense, viciously-warred-over, multi-stacked, priced-by-the-fractional-inch landscape of Manhattan is itself remarkable. Nothing quite gets your attention like *nothing* in this context, because you know that nothing is an expensive luxury in Manhattan.

Nothing is worthy of study because, not only is this building a Beaux-Arts masterpiece, one of the quintessential Manhattan experiences, maybe the finest and most public-spirited architectural experience available in New York City, not only is it filled with drama and life and tangible municipal history, Grand Central Terminal also happens to serve its purpose with supreme elegance and efficiency. It works. It is handsome, yes, but it's a *buono machina* as well as *bello*.

Something like 30,000 commuters arrive every day; something like half a million pedestrians pass through the building every day, with a minimum of confusion, few collisions, and a much lower level of stress than seems possible. Coming up on its 100th birthday it's a living triumph of traffic management and social engineering. . . . It works because it was made that way, made to work, by whiskered masters of the craft. Grand Central Terminal is an Edwardian ideal, a grand machine with humane purpose and no moving parts, silently explaining itself to each new stranger, using its 500,000 daily patrons' own energy to redistribute themselves.[10]

Reed & Stem

Charles A. Reed was born in 1858 near Scarsdale, New York. After graduating from Massachusetts Institute of Technology he moved to St. Paul, Minnesota, in 1881. Ten years later he established an architectural practice with Ohio-born Allen H. Stem (1856–1931). Stem had trained at the Indianapolis Art School, and after being articled to his father J. H. Stem, became his partner in 1880. In 1884 he conducted a practice in St. Paul with Edgar J. Hodgson as junior partner. Following Reed's death from a heart attack in 1911—15 months before Grand Central Terminal was opened—Stem continued the practice with Roy H. Haslund. Stem retired in 1920 and died in St. Paul in 1931.

Most of Reed & Stem's nonrailroad work was close to home, so to speak, including the Civic Auditorium, Athletic Club, and the Hotel St. Paul (all in St. Paul); the West Publishing Company building in Eagan; the University of Minnesota's Wulling Hall and the Yacht Club at White Bear Lake, Minnesota. Further afield, they built the Michigan City Library, the Denver Auditorium in Colorado, and the Lewis and Clark County Court House in Helena, Montana.

Reed & Stem gained national recognition for the design expertise they demonstrated in more than one hundred railroad stations throughout the United States for (among others) the Chicago Great Western, the Norfolk and Western, the New Haven, and the Michigan Central railroads. An anonymous archivist at the University of Minnesota cynically observed they were engaged to design their *magnum opus*, Grand Central Terminal, as well as "numerous other stations and structures" for the New York Central Railroad, because (in addition to their ability to capture large commissions), as noted, Reed's sister was married to William J. Wilgus, the railroad's vice president in charge of construction.

Warren & Wetmore

S. Whitney Warren was born and educated in New York. In 1887, at the age of 18, he went to study architecture at the Paris *École des Beaux-Arts* under Honoré Daumet and Charles Girault. He remained in France until 1894, forming a permanent attachment to French classicism and Beaux-Arts planning principles. On returning to New York in 1894 he established his own practice and in September his "strikingly original" entry won a competition for the design of the Newport, Rhode Island, Country Club. That gave impetus to a "long career as an architect to New York's society." In 1898 he was commissioned to design the New York Yacht Club's new headquarters, and he formed a partnership with Harvard graduate Charles D. Wetmore—categorized by one writer as a "lawyer, businessman, and real estate developer"—who had completed his architectural studies in New York in 1894.

For the first 30 years of the twentieth century, Warren & Wetmore had "one of the most successful and busy practices in the U.S., completing over 300 major projects. The charismatic Warren and the sharp-witted Wetmore read well the prevailing winds of the tastes and aspirations and their "bold and creative interpretation of classical and French styles reflected the cultural, social, and business aspirations of the country's ruling class." Among their clientele there were members of their "prominent familial and social circles" as well as hoteliers, transportation magnates, and developers. The fact that Warren was a cousin of the Vanderbilts had more than a little influence on the firm's late appointment as coarchitects of Grand Central Terminal.

That commission was followed by stations and terminals along the New York Central Line and for other railroads, such as the Michigan Central, Erie, and Canadian Northern Roads. Their practice extended to hotels: among those in Manhattan were the Ambassador, the old Belmont, the Biltmore, the Commodore, the Ritz Carlton, the Vanderbilt, and additions to the Plaza. Beyond New York, they built, among others the Ritz Carlton in Atlantic City, New Jersey, the Westchester in Rye, New York, the Belmont in Providence, Rhode Island, the Broadmoor in Colorado Springs, Colorado, and the Royal Hawaiian in Honolulu, as well as others across the United States, in Canada and in the Caribbean. Other major nonresidential works included the Seamen's Church Institute, Steinway Hall, the Heckscher building, the New Aeolian Hall, and the Chelsea Piers complex, all in Manhattan. Warren also rebuilt the Catholic University library in Louvain, Belgium (1921–1928), burnt during the German occupation in World War I; the Nazis again demolished it in 1940.

NOTES

1. National Geographic, "Inside Grand Central." http://channel.nationalgeo graphic.com/channel/insidegrandcentral/showDescription.html

2. Eckardt, Wolf, "Saving the Unfashionable Past," *Time* (February 21, 1983).

3. Stubbs, Phil, ed., "*The Fisher King* Production Notes," *Dreams*. www.smart .co.uk/dreams/fkprod1.htm

4. Nachmann, Gerald, *Raised on Radio.* . . Berkeley: University of California Press, 2000, 431.

5. Raynsford, Anthony, "Swarm of the Metropolis: Passenger Circulation at Grand Central Terminal. . ." *Journal of Architectural Education*, 50(September 1996), 8.

6. Smith, George Everard Kidder, *Source Book of American Architecture.* Princeton, NJ: Princeton Architectural Press, 1996, 325.

7. Fitch, James Marston, and Diana S. Waite, *Grand Central Terminal and Rockefeller Center: A Historic-Critical Estimate of Their Significance.* Albany: New York State Parks and Recreation Division for Historic Preservation, 1974.

8. Lowe, David Garrard, *Beaux Arts New York.* New York: Watson-Guptill, 1998.

9. Goldberger, Paul, "Now Arriving," *The New Yorker* (September 28, 1998), 92.

10. Lockley, Walt. "Grand Central Terminal as a Big Nothing." www.waltlockley .com/cgt/gct.htm

FURTHER READING

Adams, Nicholas."The Rebirth of the Grand Central Terminal, New York." *Casabella*, 62(November 1998), 36–47.

Ballon, Hilary, et al. *New York's Pennsylvania Stations*. New York: Norton, 2002.

Belle, John, and Maxinne R. Leighton. *Grand Central: Gateway to a Million Lives*. New York: Norton, 2000.

"Beyer Blinder Belle: Grand Central Terminal Revitalization." *A + U: Architecture and Urbanism* (May 1999), 102–113.

Boone, Kurt, Robert Gore Jr., and John Sarsgard. *Inside Grand Central Terminal: A Photo Essay*. Minneapolis, MN: Tasora, 2007.

Condit, Carl W. *The Port of New York, Volume 2: A History of the Rail and Terminal System from the Grand Central Electrification to the Present*. Chicago: University of Chicago Press, 1981.

Dean, Andrea Oppenheimer. " 'Heart of the Country's Greatest City'; The Many Significances of Grand Central." *AIA Journal*, 71(October 1982), 50–55.

Fitch, James Marston, and Diana S. Waite. *Grand Central Terminal and Rockefeller Center: A Historic-Critical Estimate of Their Significance*. Albany: New York State Parks and Recreation Division for Historic Preservation, 1974.

"Grand Central Station, N.Y.C." *Architects' and Builders' Magazine*. 2(1900), 201–208.

"Grand Central Terminal, 42nd Street, at Park Avenue: Reed & Stem and Warren & Wetmore, 1913." *A + U: Architecture and Urbanism* (December 1994), 90–101.

Lowe, David Garrard. *Beaux Arts New York*. New York: Watson-Guptill, 1998.

Middleton, William D. *Grand Central, the World's Greatest Railway Terminal*. San Marino, CA: Golden West, 1977.

Nevins, Deborah, ed. *Grand Central Terminal: City within the City*. New York: Municipal Art Society, 1982.

Pearson, Clifford A. "Beyer Blinder Belle's Makeover of Grand Central Terminal Involved Careful Restoration and Critical Changes. . . ." *Architectural Record*, 187(February 1999), 84–95.

Pennoyer, Peter, and Anne Walker. *The Architecture of Warren & Wetmore*. New York: Norton, 2006.

Powell, Kenneth. *Grand Central Terminal: Warren & Wetmore*. London: Phaidon, 1996.

Schlichting, Kurt C. *Grand Central Terminal: Railroads, Engineering, and Architecture in New York City*. Baltimore: Johns Hopkins University Press, 2001.

Wilgus, William J. *The Grand Central Terminal in Perspective*. New York: privately published. 1941.

Wood, Anthony C. *Preserving New York: Winning the Right to Protect a City's Landmarks*. New York: Routledge/Taylor and Francis, 2007.

INTERNET SOURCES

Official website of Grand Central Terminal. www.grandcentralterminal.com

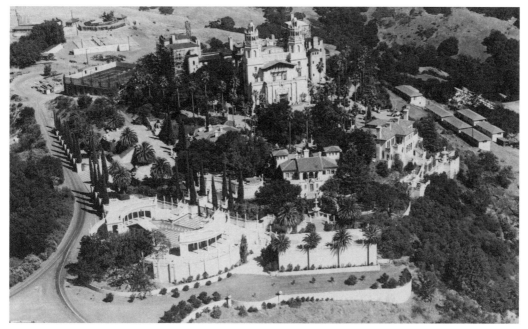

Hearst Castle, San Simeon, California

"Casas, casas everywhere!"

La Cuestra Encantada (The Enchanted Hill), the castle built by William Randolph Hearst, stands halfway between San Francisco and Los Angeles, 1,600 feet above the sea and 5 miles from the coast. Surrounded by 127 acres of landscaped terraced gardens with pools and fountains, the cathedral-like main house, *La Casa Grande* and its guest-houses—*La Casa del Mar* (The House by the Sea), *La Casa del Monte* (The House on the Hill), and *La Casa del Sol* (The House of the Sun), named respectively for their splendid views of the Pacific Ocean, the Santa Lucia mountains, and the sunset—dominate the landscape. British Journalist Alexander Cockburn writes,

> The Enchanted Hill was long seen as an outcrop of California kitsch, Camp Gothick on Camp Hill, vulgarity on a titanic scale. Now, amid shifting tastes, Hearst's castle can be seen for what it is—as powerful an expression of the American soul as the Brooklyn Bridge, Rockefeller Center or the Ford plant on the Rouge River, and all the more striking because the dream was given concrete form by one indomitable woman, Julia Morgan.[1]

The term *Gilded Age*—pointedly "gilded," not "golden"—was coined by Mark Twain and others to describe the last decades of the nineteenth century. Other historians believe that it continued until the beginning of World War I, while still others suggest that the 1929 stock market crash brought about its demise. Whatever the case, the term conjures the captains of industry and commerce who flaunted their wealth by building ostentatious houses in imitation of European models. As John Blades of the Henry Morrison Flagler Museum observes, these *nouveau riche* "of a relatively young country found context and meaning for their lives and good fortune by thinking of themselves as heirs of a great Western Tradition. [They] traveled the world visiting the great European cities and the ancient sites of the Mediterranean, as part of a Grand Tour, collecting and honoring their western cultural heritage." Sadly but inevitably, even families with "old money" were drawn into what has been described as a "whirlwind of architectural excesses."

Blades, who worked at Hearst Castle for 20 years, points out the characteristics that identify it as a Gilded Age house. It was a "true estate," designed to be self-sufficient; its owner and its architect envisioned it as a museum at the time it was built; it reflected Hearst's strong personal involvement in its design and collections; and "the antiques were blended in ways that suited the tastes of the owner and the time." *Eclectic* and *catholic* have been used elsewhere to describe Hearst's drive for "something a little different from what other people are doing in California." The British architectural historian Lord Norwich found the house to be "undeniably a hotchpotch, in which French tapestries rub shoulders with Dutch pictures, English furniture, Spanish tile work and heaven knows what else" but was forced to concede that the superb quality of the collection in the context of such "confident and assured" architecture made it impossible for him to be critical: going there "prepared to mock; [he] remained to marvel."

The Hearst family gifted the castle to the state of California in 1957, and it was opened to the public a year later. The annual number of visitors has grown to about a million. Three-quarters of them are Americans; most of the others are from Asia and Europe, so that the State Parks Department, owner of the property, now publishes brochures in nine languages beside English. In 2000 a survey of international readers by *Conde Nast Traveler* magazine voted *La Cuesta Encantada* as "The Number-One Monument in the United States," prompting hubris on the part of the local *San Luis Obispo Tribune*: "You don't have to go to the Loire Valley or Athens or the Rhine River to see a great castle. For us, *one of the all-time magnificent edifices in the world* is just a short drive . . . from home." [emphasis added]

William Randolph Hearst's house is a national and international icon of American architecture. But for nearly two decades before the public were able to see it at firsthand, it had been presented to the popular curiosity, not by fact, but fiction—in Orson Welles' classic film, *Citizen Kane*.

ORSON WELLES, ICON MAKER

A British Film Institute 2002 poll of movie directors acclaimed *Citizen Kane* as the best film of all time. Five years later the American Film Institute gave it the same rank among U.S. movies. Richard Corliss wrote in *Time* magazine in 1996, "What people know of [Hearst] today is what they remember from the movie" and pointed out that William A. Swanberg's 1961 biography of the media magnate was titled *Citizen Hearst*. Before discussing the furore that surrounded the movie, it is necessary to sketch the plot.

Tracing the life of newspaper baron Charles Foster Kane, "whose career . . . was born of idealistic social service, but gradually evolved into a ruthless pursuit of power," the film begins with his death at the age of 76 in Xanadu, his gloomy Gothic mansion in Florida. His single dying word is "Rosebud." The rest of the film describes through a series of flashbacks, the attempts of a reporter, Jerry Thompson, to discover the significance of the enigmatic word. He interviews Kane's former associates and also finds Susan, Kane's mistress (later his second wife), now an alcoholic soubrette. She speaks of their reclusive life at Xanadu and describes how Kane, oblivious of her lack of talent, tried in vain to make her into an opera star. But none of the accounts of Kane's personality and history reveal the meaning of "Rosebud." At the end of the movie, Thompson and other reporters watch Kane's art collection being packed for storage. Unobserved except by the camera, a child's sled is tossed on a fire. It is painted with its name—"Rosebud."

By age 23 Welles had achieved notoriety as a radio director with his 1938 CBS broadcast of *War of the Worlds*. The following year a contract with RKO Radio Pictures gave him *carte blanche* to make two movies. After a couple of cancelled projects, and working on a set that was closed even to

studio heads, he produced, directed, and played the title role in *Citizen Kane*. The project had been proposed by his cowriter Herman J. Mankiewicz. For whatever reason, Mankiewicz provided a copy of the final shooting script to Charles Lederer, nephew of Hearst's mistress, Marion Davies. It was returned, annotated, by Hearst's lawyers, suggesting that the publisher had read it. Following a preview screening of what she called "a vicious and irresponsible attack on a great man," gossip columnist Hedda Hopper immediately reported to Hearst. It has been claimed that, more than anything else in the film, he was enraged by the character Susan as—it must be said, not an altogether inaccurate—caricature of Davies. Welles later confessed that it had been "something of a dirty trick, what we did to [her]" and that he expected that it would upset Hearst. Anyway, all sorts of pressure were brought to bear on Welles and RKO. According to PBS's *The American Experience*:

> Welles' huge ego and his youth [blinded] him to the extent of Hearst's power and reach; he tragically underestimated Hearst's ability to counterattack. . . . Hearst threatened to expose long-buried Hollywood scandals his newspapers had suppressed at the request of the studios. His papers used Welles' private life against him, making blunt references to communism and questioning Welles' willingness to fight for his country. Major theater chains refused to carry *Citizen Kane*.[2]

Before the movie was released, another gossip columnist and crony of Hearst, Louella Parsons, lobbied the governor of New York to have it banned in that state. And Louis B. Mayer of MGM persuaded other major studio heads to jointly offer $800,000 for the negative and all prints—considerably more than production costs—so that they could be destroyed. RKO Studios were the meat in the sandwich and declined to sell; threatened with a lawsuit from Welles for his share of the profits, they released the movie in May 1941. Infuriated, Hearst ordered that none of his newspapers or radio stations should mention it, much less review it; he eventually extended the ban to other RKO productions.

Non-Hearst critics highly praised *Citizen Kane*. Red Kann's prerelease review in *Boxoffice Magazine* of April 12, 1941, called it "a milestone . . . noteworthy in its conception, its execution and, indeed, in its entire approach . . . an endeavor to be admired for the expertness and the newness of its treatment, [and] the superb characteristics of its craftsmanship." But it seems that the movie, perhaps 50 years ahead of its time, was too "arty" for cinemagoers, and box-office returns were disappointing. At the 1941 Academy Awards ceremony, although the Oscar for the best original screenplay went to Welles and Mankiewicz, the audience booed at each of their movie's nine nominations. Hearst's campaign had succeeded: the Academy had been intimidated by his advertising power, and the fear that "Hearst reporters—led by Louella Parsons—would delve into their personal lives." Following the Awards, RKO shelved the film and did not rerelease it until 1956. Welles became

Hollywood's "youngest has-been" and spent the rest of his career in Europe. But as one writer observes, Hearst's attack "backfired in the long term." The reason?—"Almost every reference of Hearst's life and career made today typically includes a reference to the film's parallel to it. The irony of Hearst's efforts is that the film is now inexorably connected to him." However, those connections are for the most part tenuous and the comparisons faulty. David Nasaw, one of Hearst's biographers, challenges them:

> Welles' *Kane* is a cartoon-like caricature of a man who is hollowed out on the inside, forlorn, defeated, solitary because he cannot command the total obedience, loyalty, devotion, and love of those around him. Hearst . . . never regarded himself as a failure, never recognized defeat, never stopped loving Marion or his wife. He did not, at the end of his life, run away from the world to entomb himself in a vast, gloomy art-choked hermitage.[3]

That brings us to Hearst's Castle and Kane's Xanadu, the latter named after the mystical palace conjured up, probably under the influence of opium, by Samuel Taylor Coleridge. Of course, in the movie *Xanadu* was only a matte painting—uncredited—by Mexican-born artist Mario Larrinaga. A "newsreel" at the beginning of *Citizen Kane* shows it in the distance, a cluster of ominous towers and pinnacles, described by Victoria Kastner as a "dark and deserted jumble of cavernous rooms filled with meaningless junk," crowned with cranes and derricks and cluttered with scaffolding to indicate its incompleteness—just as Hearst's castle was at his death. A deep voice seriously intones in the manner of old-time newsreel narrators,

> Here, on the deserts of the Gulf coast, a private mountain was commissioned and successfully built. One hundred thousand trees, twenty thousand tons of marble are the ingredients of Xanadu's mountain. Contents of Xanadu's palace: paintings, pictures, statues, the very stones of many another palace—a collection of everything so big it can never be catalogued or appraised; enough for ten museums; the loot of the world. Xanadu's livestock: the fowl of the air, the fish of the sea, the beast of the field and jungle. . . . Since the Pyramids, Xanadu is the costliest monument a man has built to himself.

In spirit at least, that described Hearst Castle. But in reality Hearst's own "Xanadu" was physically nothing like the somber pile in *Citizen Kane*.

LARGER THAN LIFE: WILLIAM RANDOLPH HEARST

Gillian Reagan wrote in *The New York Observer* in 2006 that William Randolph Hearst was the Rupert Murdoch of his day. Many Hearst biographies have presented him in widely varying lights; here it must suffice to sketch events as they relate to Hearst Castle, focussing on his wealth rather than on his political acumen and ambivalence. A former Hearst employee, John K.

Winkler, published the earliest biography, *W.R. Hearst: An American Phenomenon*, in 1928. Three more of widely varying character followed, all in 1936 when the media magnate's reputation was at its nadir. A review in *Time* magazine asserted that Ferdinand Lundberg's *Imperial Hearst: A Social Biography* "muckrak[ed its] subject with pious zeal," while *Hearst: Lord of San Simeon* by Oliver Carlson and Ernest Sutherland Bates presented "a fascist and an opportunist who placed profit above all else." The exception was Mrs. Fremont Older's *William Randolph Hearst: American*. Of the competing accounts *Time* wittily remarked, "Authors Lundberg, Carlson and Bates liberally plaster . . . Hearst with controversial tar, while. . . . Older is equally generous in coating her hero with sympathetic whitewash." Winkler's rethought *William Randolph Hearst: A New Appraisal*, released in 1955, also was generous to its subject.

William A. Swanberg observed in *Citizen Hearst* (1961) that the publisher intrigued many of his contemporaries: "They were saying that he was great—somehow—but they could not explain why." That, surmised Swanberg, was because Hearst was really two people, "Prospero and Caliban shackled together in a single body." In a review of Nasaw's 2000 biography Roy Hoopes suggested that rather he was "not two men but several: Hearst the journalist, Hearst the politician, Hearst the art collector, and Hearst the man—*bon vivant*, husband, and lover— each one living a life of tremendous passions, for power, possessions, women."

Hearst was born in San Francisco in April 1863, the only child of George and Phoebe Apperson Hearst. His father was a self-made multimillionaire, who had struck it rich in California and eventually held controlling interests in some of America's richest silver, gold, and copper mines. His schoolteacher mother, the dominating figure in his life, indulged her son. With a convoy of tutors and servants, in 1873 she took him on an 18-month tour of Europe to absorb the culture of the Old World, and at that early age William developed, as Phoebe put it, a "mania for antiquities." Back in California the Hearsts were obliged to adjust their lifestyle so that George could invest as much as possible in mining ventures. They sold their large San Francisco residence and moved to a boarding house. William's childhood was therefore unsettled, and by the time he reached the age of 10 he had (according to Nasaw) "lived many different lives":

> the rich boy in the mansion at the top of the hill, the new kid forced to attend public school because his father had run out of money, the pampered child who toured Europe, the boy who boarded with his mother. There was no center, no place that he could call his own. . . . School had provided no continuity, not even from grade to grade. He was shifted and shunted, withdrawn and newly enrolled in school after school. . . .[4]

In 1880 William was enrolled in St. Paul's Preparatory School in Concord, New Hampshire. Expelled "for the good of the school" 2 years later, he

continued his education at Harvard, where he enjoyed the social activities and joined a number of "prestigious organizations." He served as business manager of the satirical magazine, *Harvard Lampoon*, increasing its circulation by 50 percent and trebling its advertising revenue. But, already on probation, he was expelled from the university in 1885, not for the elaborate practical jokes—some no doubt apocryphal—that have become part of the Hearst myth, but simply because he did not study hard enough.

In 1880 George Hearst, seeking a voice for the Democratic Party, had acquired the failing *San Francisco Examiner* and converted it to a morning paper (that he won it in a poker game is yet more Hearst mythology). Six years later, having lost his university place, William asked his father to turn control of the paper over to him; when the request was refused, William went to work briefly as a cub reporter on Joseph Pulitzer's *New York World*. But he continued to cajole his father, and in March 1887 he returned to San Francisco and took over as "proprietor and editor" of the *Examiner*.

By 1889 he was touting the broadsheet as "the monarch of the dailies," and boasting that as the "largest, brightest and best newspaper on the Pacific Coast [it delivered] the most elaborate local news, the freshest social news [and] the latest and most original sensations." Circulation soared. For 8 years Hearst (although he lost an estimated $8 million) came into conflict with the Southern Pacific Railroad and corruption in local government, commerce, and industry and "championed the oppressed." By March 1894 the *Examiner* was selling seventy thousand copies every day.

When George Hearst died in February 1891 Phoebe inherited his entire mining, oil, and forestry fortune, then estimated at as much as $20 million. Nasaw observes that the bequest "irretrievably compromised her future relationship with her son." Phoebe's former role as merely a dominant mother was "eclipsed by her position as feudal overlord of the Hearst estates." She gave William a generous monthly allowance but continued to manipulate him. In 1895 she sold some mining interests to provide $7.5 million for him to buy the struggling *New York Journal*. But there was a catch: to get the money, she forced him to end a relationship with Tessie Powers, a Cambridge, Massachusetts, waitress who had been his "primary companion" for 10 years. One source suggests that Phoebe even secretly bought Tessie off for $150,000.

Within a year, by presenting investigative reporting and "lurid sensationalism" with banner headlines and lavish illustrations, William built the *Journal*'s daily circulation to one-and-a-half million. He did this, as he had with the *San Francisco Examiner*, by filling his front pages with stories devoted mostly to crime or high society scandal, emblazoned with provocative headlines and illustrated with extravagant images. One commentator writes that Hearst "depleted Pulitzer's [*World*] staff by offering high salaries and multi-year contracts. Objectivity had no place at the *Journal*: its prototypical story featured corrupt officialdom, a victimized public, and the newspaper as rescuing hero. And it was unflinchingly Democratic. . . ."

In July 1900 Hearst added the *Chicago American* to his newspaper empire. Two years later he launched a morning edition, the *Chicago Examiner*. Bridging his other publications, the midwest papers gave him a coast-to-coast identity and a beachhead from which to gain political office. In 1902 New York elected him to the House of Representatives, a self-styled "champion of immigrants and the working class." Although he seldom attended sittings and spoke only to further his pet projects, he was reelected in 1904. He failed to gain the Democratic nomination in a bid for the presidency, and he would fail in two attempts (1905 and 1909) to become mayor of New York City and—between them—governor of New York.

Despite his alleged shyness Hearst was quite a notorious stage-door Johnny. In April 1903, just before turning 40, he married Millicent Willson, a 21-year-old showgirl whom he had been dating since she was only 16. Of course, Phoebe disapproved. Failing to dissuade him, she took to her bed and refused to go to the wedding in New York. But Millicent, "willing to go out of her way to be attentive," soon won her mother-in-law's approval. Between 1904 and 1915, the couple were to have five sons: George Randolph, William Randolph Jr., John, and twins Randolph Apperson and David Whitmire.

William and Millicent had a motoring honeymoon in Europe, a trip that led to the publication of Hearst's first magazine, *Motor*, launched in 1903. Two years later he bought *Cosmopolitan*; then he added *Motor Boating* (1907), *World Today* (renamed *Hearst's Magazine*) and *Good Housekeeping* (both in 1911), *Harper's Bazaar* (1912), and three British magazines. By 1919, when Phoebe died and the family fortune passed to him, he owned fourteen magazines and seventeen newspapers including, besides those already mentioned, the *Atlanta Georgian*, *Boston American*, *Boston Daily Advertiser*, *Los Angeles Examiner*, *Washington Times*, and *Wisconsin News*. In 1915 he founded King Features Syndicate to distribute newspaper columns, editorial cartoons and comic strips. By 1935, according to a *Fortune* magazine report, his assets—twenty-eight papers, thirteen magazines, eight radio stations, two movie companies, inestimable art treasures, real estate, fourteen thousand shares in the Homestake Mine, and 2 million acres of land —were worth $220 million.

In 1915, when Millicent was pregnant with the twins, the 54-year-old Hearst met 18-year-old Ziegfeld Follies chorus girl Marion Davies, who soon became his "constant companion and confidante" (read, "mistress") and from about 1919 they lived openly together in California. They never married and although she had other lovers, including Charlie Chaplin and 1940s movie heart-throb Dick Powell, the relationship lasted for the rest of Hearst's life. For her part, Marion later confessed to being at first a gold digger who later had fallen in love. Unwilling to accept that although she was a very talented light comedienne, Marion would never succeed as a dramatic actress, Hearst spent a fortune to advance her career, buying film roles for her that made her look ridiculous. In 1918 she starred in the Hearst-backed *Cecilia of the Pink Roses*. Film critic Hal Erickson notes that "though most critics were

unimpressed by the film, Hearst's newspapers were 'enthusiastic to the point of lunacy.' " From this point on, Davies was the most publicized actress in the world and went on to make a total of forty-six films including sixteen talkies. In 1925 she and Hearst merged their movie company, Cosmopolitan Productions, with MGM studios in California. Three years later Marion moved into the beachfront "Ocean House" in Santa Monica, the center of a five-building, 118-room property.

Also in 1925, Hearst acquired a real castle. St. Donat's, built in 1298 on an already century-old ruin, stands a few miles south of Cowbridge in South Wales. Mine-owner Morgan Stuart Williams restored it early in the twentieth century before selling it to an American, Richard Pennoyer. Hearst bought it on the basis of photographs in *Country Life*, for "about $120,000." But he did not see it until July 1928, when he engaged architect Charles Allom—only the best for Hearst: Allom had also worked on Buckingham Palace—to make alterations. The 135 existing rooms were modernized; electricity and mains water were connected; central heating was installed, and thirty new bathrooms and a heated swimming pool were added. Hearst also bought silverware, armour and antiques, and "medieval structures from elsewhere" for St. Donat's. Some summers he and Marion would visit for a few weeks with friends and acquaintances in tow, but when the castle was put back on the market in 1938, they had occupied it for a total of hardly 4 months.

In 1926, when William's overt relationship with Davies finally became intolerable, Millicent left him to live permanently in New York; he bought her a 140-room house on Long Island, and they remained married until Hearst's death. For a few years after the separation she continued to visit The Enchanted Hill with her family and friends; as Mrs. Hearst, she even hosted important guests, including Winston Churchill. But as the years passed, her visits became less frequent.

Hearst's media empire reached its apogee about a year before the 1929 Crash. The Wall Street collapse touched *all* his business interests, but the newspapers more than any. Within a few years his shifting political stance became a major liability to the Hearst Corporation: his papers which at first had been populist, had become right-wing in the 1920s, then in the early 1930s had swung to the left, only to move to the far right a couple of years later. The economic consequence of his political bipolarity was that advertising sales and circulation declined. Nasaw writes,

> The unthinkable had come to pass. For fifty years, Hearst had ruled his empire as autocratically as his heroes Julius Caesar and Napoleon Bonaparte had theirs. He had trusted no one, rejected suggestions that he share power or delegate decision-making, and refused to name a successor. At age seventy-four, he was as hearty as ever and convinced that if left alone he could once again pull off a miracle. But no one, with the possible exception of Marion, believed him capable of making the tough decisions that were necessary and cutting back on personal and corporate spending.[5]

His creditors frustrated his attempts to raise capital through a new bond issue, and he was unable to service the Corporation's debts, which ran into millions. It went into receivership and was reorganized in 1936. Forced to relinquish control, Hearst became just another employee, subordinated to a court-appointed manager. He took a cut in pay—to a mere $500,000 dollars a year. Newspapers and other properties were sold, and his film company was closed. In April 1937 Marion "liquidate[d] her own considerable assets and, with the one million she was able to raise on the spot" from the sale of her jewelry (most of which he had given her), insisted on helping him out. Nevertheless, beginning about a year later, over 2 years half of his art collection was liquidated in a series of auctions. Sorting, cataloguing, and pricing took nearly a year. When only the less valuable pieces remained, "the trustees arranged for certain department stores in New York City to display [them] for sale to passing customers. . . . The final stitches in the garment of public humiliation hung on Hearst." All he had left was his salary and editorial control over nineteen daily papers and twelve magazines. His enemies rejoiced. In a withering chapter titled "Farewell: lord of San Simeon" in his *Lords of the Press* (1938) George Seldes cited the splenetic words of journalist Ernest L. Meyer:

> Mr. Hearst in his long and not laudable career has inflamed Americans against Spaniards, Americans against Japanese, Americans against Filipinos, Americans against Russians, and in the pursuit of his incendiary campaign he has printed downright lies, forged documents, faked atrocity stories, inflammatory editorials, sensational cartoons and photographs and other devices by which he abetted his jingoistic ends.

Defense production in World War II generated economic recovery, restoring the circulation and advertising revenues of Hearst papers, but his personal glory days "as a major independent power in American politics and culture" never returned. Those glory days, though fraught with vicissitudes, had only started following his mother's death. In 1922 he had moved to the family's 268,000-acre ranch at San Simeon and set about creating the $37 million Hearst Castle. Commenced in that year, the main house was ready for occupancy by 1927. But it was not completed until 1947; ironically, it was time then for the aged and ailing Hearst to depart. He left his "glowering and bad-tempered retirement" to be nursed by Marion in the Beverly Hills house he had built for her when she contracted poliomyelitis. He died in August 1951, age 88.

By the mid-1930s, after a series of flops and despite all Hearst's efforts to prolong it, Marion's film career had ended. One biographer says, "With the film industry rejecting her, and the relationship with Hearst under pressure, Davies wilted and became an alcoholic"—that problem, others claim, had been incipient even in her teenage years. Ten weeks after Hearst died she eloped with a former actor, Horace Brown. Associated Press reported, "The

marriage, which caught even the immediate household of Miss Davies by surprise, came a few hours after she had settled her affairs with the Hearst Corporation. . . ." Marion died from cancer in September 1961.

"THE RANCH"

In summer 1542 the Portuguese-born navigator Juan Rodriquez Cabrillo had sailed up North America's Pacific coast. Passing large white rocks offshore, he imaginatively named them "Piedras Blancas." He landed at what now is the Bay of San Simeon. Sixty years later Sebastián Vizcaíno discovered another bay, which he named after the Count of Monte Rey; although Vizcaíno described upper California as "the land of milk and honey" the Spanish ignored it for another 150 years. In 1769 Gaspar de Portolà, governor of Alta California, and Franciscan missionary Father Junípero Serra undertook an overland expedition to find Monterey. In July they reached San Diego, where Serra founded a mission; by 1823 twenty more missions would follow, including Mission San Miguel Arcángel, established in July 1797 by Serra's successor, Father Fermín Francisco de Lasuén de Arasqueta.

Mexico won its independence from Spain in 1821; the Republic was founded 3 years later. In August 1833 the Mexican Congress passed *An Act for the Secularization of the Missions of California* that provided for financing the colonization of California by selling mission property. In 1836 the government acquired San Miguel Arcángel's coastal pasture and divided it into *ranchos*: Santa Rosa, 13,000 acres; Piedras Blancas, 49,000 acres; and San Simeon, 4,000 acres. The land was granted to Mexican private citizens.

The United States' "ambition to stretch coast to coast" prompted its declaration of war on Mexico in 1846. The Treaty of Guadalupe Hidalgo of February 1848 allowed Mexicans to retain their Californian holdings. When severe drought in the early 1860s destroyed over two-thirds of their cattle, considering the pasture too poor for livestock, many *rancheros* sold to American newcomers, who "transformed the hide-and-tallow industry into beef-and-dairy cattle production." In 1865 George Hearst bought Piedras Blancas, followed shortly by the other two ranches, and made them into one of the finest stock farms in the state. A San Luis Obispo County history recorded that in 1883 its chief production was butter and cheese, adding "the Piedras Blancas lands are . . . of passing richness. Corn, peas, barley, beans, and oats are raised." George built the first San Simeon wharf in 1869, and in 1878 he constructed a 1,000-foot long deep-water pier, warehouses, other buildings, and a railway to move the products of mining and ranching to deep-draft vessels. A ranch house was built around 1878. George (and later William Randolph Hearst) subsequently acquired adjacent grazing lands until the ranch covered 270,000 acres—more than eight times the area of the County of San Francisco. In 1940, when William sold land to the U.S. government for Fort

Hunter Liggett, the Hearst Ranch was reduced to 82,000 acres, a mere two-and-a-half times the size of San Francisco.

As a child, William often camped at the ranch with his parents; they nicknamed their favorite spot—an elongated ridge with magnificent views of coast and mountains—"Camp Hill." After he married he continued those camping vacations with his own family and with friends. Observing that "Hearst imported all the luxuries of the best European hotels to 'Camp Hill,'" Nasaw describes how they "roughed it." For one trip in 1915, "the cowboys had erected a small village of Venetian-style canvas tents, the size of cottages, with brightly-colored awnings. One of them was set aside for the dining room; the others, with living and sleeping quarters, were fully furnished. Oriental rugs were placed over the wooden floors."

Tiring of such "spartan" retreats, in spring 1919 Hearst began to think about a building a house on Camp Hill. He had been cruising second-hand bookstores when he found a stack of "bungalow books"; he came across an illustration that gave "an idea of [his] thought about the thing, keeping it simple"—of what he called a "Jappo-Swisso bungalow." Just then, a bungalow was all that he could afford. But within a month of Phoebe's death he developed general scheme for a big master house dominating a group of three guest-houses. By August he was insisting that the site be surveyed within a month and chose a San Francisco architect, the remarkable Julia Morgan, to build his dream on Camp Hill. Her biographer Sara Boutelle justifiably asserts, "That she continued to work on it for more than twenty years . . . while maintaining a thriving practice in San Francisco, exemplifies her dauntless commitment to the project, to her career and to architecture."[6]

JULIA MORGAN: "A REVOLUTIONARY IN A FLOWERED HAT"

Morgan scholar Karen McNeill has described the diminutive architect—she was 5 feet tall and weighed 100 pounds—as a "prim woman in drab suits, her hair pulled back in a tight bun, [whose] only apparent nod to fashion was her collection of hats, most from Paris." But as Mark Wilson, another biographer, writes, "She was a revolutionary in a flowered hat."

> . . . a quiet feminist, who blazed a trail for women in a profession that had never allowed them to participate fully, until she came along. She was America's first independent woman architect. . . . But most of all, she was an artist, a creator of beauty, who left us an incomparable legacy of over 700 buildings that delight the senses, and inspire the mind.[7]

Born in 1872, Julia was the second of five children—three boys and two girls—of Charles and Eliza Morgan. Her father, a mining engineer, left child-raising to his wife, who was clearly enlightened enough to allow her daughters

to choose their own courses in life. Although her sister Emma became a law-yer, Julia demonstrated a more scientific bent; after graduating from Oakland High School in 1890, she outrageously set her course toward architecture—no job, people then believed, for a woman! Because there were no architecture schools on the West Coast, Julia enrolled in civil engineering at the University of California, Berkeley (UC Berkeley). In her senior year she met the Arts and Crafts architect Bernard Maybeck, who had been hired to teach drawing. He also conducted informal seminars in architecture for his favorite students. In 1894 Julia became the second woman to receive Berkeley's BS in civil engi-neering. She worked for Maybeck for a while.

In 1896, encouraged by him and financed by her family, she went to Paris intent on studying at the *École Nationale Supérieure des Beaux-Arts*, the pres-tigious design school and exclusively male domain. Julia sat the *École*'s entrance examination in 1897, only to be turned down. In a letter to a cousin, architect Pierre LeBrun, she complained that she had been excluded on the basis of gender. Again taking the examination in November 1898, she was placed in the top four percentile candidates and, commended by the French architect Jean Louis Pascal and supported by letters from Maybeck and "other important figures," became the first woman admitted to the school. She chose the atelier of François-Benjamin Chaussemiche and in 2 years in the Second Class, she was awarded seventeen mentions and two medals in architecture, design, and mathematics. From August 1900 she spent 2 years in the First Class, receiving another eight mentions and two medals. Graduating in 1901, she continued to draft for Chaussemiche; in her free time she traveled in Europe, making sketches.

When Julia Morgan returned to San Francisco in 1902 she worked for John Galen Howard, who was then designing buildings at UC Berkeley, including the Hearst Mining Building and the Hearst Greek Theater, both endowed by Phoebe Apperson Hearst. Mrs. Hearst's patronage was helpful to Morgan as she began her professional career.

> In Alameda County, 250 miles south of Wyntoon, Phoebe's county estate realized by Maybeck, lay another property . . . on which, in 1895, [William] decided to raise an edifice "totally different in every way from the ordinary country home." He commissioned A.C. Schweinfurth to build the . . . *Hacienda del Pozo de Ve-rona*, described by the architect as "provincial Spanish Renaissance." . . . Phoebe was in Europe when she was apprised of this surreptitious endeavour. She has-tened west and expropriated the expropriator. Desiring to make the *Hacienda* into a home for herself, she commissioned Morgan to remodel it. Here, in 1902, Julia Morgan met William Randolph Hearst for the first time. . . .[8]

In 1904 Morgan was licensed to practice architecture in California and opened her first office. That year she built a Mission-style bell tower at Mills College in Oakland, a 72-foot high reinforced concrete structure that with-stood the 1906 San Francisco earthquake. The recognition she received for

this established her practice, but the earthquake destroyed the building that housed her office. In 1907 she relocated in the Merchants Exchange Building with a partner, Ira Wilson Hoover, who had also worked in Howard's office. They had several sizeable commissions, including the Mission-style Carnegie Library at Mills College (1905–1906); structural renovation of the Reid Brothers' quake-damaged Fairmont Hotel (1906–1907); and the arts and crafts style St. John's Presbyterian Church in Berkeley (1908–1910). In 1910, ever footloose, Hoover moved back to the East Coast and the firm became simply "Julia Morgan, Architect."

She designed several arts and crafts-style residences in Piedmont, Clare-mont, and Berkeley. Architectural historian Elinor Richey writes that in using structure as a means of architectural expression she was a decade ahead of most Californian contemporaries and claims that her early redwood shingle houses gave rise to the Bay Area shingle style. A third of Morgan's clients were women or "increasingly active women's organizations"; from 1912 she produced nearly thirty works for the Young Women's Christian Association in Utah, Hawaii, and California, including thirteen arts and crafts buildings at Asilomar near Monterey.

Her eclectic architectural vocabulary included Classical, Gothic, Renaissance Revival, Mediterranean, Tudor, Spanish Colonial, and even extended to Islamic and Chinese styles. All grist to her aesthetic mill, they were "pieced together and overlapped with arts and crafts elements as needed." Boutelle writes,

> Her primary attention was directed to the client's wishes and to the site; everything else followed from those two considerations. Before designing a house . . . , Morgan would visit the family, often sitting on the floor with the children, and make every attempt to understand what the client wanted, however quirky. . . . After this information was gathered, the plan itself became her most significant concern. . . . [She] designed each building from the inside out, with the exterior being of secondary importance.[9]

So Morgan never developed a distinctive personal style. Her clients always got what they wanted. That boded well for her working relationship with William Randolph Hearst. When he was a child, his father had once said, "There's one thing sure about my boy Bill. I've been watching him and I notice that when he wants cake, he wants cake, and he wants it now. And I notice that after a while he gets the cake."

There is a myth that Hearst "made" Morgan; that he found this relatively unknown architect to design his estate, "gambled on her qualifications and then monopolized her career." That was not the case. Morgan had been known to his mother since the turn of the century—perhaps even earlier. When she began work on San Simeon, she had already produced about four hundred fifty buildings and projects, including unrealized designs for a house in Sausalito (1912–1914), a cottage at Grandview Point near the

Grand Canyon (1914), and the *Los Angeles Examiner* building of 1915 for Hearst himself.

Throughout the three decades that *La Cuestra Encantada* occupied her weekends, Julia Morgan built other Hearst commissions: a Bavarian-style village on Wyntoon (1924–1943); Jolon, the hunting lodge at Milpitas Ranch—really an adjunct to the Castle (1926–1928); the Phoebe Apperson Hearst Memorial Gymnasium at UC Berkeley (1926–1927, with Maybeck); alterations to Marion Davies' Santa Monica beach house (ca. 1929); and remodeling the Hearst Building in San Francisco (1937). Unrealized projects included a hotel at the Grand Canyon (1936), a Medieval Museum for San Francisco's Golden Gate Park, and the Babicora Hacienda in Chihuahua, Mexico (both in the 1940s).

Over the same period she conducted a thriving "week-day" practice from San Francisco, continuing throughout World War II. In 1951, age 79, Julia Morgan finally retired; after years of failing health, she died in February 1957. It is outrageous that when the Enchanted Hill became the property of the State of California and was later opened to the public Morgan's role in its creation was ignored. Visitors to the site—hundreds of thousands of them each year—see tributes to Hearst and his mother; but as Cockburn asserts, "if *La Cuestra Encantada* is the story of a dream arduously achieved, it was Morgan rather than Hearst who prevailed over the more formidable odds."

LA CUESTA ENCANTADA

Hearst had formed a rather clear idea of what he wanted to build. In a letter to Morgan, noting that the 1915 San Diego Exposition "is the best source for Spanish in California," he suggested that an alternative to Mission style was "to build . . . in the Renaissance style of Southern Spain. We picked out the towers of the Church at Ronda. I suppose they are Renaissance or else transitional, and they have some Gothic feelings." Having thus marked his territory, Hearst confessed (as though it wasn't obvious), "I am not very sure about my architecture. . . . But after all, would it not be better to do something a little different than other people are doing out in California as long as we do not do anything incongruous?" He assured the architect, "I would very much like to have your views on what we should do in regard to this group of buildings, what style of architecture we should select. . . . I do not want you to do anything you do not like." So Spanish it would be, with variations—it might be said, "with licence." Art historian Patricia Failing wittily categorizes the architectural style of *La Cuestra Encantada* as "Bastard-Spanish-Moorish-Romanesque-Gothic-Renaissance-Bull Market-Damn-the-Price."

Julia Morgan described the project, "We are building . . . a sort of village on a mountaintop overlooking the sea and ranges of mountains, miles away from any railway, and housing incidentally [Hearst's] collections as well as his

family." The three fussily ornamented "Mediterranean revival" guest houses, with a total of forty-six rooms, were completed by 1922. Hearst lived in the first and largest until the central wing of *La Casa Grande*, the main house, was ready for occupation in 1927. At a given time over the next 28 years anything between twenty-five and 125 laborers, tradesmen, and craftsmen—masons, carpenters, concrete workers, plasterers, tilers, woodcarvers, decorators— would be employed on building the house. During the Great Depression it was the largest private construction site in California. Hearst's financial problems hampered progress for a while after 1937; in 1946 it resumed until early 1948. But the castle was never finished.

Once *La Casa Grande* was underway, Morgan maintained an on-site studio, "the shack"—a humble wooden lean-to against the great house. On nearly 560 Friday nights between 1919 and 1939 she made a 6-hour train journey from San Francisco to San Luis Obispo, then traveled 50 miles to San Simeon by taxi, arriving at 2 A.M. After a weekend working on site she returned to her city office in time for other business on Monday morning, leaving her superintendent Camille C. Rossi in charge at Hearst Castle.

As well as the houses atop the enchanted hill, Morgan designed pools, a zoo and aviary, a poultry ranch, landscaping, greenhouses, tennis courts, and a 5-mile long pergola, tall enough for "a tall man with a tall hat on a tall horse." She reconstructed the pier at San Simeon village—from 1919, building materials for the estate arrived by steamer—and oversaw the construction of steel-framed warehouses where those materials were stored until chain-driven trucks hauled them up the steep grade to the site. In the village, she built five Mission-style timber-framed residences for Hearst's supervisors and a reinforced concrete warehouse to temporarily house artworks awaiting installation in the house and garden. She also assisted Hearst to appropriately distribute his vast art collection through the buildings and the gardens.

It seems that Morgan was given the final word in professional and technical matters from the outset; in December 1919 Hearst told her, "I make a lot of suggestions and if any of them are impractical or imperfect from an architectural point of view, please discard them and substitute whatever you think is better." Almost as a matter of course, he impulsively and frequently revised his requirements, sometimes after a part of the work was finished. For example,

> Following completion of a fireplace in *Casa del Sol*, Hearst decided he wanted it moved to the other side of the room. That done, he decided he liked it better the first way. After Casa Grande's towers were finished, Hearst decided he wanted to have bedrooms in them. Morgan designed new towers to accommodate these "Celestial Suites." The famous Neptune Pool evolved over twelve years from a lily pond into an Olympian terrace complete with cypress trees, a cascading fountain, marble colonnades, statues, and the facade of a Greco-Roman temple.[10]

Clearly, Morgan knew how to handle her ambivalent client, and the professional relationship was secure and unruffled. Over the course of the work many formally addressed letters that "focused on the details of the construction," passed between the pair. The more than one thousand that survive are evidence of "a collaborative relationship . . . in which Morgan gave Hearst's ideas great respect." And more than ten thousand of Morgan's drawings survive. She employed a woman, C. Julian Mesic, to build a model that showed progress at San Simeon; when it grew too large to ship, she mailed tinted photographs of the current state of the buildings to Hearst.

The four-story *La Casa Grande* crowned the site, its twin towers flanking a gabled pavilion around the main entrance on the west façade. As noted, Hearst had nominated a church in Ronda, Spain—the cathedral of Santa Maria la Mayor—as a model; other sources suggest the eighteenth-century Jesuit mission church of San Xavier del Bac in Tucson, Arizona. Possibly the towers were based on the Spanish cathedral and the general composition of the façade on the colonial mission church. Founded upon piers reaching bedrock and braced to resist earthquakes, the *in situ* reinforced concrete walls were clad externally with white marble. Their flamboyant ornamentation incorporated Spanish Gothic sculpture and other architectural fragments—and *fragments* is the word—from Hearst's collection, augmented with cast reconstituted stone.

Originally, *La Casa Grande* had "about" 115 rooms including a two-story, 2,400 square foot assembly room extending across the front; a 2,000 square foot dining room; a movie theater; two libraries; a billiard room; and a beauty salon. There were twenty-six bedrooms and thirty-two bathrooms (by 1951 there were thirty-eight bedrooms and forty-one bathrooms) and fourteen sitting rooms. And there were thirty fireplaces. In addition, the main building's service wing housed a kitchen and pantry, a servants' dining room, twelve bedrooms, ten bathrooms, and seven other rooms used by domestic staff.

From 1927 until 1937 Hearst occupied the third-floor Spanish Gothic Suite, full of objects bought from the collection of Jose Maria de Palacio. Describing how he worked "through the night in his private office behind the Gothic study, reading his newspapers [airmailed] to San Simeon from all quarters of his empire," Cockburn opines, "San Simeon must have seemed to him to be the final résumé: the triumph of the New World, expressed as a triumph of art and architecture imported from the Old, down the centuries from the Athens of Phidias and Pericles." Indeed, the house's interiors, crammed with *objets d'art*, were enriched with eclectic ornament of plaster, tile, cast stone, and carved wood, and with whole elements of buildings—doors, mantels and even ceilings—plundered from post-Great War Europe. Hearst once boasted of sending an agent "pictures of possible looking patios and cloisters, and surely some of those Signors, Dukes, etc. are hard enough up to part with one of them." Cockburn calls Hearst's agents, "shock troops [who] fanned across Europe in the service of his rabid collecting." The publisher's lasting and

particular enthusiasm for ancient Greek vases meant that they represented the most extensive part of his collection at the castle. But Hearst's vast art collection—paintings, tapestries, religious textiles, oriental rugs, antiquities, sculptures, silver, furniture, and antique ceilings—was so extensive that *La Casa Grande* housed just a tenth of it. Much of the rest was at his other properties or in warehouses on both coasts. When much of it was sold off in the late 1930s, and even at the time of his death, some had never been unpacked; some had never been catalogued, and some pieces he had seen only in photographs.

Julia Morgan was complicit in his extravagant theatricity. American writer David Peevers claims that he hired "to turn [Hearst's] fancies into reality," she was "continually jerked around by Hearst amongst various wings and salons. . . . As Hearst hauled in cathedral ceilings [*sic*] and Roman columns, Morgan did her best to rake his accumulation into something habitable."[11] But Morgan herself had insisted, "What we would like are ceilings, especially door trims, interesting architectural motifs—not so much furniture as objets d'art" because she needed "big things to use to make settings with. . . ." *Make settings?* The expression seems to reduce the architecture, inside and out, to a mere backdrop for the great man's accumulated artefacts.

Any essay about The Enchanted Hill must mention the pools. The first version of the Neptune Pool was a lily pond in Hearst's proposed Temple Garden (complete with temple). In March 1924 he instructed that it be lengthened and deepened, to be used as a swimming pool by the family. Morgan redesigned it. Then in 1926 he decided that he wanted a larger pool with a cascade and more statuary; Morgan again obliged, and by 1927 she completed the second version with concrete steps at the southern side, down which water flowed from natural springs. Dressing rooms were added in 1928. The third and final version, built in 1934–1936, was over 100 feet long and 60 wide, its semicircular ends flanked by segmental classical loggias built of Vermont marble and watched over by groups of classical statuary. Its visual focus is a Roman temple portico that Hearst had purchased for his collection; a terrace opposite the portico has seventeen dressing rooms, with baths and mirrors. Reinforced concrete beams suspend the pool, so that if there were an earthquake it will sway but not break. The indoor Roman Pool and the surrounding room were built 1927 to 1934. The surfaces from floor to ceiling were decorated by Camille Solon with (mainly) blue and gold 1-inch square glass mosaics, in patterns based on the vaults of the Byzantine Tomb of Galla Placidia in Ravenna, Italy. Placed around the pool are eight marble statues, rough copies by Carlo Freter of classical works. The Roman Pool complex was intended to include sweat baths, a handball court, an exercise room, and dressing rooms.

As a general rule, Morgan was reluctant to surrender the roles of landscape architect and interior designer to another, according to her associate Walter Steilberg: "Julia had a horror of interior decorators coming in and spoiling

a house and of landscapists who were not really trained." The landscaping of *La Cuesta Encantada*, with what Morgan called its "endless steps and terracing," and employing Italian cypresses, Canary Island date palms, and California oaks as its vertical elements, has been acclaimed as one of America's finest Italian and Spanish gardens. The winding "Esplanade" was bordered by colorful specimen plants including agapanthus, azaleas, camellias, eucalyptus, citrus trees, oleanders, rhododendrons, and purple lantanas. Statues, balustrades, and terraces were as important in Hearst's garden as trees and flowers and "displayed the sparkling fountains and statuary Hearst collected from around the world." The ornamental staircases that connected the broad sweeping terraces and the low retaining walls were draped with bougainvillea, fuchsias, lavender, star jasmines, and wisteria. The terrace in front of *La Casa Grande*'s main entrance was more formally laid out; Hearst was passionate about his roses, so roses predominated.

Away from the houses and landscaped areas at San Simeon, he established the world's largest private zoo. He began collecting in 1923 and at its peak the grandly named Hearst Garden of Comparative Zoology held fifty species of herbivores—in all, more than three hundred animals—in fenced enclosures. White fallow deer formed the largest herd, and there were other species of deer from India, Europe, and Asia. There were also African and Asian antelope, Bactrian camels and dromedaries, llamas, ostriches, kangaroos and emus, Barbary and Alaskan big horned sheep, musk oxen, yaks, zebras, and even giraffes. Hearst wanted his guests to believe that they were driving through an area enclosing animals in their natural state. After visiting The Enchanted Hill, the English author P. G. Wodehouse, noting that "the specimens considered reasonably harmless are allowed to roam at large," drily observed, "You are apt to meet a bear or two before you get to the house, or an elephant, or even Sam Goldwyn." In fact, the zoo had two parts. A menagerie of less sociable creatures—at various times, bears, big cats, apes and monkeys, macaws, kinkajous, coatimundis, a tapir, and an elephant—was located about 100 yards north of the *casas* in unprepossessing "animal shelters" designed by Morgan. Like most of the outbuildings at San Simeon, they were built of reinforced concrete.

About 20 years earlier Julia Morgan had pioneered the material on the West Coast. It first had been used to make boats and garden pots in France early in the nineteenth century, employing a technique that was patented in 1867. America's first landmark reinforced concrete building was William E. Ward's house in Port Chester, New York by the architect Robert Mook. No doubt Morgan became familiar with reinforced concrete when in France, and her use of it for UC Berkeley's Hearst Greek Theatre in 1903 is exactly contemporary with Auguste Perret's celebrated apartment building at 25 bis Rue Franklin, Paris; it predates by 3 years Frank Lloyd Wright's internationally feted Unity Temple in Oak Park, Illinois, sections of which are also in reinforced concrete. Structurally speaking, Morgan's buildings at San Simeon

were not put to the test (as it were) until December 22, 2003. Hearst Castle was evacuated when a big earthquake rocked the region, but as the *San Francisco Chronicle* reported, "*Casa Grande* and its sumptuous outbuildings survived with no apparent structural damage."

"THE SOCIAL LIVES OF PROMINENT PEOPLE. . . "

In the late 1920s and early 1930s Hearst and Marion Davies threw extravagant and extended house parties at the castle for his business associates and movie stars. Some guests flew in to the estate's airfield. Others arrived at San Luis Obispo station from Los Angeles in a Hearst-owned private railroad car to be chauffeured to the house. Wodehouse marveled that there were "always at least fifty guests. . . . The train that takes guests away leaves after midnight, and the one that brings new guests arrives early in the morning, so you have dinner with one lot of people and come down to breakfast next morning to find an entirely fresh crowd." Someone has written that an invitation "was highly coveted: it meant either that you were rich and famous, or that you'd get to fraternize with those who were. San Simeon was a place where connections were made, power was wielded, and alliances forged." *La Cuestra Encantada*'s "A list" was (of course) a Hollywood *Who's Who* that included, to name a few of the perhaps still-familiar names: Gary Cooper, Charlie Chaplin, Joan Crawford, Errol Flynn, Greta Garbo, Clark Gable, Cary Grant, Harpo Marx, Dick Powell, and Barbara Stanwyck. Studio bosses Louis B. Mayer, Irving Thalberg, and Jack Warner also enjoyed Hearst's hospitality; so did politicians such as Calvin Coolidge and New York Mayor Jimmy Walker, and celebrities such as Charles Lindbergh. Katharine Hepburn once said that turning down an invitation was her biggest mistake in show business.

The Lord of San Simeon imposed his own contradictory moral code. Except for Hearst and Marion, only married couples could share rooms. He allowed neither coarse language nor immodest dress, and though he could see his mistress fast declining into alcoholism, he despised drunkenness. He was only a moderate drinker himself, with no taste at all for spirits. Although Prohibition remained in force until 1933, he served alcohol to his guests. William Randolph Jr. recalled, "Guests usually limited themselves to one drink. Pop . . . put the word out that no guests were to bring their own booze to the place. But some did and got drunk. He would have someone ask them to leave, and they would be driven to the [San Luis Obispo station.]"

Guests were left to amuse themselves during the day—there was plenty to occupy them—but all were expected to be present for dinner. Evenings would begin with cocktails before dinner. Guests would gather in the Assembly Room, and Hearst would enter through a concealed door. Dinner was served at nine, and the group would move into the Refectory with its carved coffered ceiling, and replete with arched Gothic windows, carved fifteenth-century

choir stalls, Sienese silk festival banners, and chandeliers. Diners were seated on antique Italian "Dante" chairs at a long oak table. Laid out beside the sumptuous silverware were ketchup bottles, mustard jars, and paper napkins; all of which served as "a reminder to all that Hearst ... wanted informal western hospitality to be the tone of his own convivial celebrations." Wodehouse noticed that diners were placed according to the host's preference for their company,

> with Hearst sitting in the middle on one side and Marion Davies in the middle on the other. The longer you are there, the further you get from the middle. I sat on Marion's right the first night, then found myself being edged further and further away till I got to the extreme end, when I thought it time to leave. Another day, and I should have been feeding on the floor.[12]

At 11 o'clock guests would watch a newsreel, followed by a movie. Often Hearst would grow irritated a half-hour into a film and "instruct the projectionist to substitute an old Davies feature."

"DISNEYLAND MEETS HOLLYWOOD"—SO WHAT?

It has been claimed that *La Cuesta Encantada* is not a "freak" but a "representative example of the American country-house tradition." One pusillanimous anonymous Australian critic, writing from a socialist-objective Modernist perspective, recognizes (and ridicules) the castle as an "easy target of scorn." Labelling it "a monument to the bowerbird tastes of [a] latter day carpetbagger," he continues,

> A cashed-up Hearst swept through a devastated cash-strapped Europe after both world wars buying up decorative arts . . . without much of a coherent plan of what to do with it all when he got back home. . . . Most of [Hearst Castle] is of the "Mediterranean Revival" style with various other styles thrown in . . . a sort of rich man's pastiche of Disneyland meets Hollywood. The main building looks like a cross between a Mediterranean church and a Tyrolean Berghaus. The plethora of religious decoration on display almost leads one to think that Hearst was a devout man of Catholic faith. Apparently the only Catholic thing about [him] was his taste.[13]

What can be concluded about the architectural quality of Hearst Castle in this present age of fading post-Modernism? Form no longer necessarily follows function; a house is no longer Le Corbusier's "machine for living in"; and certainly less is not more anymore. Anything goes, just like it did when Mr. Hearst built his dream house. Peevers remarks, "It's certain that absolute power combined with unlimited wealth accounts for some of the most heinous architecture in all of history. But occasionally these lurid legacies . . . are

of such a scale and lunacy that they become oddly endearing. Witness Hearst Castle."

As is the case with other buildings treated within these pages, the iconic status of William Randolph Hearst's great house lies neither in its stylistic integrity—because it has none—nor in the considerable patience and professional skill of Julia Morgan, its architect. Rather, it springs from the popular appeal of its associations with a past generation of the "beautiful people" at the very end of the Gilded Age. It is coincidental that it was opened to the public just 2 years after the rerelease of *Citizen Kane*, when popular curiosity had been excited by Xanadu, the "stately pleasure-dome."

NOTES

1. Cockburn, Alexander, "Ranch, my Foot; it's a Castle," *The Drawbridge* (Autumn 2006). www.thedrawbridge.org.uk/issue_3/

2. Azavedo, Michael, "The Battle over Citizen Kane." www.pbs.org/wgbh/amex/kane2/

3. Nasaw, David, *The Chief: The Life of William Randolph Hearst*. Boston: Houghton Mifflin, 2000, 574.

4. Nasaw, 21–22.

5. Nasaw, 538.

6. Boutelle, Sara Holmes, *Julia Morgan, Architect*. New York: Abbeville, 1995, introduction.

7. Wilson, Mark, *Julia Morgan: Architect of Beauty*. Salt Lake City, UT: Gibbs Smith, 2007.

8. Cockburn.

9. Boutelle.

10. Boisson, Steve, *The Hearst Castle: A Castle for the Chief*. Available at http://away.com/primedia/arts_arch/hearst_castle.adp

11. Peevers, David, "A Boy and His Castle." www.travelmag.co.uk/article_299.shtml. Originally published in the Lonely Planet Guide to California.

12. Cockburn.

13. "Razzbuffnik," "La Cuesta Encantada . . ." http://blog.allthedumbthings.com/2007/05/28/

FURTHER READING

Boutelle, Sara Holmes. *Julia Morgan, Architect*. New York: Abbeville, 1995.
California State Parks Service. *Hearst Castle: Hearst San Simeon State Historical Monument*. Sacramento, CA: The Service, 2001.
Guiles, Fred Lawrence. *Marion Davies*. New York: Bantam, 1972.

Henke, Ellen. "*La Cuesta Encantada*: The Formal Gardens of the Hearst Castle. . . . " *Flower and Garden Magazine* (February-March 1996).

Hoopes, Roy. "The Forty-Year Run." *American Heritage Magazine*, 43(November 1992).

Kastner, Victoria. *Hearst Castle: The Biography of a Country House*. New York: Abrams, 2000.

Kastner, Victoria, and Jana Seely. *Hearst Castle: The Official Pictorial Guide*. Santa Barbara, CA: Companion Press, 1991.

Kastner, Victoria, and Jana Seely, eds. *San Simeon Revisited: The Correspondence between Architect Julia Morgan and William Randolph Hearst*. San Luis Obispo: Library Associates, California Polytechnic State University, 1987.

Longstretch, Richard W. *Julia Morgan: Architect*. Berkeley, CA: Architectural Heritage Association, 1977.

Nasaw, David. *The Chief: The Life of William Randolph Hearst*. Boston: Houghton Mifflin, 2000.

Pavlick, Robert. "Something a Little Different." *California History* (Winter 1992-1993), 462–477.

Procter, Ben H. *William Randolph Hearst: The Early Years, 1863–1910*. New York: Oxford University Press, 1998.

Procter, Ben H. *William Randolph Hearst: The Later Years, 1911–1951*. New York: Oxford University Press, 2007.

Quacchia, Russell L. *Julia Morgan, Architect: and the Creation of the Asilomar Conference Grounds: including a Special Comparison with the Hearst Castle*. Philadelphia, PA: Xlibris, 2005.

Swanberg, William A. *Citizen Hearst, a Biography of William Randolph Hearst*. Norwalk, CT: Easton Press, 1988.

Wilson, Mark. *Julia Morgan: Architect of Beauty*. Salt Lake City, UT: Gibbs Smith, 2007.

Winslow, Carleton M., and Nickola L. Frye. *The Enchanted Hill: The Story of Hearst Castle at San Simeon*. Millbrae, CA: Celestial Arts, 1980.

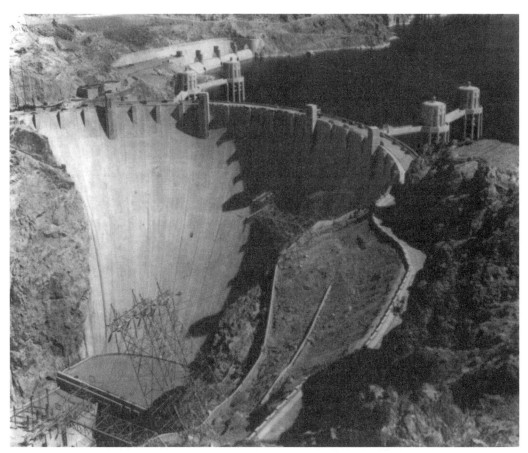

Courtesy Library of Congress

Hoover Dam, Colorado River, Nevada/Arizona

"A symbol of American ingenuity"

Over 726 feet high and 660 feet thick at its base, Hoover Dam stretches 1,444 feet across the Colorado River between the breccia walls of Black Canyon, 30 miles southeast of Las Vegas. The beginning of the U.S. Bureau of Reclamation's Lower Colorado Dams Project, it was completed in fewer than 5 years. Davis Dam, 45 miles downstream, followed in 1951 and Parker Dam, 110 miles further, in 1954. The principal means of effecting flood control in the southwestern United States, Hoover Dam also provides water for nine cities and supplies hydroelectric power for 1.3 million people. Behind it, the Colorado backs up for 110 miles in Lake Mead, harnessing irrigation water for the Palo Verde Valley, the Colorado River Indian Reservation, the Yuma and Gila projects in Arizona, and California's Imperial and Coachella valleys.

The American Studies Program at the University of Virginia distills the iconic status—more correctly, the iconic *stature*—of Hoover Dam:

> Almost from the beginning of its construction, the Hoover Dam possessed an epic quality that animated the national imagination. Perhaps originally it was the very bigness of the dam that attracted tourists and inspired writers. Soon it became apparent that the meaning of the dam itself was beyond even that of a structure that equaled the vast landscape it inhabited; the dam, and the Americans who built it, controlled nature in a new and powerful way. The Hoover Dam, built during America's worst depression, spoke directly and profoundly to a people who were afraid and unsure; the massive structure silently addressed the power of technology, the hope for the future, and the ability of man to change the natural course of things. As it rose physically from the desert floor, damming the Colorado and altering the very shape of the land, its image rose from the desert of the 1930's and offered an alternative narrative to the that of the Great Depression.[1]

Historian Theodore Steinberg's assertion that dam was "a symbol of American ingenuity and the mark of a nation that was fast rising to global dominance . . . supposed to signify greatness, power and domination. . . . It was planned that way"[2] is affirmed by another (anonymous) writer's observation that the act of building the dam as an "icon of faith" because "the narrative that arose in the popular imagination contained all the elements that would validate and promote the government's role in such projects."

As though it needed formal recognition, in 1955 the American Society of Civil Engineers (ASCE) included Hoover Dam among America's Seven Modern Civil Engineering Wonders. It was added to the National Register of Historic Places in 1981, designated an ASCE Historic Civil Engineering Landmark in 1984, a National Historic Landmark in August 1985, and a Monument of the Millennium in 2001. Over a million people visit it each year.

THE COLORADO RIVER: EUROPEAN EXPLORATION

The seventh longest river in the United States falls over 12,000 feet on its 1,440-mile course from the Rocky Mountains to its natural outflow in the

Gulf of California. Fed by tributaries and now shaped by dams, it flows through Wyoming, Colorado, Utah, Nevada, Arizona, New Mexico, California, and into Mexico; its drainage basin covers one-twelfth of the area of the continental United States. The Colorado turns south after its confluence with the Virgin River; below Hoover Dam it forms part of the Arizona–Nevada and Arizona–California state borders. Then it runs through a broad estuarine plain, much of its channel contained within levees that cut off its flow, to the low-lying Salton Trough in southern California. Its lowest reaches and its once tidal delta are now little more than a trickle.

Spanish explorations of the Colorado in the south were prompted by the quest for either precious treasure or precious souls—perhaps both and almost certainly in that order. In July 1539 Hernándo Cortéz sent Francisco de Ulloa to find the "streets lined with goldsmith shops . . . and doorways studded with emeralds and turquoise" of the fabled Seven Cities of Cibola. Exploring the Gulf of California, Ulloa reached the estuary of the Colorado but did not navigate it. The following year Hernándo Ruiz de Alarcón ventured 100 miles upstream; Captains Melchior Díaz and García Lopez de Cárdenas, members of Francisco de Coronado's overland expedition also reached the river. The Spanish showed little further interest until 1604 when Juan de Oñate, governor of New Mexico, seeking a route to the west coast of North America, followed the Colorado to its mouth. About 100 years later a Jesuit Eusebio Kino of San Xavier de Bac Mission investigated the estuary, and for the rest of the eighteenth century most explorers were priests more concerned with converting Native Americans than investigating the geography of the river. In 1770 Father Francisco Garcés, also of San Xavier de Bac, traveled down the Gila River and almost to the mouth of the Colorado, which he renamed because of its red color—formerly it was called Rio del Tizon or Rio de Buena Guia. In 1776 the Franciscans Silvestre Velez de Escalante and Francisco Dominguez, returning from an unsuccessful attempt to find a northern route to Monterey from Santa Fe, crossed the Colorado near Marble Canyon.

American beaver trappers charted the Colorado's northern reaches. In March 1825 the fur traders William Ashley and Andrew Henry accompanied Jedediah Smith's expedition from the River Platte westward across South Pass in the Continental Divide. They navigated Green River, a tributary, and provided the first authentic information about the upper Colorado. In August 1826 Smith, in search of furs, led another expedition from near the Utah–Idaho border, reaching the Virgin River near the southwestern corner of Utah in October. Following it, he arrived at the Colorado. A little over a year later, one Sylvester Pattie, his son James Ohio, and six other trappers arrived at the junction of the Gila and Colorado rivers. They rafted down to the Colorado's tidal reaches, where they buried their furs and traps before trekking overland to San Diego. There, officers of the incipient Mexican Republic accused them of spying for the Spanish government, and they were imprisoned for several months in the Presidio. Undertaking a second expedition in 1828, James Pattie followed the Gila to the Colorado, where he turned north and continued

for 300 miles upstream to a place "where the mountains shut in so close upon the shores [of the river] at an immense depth beneath." This was probably at the mouth of the Black Canyon, later the site of the Hoover Dam.

In 1856 one Captain George Johnson began trading on the Colorado with the side-wheeler *General Jesup*. In December 1857, despite a disappointed application for government funding of a project "to determine the limit of navigation" he traveled the river to within 20 miles south of Black Canyon. At almost exactly the same time the War Department sent Lieutenant Joseph Ives of the Topographical Engineers Corps to investigate the logistical feasibility of transporting troops and supplies on the Colorado; his stern-wheeler *Explorer* reached Black Canyon but struck a rock and was abandoned.

Major John Wesley Powell, "the greatest explorer of the Colorado" made the connection between the river's ends in 1869; he was then 35 years old and a hero of the Civil War, in which he had lost an arm. Late in May, traveling in four specially-built boats with a party of nine others, he left Green River in Wyoming. Ninety-eight days later six men—the others had deserted—ended their hazardous 900-mile journey at the mouth of the Virgin River. Funded by Congress, Powell embarked on an extended survey in May 1871; it took him 4½ months to reach the mouth of the Paria River from Green River. In August 1872 he started down river from Lee's Ferry, but because of dangers he went no further than Kanab Canyon near the Grand Canyon. Sponsored by the federal government he continued to study the Colorado River region and "became impressed with the problems of settling the arid western lands." Congress published his *Report on the Lands of the Arid Region of the United States* in 1878; in it, he proposed "legislation for the organization of irrigation and pasturage districts."

TAMING THE COLORADO

Other ambitious proposals were made to control and utilize the vast volume of water that flowed down the Colorado. For example, by the time that he died in 1887, a prominent San Francisco physician named Oliver M. Wozencraft had pursued for 30 years his vision to irrigate southern California's Imperial Valley with water from the great river, using a dry channel known as the Alamo River. In 1859 the Californian State Legislature asked Congress for 6 million acres of land, including the entire Salton Trough; if his idea could be realized, Wozencraft would be granted rights to it—that was necessary if he was to secure finance for his scheme. He spent his life savings trying to excite the federal government; it showed cautious interest, but when events were overtaken by more urgent issues, not least of all the Civil War, the plan was shelved.

In 1891 the Californian John C. Beatty, "a man of imagination and foresight," founded the Arizona and Sonora Land and Irrigation Co. to operate

on the Arizona side of the river. His proposal later changed, following the assurances of irrigation engineer Charles R. Rockwood that 2 million acres in the Salton Trough and Baja California could be served by a single channel. Rockwood proposed a 40-mile conduit that would carry water into Mexico from 12 miles above Yuma, then westward and back across the border to Imperial Valley. The venture, rebadged as The Colorado River Irrigation Co., declared bankruptcy during the 1893 stock market panic, but Rockwood revived the scheme 3 years later. In August 1900, backed by George Chaffey, who had successfully launched irrigation settlements in Australia, The California Development Co. began building the Alamo Canal to deliver water to the Alamo River; 9 months later the Colorado flowed into it, and by September 1904 no fewer than 700 miles of canals were irrigating 75,000 acres.

In 1902 President Theodore Roosevelt signed the Reclamation Act, by which sales revenue from semiarid public lands financed irrigation projects in most western states. In turn, sales of newly irrigated land funded subsequent projects, setting up a cycle that eventually led to the damming of most major western rivers. The Act also created within the Department of the Interior the U.S. Reclamation Service (later the U.S. Bureau of Reclamation). The potential utilization of the Colorado River was on its agenda.

Silt deposits demanded almost continuous dredging of the Alamo Canal. A diversion canal was cut in the Colorado's west bank, and a flood protection levee system was built. But in March 1905 the river, swollen by heavy rains, breached it and inundated farms—indeed, whole communities—and the Southern Pacific Railroad's main line in the Imperial Valley. Partially changing its course, it continued to flow into the Salton Trough until February 1907, destroying 330,000 acres of agricultural land and forming the Salton Sea. Roosevelt paid for the Southern Pacific Railroad Company to close the breach, and water was once again diverted through the Alamo Canal.

The wheels of government began to grind slowly, as wheels of government do. About a decade later, perhaps in response to the unprecedented 1916 flooding of the Yuma Valley or to representations from the Imperial Irrigation District, Arthur Powell Davis, director and chief engineer of the Bureau of Reclamation (and, incidentally, John Wesley Powell's nephew), suggested in 1918 that the Colorado's capriciousness could be countered by constructing a dam near Boulder Canyon. Accordingly, the Department of the Interior created the All-American Canal Board and subsidized a study of a canal to serve the Imperial Valley that would be entirely within the United States—hence "All-American"—unlike the Alamo Canal, most of which was in politically unstable Mexico. In July 1919 the board recommended building such a canal, with a diversion dam and desilting works, and also that the federal government should construct large multiple-purpose reservoirs on the lower Colorado. Enabling legislation was introduced into the Congress in 1919 and 1920, but the bills failed to come to a vote. In May 1820 Congress passed the

Kincaid Act, calling for further investigation. Late in February 1922 Davis (as the report's principal author) and Secretary of the Interior Albert Fall submitted *Problems of Imperial Valley and Vicinity* to the federal government. The so-called Fall–Davis report recommended building the All-American canal and a high dam on the Colorado River "at or near" Boulder Canyon and proposed that the capital outlay could be recouped by selling hydroelectric power to southwestern cities. Its findings would be developed in the Bureau of Reclamation's *Report on the Problems of the Colorado River* (the Weymouth Report) 2 years later.

President Herbert Hoover, with some training in geology and mining engineering, was a key player in the realization of the dam that bears his name. The Boulder Canyon Project was the pièce de resistance of his campaign for flood control, river management, and generation of hydroelectric power; and when he was appointed secretary of commerce in 1921, the construction of a high dam in Boulder Canyon had been among his earliest initiatives. In 1922 Hoover settled old disputes and secured agreement over water allocation. The Colorado River Compact (aka the "Hoover Compromise") signed on November 24 partitioned water rights between Upper Basin States (Wyoming, Colorado, Utah, and New Mexico) and Lower Basin States (Arizona, California, and Nevada), making the construction of the dam possible. Only Arizona, disgruntled because it "considered the dam a theft of its natural resources," rejected the Compact. The Supreme Court would confirm the Lower Basin apportionment in 1963, after years of litigation.

In April 1922 Representative Philip Swing and Senator Hiram Johnson unsuccessfully introduced a bill to authorize the Fall–Davis proposals; over the next 6 years the matter was reintroduced three times before Congress finally being passed by Congress. The final version called for a dam with a reservoir capacity of at least 26 million acre-feet and a power plant that could be leased to public or private organizations. President Calvin Coolidge signed The Boulder Canyon Project Act into law on December 21, 1928; about 6 months later, Hoover, by then president, proclaimed it to be in effect. The choice of site had been left jointly to him (while he was president-elect) and Ray Lyman Wilbur to the secretary of the interior. The Act also authorized the All-American Canal System; its construction would commence in 1934.

Hoover was inaugurated on March 4, 1929. It was not until 18 years later that Congress would catalogue his contributions to the dam in an April 1947 Congressional resolution establishing in law its name as "Hoover Dam"— after years of bitter, politically fuelled debate. Besides proclaiming the Act, (which any president could have done), Hoover "took an active part in settling the engineering problems and location of the dam in Black Canyon; was required by the Project Act to obtain power and water contracts adequate to assure some $200 million of revenues before construction was begun; settled the difficult and controversial questions involved in the allocation of the power, and made the revenue contracts which Congress required."

SO WHAT'S IN A NAME?

At the dam's Silver Spike Ceremony on September 17, 1930, Ray Wilbur announced, "In accordance with many requests . . . I choose that of the great engineer whose vision and persistence . . . has done much to make it possible and declare that the dam to be built . . . under the Boulder Canyon Project Act shall be called the Hoover Dam." Congress endorsed the choice 5 months later; all official references to "Boulder Dam" were changed, and the wording of earlier contracts was amended. When Franklin D. Roosevelt became president, Harold Ickes replaced Wilbur as secretary of the interior. Ickes disliked Hoover, and in May 1933 Ickes indicated that he had decided the dam should no longer bear Hoover's name. Out of what *The New York Herald Tribune* called "mere petty political spite," he set out openly to reinstate the original name: "Boulder Dam is a fine, rugged, and individual name. The men who pioneered this project knew it by this name," Ickes argued that the legislation enabled the initiation of the project had been passed during the Coolidge administration, and that Wilbur "had acted inappropriately." The attorney Ward Bannister warned the incoming president that Ickes' action was a "great offense to countless thousands of citizens and an inglorious blot" on the Roosevelt administration. Yet in his dedication speech at the dam on September 30, 1935, FDR used the name *Boulder Dam* five times; he did not mention *Hoover* once. The debate raged until *Selected Papers of Homer Cummings, Attorney General of the United States, 1933-1939* was published in 1939. It included Cummings' opinion, given to Ickes early in 1935, that "Hoover Dam" was the legal name. *The San Francisco Chronicle* noted with relish, "It may be Boulder Dam to Secretary Ickes, but to the rest of the people of the United States, by no less than Congressional action, it is Hoover Dam. . . . But it was a swell fight while it lasted. Thank you, Mr. Cummings, because at last . . . That dam thing's settled."

WHAT KIND OF DAM?

To remain stable, a dam must resist the horizontal force imposed by the huge mass of water that it holds back; that is, the structure itself and the rock underneath and beside it must exert an equal and opposite force to that exerted by the water. Gravity dams achieve this by sheer mass; arch dams transmit loads along their curve to the flanking support structures—in this case, the walls of Black Canyon. The maximum hydrostatic pressure at the bottom of Hoover Dam, a hybrid gravity-arch structure, is about 22 tons per square foot; the average on the dam wall is, of course, about half that. Because vertical walls are more likely to collapse under such immense loads, the downstream side of the dam is sloped; the Lake Mead side is almost perpendicular. The final profile of the wall was evolved over almost a decade of study by

about two hundred engineers and other staff at the Bureau of Reclamation's Denver design office; private consultants also were retained.

A tentative design of around 1920 envisaged a simple concrete gravity dam; at first there was no intention to generate hydroelectricity, so no powerhouses were included in the scheme. For a couple of years other dam types were considered: earth and rock-fill, concrete-faced rock-fill, as well as all-concrete alternatives—gravity, arch, and multiple arch. Proposals began to firm up after the Fall–Davis Report was published. Although alternative sites were available, Boulder Canyon and the nearby Black Canyon, 20 miles downstream, both had the advantage of being deep narrow gorges with steep walls; moreover, they offered large storage capacity and proximity to prospective users in Southern California. Davis initiated work on a high dam and hydroelectric plant in the vicinity of Boulder Canyon. By the start of 1924, all alternatives except concrete-faced rock-fill and concrete gravity or arch structures had been discarded. In February Davis's chief engineer Frank Weymouth produced an alternative preliminary design for a concrete arch structure at Black Canyon, because that site would allow for a more economical solution springing from savings in "logistical expenses." It would also provide a larger reservoir for a given height of wall. Weymouth's massive curved gravity dam included three diversion tunnels on the Nevada side but no spillways; in the event of unusual floods the wall would be overtopped. Although outlet conduits through the structure were provided against future development, the scheme did not include hydroelectric generation.

The passing of the Boulder Canyon Project Act allowed the Reclamation Bureau's Denver office to accelerate work on the design. The secretary of the interior had already appointed the Colorado River Board—engineers and geologists who would evaluate the economic, safety, and engineering feasibility aspects of alternative proposals. By 1928 hydroelectric generation had become an integral part of the project. John Savage, the Bureau's designing engineer, revised Weymouth's "a preliminary study [for] estimating cost" and produced two alternative schemes for gravity-arch structures, One located the power plants and outlet works on the Nevada side of the canyon with two circular vertical shaft spillways on the Arizona side. The other, which formed the basis for the final design, included a U-shaped powerhouse at the base of the dam with spillway tunnels and double banks of outlet works contained in *both* canyon walls. Water would be supplied to the power plant turbines from intake towers. The scheme included two diversion tunnels on each side of the river and two unregulated "glory-hole" spillways connected to the diversion tunnels—by July 1930 they had been superseded by two side-channel spillways with control gates. By the time that the construction contract was awarded in 1931, a few more refinements had been made. The design of Hoover Dam as it was modified and built was (as all such vast and complex projects are) a collaborative effort by Davis, Weymouth, and Savage and many others, and cannot be credited to any individual.

In July 1930 the U.S. Congress appropriated $10.66 million for the commencement of the Boulder Dam Project. *Time* magazine announced that Wilbur approved a construction order and had sent a telegram to resident U.S. engineer Walker R. "Brig" Young in Las Vegas: "With dollars, men and engineering brains we will build a great natural resource . . . make new geography . . . start a new era . . . conquer the Great American Desert. To bring about this transformation requires a dam higher than any the engineer has hitherto conceived or attempted to build." Boulder City, a town for workmen, was to be established near the dam site; a spur line of the Union Pacific Railroad was to be built to connect the new settlement to Las Vegas, 23 miles away, and to the dam site, 7 miles away; and transmission lines were needed to bring power 220 miles from San Bernardino.

In January 1931 the Reclamation Bureau invited bids for the dam and power plant. Each bidder was asked for a refundable $2 million bid bond, and the winner had to lodge a $5 million performance bond. Three tenders "met the conditions laid down" and on March 4 the government accepted that of Six Companies Inc., a "hastily formed" (and, it might be added, unimaginatively named) consortium of half a dozen smaller contractors, that had been gathered together by Harry W. Morrison, cofounder and president of Morrison-Knudsen Construction Company. Only a conglomerate could muster enough experience, capital, and resources for the huge undertaking. Morrison sought financial backing for the project from the San Francisco banker Leland Cutler and as a result a broad range of expertise was assembled:

> The Wattis Brothers of Utah Construction were well known for their expertise in building the early railroads in the western United States and Mexico. The JF Shea Company had started out as a plumbing business and was experienced in tunnel building and other underground work. Charles Shea knew people at the Pacific Bridge Company, and he convinced them to bring their expertise and capital to the project. Felix Kahn of San Francisco's MacDonald and Kahn had built a number of large buildings in San Francisco and contributed $1 million to the project. Henry Kaiser and Warren Bechtel were experienced in road building.[3]

Six Companies' successful bid was $48,890,955. For reasons that are suggested below, the figure was only $24,000 above the Reclamation Bureau's own estimate. The next lowest tender was $5 million higher, and the other $10 million. Six Companies agreed to pay a daily penalty of $3,000 if the 7 years allowed for the work was exceeded. As it happened, the dam would be completed 2 years, 1 month, and 28 days ahead of schedule.

That brings us to Frank T. ("Hurry-up") Crowe, whom Six Companies cannily appointed as construction superintendent, who was then 59 years old. Since 1905 he had worked on projects for the Reclamation Bureau, latterly as its general superintendent of construction. In 1921 he had resolved, "I'm going to build Boulder Dam!" Having worked on preliminary costings with Davis in 1919 and having assisted with the design in 1924, he was already

intimate with the dam. He had also worked with Walker Young, who was to be the construction engineer. When in 1925 the Reclamation Bureau began outsourcing work to private firms, instead of building its own dams, Crowe was confronted with a dilemma: he could remain in the government's employ, promoted to a desk job, or he could seek work in the private sector. He moved to the Morrison-Knudsen Construction Co. and (according to some sources) when the government announced that the dam on the Colorado would proceed, it was Crowe who convinced Morrison to form the consortium and bid for the contract, using the estimates that Crowe himself had worked up.

FIRST, HOUSE THE WORKERS, THEN BUILD THE DAM

Arriving at Six Companies' Las Vegas offices on March 11, 1931, Crowe first had to address the government's plans for Boulder City. Then, the town site comprised only a rail yard and Government Survey Camp Number One; set up in August 1930 it was surrounded by a makeshift camp called McKeeversville. Within days of the signing of the Boulder Canyon Project Act, the *Las Vegas Age* surmised that seven thousand workers would be needed. The news spread and, despite Wilbur cautioning against "a great rush of workmen to the barren dam site" where their services were not yet needed," more than five thousand men, many with their families, flooded into the area in hope of finding a job. Before work even began, Six Companies' offices received over twenty-four hundred applications and twelve thousand letters of inquiry. Local riverman Murl Emery recalled, "People came with their kids . . . with everything on their backs. Their cars had broke down before they got here and they walked." By May 1931 hundreds of families had set up squats along the highway between Las Vegas and the dam site. Probably the most notorious settlement was Hooverville—indeed, there were shanty towns called Hooverville all over the United States, established by those made homeless by the deepening Great Depression—where "the shacks were built out of most anything—tin cans, cardboard boxes, piano boxes, anything that they could find to live in."

Two other communities, called Oklahoma City and Pitcher respectively, were the focal point of the many disturbances and "most of the murders." Other writers have identified Williamsville, a sprawling squatters' camp "down by the river where the heat was most intense," as "the most infamous community" (its inhabitants dubbed it "Ragtown" or "Hell's Hole"). In July 1931 the average daytime temperature was 119° Fahrenheit; on one day, it reached 143° at noon. That summer, more than twenty-five workers and Ragtown residents died of heat prostration. Fresh food spoiled, even if was stored underground. To help out, Emery trucked canned goods from Las Vegas, charging people what they had paid "back home" on an honor system. His generosity went far toward creating, in such improbable circumstances, a sense of community. As well as his store there was a baker and a barber, and

the "rudimentary dirt streets had high-sounding names such as Broadway and Riverside Drive. There were church services and a small school. Citizens formed a Welfare Club and Ladies' Aid Society. . . . There was a post office and an information bureau." By fall 1931, Ragtown's population had reached four-teen hundred, exacerbating health problems: the silty water from the Colo-rado was unfit to drink, causing recurrent outbreaks of dysentery. Sanitation, too, was extremely primitive.

Walker Young had chosen a wind-swept ridge as the location of Boulder City, and the Denver architect Saco DeBoer had been commissioned to design America's first "fully developed and implemented experiment in town plan-ning." After the 1929 market crash his opulent proposal, that included a green-belt and golf course, was "scaled back," and Walker and Crowe produced a simpler plan that selectively followed DeBoer's. One critic laments, "Unfortu-nately, DeBoer's plan was scrapped as ridiculous . . . in favor of a more Levittown approach: build quickly, sensibly, and rectangularly, and leave the landscaping for others to worry about. The town was thrown into place." Boulder City's train station opened in February 1931, and construction of the triangular town began. The Bureau's Administration Building stood at the northern apex. South of it, landscaped streets were lined with "nice little [two-roomed houses with] nice porches" for the government's small opera-tions and maintenance crew, who would remain Boulder City after the dam was completed. There was also a mansion for Crowe.

Six Companies was required to provide housing for 80 percent of its workers—buildings that would be demolished when the project ended. For single men it built eight dormitories and a large open-sided wood and can-vas mess hall, catered by Anderson Brothers Supply Co. For families the company built "monotonous rows of slapdash wooden cottages." They were dubbed "dingbat houses" because of their shoddy, quick construction, and dust blew in through cracks in the walls and doorways. The streets were unpaved, and the lots were not landscaped. In November 1931 Six Compa-nies opened a twenty-bed hospital. It also printed scrip—tokens in place of U.S. currency—and issued credit cards to be used in the company store. Workers who set up a tab would have what they owed deducted from their next pay check.

Despite being conceived as a temporary town, Boulder City soon became a community. Residents began planning long-term development, and they soon successfully petitioned Six Companies and the federal government to replace the cottage schools that were already operating with a state-funded school. By late spring 1932—which just happened to be a presidential election year—Ragtown and the other camps had been vacated, and the new town had "lawns, city parks that were more than dust lots, and trees that shaded its inhabitants from the unforgiving sun," all laid out by a landscape gardener ironically named William Weed. At the pinnacle of construction activity at the dam, Boulder City's population of seven thousand Whites and a few Native Americans was the highest of any town in Nevada. But African Americans

were excluded; the handful who worked on the dam were forced to commute every day from Las Vegas.

The cadaverous Sims Ely—his son was Ray Wilbur's personal assistant, so there was a whiff of nepotism in the air—was appointed as Boulder City manager. His iron fist "controlled every aspect of the city's economy and morality," exercising absolute power. And although the Reclamation Bureau appointed an advisory committee, its members were picked by Young and answerable through Ely to him. Although the governance of the municipality was for the most part benevolent, it was a benevolent dictatorship, and the residents had no say in running it. Historian Dennis McBride writes,

> If there was any resentment of . . . the creation of a police-state atmosphere, it was not expressed loudly. . . . [The official list] of applicants for jobs at Hoover Dam, numbering twenty-two thousand at the close of 1932, cast a long shadow . . . and it was evident that from the outside looking in, Boulder City, where everyone had a job, a full stomach, and a roof overhead, appeared to be the model town the government said it was, whatever the reality.[4]

BUILDING THE DAM

The primary task on the Colorado was to divert the river, so that the dam could be built. At first, workers and equipment were ferried in on Murl Emery's barges; later, roads were built, and the site was reached by truck. In May 1931 excavation began at each end of four 56-foot diameter, 4,000-foot long tunnels through the rock, two on either side of the river. The heat, dust, fumes from explosives, and exhaust gases from trucks—quite apart from the deafening noise—made conditions unbearable, literally so for some. Working in three shifts around the clock, many men became ill. In the summers several died of heat prostration; in the winters it was freezing.

To expedite the work eight "drilling jumbos" were built—steel-framed, two-level platforms on the backs of army trucks that carried up to thirty men with pneumatic drills. The jumbo was backed up to the working face, and the drillers went to work making holes in which to pack the explosive charges. This allowed all of the holes needed in one-half of the tunnel face to be prepared simultaneously. Then the jumbo was moved to the other side of the tunnel so that drilling could begin while the finished holes were packed with powder and wired. When both sides were drilled and the entire rock face was filled with explosives, the jumbo was removed and the wall was blasted. After a safety inspection, the thousands of tons of rock and earth spoil were removed by conveyor belt "mucking" machines, loaded into trucks, and dumped in down-river side canyons. On average one jumbo crew drilled, blasted, and mucked 46 feet of tunnel in an 8-hour shift. In March 1932 work began on lining the tunnels with concrete, 3 feet thick; they were completed a year ahead of schedule.

The purpose of the cofferdams was to isolate the dam site as the waters of the Colorado were diverted through the tunnels. The "upper" cofferdam of concrete-faced rock was started in September 1932, about 600 feet downriver from the tunnel inlets. It was 98 feet high, 450 feet long, and 750 feet thick at the base and before it could be built, 250,000 tons of silt were removed to expose a bedrock foundation. Already the workers known as "high scalers" were removing loose material from the canyon walls above the main dam and power plant sites, establishing a stable interface between the natural rock and future concrete. Construction of the lower rock-filled earth cofferdam, 66 feet high, 350 feet long, and 550 feet thick, and protected by a rock barrier, was postponed until that work was complete. All the diversion work was finished before the spring floods of 1933. The mighty Colorado was channeled through the tunnels, and the main task could begin.

The quantities of materials used to build Hoover Dam are too great to have any meaning for us. The Bureau of Reclamation lists, for example, more than 5 million barrels of cement (almost as much as it had used in all its works over 27 years), 45 million pounds of reinforcement steel, gates and valves weighing 21.67 million pounds, 88 million pounds of plate steel and outlet pipes, 6.7 million pounds (840 miles) of pipe and fittings, 18 million pounds of structural steel, and 5.3 million pounds of "miscellaneous metal work." Such figures convey little to us.

Power shovels dug out the silt of millennia—1.76 million tons of it— to reach bedrock at an average depth of 120 feet. On June 6, 1933—now 18 months ahead of schedule—Six Companies started pouring the dam's concrete base; 5 months later pouring began at the U-shaped powerhouse at the toe of the dam. A river-level plant upriver from the site had been used to mix concrete for lining the diversion tunnels, and its output was now turned to the lower levels of the dam, and carried to the site in 4- and 8-cubic yard bottom dump buckets by truck or (later) by electric trains. Crowe employed a sophisticated and efficient system for delivering the concrete (and even workers and equipment) that he had developed at the Arrowrock Dam on the Boise River in Idaho in 1911. The huge dump buckets were lifted from the cars and lowered into place from an overhead cableway. Of the nine such cableways at Hoover Dam, five were carried on moveable towers, allowing them to be repositioned. Later, as the dam rose, an automated concrete mixing plant was built on the canyon rim.

The strength of concrete depends on the ratio of water to cement—the more water, the less strength. For all parts of the dam, a very dry mix was needed. Concrete hardens through a two-stage chemical process, known as an initial and final set or curing; the dryer the mix, the more rapidly the initial set takes place. If it was moved too slowly between the mixing plant and the dam, curing would begin while the concrete was still in the dump bucket. So crane operators became the critical workers on the project, and they were paid three times the minimum wage. As each bucket of concrete was dumped, a team of seven "puddlers" consolidated it with shovels and pneumatic vibrators.

The huge mass of concrete in the dam generated tremendous heat as it cured. The Bureau of Reclamation's engineers calculated that if the dam were built in a single continuous pour (in itself, that was logistically impossible), the concrete would have taken 125 years to cool to air temperature, while the resulting stresses would have caused the dam to crack. The problem was overcome in two ways. First, the dam was built in 5-foot lifts as a series of interlocking trapezoidal columns, varying in size from about 25 feet square at the downstream face of the dam to about 60 feet square at the upstream face (someone has said, "Think 'giant Lego set'"). Second, the prefabricated wooden formwork for each of the columns, besides the cage of steel reinforcement, contained coils of thin-walled steel pipe; when the concrete was poured, river water was passed through these coils, followed later by chilled water from a refrigeration plant. When each module had cooled the pipes were cut, and grout was injected under pressure. The interlocking grooves between the columns were also grouted, creating what amounted to a monolithic structure.

The last concrete was placed on May 29, 1935. President Roosevelt dedicated the dam on September 30, but the powerhouses, spillways, and other features were not completed for another 5 months. By the end of 1936 the first three hydroelectric generators were in service; two more followed in 1937, and another two in 1938. By 1961 there were seventeen turbines in operation.

A WORD ABOUT ARCHITECTURE: "TAKING THE PLAINNESS OFF"

It seems that the Reclamation Bureau engineers were content for the aesthetic of the dam to follow "a Neo-Classic style." Appropriately, they were more concerned with performance than appearance. But such an epic-making technological icon hardly lent itself to historical architectural styles. As one critic points out,

> As a marvel of engineering, the Hoover Dam would inevitably be associated with the modern. No dam of this scale had been attempted before; that fact that technological innovations were required to build it was understood implicitly. In this context, though, the word modern simply implies advancement, an adherence to the forward-looking quality of design as new materials and new techniques became available through the first half of the twentieth century.
>
> The Hoover Dam also became an icon of modernism, that certain mode of design which emerged from Europe in as disparate forms as Gropius's Bauhaus or the 1925 Paris *Arts Décoratifs et Industriels Modernes* show; out of these came the International Style and Art Deco. Although the Hoover Dam's design was not specifically allied with a sub-movement of modernism, the attempt was made to create an aesthetically pleasing—and Modern—façade.
>
> The original design for the dam's facade by Bureau of Reclamation engineers made it clear that an architect needed to be brought in. Although the engineers' design was highly functional, the unbalanced outlet houses, government-office

powerhouse, and massive eagles set on the roadway towers clashed violently with the image projected of Hoover Dam as a modern structure.[5]

From 1927 Americans had access to an English translation—*Towards a New Architecture*—of the Swiss architect Le Corbusier's seminal work of 4 years earlier, *Vers une architecture*. He wrote: "The engineer's Aesthetic, and Architecture, are two things that march together and follow one from the other: the [first] being now at its full height, the other in an unhappy state of retrogression. The Engineer, inspired by the law of Economy and governed by mathematical calculation, puts us in accord with universal law. He achieves harmony."[6] According to Le Corbusier's ideal, the engineering constraints of Hoover Dam, and not some arbitrary style, should have been the wellspring of its aesthetic. For about a decade before design of the dam started, European architects, especially in Germany and The Netherlands, had sought to express *zeitgeist*—"the spirit of the age," and as early as 1914 the manifesto *Futurist Architecture*—possibly written by the Italian Antonio Sant'Elia—had declared, "The decorative value of Futurist architecture depends solely on the use and original arrangement of raw or bare or violently colored materials." Sant'Elia in fact had built little, but his dramatic drawings (ironically, inspired by American industrialism) survive; many from 1913 to 1914 are of power stations.

Yet, as noted elsewhere in this book, well into the twentieth century most American architects continued to embrace styles inappropriate to the industrial age. It seems that European Modernism was too austere for them, or at least a case of "too much, too soon." Perhaps political reasons gave rise to their caution; after all, most Modernists were socialists, and some even communists; the *Neue Bauen* (New Building) came from Germany, a recent enemy. On the other hand, the 1925 Paris *Exposition Internationale des Arts Décoratifs et Industriels Modernes* had a major (albeit superficial) influence in America, and the "Art Deco" style—"modernism with the plainness taken off"—was acceptable. So "Modern" was out; "Moderne" was in.

In 1931, while the Los Angeles architect Gordon B. Kaufmann was helping to design the prosaic Boulder City Administration Building, he was asked to comment on the aesthetics of the dam. His response, no longer available to us, seems to have moved the Reclamation Bureau to engage him to "develop a more modern appearance" for it. As one writer put it, "the circumstance of hiring [Kaufmann] . . . occurred very late in the design process and was very much separate and distinct from the rest of project."

Arriving in California in 1914, London-born Kaufmann had established a parochial reputation with his Moderne works, described by some as "Spanish Mission-Art Deco hybrid." Before and during his involvement with Hoover Dam he built Scripps College, Claremont, California (1927–1930); the Athenaeum and dormitories at Caltech (1928); and the *Los Angeles Times* Building (now the *Times-Mirror* Building) of 1931 to 1935. Architectural historian

Richard Guy Wilson asserts that Kaufmann, given the chance to make his mark on Hoover Dam, "took the banal details of the engineers and [turned them] into one of the great moderne landmarks of the 1930s." The Englishman sought "a visual scheme that would complement rather than clash with the engineer's design." He later insisted that "There was never any desire or attempt to create an architectural effect or style but rather to take each problem and integrate it to the whole in order to secure a system of plain surfaces relieved by shadows here and there." Wilson describes the outcome:

> On the crest, the overhanging balcony and four unequal towers gave way to a series of observation niches and towers that rise from the wall and continue upward unimpeded. The emphasis, according to Kaufmann, was on "an orderly series of small vertical shadows punctuated by the larger shadows of the elevator and utility towers." He treated these extrusions as continuations of the dam face, not as separate moldings. The four large towers have cutback corners and tops reminiscent of the set-back *Los Angeles Times* Building, but were treated much more simply. The two outer towers were for utilities and public restrooms, while the two inner towers acted as public entrances to the dam.[7]

It has been said that Kaufmann gave the dam its futuristic style, with the electrical transformers anticipating sets in the 1939 space movie *Buck Rogers* and the intake towers emerging from the lake "like rockets to the moon." He also streamlined the spillways, redesigned the two 230-foot-high wings of the power plant in the stripped-Classicism style and created the night-time illumination of the dam with lights atop the intake towers. At Kaufmann's invitation, the Denver muralist Allen Tupper True decorated the power plant's terrazzo floors with Art Deco medallions translated from Southwestern Native American geometric motifs. A team led by Italian immigrants Joseph and John Martina, also of Denver, laid the floors in 1936 and 1937.

The dedicatory monument on the Nevada side of the dam was created by the Norwegian-born sculptor Oskar J. W. Hansen, following a national competition held in 1935. A 142-foot flagpole stands between two 30-foot-high seated bronze figures on 6-foot black diorite bases. Naming them the "Winged Figures of the Republic," Hansen saw them as "an inspirational gesture . . . that symbolizes the readiness for defense of our institutions and keeping of our spiritual eagles ever ready to be on the wing" that expressed "the immutable calm of intellectual resolution, and the enormous power of trained physical strength, equally enthroned in placid triumph of scientific accomplishment," whatever that meant. Richard Guy Wilson calls them "surrealistic apparitions" that "underscored the unreality of a dam and lake in the middle of a hostile desert." The black terrazzo floor around the bases is inlaid with a celestial map that Hansen believed would indicate "in remote ages to come" the precise astronomical time of the dam's dedication. Nearby and raised above the floor is a compass, framed by zodiacal signs.

Hansen also designed a low-relief bronze triptych commemorating those who died building the dam. Originally placed in the canyon wall on the Arizona side, is now near the Winged Figures. It reads,

> They died to make the desert bloom. The United States of America will continue to remember that many who toiled here found their final rest while engaged in the building of this dam. The United States of America will continue to remember the services of all who labored to clothe with substance the plans of those who first visioned the building of this dam.

The only external ornament on the dam is also by Hansen: panels of five cast-concrete low-reliefs above the entrances of the two elevator towers. Those on the Arizona tower, with the inscription "Since primordial times, American Indian tribes and Nations lifted their hands to the Great Spirit from these ranges and plains. We now with them in peace buildeth again a Nation," portrays the original inhabitants of the region. Those on the Nevada tower illustrate the dam's purposes: flood control, navigation, irrigation, water storage, and power. Of course, all Hansen's work—monument, plaque, and reliefs—was of its time. The question could be asked: Is it Kaufmann's architecture or Hansen's sculpture and True's mosaics that have led some critics and historians to classify Hoover Dam as "Art Deco"?

THE "WORKING STIFF"

Frank Crowe received a $350,000 bonus for his role in building Hoover Dam. But altogether, twenty-one thousand men worked on the project. When activity peaked in June 1934 the daily number reached 5,128, although the average over the history of the job was thirty-five hundred. The lowest-paid received fifty cents an hour, the highest a princely $1.25.

Only American citizens were employed, and Six Companies gave priority to World War I veterans and even some from the Spanish-American War (most of whom would have been at least 50 years old). The contractor specifically prohibited hiring Chinese, whom it styled "Mongolians." And despite government pressure, Six Companies hired very few African Americans—around thirty in all—and for only the worst jobs. Native Americans worked as high scalers. In 1933, *Fortune* magazine described the White "working stiff" who predominated at Hoover Dam:

> His average age is thirty-three. His average wage is sixty-eight cents an hour. He is taller and heavier than the average U.S. soldier, runs a greater risk of losing his life, and has passed a more drastic physical examination. . . . He likes hunting better than baseball, horse racing better than either. He'll pick a grudge, or smell bad luck, mosey out and hit the road or the rails, but while he works he is inspired with a devil of loyalty, shrewdness, and skill.[8]

Hoover Dam construction began with nonunion workers. The isolation of the construction site enabled the government to run it as a federal reservation, allowing access only those willing to work on the government's terms. The first intervention by the militant union, Industrial Workers of the World (IWW) occurred in 1931. On August 7 Six Companies cut the pay of about thirty "muckers"—the lowest-paid laborers who loaded spoil from the diversion tunnels onto trucks. Despite assurances that nobody else's pay would be affected, 125 workers went on an 8-day protest strike and seized the occasion to air other grievances. They demanded clean water and flush toilets; they also wanted the contractor to conform to the mining laws of Nevada and Arizona. Frank Anderson, an IWW organizer, urged the strikers to unionize. But regarding him with "suspicion and contempt," and (of course) afraid of losing their jobs in the Depression, they voted to steer clear of the union.

Crowe enjoyed a "tough but fair" reputation in labor disputes. Because the men knew he valued—even needed—their skills, they expected him to put their case to the Six Companies' directors. They were wrong. He rejected all their claims, and the Bureau was forced to shut down the job for a week. Everyone was fired, and the contractor began hiring new crews. Young cleared the government reservation of anyone without a pass signed by him, and Six Companies sent in armed union busters to evict the troublemakers. Sims Ely and Boulder City's security chief had been conducting "covert surveillance to weed out, blacklist, and otherwise harass men perceived to be union agitators." Between October 1931 and October 1932 over one thousand were run out of town. Anderson was jailed on trumped-up vagrancy charges. The strikers' appeal to the U.S. Secretary of Labor William Doak was also turned down. Six Companies refused to reverse the pay cut, promising it would be the last, but they did provide better water and lighting. And they accelerated house building in Boulder City.

A year later the Central Labor Union of Clark County, Nevada, presented to the U.S. Senate Investigating Committee on Irrigation and Reclamation a formidable list of the "great injustices" being faced by the Six Companies' employees at Boulder Dam. Skilled mechanics were being paid less than three-quarters the rates paid elsewhere; the rents for the "dingbat" houses were 20 percent higher than those for the better houses of Reclamation Bureau employees; unmarried workers paid 30 percent more for food and lodging cost than Reclamation workers (and 65 percent more than workers in most Nevada mining camps); charges for utilities were "exorbitant and arbitrary"; and because schooling facilities were "sadly inadequate" and workers couldn't afford private school tuition, many of their children simply didn't go to school at all. Moreover, labor had "no voice in the settling of wages, hours of labor, working conditions, safety or living conditions." Yet except for a second IWW strike attempt in August 1933—also futile—there were no further major labor problems at Hoover Dam. That is not to say that working conditions had improved, but rather that industrial peace prevailed because work was so desperately scarce in those years of deepening economic depression.

Crowe had violated state law by using gasoline-powered trucks to haul debris from the diversion tunnels. At best, exhaust fumes caused respiratory problems for many workers; at worst, they were potentially or actually lethal. But company doctors insisted that the gassing victims had pneumonia. Nevada's inspector of mines threatened to sue Six Companies if it continued the practice. The contractor stalled for time, but when charges were finally laid, it brought in the U.S. Attorney's office to argue that state laws did not apply to a federal project. By the time the legal niceties of that claim were decided the tunnels were almost complete. When Nevada renewed its lawsuit, a federal court ruled that the regulation excluding gasoline-powered trucks applied to mining, but not to dams. In 1933, when several workers took civil action, Six Companies resorted to smearing the plaintiffs' reputations, and even to witness intimidation and jury tampering. Many more former employees subsequently sued, but it was not until January 1936 that fifty out-of-court settlements were made, for undisclosed amounts.

Officially, there were ninety-six industrial fatalities during the construction of Hoover Dam; some sources put the total at 112. Based on the often-cited figure of one death per million dollars spent on contemporary major projects, either statistic is alarming. Moreover, the *actual* death toll was probably higher because the casualty list excluded injured workers who died off-site as a result of on-site accidents, those killed by the insufferable heat, or those who died years later from illnesses resulting from working on Hoover Dam. No record was kept of the permanently disabled, and the only time a family was compensated was when its breadwinner was "killed dead on the spot." Reviewing Joseph Stevens' *Hoover Dam: an American Adventure,* historian Gregg R. Hennessey writes,

> Emerging from these pages is a callous and irresponsible Six Companies, aided and abetted in the early years of the project by a sympathetic Hoover administration, which exploited desperate victims of the Depression—killing and maiming hundreds—to meet deadlines, earn profits, and make reputations. The Six Companies amassed a dismaying list of ruthless actions. . . . Frank Crowe callously pushed the workers in spite of unsafe and unhealthy conditions in pursuit of company profits, in which he had a direct stake.[9]

POPULAR CULTURE

It was inevitable that such an audacious undertaking as Hoover Dam would be embraced by popular culture. Indeed, Otis Burgess Tout's *Silt: Paula helps build Boulder Dam,* the first novel about the project, was published even before the Boulder Canyon Project Act was passed. But it was some years before other fictional works appeared, including the (then) anachronistically titled *Boulder Dam,* by the prolific Zane Grey (1963) and Mack L. Townsend's obscure *Rose of Calnevaria* (1964). Later books reflected social issues: John Haase's historical novel *Big Red* (1980); *And the Desert Shall Blossom* by

Phyllis Barber (1991); *Pigs in Heaven* by Barbara Kingsolver (1993); the no-fuss titled *Hoover Dam: An Historical Novel* by Harry Birchard, "a fictionalized biography of the people who contributed to this remarkable structure" (2000); and Bruce Murkoff's critically acclaimed *Waterborne* (2004). In a different genre was Robert Davis's widely panned and implausible 1997 thriller, *The Plutonium Murders*, that reaches its climax on the Dam.

Hoover Dam has appeared in at least thirty-five movies spanning 60 years, and beginning in 1933 with some crude back projection in Twentieth Century Fox's "stylish light melodrama" *I Loved You Wednesday*. In most made since then, Hollywood ventured off the sound stages. The spectacular natural vistas and proximity to Las Vegas have provided "must-have" location shots; space prohibits listing them. But sometimes the dam had more than a bit part.

RKO Radio Pictures' *The Silver Streak* (1934)—another melodrama—included action on the cable lift, and in some movies the structure more or less was integral to the plot. The first was Warner Brothers' *Boulder Dam* of 1936 that told of a fugitive who found redemption through working on the dam; interestingly, "though many action scenes [took] place at the dam, principal photography was not allowed. A second unit filmed the site and that footage was used in rear-projection scenes." The dam is at its best in cinematic climaxes. That all started with American International Pictures' nonsensical sci-fi movie, *The Amazing Colossal Man* (1957), about a 60-foot mutant produced by a nuclear accident, who is cornered by the army on top of the dam and falls to his death in the Colorado. In *Superman: The Movie* (1978) evil Lex Luthor's nuclear ICBM triggers an earthquake whose aftershocks breach the Hoover Dam—but everything turns out fine, because the man of steel compromises himself by reversing time, and the damage is repaired by playing the special effects footage backwards. In 2007 audiences were compensated for the unconvincing model in *Superman* by the stunning special effects in *Transformers*, in which a conflict between robots in an intergalactic war begins at Hoover Dam, reprising the plot of a 1983 animated cartoon. What's more, the dam is the prison of a cryogenically frozen alien and serves as the headquarters of a secret U.S. military unit.

Hoover Dam was brought before the American public on a three-cent postage stamp (the domestic letter rate) of which nearly seventy-four million were issued in September 1935; it bore the Ickesian banner, "Boulder Dam." Since 1932 postcards—photos, drawings, monochrome, color—have proliferated, as postcards will. And there has been an avalanche of tawdry tourist stuff: clothing, calendars, lapel buttons, refrigerator magnets, coffee cups, shot glasses, paperweights, 2- and 5-inch "replicas," and of course snow domes (those with silver glitter and moving dice double as Las Vegas souvenirs, all at no extra cost).

It is stressed that Hoover Dam has not been made an icon by books, films, or souvenirs, whether serious cultural creations or spurious commercial kitsch; rather, *they* exist because *it* has been always an icon of greater values. That quality is eloquently explained in the words of others.

A WONDER OF THE INDUSTRIAL WORLD

One website inexplicably includes the dam among the "Seven *Forgotten* Modern Wonders of the World." Such nonsense is not worth referencing. Even if the claim were justified—and certainly it is not—in 2003 the British Broadcasting Corporation dramatically recalled the great structure to mind in its internationally broadcast and stunning "docu-drama" series, *Seven Wonders of the Industrial World*. The prerelease publicity read,

> As people found their way across the vast American continent, they were stopped only by a poor or hostile environment, such as the desert regions of Arizona and Nevada. Even here . . . engineers began to realise it would be possible to make the desert bloom by building a dam across the Colorado River. Sixty stories high and with a larger volume than the Great Pyramid at Giza, Hoover Dam would break all records.

Herbert Hoover, making a spur-of-the-moment change of itinerary in November 1932 so that he could visit the construction site, proclaimed, "Civilization advances with the practical application of knowledge in such structures as the one being built here in the pathway of one on the great rivers of the continent. The spread of its values in human happiness is beyond computation." That is, if one sets aside the poverty, unhappiness and suffering of the men who built it. Yet, 70 years later historian Dennis McBride perceptively wrote,

> Even though its foundation was laid in a mire of economic misery and personal tragedy, Hoover Dam stands today as an inspiring example of ingenuity and perseverance. As more years divide the dam's present from its past, those who were involved in its construction regard it with pride and affection. Its place in the history of the United States and in the development of engineering methods remains unchallenged. Long after the story of its making has been forgotten, Hoover Dam will endure, its origins lost in time, its builders passed into myth.[10]

NOTES

1. Haven, Janet, The Hoover Dam: "Lonely Lands Made Fruitful." http://xroads.virginia.edu/~MA98/haven/hoover/intro.html

2. Steinberg, Theodore, "That World's Fair Feeling: Control of Water in 20th-Century America." *Technology and Culture,* 34(April 1993), 401–409.

3. "Historic Construction Company Project: Hoover Dam." www.constructioncompany.com/historic-construction-projects/hoover-dam/

4. McBride, Dennis, "Sims Ely: The Boulder City Dictator," in A.D. Hopkins and K.J. Evans, eds., *The First 100: Portraits of the Men and Women Who Shaped Las Vegas.* Las Vegas: Huntington Press, 1999.

5. Le Corbusier, *Towards a New Architecture*. New York: Payson and Clarke, 1927. Introduction. Translated by Frederick Etchells.

6. Haven, Janet. "Modernity and the Hoover Dam." http://xroads.virginia .edu/~ma98/haven/hoover/modern.html

7. Wilson, Richard Guy, "American Modernism in the West: Hoover Dam," in Thomas Carter, ed., *Images of an American Land*. Albuquerque: University of New Mexico Press, 1997, 302–303.

8. Anon. "The Dam." *Fortune* (September 1933), 74–88. www.usbr.gov/lc/ hooverdam/History/articles/fortune1933.html

9. Hennessey, Gregg R., [Review of] Joseph E. Stevens, *Hoover Dam: An American Adventure*. *Journal of San Diego History*, 35(Spring 1989). www .sandiegohistory.org/journal/89spring/br-hoover.htm

10. McBride, *op cit.*

FURTHER READING

Allen, Harris C. "It Can Happen Here: A Classical Scholar Learns a Modern Language." *Architect and Engineer*, 129(May 1937), 13–33.

Billington, David P. *Big Dams of the New Deal Era: A Confluence of Engineering and Politics*. Norman: University of Oklahoma, 2006.

Boulder Dam Association. *The Federal Government's Colorado River Project*. Washington, D.C.: U.S. Government Printing Office, September 1927.

Brooks, Nancy Growald. "Hoover Dam: Building an American Icon." *Blueprints*, 16(Summer 1998), 4–7.

Cooley, John, ed. *Exploring the Colorado River: Firsthand Accounts by Powell and his Crew*. Mineola, NY: Dover, 2004.

Dunar, Andrew, and Dennis McBride. *Building Hoover Dam: An Oral History of the Great Depression*. New York: Twayne Publishers, 1993. Reprinted University of Nevada Press, 2001.

Hansen, Oskar. *Sculptures at Hoover Dam*. Washington, D.C.: U.S. Government Printing Office, 1968.

Kaufmann, Gordon B. "The Architecture of Boulder Dam." *Architectural Concrete*, 2(no. 3, 1936), 3–5.

Lyman, Wilbur Ray, and Northcutt Ely. *Hoover Dam Documents*. Washington, D.C.: U.S. Government Printing Office, 1948.

McBride, Dennis. "Frank Crowe (1882–1946)." In A. D. Hopkins and K. J. Evans, eds., *The First 100: Portraits of the Men and Women Who Shaped Las Vegas*. Las Vegas, NV: Huntington Press, 1999.

Rocca, Al M. *America's Master Dam Builder: The Engineering Genius of Frank T. Crowe*. Lanham, MD: University Press of America, 2001.

Stevens, Joseph. *Hoover Dam: An American Adventure*. Norman: University of Oklahoma Press, 1988.

U.S. Department of the Interior, Bureau of Reclamation. *Hoover Dam*. Washington, D.C.: U.S. Government Printing Office, 1950.

U.S. Department of the Interior, Bureau of Reclamation. *Hoover Dam, Power Plant and Appurtenant Works: Specifications, Schedule, and Drawings*. Washington, D.C.: U.S. Government Printing Office, 1930.

U.S. Department of the Interior, Bureau of Reclamation. *The Story of Hoover Dam*. Washington, D.C.: U.S. Government Printing Office, 1966.

Wilson, Richard Guy. "American Modernism in the West: Hoover Dam." In Thomas Carter, ed. *Images of an American land*. Albuquerque: University of New Mexico Press, 1997.

Wilson, Richard Guy. "Machine-Age Iconography in the American West: The Design of Hoover Dam." *Pacific Historical Review*, 54(November 1985), 463–493.

Wilson, Richard Guy. "Massive Deco Monument: The Enduring Strength of Boulder (Hoover) Dam." *Architecture: The AIA Journal*, 72(December 1983), 45–47.

Wolf, Donald E. *Big Dams and Other Dreams: The Six Companies Story*. Norman: University of Oklahoma Press, 1996.

INTERNET SOURCES

Haven, Janet, et al. *The Hoover Dam: Lonely Lands Made Fruitful* (University of Virginia American Studies Program and the 1930's Project). http://xroads.virginia .edu/~1930s/DISPLAY/hoover/ (Accessed June 2007).

Official Hoover Dam website. www.usbr.gov/lc/hooverdam/

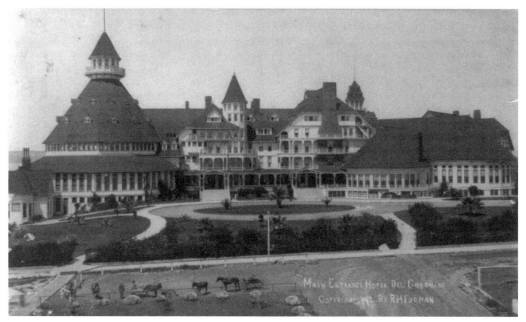

Hotel del Coronado, San Diego, California

"A vestige of the gilded age"

The contrived publicity and name dropping that permeates most of the literature about the Hotel del Coronado is hardly needed to establish or even add to the building's iconic standing: that already existed early in the twentieth century. In 1931 the novelist Edmund Wilson described it in *The New Republic* as "the most magnificent example extant of the American seaside hotel" of the Gilded Age. Observing that it still had "its beauty as well as its magnificence," he wrote, "White and ornate as a wedding-cake, polished and trim as a ship, it makes a monument not unworthy to dominate the last blue concave dent in the shoreline before the United States stops and the Mexican Republic begins." Those similes were seized upon by advertising copy-writers for years to come and even borrowed to describe other hotels.

Today his view is widely shared. In 2007 the American Institute of Architects conducted a popular survey to determine the nation's favorite architecture. The hotel was placed eighteenth in a list of one hundred fifty buildings. The grand hotel began climbing the "landmarks ladder" in 1970 when it was placed on the California Landmark Registry as a San Diego County Historical Landmark. In May 1977 the U.S. National Parks Service designated it a National Historic Landmark, with the accolade, "this enormous timber structure, rising from the Coronado Peninsula like a castle, was one of the last of the extravagantly conceived resort hotels in Southern California." It is also one of fewer than twenty-five hundred nationally significant places on the National Register of Historic Places, so "designated by the Secretary of the Interior because they possess exceptional value or quality in illustrating or interpreting the heritage of the United States," and therefore a "cultural [resource] worthy of preservation." Consequently, several travel guides remark that the Hotel del Coronado "[enjoys] more fame and historical significance than perhaps any hotel in North America."

The hotel is one of only three commercial buildings in this book. An undoubted icon for all the above reasons, from the beginning its reputation has been—and continues to be—carefully constructed by perceptive marketing that turned what could have been a financial disaster into a highly profitable business. But, as will be shown, that had little to do with the notion of icon.

CORONADO

According to anthropologists, the coastal mesas around San Diego, California, were the home of a succession of indigenous cultures—the so-called San Dieguito, the La Jollan (until between 1,000 and 3,000 years ago), and the Kumeyaay, the peaceful hunter-gatherers who arrived about 500 A.D.

The Spanish *conquistadores* of Central America lost little time in exploring the Pacific Coast to the north. In June 1542 the Portuguese-born navigator Juan Rodriquez Cabrillo sailed from Navidad on Mexico's west coast with three ships—*Vittoria*, *San Diego*, and *San Salvador*—bent upon finding gold

and the legendary northwest passage between the Pacific and Atlantic oceans. Three months later he made landfall—the first European to set foot upon California—at "a very good enclosed port" that he named San Miguel. Remaining for about a week, he established contact with the Kumeyaay before continuing north. He died in January 1543 while his fleet was wintering in the Channel Islands.

Sixty years later the Spanish explorer Sebastián Vizcaíno set out, also with three ships—*San Diego, Tres Reyes*, and *Santo Tomás*—virtually following Cabrillo's route. On November 8, 1602, he sighted, 17 miles off the coast, four islands that missionaries traveling with him named *Las Yslas Coronadas* (crowned ones) in honor of a family of four stone carvers who been martyred in 287. Five days later the little fleet reached Cabrillo's San Miguel. Vizcaíno renamed it, either in honor of San Diego de Alcalá (because it was his feast day) or for Vizcaíno's own flagship. Continuing north, in mid-December he arrived at a bay discovered by Sebastián Rodríguez Cermeño some years earlier; he renamed that also after the Count of Monterey, the viceroy of New Spain.

Despite Vizcaíno's assurance that San Diego Bay was the best port to be found in the Pacific the Spanish ignored it for more that 150 years. Then in 1769 the governor of California, Gaspar de Portolá, and Franciscan Father Junípero Serra led an overland expedition to find a route to Monterey; they reached San Diego at the end of June. Serra founded a mission on a prominent and strategic hill above the San Diego River, and the Presidio de San Diego, built to protect the missionaries, was the first of what would be twenty-one such settlements in California. Spanish maps identified the narrow peninsula that separates San Diego Bay from the Pacific Ocean as *San Diego Ysla*, but it is not an island and as late as 1877 English-speaking sailors knew it as "The Spit."

After a decade of war, Mexico gained its independence from Spain in 1821; 3 years later the Mexican Republic was founded. In May 1846 Pio Pico, the last Mexican governor, granted the 4,185-acre *Yslas o Penínsulas de San Diego* to "a prominent and well-connected citizen," Don Pedro Catarino Carrillo and his wife Josefa Bandini; some sources say that it was a wedding present. The parcel of land included today's Coronado, the narrow southern connection to the mainland (now known as Silver Strand) and North Island, then separated from Coronado by a narrow swampy isthmus. Some wedding present! Sometimes it was cut off by tides; it was overrun by shoulder-high chaparral; in fact all it had to offer was abundant game—ducks, pigeons, quails, and rabbits. Don Pedro, naming it *Ranchos Peninsula de San Diego*, attempted to use it for pasture. But 5 months later he sold it for $1,000 to Captain Bezer Simmons of the trading vessel *Magnolia* "because he couldn't find anybody who could pay more."

Four years later Simmons sold it to Archibald Peachy (a relative), William Aspinwall, and others for $10,000. Of course, by then it was part of the

United States. The Mexican–American War had spread westward from Texas, and by 1847 the Californios had surrendered. After the signing of the Treaty of Guadalupe Hidalgo in 1848 the United States purchased Mexico's territories in the southwest. That same year gold was discovered near Sacramento, and when in 1850 a burgeoning California had become the thirty-first state of the Union, the County and City of San Diego were established. Over the next decades ownership of the *Ranchos Peninsula de San Diego* changed several times. It was hardly surprising that nobody kept it for long; according to one writer, "Years and owners passed, as did experiments in growing wheat and establishing a whaling station. But with no fresh water and little rain, the land held few prospects." Then it was announced in July 1885 that an "eastern syndicate" had acquired the property.

THE CORONADO BEACH COMPANY

In that year, San Diego's population would swell from twenty-four hundred to about ten thousand. The first transcontinental train reached San Diego on November 21, 1885. Inevitably commerce in San Diego grew, with increased opportunities for trade within and beyond California. Rival railroads, having vast tracts of land to sell or lease, began undercutting each other (some offered passenger fares from Chicago to Los Angeles less than $100). The quiet years were over, and a boom was on the horizon. The County Immigration Association was established to advertise local opportunities, not least the healthy climate. San Diegan Theodore S. Van dyke wrote that since 1875 newcomers

> were in fact buying comfort, immunity from snow and slush, from piercing winds and sleet-clad streets, from sultry days and sleepless nights, from thunderstorms, cyclones, malaria, mosquitoes and bed-bugs. All of which, in plain language, means that they were buying climate, a business that has been going on now for fifteen years and reached a stage of progress which the world has never seen before and of which no wisdom can foresee the end. The proportion of invalids among these settlers was very great, at first; but the numbers of those in no sense invalids but merely sick of bad weather, determined to endure no more of it, and able to pay for good weather, increased so fast that by 1880 not one in twenty of the new settlers could be called an invalid. They were simply rich refugees.[1]

Among them was Elisha Spur Babcock, a retired railroad executive from Evansville, Indiana. When he was only age 36 and showing symptoms of tuberculosis, his physicians had advised him to make the move to the Southwest. In San Diego he met Chicagoan Hampton L. Story of the Story and Clark Piano Company, who also seems to have been there for health reasons. The circumstances and timing of their meeting remains unknown. But the two

men often rowed across the bay to what was then known as the San Diego Peninsula to hunt and fish.

Even in retirement, the capitalist was not far beneath Babcock's skin. Although he was not the first to do so (a San Diego consortium led by Milton Santee already had proposed building a resort) Babcock recognized the peninsula's potential as real estate, and he knew that a community established around a grand hotel spelled respectability for prospective home owners. As for a supply of buyers, he could depend upon the competing railroads. In December 1885 a syndicate with him as president, Story as vice president and San Diego banker Jacob Gruendike as secretary-treasurer paid $110,000 for the entire peninsula, including North Island, from the head of the bay to the mouth of the harbor. Indiana railroad stockholder Josephus Collett, lumber merchant Heber Ingle (Babcock's brother-in-law), and flour miller John Inglehart were drawn into the scheme as well.

A competition, offering a $50 prize, was launched in January 1886 to (re)name the peninsula. Very few of over one hundred entries were Spanish. Beulah, Brooklyn, Cork, Hiawatha, Lands End, Shining Shore, and Welcome City were more typical. "Miramar" was chosen and released to the local press, but one of the owners wrote to the *San Diego Union* "protesting that [it] was difficult to pronounce and recommending Coronado Beach, because it was a local name referring to the nearby islands." Ignoring geographical exactness, residents still prefer "Coronado Island."

Hundreds of laborers were employed to build an urban infrastructure—subdivision, roads, landscaping, railroad tracks, and (later) a water supply, fed by submarine pipes from the mainland. In April 1886 the Coronado Beach Company issued a prospectus, probably either written or supervised by Babcock, announcing its capitalization of a million dollars, divided into ten thousand shares. The florid preface of this "classic among early-day real estate promotions" assured investors, "we have, however, done much—in fact we have left nothing undone—preparatory to offering of Coronado beach to the esthetic [*sic*] as an Elysium, the more practical and less critical as a home, to the invalid as a sanatorium, or to the fashionable as a seaside resort of unrivalled beauty." The scheme was vigorously promoted. Purchasers were offered such bonuses as a year's free supply of water if they spent $1,000 on improvements to their land, or given 120 tickets per month—some sources say 150—for the San Diego Electric railway, the Coronado ferry and the Coronado railway. The Santa Fe Railway included a Coronado advertisement in seventy-five thousand copies of its timetables.

In May 1886 the *Los Angeles Times* reported:

> The entire peninsula has been surveyed, and the central and larger portion . . . elevated some forty feet above the sea level, has been beautifully platted and largely planted to choice trees, shrubbery, etc. The soil [is] exceptionally good. . . . A nursery of a hundred thousand plants has been established. . . .

A street railroad, to run across the peninsula from shore to shore, is under way and will be completed shortly. . . . [There is a] telephone line . . . running almost the entire length of the peninsula connecting with the main-land. . . . There are two ferry companies, a street railroad company, a hotel company, a bathhouse company, etc. . . . The hotel, it is promised, will be a grand structure, ahead of anything on the coast.[2]

In July the San Diego Development Company's W. H. Holabird was appointed to the company's sales department. Over six thousand people turned up for the first land auction on November 13, when the sale of three hundred fifty lots recouped the $110,000 paid for the peninsula. In the ensuing weeks sales often reached $25,000 a day; altogether, they generated $2.2 million. Every title included an unpopular clause stating that "no liquors shall ever be sold or drunk on the premises"; residents could drink legally only at the hotel, once it was built.

CROSSING THE WATER

Immediately after buying the peninsula Babcock and Story established the San Diego and Coronado Ferry Company. Its primary function was to transport construction workers to build the Hotel del Coronado; second, it was to promote the development of Coronado as a health resort. In 1885 the ferry *Della* went into service; first in a succession of wooden-hulled side-wheel steamers, the 21-foot craft could carry only a handful of passengers on board, so she was put to more efficient use, towing them in an open boat. Within a year she was replaced by the 100-foot *Coronado*, which continued in service from August 1886 until 1922. In 1888 the screw-driven *Silver Gate*, twice the length of *Coronado*, was launched; but 2 years later she was sold, having proven, for some unstated reason, "a complete failure as a ferry." The 92-foot *Benicia* joined the fleet at the same time as *Silver Gate*; decommissioned in 1903, she was replaced by the 118-foot *Ramona,* "the most successful of the early ferries" that plied the short route for over 25 years. *Morena*, last of the side-wheelers, served the Coronado community from 1924 until 1934.

From the late 1920s the Company bought diesel-powered vessels, all around 200 feet long. A couple were "recycled"—M.V. *North Island* (1939) and M.V. *Silver Strand* (1944)—but three were custom-built: M.V. *Coronado* (1931), M.V. *San Diego* (1931), and M.V. *Crown City,* "the jewel in the San Diego-Coronado Ferry Company fleet [and] the most modern ferry on the water." When the San Diego-Coronado Bridge opened in August 1969, the ferry service became redundant, although the Coronado Commuter Ferry still operates.

To complement their ferry company, Babcock and Story established the Coronado Railroad Company in 1886. Its first line ran about 1½ miles from the Coronado Ferry Landing to the future site of Hotel del Coronado. Until a dummy (a small steam engine considerably disguised as a coach to not frighten

horses) arrived in August, *actual* horsepower was used. A second line from the landing to Coronado Heights down the peninsula was built by the end of 1887. Six months later the company completed the Coronado Belt Line, a railroad from San Diego around the south end of the bay and up the peninsula to Coronado. Once the hotel was opened, most guests traveled to it by train; the wealthy took a private railcar because the journey from the East Coast took 7 days. The Coronado Railroad Company merged with the National City and Otay Railway in 1908 and was rebadged as the San Diego Southern Railway; following another merger in 1912, the San Diego and South Eastern Railway was established. Regular passenger services ceased in the mid-1890s, although special excursion trains continued for several years. However, freight services—two trains a week—were maintained until 1970. A "casualty" of the San Diego-Coronado Bridge, the railroad was removed in 1971.

The bridge is now the principal link between Coronado and the "mainland." The 2-mile long box girder structure, with five lanes "designed exclusively for motor-vehicle traffic" soars 200 feet above San Diego Bay—high enough for the aircraft carriers *U.S.S. Nimitz* and *U.S.S. Reagan* to sail beneath it. Begun in February 1967 and completed in mid-1969 at a cost of $50 million, it earned the "Most Beautiful Bridge" Award of Merit from the American Institute of Steel Construction in 1970.

"THIS GORGEOUS STRUCTURE OF ORIENTAL MAGNIFICENCE"

Of the hotel, Babcock's purple-prose prospectus claimed (note the tense; after all, this was written *before* the hotel was built):

> Inside the Hotel Del Coronado, the guest is at once gratified and delighted with the perfection of all the appointments. You wonder if you are in a fairy palace or a hotel of the nineteenth Century. The soft Persian rugs, the Oriental tapestries, the antique design of the furniture, the luxurious baths, the odor of orange and pomegranate blossoms, all appeal to you and you join the throng of devotees to Coronado the Lovely. . . . Close by . . . is the lawn tennis court, and when the guests, costumed like the knights errant of olden time appear, you might imagine yourself transported to the court of Louis the Fourteenth.

Even if he sometimes lost touch with reality, Elisha Babcock had maintained contact with Evansville architects James W. and Merritt J. Reid, who had worked some of his railroad projects in Indiana. James later wrote that his former client pressed him to visit Coronado and in December 1886 had "telegraphed most earnestly to come on, no matter how brief the stay." When he arrived, Babcock told him, "Right here . . . we must build a house that people will like to come to long after we are gone—I have no time, it's all up to you." It is uncertain whether "no time" referred to Babcock's busy schedule, or to his fleeting life, or to the urgency to build; in the light of events, the

latter seems most likely. The entrepreneur told his architect that the grand hotel

> would be built around a court—a garden of tropical trees, shrubs and flowers with pleasant paths—balconies should look down on the open court from every story. From the south end, the foyer would open to Glorietta Bay with verandas for rest and promenade. On the ocean corner there would be a pavilion tower and northward along the ocean, a colonnade terraced in grass to the beach. The dining wing would project at an angle from the southeast corner of the court and be almost detached to give full value to the view of the ocean, bay and city.[3]

Presented with this "vision of designing an Americanized castle in an incomparable setting" and given the chance to build what Babcock and Story promised would be "the largest hotel in the world . . . too gorgeous to be true," the Reid brothers could hardly decline the commission. As the firm's chief designer, James immediately began to make sketches. But Babcock was so impatient for work to start and no time was allowed for design development. That process was irregular: according to the architect, "Preliminary sketches were quickly prepared and . . . remained the unchanged basis of construction." More surprisingly, and despite the design-and-build arrangement with the architects, later "it was decided that the most speed in construction would be obtained if the delay of preparing drawings for contracting was avoided." At the end of the project one of the Reids' draftsmen commented upon this organic approach—although "slapdash," "hotch-potch," and "hit-and miss" are adjectives that come more readily to mind. He said that "the hotel never did seem to stop growing. . . . It was amazing how many rooms were built that were not even planned for at the start of construction."

The first practical problem Reid faced was securing enough lumber for such a large building. Little was to be had in San Diego. He recalled, "From the sketch, a lumber bill [of quantities] was taken off. With many misgivings as to adequacy and accuracy, [I took it] to San Francisco, accompanied by Mr. Heber Ingle." Together with Herman Shuster, a minor stockholder, Reid and Ingle "negotiated" to be given priority in cutting and shipping everything that the Dolbeer and Carson Lumber Company could supply. The green, rough-cut Douglas fir, sugar pine, and redwood were transported down the coast from the northern California forests on ships and barges; some were even floated as "monster rafts," towed by steam tugs. Once on-site the lumber had to be cured—because time was of the essence of the project, that simply was not to happen—planed, and finished.

Progress was also overshadowed by a shortage of skilled labor. The boom in downtown San Diego was providing plenty of work for carpenters, so Babcock offered to pay more, attracting tradesmen from as far as Chicago, although some, when they reached the Southwest found that there was more to made from real estate speculation than from "nail-pounding." But some accepted

the work and trained the novices. Forced to use inexperienced workers, Reid reported, "It was not difficult to obtain good, unskilled labor, of the only kind there was, by applying to the Chinese Seven Companies in San Francisco. As many as could work were employed at once." He developed a strategy:

> Realizing the difficulty of obtaining skilled workmen, where everyone was rich, or would be tomorrow, the foundations were started along the north front, as simpler in construction, progressing southward. The men's workmanship would gradually improve and in the meantime perhaps more and better help would be found. This proved true to some extent, but progress was constantly hampered for want of competent men and leaders, both in the drafting room and in the field.[4]

The three-story Coronado Boathouse on Glorietta Bay, built before the hotel was started, is thought by some to have been "practice run" for what was at first a largely unskilled workforce. Loosely described as a "diminutive Del and a visual masterpiece in its own right," the 40-foot square building has "a bellcast-hipped roof with a widow's walk supported by brackets; a variety of dormers graces all four sides of the roof . . . an exterior observatory area at its peak."

Soon after Reid returned from San Francisco work started on the Coronado Brick Company's oil-fueled kiln; using clay from deposits near the hotel site, it turned out half a million bricks a day for the foundation, fireplaces, and chimneys, as well as for other Coronado buildings. Chinese laborers also built a planing mill and joinery shop, a metal shop and iron works, and living quarters for several hundred workers. Permanent "auxiliary" buildings included a plant room with a 100-foot steel-and-brick smokestack that housed a steam boiler and electrical generating equipment and a laundry; it was connected to the hotel by an access tunnel. When it opened, the hotel was the largest building outside New York City to be electrically lighted. The story of Thomas Edison's personal involvement is apocryphal; there is no sign of Edison at the Hotel Del Coronado until October 1915.

Babcock's wife Isabel and Story's wife Emma performed the groundbreaking at the March 19, 1887 ceremony; 3 weeks later the first floor framework was complete. Constantly pressed to speed up construction, James Reid had to allow for the inevitable shrinkage problems that would result from using unseasoned lumber for the structural elements and wall framing. He was able to report that "the work went steadily and rapidly on in spite of drawbacks, and was greatly accelerated toward the later middle period"—that would have been 6 months into the contract—by the assistance of his brother Watson, and "Mr. Ingersoll, a young mining engineer." Although it would not be finished for another 2 years, the hotel welcomed its first guests on February 19, 1888. On that day nearly fifteen hundred people crossed San Diego Bay to see it.

As Babcock had planned, most of the 399 guest rooms were ranged in three, four, or five stories on the north, south, and west sides of a central

landscaped court, almost an acre in area. It was laid out by Katherine Olivia ("Kate") Sessions, who later became San Diego's official "city gardener." The east wing housed the main entrance and lobby, verandas, and some guest rooms. "Spared no elegance," the guest rooms almost all had a fireplace surrounded by a wooden mantel. Naturally conscious of fire hazards in a building constructed entirely of wood, Reid installed automatic gravity-feed sprinklers fed from tanks on the upper story. In 1916 they were replaced by twelve thousand pressure sprinklers. He also provided two huge concrete cisterns in the basement for storing rainwater—"a plan that never came off." Because the rooms have been continually redecorated or renovated, their original aesthetic quality is now hard to judge, but Australian architectural historian Miles Lewis remarks that a vintage photograph of a bridal suite reveals an "insipid interior with triple arcade across." The seventy-three bathrooms were communal.

It is clear from surviving images—albeit monochromatic ones—of the original interiors that stylistic integrity was not high on the Reid Brothers' agenda nor on that of their clients. The two-story lobby, with paneled walls and a coffered ceiling in dark wood, had a grand stair leading to a mezzanine; formally arranged chairs were set out within range of strategically placed spittoons. The lobby led to public rooms: some, reserved for reading and chess, also had coffered ceilings and wooden wainscoting; they were furnished with easy chairs and wicker chairs—in the manner of late Victorian interiors, all finishes were rather dark and most rooms were quite full of furniture. Other rooms were set aside for smoking, writing, and music. The bar room boasted a 46-foot long ornate mahogany bar, described by Lewis as having "a projecting polygonal corner, and a sort of baldacchino." It was crafted in Philadelphia and (reportedly) shipped around Cape Horn, fully assembled. But it should be noted that, by contrast, there was a "white and gold" drawing room, complete with white joinery and furniture, a Neo-Classical ceiling and a tiled fireplace and mantel. The hotel also provided thirty billiard tables for its clientele—four for the exclusive use of ladies—as well as four bowling alleys. Telephones were available, but not in the guest rooms.

The most universally resonant image of the Hotel Del Coronado is the great red-shingled conical roof at the southwest corner. Ringed by two levels of dormer windows and crowned with an observation gallery and flagpole, it spans, without intermediate supports, the hotel's 11,000 square-foot circular ballroom. The vast space, ringed with windows at floor level, has sloping walls rising to its flat ceiling. On the diagonally opposite corner of the hotel, crowned with steep gables and a pinnacle, is the seven-hundred-seat dining room—the Crown Room. Said to be Reid's "special pride," it is summarily and pragmatically described by one writer as "156 feet long, 62 feet wide and 33 feet high, built without pillar or post. It is ellipsoidal in plan and has self-supported vaulted ceilings." In fact the rib-vaulted sugar pine ceiling was "fitted together with pegs and glue, without a nail in it." A more

effusive account of the space appeared in *The San Diego Union* in February 1888:

> This vast and elegant room, with its wealth of appointment, is a rare sight, especially under the brilliant incandescent lights that illuminate it. The polished floors, over which an army of trained servants noiselessly glide, the high inlaid ceilings, the snowy linen and the flitter of the silverware and glassware combine to make it a most charming picture. The room may have its equal . . . but it certainly is not surpassed anywhere.[5]

The hotel's architecture often is classified as Queen Anne Revival style. The broader Queen Anne movement, sometimes called Vernacular Revival, originated in England at the height of Empire as the result of search for a home-grown form, "modeled loosely on Medieval Elizabethan and Jacobean architecture." The American version, as the English, was a hybrid (less-kind critics would say "mongrel"); that puts it beyond objective assessment because it is not based upon a formal system of architectural "correctness." In the United States, whatever distinctives it had can be found mixed with Colonial Revival Italianate, Stick, or Victorian styles. Babcock's brochure represented the building as "a gorgeous structure of Oriental magnificence," pointing out that the design was "a combination of old classical architecture, so modernized and modified as to partake of the excellencies of the different schools it represents. The whole has been so successfully harmonized as to produce a structure remarkable for its size, symmetry and grandeur."

An early piece in *Leslie's Illustrated Newspaper* expansively concluded that "the story of Aladdin and his wonderful palace, built in a single night, comes closer to being realized into actual fact upon this Coronado beach than possibly any other place on earth known to man." But for hyper-hype Babcock's own propaganda for the Hotel del Coronado is hard to beat:

> The building is grouped around a quadrangular court . . . which is exquisitely beautiful and already noted for the variety of its tropical and subtropical shrubs and plants. It is said to be unequaled either in Europe or America. . . . The grounds in front of it are terraced down to the very beach, where the waves of the gentle Pacific sometimes overleap their limits to steal a kiss from the bright green grass that there fringes on the skirts of Mother Earth.

Moreover (he said), "As a real sanatorium, and a pleasant all-the-year-round resort, Coronado is believed to be unrivalled." He even compared the location to Eden, with a climate "mild, dry and as pure as that of the primeval paradise. . . . From April to October there is seldom any rain here [and] the rain falls mostly at night. Here the whole year may be said to be almost one continuous summer, for flowers and fruits continue to grow simultaneously nearly all the year." That sounded like a line from Lerner and Loewe's *Camelot*. Babcock promised that anyone who suffered from "hay fever, asthma and other ailments

of the respiratory organs" would benefit from the climate, and added that the "inexhaustible springs of pure and wholesome mineral water [have] remarkable curative properties, especially in kidney and bladder ailments. Hundreds have been cured of troubles, which had long resisted medical treatment." He failed to mention that the magical bottled water—and it really *was* full of minerals— was drawn from the general supply that also filled the bathtubs at the hotel.

The advertisement in which all these lofty promises appeared concluded more practically, "Yet with all the magnificent splendor, elegant surroundings, and the other excellencies . . . the rates here are as moderate as those of any ordinary hotel, ranging from $2.00 per day and upwards by the month; transients from $3.00 per day and upwards." Babcock signed it as the manager of the Hotel del Coronado; but he was no longer the owner.

CHANGES

In 1887 the San Francisco sugar millionaire and shipping magnate John Diedrich Spreckels visited San Diego on his yacht *Lurline*. Drawn by the real estate boom, he invested in a wharf and coal bunkers. Following a financial crash in the following year, he loaned Babcock $100,000 to complete the hotel and in July 1889 bought out Story's one-third interest in the Coronado Beach Company for about half a million dollars. He soon owned controlling interest, and by 1894 the J. D. and A. B. Spreckels Investments and Securities Companies were sole proprietors. Some sources say Babcock was paid over a million dollars for his share, but how much, if anything, changed hands cannot be determined. Contemporary hotel literature recorded Spreckels as owner and Babcock as manager; by the beginning of the twentieth century, Spreckels' manager was one John J. Herman. So what became of Elisha Babcock? According to a brief biography in the online *San Diego Reader*, he "built the city's first electric-lighting network in 1904 and developed over 4,000 acres of San Diego property. However, he ended up nearly bankrupt after a flood ruined many of his businesses in 1916 and his enterprise, the Western Salt Company, failed." He died in 1922.[6]

Four years later Spreckels also died, but the Hotel del Coronado was retained by the Family Trust until April 1948. Apart from renovations, the hotel remained more or less unchanged until the 1930s, when parts of the main building were converted into convention facilities and banquet rooms. Modem heating and plumbing were provided to the guest rooms. In the late 1940s, a fifth floor containing fifty more guest rooms was added.

The Del was then sold for a reported $2 million through southern California developers, Herman Miller and M. Bert Fisher to "a nationally known hotel owner and East Coast land developer," Robert A. Nordblom and his associate Josephine C. Moore. Exploration of the tortuous deal is beyond the ambit of this essay, but Nordblom sold the property 2 days later to Barney

Goodman, during whose proprietorship the hotel was allowed to "grow shabby. The basic architecture remained superb, but the interior showed lack of care. The furniture was a combination of sagging wicker, 1920 overstuffed, 1930 chrome and 1950 Grand Rapids. A slightly musty air of neglect hung about the upper rooms."

Ownership next passed to San Diego millionaire John Alessio, who in 1960 engaged the Hollywood scenic designer Al Goodman to oversee a $2 million interior refurbishment with "special wallpaper, carpets woven to order, a spruced-up lobby, new private dining rooms and a plush new bar." In 1963 the renovated hotel was sold on to M. Larry Lawrence, who (it is said) intended to eventually demolish the 75-year-old building and redevelop the site. Instead, Lawrence undertook a 30-year refurbishment, restoration and expansion, extensively overhauling mechanical and electrical services and the heating and ventilation systems. He made structural changes and nearly doubled the available accommodation. The program, according to some sources, is estimated to have cost over $150 million.

In 1972 the Grande Hall Convention Center, providing facilities for up to fifteen hundred people, as well as offices and "back-of-house" functions, was completed on the northeastern corner. The following year the seven-story Ocean Towers, with 214 guestrooms, was added at the southwestern corner. Through the remainder of the decade a spa, tennis courts, two heated swimming pools, expanded dining spaces, retail shops, and additional car parks were built. In 1979 the Poolside Building, housing meeting rooms, and ninety-six guestrooms (bringing the total to 692) was opened. Lawrence died in January 1996; his family trust continued to operate the Hotel del Coronado until the following September, when it reverted to Travelers Insurance Company (formerly Primerica Corporation), through whom it had been refinanced in 1987.

The new owners put the resort under the management of Wyndham Hotels, a professional management company, before selling it for $330 million to Lowe Enterprises in August 1997. "Lowe Enterprises then promptly installed Destination Hotels and Resorts, their Denver-based management subsidiary, as manager." A 3-year, $55 million structural preservation, restoration, and redecoration program that included beachfront landscaping was completed in August 2001. That was not the end of The Del's story.

Two years later, the hotel was sold to a partnership of KSL Resorts Inc. and CNL Hotels and Resorts, who carried out a further $10 million renovation of guest rooms and announced the development of "North Beach," that would offer "several dozen luxury villas on the northern edge of the hotel's property. The North Beach villas would serve as both residences to their owners and hotel suites when not occupied." According to the hotel's publicity, "Beach Village consists of twelve beach front villas [that] feature dining and living spaces with fully-equipped kitchens and appliances, cozy fireplaces, spa-style baths with soaking tubs, and private terraces . . . Within this exclusive enclave,

owners and guests will also enjoy private pools and hot tubs, personalized concierge service and private access to the beach."

Needless to say, the $2 and $3 daily tariffs that Babcock advertised around 1900 have been superseded. Now, the humblest rooms at the Hotel del Coronado cost around $325 a night; for those *really* determined to enjoy luxury, $4,900 a night suites are available.

"THE PRINCE OF WALES NEVER SLEPT HERE"

During John Spreckels' ownership, the Hotel del Coronado catered to wealthy patrons from the East and Midwest. Most arrived with a retinue of servants, to "winter" for months on end. At the turn of the last century the hotel was "literally San Diego's biggest single industry":

> Tourism . . . was something more than just visiting new places. Travelers, especially the wealthy, did so for their health, believing that salt air and balmy breezes would cure asthma and gout and other minor medical disturbances. And the hotel was quick to seize on these beliefs. But perhaps the most charming bit of Victorian style physical activities were the regular rabbit hunts. Guests would dress in a variety of English hunting attire or cowboy outfits to go galloping over the sand dunes . . . chasing jack rabbits.[7]

More refined entertainments included archery, bicycling, boating, bowling, croquet, golf, swimming, and of course fine dining.

As noted, the hotel is one of only three commercial buildings among the icons in this book. Even in the days when *icon* did not have its present meaning, successive owners recognized the business value of iconic status. Although the Del's heritage department has been since 1998 "committed to safeguarding and sharing the hotel's wonderful . . . history"—"elaborating" may be politely added—over the years fable has replaced fact. Long after being disproved by reputable historians, myths continue to spread; a case in point, already mentioned, is the fiction of Edison's role in setting up the building's original electric lights.

In about 120 years, many of the rich and famous have made the Del their destination. Its public relations department has published "A-lists" of presidents from Benjamin Harrison to George W. Bush, politicians and literary figures, as well as a cavalcade of sports heroes and movie stars to support—it must be repeated, quite unnecessarily—its claim to "icon." To some of those individuals, apocryphal stories have become attached. Just a couple will make the point.

On April 7, 1920, the Crown Room was the setting for a gala banquet in honor of Britain's Prince of Wales whose ship *H.M.S. Renown* sailed into San Diego for a couple of days. Although it is apparently too romantic to die, the myth that he met Mrs. Wallis Spencer (later Simpson), for whom he later gave

up throne and empire, was convincingly scotched by Professor Benjamin Sacks in 1998.

Between 1904 and 1910 L. Frank Baum, creator of *The Wonderful Wizard of Oz*, wintered at the hotel for months at a time and there wrote several of the sequels to his successful story. Until recently there was an unsubstantiated tradition that he designed the crown-shaped chandeliers in the Crown Room (the existing ones are 1920s copies), because he thought originals "were too plain." The story was extended to assert that he also designed the chandelier in the lobby. But a 2007 press release from the hotel omitted the claims.

POPULAR CULTURE

In the 1920s "a young, carefree Hollywood discovered Del Coronado" and the clientele began to change. But for decades the resort had been no stranger to the movie industry.

The Hotel del Coronado was introduced into popular culture as a "bit player" in *Off for the Rabbit Chase*, a movie made by James White and Frederick Blechynden of the Edison Manufacturing Company Kinetograph Department and released in February 1898. A synopsis is almost as long as the film: "Two groups of horseback riders, accompanied by packs of hounds, are galloping away from the Hotel Coronado [*sic*], San Diego . . . on their way to the hunt." Three years later a Los Angeles cinephotographer named Ramsey shot scenes of the Coronado Ferry and Tent City. None of these early filmic essays was a blockbuster because there were very few venues where they could be exhibited; besides, before about 1913 the motion picture was hardly a respectable medium.

In spring 1912 Allan Dwan of the Santa Barbara-based "Flying A" Studios filmed the feature, *The Maid and the Man* at the Hotel del Coronado. In the same decade Lubin Studios of Philadelphia and the producer-director Harry A. Pollard filmed on location at the Del. Hollywood studios began to recognize its possibilities as a location after 1918, when Maxwell Productions used it for Rudolph Valentino's intriguingly titled *The Married Virgin* (aka *Frivolous Wives*). Some historians believe that in 1922 Valentino and Gloria Swanson made the now recovered *Beyond the Rocks* there. Swanson also starred in Dwan's *The Coast of Folly* of 1924, set in Palm Beach, Florida, but reputedly made on location at Coronado. Fox Film Corporation filmed *My Husband's Wives* there in the same year.

Whatever the case, these movies established the hotel as a location for films about "young men in search of fortunes and heiresses in search of romance." One critic believes that its stereotyping as a playground for the rich was fixed in 1935 with *Coronado*. Starring Johnny Downs and Jack Haley, the "typical Paramount Grade-B" movie was described by critic Hans J. Wollstein as an "utterly charming little musical comedy that was rather obviously meant as

an advertisement for San Diego's most famous hostelry, on the grounds of which it was partially filmed." Paramount's critically-panned *Yours for the Asking* (1936) also used the resort.

But there is little doubt that Billy Wilder's 1959 comedy, *Some Like It Hot*, shot partly on location at the Hotel del Coronado, did more than any other movie to affirm the hotel—albeit in the role of the fictitious Seminole Ritz Hotel in Miami—as a popular icon of American architecture. About 40 years later the American Film Institute named it as the greatest American comedy film of all time. Starring Marilyn Monroe, Tony Curtis, and Jack Lemmon it tells the story of two men who witnessed the 1929 Valentine's Day massacre in Chicago and are on the run from the mob, disguised as members of all-girl jazz band. Wilder is quoted: "We looked far and wide, but this was the only place we could find that hasn't changed in thirty years. People who have never seen this beautiful hotel will never believe we didn't make these scenes on a movie lot. It's like the past came to life."

The Del was not used again by Hollywood until 1973, when it became the anonymous setting of MGM's *Wicked Wicked*, an annoying split-screen horror film about a masked psychopath—the hotel handyman—who dismembers and reassembles a succession of blond victims. It may have been an unguarded moment on the part of management that made the hotel the setting for a slash movie. As if the resident ghost of Kate Morgan were not enough!

To go from the ridiculous to the sublime: in 1980 Twentieth Century-Fox released *The Stunt Man*, produced and directed by Richard Rush. Although hailed by critics, it was deemed "commercially unviable." One reviewer counted it among "the best American films of the 1980s, and, ironically, one of the most overlooked and unknown." The plot? According to one simplistic summary: "An escaped convict accidentally destroys a stunt shot while a movie is being filmed. When the stunt driver dies in the subsequent car crash, the film's director decides to replace him with the convict saving them both from the police." Most of the action happened inside and around the Hotel del Coronado, which the Special Effects Department dynamited in the movie-within-the-movie; architect J. Michael Abbott later ambiguously commented, "The Del . . . never looked better, including parts where they blow it up!" The *New Yorker* reviewer Pauline Kael insisted that "if there were such a thing as a masterpiece of a location," the hotel was it. A "poignant but bitter" made-for-video documentary, *The Sinister Saga of the Making of* The Stunt Man, coincided with the cult movie's 2000 DVD release.

At the end of the 1980s Coronado Beach and the hotel were locations in Universal Studios' *K-9* and Warner Brothers' *My Blue Heaven*. In 1995 Touchstone Pictures filmed *Mr. Wrong* at the hotel; starring Ellen DeGeneres, it was described by one reviewer as a "slow-motion train wreck."

Television is a much more pervasive medium than cinema, and since the 1970s several series have included episodes filmed at the Del, among them *Baywatch* (complete with its ghost, the building played itself, so to speak),

Ghost Story, Hart to Hart, Hunter, Lifestyles of the Rich and Famous, Silk Stalkings, and *Simon and Simon.* A number of made-for-TV movies—*The Girl, the Gold Watch, and Everything* and *Loving Couples* (both in 1980)— and miniseries, *Captains and the Kings* (1976), *Rich Man, Poor Man* (1976), and *Space* (1985) have used it as a location.

Richard Matheson's 1975 novel *Bid Time Return* (republished in 1999 as *Somewhere in Time*) is set in the Hotel del Coronado. The hero Richard Collier, dying from a brain tumor, decides to spend his last days at the hotel. He is fascinated by a photograph of an actress who performed there almost a century before and discovers that she had an affair with a mysterious man. He travels back in time to become that man. Disappointingly, when in 1980 Universal Studios made the book into a film, *Somewhere in Time*, it was shot at the Grand Hotel on Mackinac Island, Michigan.

"PUTTING YOUR GHOSTS TO WORK"

The hotel also has been popularized in another literary genre by such books as Alan M. May's *The Legend of Kate Morgan: The Search for the Ghost of the Hotel del Coronado* (1990) and John T. Cullen's *Dead Move: Kate Morgan and the Haunting Mystery of Coronado, a Novel* (2007). The spectral legend proliferates in many "true" ghost story anthologies and on websites dealing with the paranormal.

The following item appeared in the *San Diego Union* on November 30, 1892:

> Night before last, an attractive, prepossessing and highly educated woman came down from her room at the Hotel del Coronado and between 9 and 10 o'clock stepped out upon the veranda facing the ocean. The sea was lashed into a fury by the tempest that was sweeping over the whole coast. She was quietly and elegantly dressed in black, and wore only a shawl over her head. Nothing more was seen of her until at 8:30 yesterday morning, when the assistant electrician of the hotel, passing by the shell walk at the end of the western terrace, saw her lying on the steps leading to the beach. She was dead. . . .

The woman was eventually identified as 24-year-old Kate Morgan; her story has been told often, so here a synopsis will suffice. She and her husband Thomas were grifters who had made reservations at the Hotel Del Coronado under aliases: Lottie Anderson Bernard and Dr. M. C. Anderson. Their well-practiced scam involved having the attractive Kate pose as Thomas' sister; after forming a liaison with a young man—as noted, a resort hotel was a good environment for that—and then insisting that he gain her "brother's" approval to court her by playing his favorite game, poker, with him. Thomas would cheat him out of his money, and the couple would move on to their next "mark."

Using her alias, Kate checked into room 302 on November 23; Thomas was to join her a few days later. When he didn't turn up she searched San Diego for him; she also bought a pistol. Only a week after she arrived at the hotel, Kate was dead. According to one source, the hotel reported her death a suicide by poison to protect its good name; "a large bottle of quinine was found in her room and they suspected she had tried to abort [a] baby." But in fact she was shot in her right temple, but not by the gun that she had bought. There was no exit wound or blood on her hand or the gun, which was found "two steps above her hand" just outside the hotel.

By the next afternoon a jury returned a verdict of suicide to San Diego's Deputy Coroner. Cullen observes that because her identity was unknown "by modern standards it would be impossible to determine motive [or] to close the legal proceedings in one day." Police circulated a sketch portrait throughout the United States, leading to several identifications: two were aliases of Kate Morgan. No one claimed her body, and on December 13 she was buried at San Diego's Mount Hope Cemetery. Cullen writes that "the circulating sketch, plus speculation about her last hours and her motives, fed the media tempest. . . . First the San Diego newspapers [coincidentally, owned by John Spreckels, who also owned the Hotel Del Coronado] and soon, Hearst and other newspapers . . . began a telegraph-hyped campaign of daily and hourly bulletins, rumors, guesses, and glamorized half-truths . . . [Kate Morgan's] death . . . became high drama in circulation-starved newspapers." The cynical among us may be excused for believing that Spreckels recognized the advertising potential of the lurid episode. And that gave rise to the legend of the ghost of the Hotel del Coronado.

But it is pointed out that wooden buildings—especially those built of unseasoned material—continue to creak for decades, even centuries. It is suggested that a perfectly natural phenomenon, unconsciously (or consciously) fuelled with a little imagination and a desire for excitement can grow into a preternatural one until it becomes a fully-fledged urban myth. The publicity department of the Hotel del Coronado continues to capitalize on this. For example, in summer 2006 one of its press releases stated,

> Hotel guests, employees, and even paranormal researchers have attested to some supernatural occurrences at The Del. Witnesses report flickering lights, televisions that turn on and off by themselves, dramatic shifts in room temperatures, odd scents, unexplained voices, the sound of strange footsteps, mysterious breezes which cause curtains to billow when windows are closed, and objects which move of their own accord; still others claim to have seen the ghost of Kate Morgan herself. . . .
>
> Paranormal researchers have used infrared cameras, night vision glasses, radiation sensors, toxic-chemical indicators, a microwave imaging system and high frequency sound detectors to document unexplained temperature fluctuations, magnetic fields, electronic emissions, and other paranormal activity.

It also notes, "Not surprisingly, the media has closely followed the legend of Kate Morgan, and stories about The Del's ghost have appeared nationally and internationally in newspapers, magazines and on television." Not surprisingly, indeed!

In 2002 Christine Donovan of the hotel's heritage department published *Beautiful Stranger: The Ghost of Kate Morgan and the Hotel del Coronado,* that includes excerpts from more than a dozen accounts of purported encounters with a ghost. One commentator writes that at that moment "Morgan's ghost emerged as the hotel's sole otherworldly resident." Donovan admitted, "A lot of historic hotels have ghost stories. It's a given, and they can take on a life of their own—the legends get passed down. . . . We reined it in and toned it down." She added, "My attitude was I'd rather have one ghost story that seems legitimate rather than a whole lot of ghost stories just because people are telling them."

For many years Kate Morgan's ghost—or any ghost—was regarded as a commercial liability. One reviewer of *Beautiful Stranger* wrote,

> Up until about a dozen years ago, a bellman who led public tours told the tale of a female guest who died in her room the night the hotel opened in February 1888. Management was so fearful that the potential scandal could ruin the venture before it got off the ground, the story went, that it spirited the body away and erased her name from the register.

In a 2006 hotel trade magazine article, "Putting Your Ghosts to Work,"[8] Glenn Haussman wrote that though at one time "having a haunted hotel was something an owner would want to keep under wraps . . . these days, having a resident ghost around to taunt or tease guests with glimpses of the underworld is turning into a bonus for the property's public relations department." The Hotel del Coranado's general manager agreed that Kate Morgan's carefully cultivated shade has been a "boon for property publicity," remarking "Having a resident ghost garners us a lot of attention. These kinds of stories are what makes this hotel great and this is part of our wonderful and unique history." It is in the Hotel's commercial interest to keep the phantasmagorical pot—this icon-within-an-icon—on the boil.

And because there's money it, others have climbed on the Del's ghostly bandwagon. In 2007 a media-conscious San Diego "project psychic" and self-styled "spirit advocate" claimed, "Not only is this legend completely untrue for Kate Morgan, it is even more wrong when the legend is not even about the correct person." Using "interdimensional communication," she claimed to have spoken to the Phantom of the del Coronado and announced, "Mrs. Lottie A. Bernard claims she is not Kate Morgan." As a footnote, her press release happened to mention that more cash was needed for ongoing research.[9]

Even *sans* celebrities, *sans* moviemakers, and *sans* ghosts, the Hotel del Coronado, though neither "the talk of the western world" that Elisha Babcock

predicted, or "the finest all the year round seaside resort in the world" could (and did) lay legitimate claim to being "America's all the year round seaside resort and sanatorium." As he put it so many years ago

> All who have visited Coronado are loud in its praises, and seem at a loss to find language sufficiently strong to express their great admiration of the many charms of this locality, the magnificence of its gorgeous Hotel and the amount of varied comfort and enjoyment provided for the guests. As a real sanatorium, and a pleasant all-the-year-round resort, Coronado is believed to be unrivalled.

The Designers of the Hotel del Coronado

The Reid brothers—James William (ca. 1851–1943), Merritt J. (1855–1932) and Watson Elkinah (1858–1944)—were Canadian-born architects who practiced mainly in the United States. Around 1872 James left St. John, New Brunswick, to study industrial arts at the Lowell School of Practical Design in Boston. The details of his professional education are unclear; some sources claim that he studied also at McGill University, Montreal, Massachusetts Institute of Technology, and at the *École des Beaux-Arts* in Paris, but it seems that he graduated from none of them. Merritt had followed his brother to Boston, where he also worked as a drafter.

While in Boston, William had worked in several architectural firms and on returning from France in 1875 settled briefly in Terre Haute, Indiana, as assistant to Charles Eppinghousen, who was then designing the McKeen Bank in the city. When his employer went to Italy to obtain sculptures for the building Reid took over supervision. He probably also worked on Eppinghousen's unsuccessful entry in an 1877 design competition for the Indiana state capitol. Around then he moved to the office of H. H. Brickley, later buying the practice. When he was commissioned to design a new depot for the Evansville and Terre Haute railroad Merritt joined him to form Reid Brothers, Architects. Through that connection they became known to Elisha Babcock. One source claims, probably hyperbolically, that until 1886 they "altered the landscape of Evansville, southern Illinois and northern Kentucky."

Many of those "landscape-altering" buildings have been demolished. An interesting survivor is the People's National Bank (1880–1882), built for Aaron Guard Cloud in McLeansboro, Illinois, "a nominal Second Empire design with frenetic details. In 1884 the Reids also designed Cloud's "Gothicky" residence in McLeansboro; now housing the Mary E. Cloud McCoy Library, it is assessed by its present owners as "majestic, inspiring, and beautiful." Also in the grotesque Gothick style is their Willard Library in Evansville, of 1885.

Reid Brothers' performance for the Evansville and Terre Haute railroad, and perhaps their stylistic versatility, led to the commission for the Hotel del Coronado

in December 1886. James, the partnership's principal designer, moved to San Diego; Watson joined him a year or so later, while Merritt managed the Evansville practice. Following the completion of the Del in 1889, James and Merritt Reid opened a San Francisco office, leaving Watson in charge in San Diego until May 1891 when William Sterling Hebbard, who already had a thriving practice, subsumed the firm. Watson returned to New Brunswick.

In 1891 James and Merritt designed the *Portland Oregonian* building, the first steel-framed skyscraper west of Chicago. The first residential work in San Francisco was a six-house Victorian terrace of 1894, and between 1895 and 1905 they designed several large residences for the Spreckels family. In 1898 John D. Spreckels commissioned them to design a new headquarters for the *San Francisco Call* newspaper; completed 2 years later, the eighteen-story steel-framed tower, with an ornate four-story dome redolent of the Hotel del Coronado's conical roof, was for many years the tallest building west of the Mississippi. In 1899 they built the grandly named Spreckels Temple of Music, an "Italian Renaissance-inspired terra cotta and sandstone band shell" in Golden Gate Park. Two years later, also for Spreckels, they produced the San Francisco and San Mateo Electric Railroad Company's Geneva street offices and powerhouse.

What someone has called "the prolific Reid Brothers partnership" ended with Merritt's death in February 1932; then over 80 years old, James retired from practice. He died in September 1943. The firm had produced office blocks, warehouses and other commercial buildings, residences, and nearly thirty cinemas along the entire West Coast. Perhaps worth noting among them was the understated Neo-Classical replacement for San Francisco's famous Cliff House, of 1909; one writer points out that "ironically, it was the Reid Brothers' Hotel del Coronado in San Diego that [the owner] directed his architects to use as a model for his overwrought Victorian palace."

"The Great Coronado Tent City"

Throughout the second half of 1900, when the Hotel del Coronado was closed for renovations, holiday-makers were accommodated in tents and pavilions on the beach south of the building. Beginning as what a San Diego newspaper called a "tiny camp," within 15 years the initiative grew into the Coronado Tent City, "wherein accommodations for thousands are afforded in spacious, clean tents and individual cottages with their comfortable equipment." Too popular and too profitable to remove, Tent City—sometimes called Camp Coronado—continued as inexpensive middle-class alternative to the hotel (but integrally associated with it) until the owners announced its closure in June 1936, possibly because of falling demand in the Depression years. It was dismantled in 1939.

In his 1908 *History of San Diego*, William Smythe praised Coronado as a "pleasant across-the-bay residence district [*sic*]," noting

> On the narrow peninsula east of the hotel, several hundred tents and palm leaf-covered cottages [being directly beside the beach, these seem to have been "superior" accommodation] are erected early each summer, where a large number of people go to spend a few weeks beside the ocean. Here there is boating, bathing, fishing, and all the pleasures of camp life, combined with most of the conveniences of life in the city.

The semipermanent gaily striped tents, lit by electricity, had rough wooden floors and sparse furniture—lumpy beds and folding chairs. Privacy was achieved by canvas curtains on wires. For less affluent campers who wanted to cook for themselves, for an extra tariff a kerosene stove and kitchen paraphernalia were provided in separate "cook tent" behind the living quarters; personal cleanliness was maintained with a jug and bowl. And "each day a maid of sorts would give [the] shelter a cleaning of sorts." A 1903 photograph of an interior shows an elderly woman surrounded by a great deal of furniture, overstuffed cushions, and even framed photographs hanging on the canvas walls. William Chandler of the San Diego Museum of Art remarks, that she was had no intention of "roughing it at the beach. Surrounded by parlor chairs and table, draperies and a very sturdy dresser-bureau, she surveys us with the dry calm of a hostess At Home."

One writer recalls, "According to my aunt . . . , anyone who was in the *Who's Who* spent a few weeks of the summer at Coronado." She describes how "a simple breakfast was prepared in their tent, usually around 11 o'clock. In the afternoon there was a round of calling or card playing, then a dress-up dinner at the Hotel, followed by an evening of music, dancing or cards."

Tent City also offered amusements: a Ferris wheel, a carousel, carnival booths, and "numerous activities for the entire family." And for at least some time there was even a children's bull fight. Although that may offend modern sensibilities, it underlines how different we are from our grandparents; as the English novelist L. P. Hartley said, "The past is a foreign country; they do things differently there." Such a realization goes some way toward explaining the appeal that Tent City held for a pre-motel, pre-Winnebago generation.

NOTES

1. Van dyke, Theodore Strong, *Millionaires of a Day: An Inside History of the Great Southern California "Boom."* New York: Fords, Howard & Hulbert, 1890.

2. Smythe, William Ellsworth, *History of San Diego, 1542-1908. . . .* San Diego, CA: History Co., 1907.

3. Reid, James W., "The Building of the Hotel del Coronado," [unpublished six-page booklet, n.d.], 3.

4. Reid.

5. Burke Ormsby, "The Lady Who Lives by the Sea. . . ," *Journal of San Diego History*, 12(January 1966). www.sandiegohistory.org/journal/66january/ladybysea.htm

6. Sanford, Jay Allen, "Underground with the Celebrity Dead." www.sandiegoreader.com/news/2005/oct/27/underground-celebrity-dead/

7. Ormsby.

8. Hausmann, Glenn, "Putting Your Ghosts to Work." www.hotelinteractive.com/index.asp?page_id=5000&article_id=6493

9. Vent, Bonnie, ". . . Legend Busted." www.unexplainable.net/artman/publish/article_7181.shtml

FURTHER READING

Aslet, Clive. "Freedom and Luxury Restored: The Hotel del Coronado, San Diego; Architects (1887): James William Reid, and Others." *Country Life*, 178 (September 26, 1985), 902–903.

Banham, Reyner. "Coronado, or, Don't Smoke in Bed." *Architects' Journal*, 143(February 1966), 317, 319.

Brandes, Ray, and Katherine Eitzen Carlin. *Coronado, the Enchanted Island*. Coronado, CA: Coronado Historical Society, 1988.

Buckley, Marcie. "California Preserves Victorian monument: Hotel Del Coronado . . . , California; Architects: J. & M. Reid." *Architect*, (July 1971), 52–53.

Buckley, Marcie, and Stephen S. Oakford. *The Crown City's Brightest Gem: A History of the Hotel del Coronado, Coronado, California*. Coronado, CA: The Hotel, 1979.

Cullen, John T. *Dead Move: Kate Morgan and the Haunting Mystery of Coronado, a Novel*. San Diego, CA: Clocktower, 2007.

Donovan, Christine. *Beautiful Stranger: The Ghost of Kate Morgan and the Hotel del Coronado*. Coronado, CA: The Hotel, 2002.

"Grand Hotels: The Del Coronado." *Colonial Home*, 14(October 1988), 36–38, 40, 42.

Hennessey, Patrick. *Hotel del Coronado: The First Hundred Years*. Coronado, CA: The Hotel; Bullock and Associates, 1987.

Kantor, Ann. "The Hotel del Coronado and Tent City." *Nineteenth Century*, 8(no. 1–2, 1982), 88–95.

Lee, Madeline. "Hotel Del Coronado at 100 in San Diego, California." *Victorian Homes*, 7(Spring 1988), 70–74.

Malinick, Cynthia Barwick, "The Lives and Works of the Reid Brothers, Architects 1852–1943" (M.A. thesis, University of San Diego, 1992).

Morrow, Thomas J., and William Sullivan. *Hotel del Coronado*. Coronado, CA: The Hotel, 1984.

Oakford, Stephen S. *Official Illustrated History Hotel Del Coronado*. Coronado, CA: The Hotel, 1982.

Pourade, Richard F. *The Glory Years*. San Diego, CA: Union-Tribune, 1964.

Williams, Gregory L. "Filming San Diego: Hollywood's Backlot, 1898–2002." *Journal of San Diego History*, 48(Spring 2002).

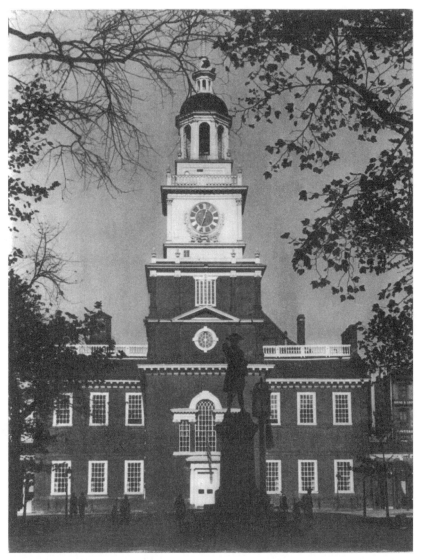

Independence Hall, Philadelphia, Pennsylvania

"Aspirations for justice and freedom"

To borrow from Shakespeare's *Twelfth Night*: some buildings are built as icons, some achieve iconic status, and some have iconic status thrust upon them. Which is the case with Independence Hall, that began life as Pennsylvania's State House, survived its midlife crisis as a museum, to finally become a national shrine? If the American colonies' struggle for independence had failed, it would still be just the State House; if the Constitution had not been ratified in it, it possibly would have been demolished long since, as Philadelphia's central business district grew. But as Pulitzer Prize-winning biographer Carl van Doren wrote,

> Instead, Pennsylvania's State House has become Independence Hall for the entire United States. Nor is that all. On account of the Declaration of Independence, it is a shrine honored wherever the rights of men are honored. On account of the Constitution, it is a shrine cherished wherever the principles of self-government on a federal scale are cherished.[1]

Thus though Independence Hall itself is merely a building of no particular architectural merit, it is made iconic by the world-changing historic events that took place in it. However, like many other buildings of national historical significance, its apparent authenticity is a self-conscious construct; as one has written, government intervention, effected by the National Park Service (NPS) and climaxing a century of metamorphosis, simply formalized the will of the people.

In 1979 the United Nations designated Independence Hall a World Heritage Site, recognizing it as "an important part of the world's cultural heritage [that] deserves to be protected for future generations." That was because of its association with the Declaration of Independence and the Constitution, both of which "enunciate enduring as well as universal principles and eloquently express mankind's aspirations for justice and freedom. The two charters have transcended the particular circumstances of their creation and any deficiencies in their scope or application to become part of the political and philosophical heritage of the world."[2]

A PLACE IN POPULAR CULTURE

Independence Hall is fixed early in the minds of young Americans in the schoolroom and through a profusion of children's literature; there have been nearly twenty such books since the turn of the century. Moreover, American and international visitors throng to Independence Park every year; although there was a sharp decline following the tragic events of September 11, 2001, 2 years later the figure climbed to 1.8 million. During the U.S. Bicentennial year there were 3.2 million visitors.

Tourism feeds the tawdry trinket trade—popular culture at its lowest ebb. In the case of Independence Hall, which more than any other place in America

is linked to the noble principles upon which the nation was founded, such vulgarity (it is suggested) is most offensive. The Germans have a word for low-art artefacts: *kitsch* (from *verkitschen*, meaning "to make cheap"); more than just bad design, many of them are inappropriate, and most demean a sublime idea. But in a free enterprise economy, if a dollar can be made, even the sacred may be profaned. So Independence Hall has been distorted in coarsely detailed, out-of-scale miniatures cast in metal or resin; on memorial plates (some finely decorated, others crudely); and impaled on the ends of silver teaspoons (some made in The Netherlands). There is even a tea-towel printed with an amateurish drawing of a pea-green Independence Hall.

Miniature liberty bells also are offered—complete with a crack—ranging from small to large (touted as "lightweight") and large ("heavyweight"). The vendor boasts, "All models are complete with a clapper and produce a fine, clear tone. Each replica . . . is finished in antique bronze and is perfect for school presentations, display, promotions, teaching, patriotic wedding favors or gift presentations. Excellent mementos of Philadelphia and made in the USA!" At least they are made in the United States; many such souvenirs aren't. Another gift store advertises, "Miniature Liberty Bells? Snow globes featuring Independence Hall? Tea towels illustrated with the Betsy Ross story? All this and much more is available just around the corner from the sights themselves." Much more indeed!

Independence Hall appeared in Columbia Pictures' 1968 *Where Angels Go, Trouble Follows* (a road movie featuring nuns—really!), and it was incidental to films set in Philadelphia, including *Rocky II* (1979), Brian de Palma's 1981 thriller *Blow Out*, and the 1983 comedy *Trading Places*. It figured more importantly in a number of historical "docu-drama" TV series broadcast between 1972 and 2000. But it was germane to the plot of the 2004 *National Treasure*, an Indiana-Jones-meets-*The da Vinci Code* movie that resurrected the hackneyed conspiracy theories about connections between the founding fathers and the Knights Templar and Freemasonry. A scene in Paramount's *Shooter* (2007) was filmed on location in front of the building.

THE PENNSYLVANIA STATE HOUSE

For many years after 1681, when the Province of Pennsylvania was founded, colonists "took little active thought of" where their governing Assembly should meet; they used all sorts of temporary venues, most of which were in Philadelphia—a coffeehouse, an inn, a market house, a meetinghouse, or the home of some legislator. Then in February 1729 the Assembly was petitioned to "impower . . . the city and county of Philadelphia to build a Market and State House in High Street." Three months later it unanimously appropriated £2,000 for the project. Construction of the Pennsylvania State House—at the time considered by many to be the most ambitious public building in the colonies—began in 1732 and continued throughout the 1740s.

Until well into the twentieth century credit for the elegant design was given to Andrew Hamilton, speaker of the assembly. Despite modern scholarship's discoveries to the contrary, some sources still prevaricate about authorship; we are often loath to relinquish our cherished fables. But as most architectural historians know, in the late nineteenth century many older buildings were attributed to the person whose name appeared most frequently in the records—often the contract supervisor, the clerk of works, or the chairman of a building committee. The phenomenon was hardly new: the great medieval abbeys and cathedrals were for centuries ascribed to the abbots and bishops who commissioned them, and hardly ever to the master masons who conceived and constructed them. Most scholars now believe that Hamilton was a dilettante architect "who contributed very little, if at all, to Philadelphia architecture," including the design of the State House.

Born in Scotland in 1676, after studying law in London, Hamilton had emigrated to Virginia around 1697. For a while employed as steward on a plantation, he married the owner's widow and established himself in colonial society. He was admitted to the bar in 1712 and moved to Philadelphia some time before 1716. In 1717 he became attorney-general of Pennsylvania and five years later was called to the colony's Provincial Council, a position he held until 1724. In 1727 he was appointed principal clerk of the Supreme Court and Recorder of Philadelphia, and also elected to the governing Assembly. He was made its speaker in 1729 and reelected annually (except in 1733) until he retired a decade later. Hamilton is best known for his legal prowess, especially his defense in 1735 of newspaper publisher John Peter Zenger, a famous victory that is thought to have given rise to the term *Philadelphia lawyer* to describe an adroit attorney. He died in Philadelphia in 1741.

What was Hamilton's role in realizing the State House? To begin with, one historian writes, he "became chief proponent of a site and of a plan for the structure . . . and spurred preparations." Between October 1730 and 1732 Hamilton and his son-in-law William Allen bought the site on Chestnut Street between Fifth and Sixth Streets. That superseded a location that had been proposed earlier, on High Street. Hamilton also purchased the building materials for the House. Finally, in 1732 he "produced a Draught . . . containing the Plan and Elevation of that Building; which being viewed and examined by the several members, was approved by the House." The 3-year gap between the initial approval of funding and the commencement of building work resulted from disputes within the building committee. It is clear that Hamilton hired "the two Carpenters employed in building the State-house"—the architect-builder Edmund Woolley and master house carpenter Ebenezer Tomlinson (some documents call them "mechanics"). Once the building was started, Hamilton doubtless would have been consulted, and as architectural historian Roger W. Moss suggests, "he probably carried the plans back to his principals for discussion and approval. But the ultimate form, and especially the final details, were the result of the knowledge and skill of the master builder and his crew of workmen."

It is likely that Hamilton's "draught"—a rather elementary line drawing—was intended to give Woolley and Tomlinson a general idea of layout and appearance. The former, an early member of The Carpenters' Company of Philadelphia, was born in England; he is known to have been in Philadelphia by 1705 and became a freeman in 1717. Tomlinson seems to have arrived from New Jersey before 1728; he also was a member of The Carpenters' Company. Anyway, the pair was were contracted to build the "Floors, Outside Windows, Doors, Roof and Eves [*sic*], Turret, Balcony, and the Stairs"—of course, all carpenters' and joiners' work. Despite the high quality of the brickwork, it is puzzling, as one writer notes, that "nothing appears [in surviving documents] as to the work of the brick and stone masons during this period."

In August 1732 Woolley and Tomlinson, claiming that "the work expected from them was heavy, and [required] to be carried on in an extraordinary manner," negotiated a higher price. Shortly after work started the brief was changed: the Assembly instructed that offices should be built as wings flanking the main building and connected to it by open loggias (Woolley called them "piazzas"). By the time the Assembly was able to meet in the partly finished building in September 1735, neither the glazing nor the internal joinery were complete; the paneling and wainscoting would take several more years. The office wings were probably finished early in 1736; "despite various county and provincial public officials' objections to moving into them, they were soon occupied." In July Woolley submitted an account for £5 for "drawing the Elivation of the Frount one End the Roof Balconey Chimneys and Torret of the State House With the fronts and Plans of the Two offiscis And Piazzas Allso the Plans of the first and Second floors of the State House." The creative spelling and the punctuation are his.

In 1740 Woolley and Tomlinson asked "to be excused from doing any more of the work." There were other delays, some caused by the dearth of skilled workmen, a not infrequent problem in the colonies. In summer 1741 the Assembly demanded that the walls and windows—presumably joinery work of some kind—in the meeting hall be finished immediately and the rest of the building be completed "without undue delay." However, plans for the Supreme Court chamber were not presented until more than 2 years had passed and the Council Chamber on the second floor was not ready to be occupied until February 1748.

Late in January 1749 the Assembly authorized "a Building on the South Side of the said House to contain the staircase, with a suitable Place thereon for hanging a Bell." Woolley returned to the site. He had a significant role in building the tower and even may have designed it. Anyway, he was paid more than £1,000 pounds for a wide range of services, including drafting; compiling bills of quantities; building the staircase, stairs, and other joinery; waiting on other trades and constructing scaffolding for them; breaking out and making good the existing building; fixing "many thousands of Shingles"; "getting the Bell up & down & up again & twice hanging Bells"; and "the rest of ye

work belonging to the tower as now finished both out & inside from the Vane to the foundation . . . with many Other Jobs not here mentioned."

The tower's stone foundation was completed in 1750, and the framing of the steeple probably was finished in fall 1751, before the delivery of the original Liberty Bell. Work on the interior and various "supplementary projects" seem to have continued through September 1756. The tower contract also employed a number of Woolley and Tomlinson's apprentices including Thomas Nevell, who, ironically, would demolish the steeple in 1781 when it had become structurally unsound. In 1752 the Assembly engaged a local clock-maker, Thomas Stretch, to install clock faces just below the eaves on the eastern and western walls of the State House; an ornate soapstone structure imitating a tall case clock was built under the western face, and a bell was housed in a rather nondescript turret on the roof. Removed during one of the "restorations," the clock and pedestal were later replaced.

STYLE AND SOURCE

In *The Book of Philadelphia* (1918) Robert Shackleton effused,

> Building of serenity and symmetry, of fine amplitude, a gracious, alluring build-ing, rich in noble memories, yet touched also with a living sweetness; such is the beautiful old State House in Philadelphia, often referred to as Independence Hall. . . . But it must not be thought that it is beautiful or interesting principally on account of age. Age adds to a beautiful building the salt and savor of time, the romantic patina, literal or metaphorical, that comes with the decades. But the State House is beautiful in itself; it was beautiful when it was young and new; it will remain beautiful as long as it stands, with its traditions growing more interesting with time.[3]

The sturdy two-story building with walls of red brick laid in Flemish bond was an elegant example of (what was in its day) "modern" architecture. Architectural historians, who seem to need categories, have dubbed the style "Georgian" because it was fashionable in Britain and her colonies during the Hanoverian dynasty of Kings George I, II, and III. Boston academic Jonathan M. Chu reminds us that later they would generate mixed messages because after the Revolution, Georgian architecture would represent "reactionary ele-ments, a cultural dependence upon things British, and an unlikely symbol of republican nationalism." But we must stay on track.

The layout of the State House also linked it—although it was a low-budget version—with the larger pre-Georgian stately homes of England, such grandi-ose essays of the English Baroque as Blenheim Palace or Castle Howard. The influence of that style, perhaps even hints of the work of Wren, is evident in the last-minute addition (an afterthought?) of the tower and wooden steeple. The central door in the tower, flanked by Tuscan columns, stands beneath

a large Palladian window. The lower two levels are separated from those above by the extension of the deep cornice that surrounds the whole building. The free-standing third level is comparted by superimposed brick pilasters; it has an oculus on each side under a bold, rather odd pointlessly pedimented molding. Each face of the topmost level has a large central window. Shackleton confusingly wrote that "above this is a clock-tower, square at the bottom and rising in eight-sided diminutions to a six-sided narrow pinnacle which is topped by a trident-link weathervane of gilt."

By contrast, the building's north front was restrained and truly Georgian. It was divided into nine bays and flat string courses and a row of fielded spandrels, all in marble, separated the two stories. The large, twenty-four pane double-hung windows, identical at both levels, were well proportioned; their brick lintels had rather plain marble keystones. The entire symmetrical composition around a quite ordinary door was crowned with a carved wooden cornice and framed by raised soapstone quoins. A wooden balustrade stretched between ranges of four chimneys at either end of the gable roof; at its center was an insignificant cupola that bore no relationship to the interior. The building provided a simple layout with "suitable space for the various agencies of government." The first floor contained two modestly-finished 40-foot square rooms, either side of a 20-foot wide central hall. The one on the eastern end was the meeting room of the governing Assembly; that at the other end accommodated the Province's Supreme Court and was entered through open archways. A stair at the south end of the central hall gave access to the 20- by 40-foot Provincial Council chamber in the southwest corner of the upper floor. The "gallery," or "long room," measuring 100 by 20 feet and used for public functions occupied the entire Chestnut Street frontage. The arched walkways—Woolley's "piazzas"—gave access to the identical two-story hip-roofed east and west wings. The former was used as a public records office. Until 1773 the upper floor of the latter housed the Library Company of Philadelphia; the doorkeeper of the Assembly lived downstairs with his family.

There is little doubt that Edmund Woolley, who had no formal training in architecture, found his inspiration in one (or perhaps more) of the architectural pattern books that then were beginning to proliferate in Britain and her colonies. They provided plans and elevations of their authors' works, "as well as formulae for the orders, for doorways, mantels and other details" and served as guides to builders, amateur architects, overseers, bricklayers, and carpenters. Treatises of a more theoretical kind included *Vitruvius Britannicus* by Colin Campbell (1717–1725); *Designs of Inigo Jones* by William Kent (1717), and *Andrea Palladio* by Giacomo Leoni (1715–1720), but they had been predated by a flood of pattern books by Halfpenny, Langley, Hoppus, Ware, and Salmon. Many were issued as "pot-boilers" by less-than-successful architects as advertisements for their services. As early as 1700 *The First Book of Architecture* by Godfrey Richards commented on the current dearth of builder's handbooks, "we have but few Books which we can recommend . . .

besides the Excellent Discourses of Sir Henry Wotten and John Evelin, . . . where they have comprised fully and clearly the most weighty observations of the art in general." Edmund Woolley is known to have had an architectural library; its extent cannot be confirmed except for a copy of *Practical Architecture* (1730), one of three books by English architect and carpenter William Halfpenny that predate the State House.

INDEPENDENCE: THE PHILOSOPHER'S STONE

The first half of the eighteenth century saw Britain and France in continued competition for territory in North America. In fall 1753 Robert Dinwiddie, lieutenant-governor of Virginia, sent young George Washington with a party of militia to oust French troops who were building forts south of Lake Erie. Because his diplomatic attempts were ignored, a few months later he sent a one-hundred-fifty-strong force to drive them out. The ensuing skirmishes gave rise to the French and Indian War (1754–1763), that spread to Europe in 1756—the Seven Years War, in which Britain was victorious.

To pay for the costly conflict, parliament imposed direct levies on the colonies, beginning with the 1765 *Duties in American Colonies Act* (the so-called *Stamp Act* that taxed all legal documents). The *Townshend Acts* followed in 1767, taxing lead, paint, paper, glass, and tea imported from Britain; when the Americans' simple "refusal to purchase only British manufactured goods negated [them]" they were repealed in 1770. Nevertheless, dissent continued in the colonies. In December 1773, protesting against yet another imposition, a new *Tea Act*, one hundred fifty Bostonians boarded three ships moored in the harbor and dumped 342 chests of British tea overboard. As news of the "tea party" spread through the colonies, other seaports followed the Bostonians' example and staged similar protests. When the Bostonians refused to pay for what they had destroyed, in the middle of 1774 King George III and Lord North, the British prime minister, rushed through the parliament legislation known as the Coercive Acts, to be applied only against Massachusetts. In these four acts, Parliament closed the port of Boston; severely limited the colony's powers of self-government; permitted officers of the crown, if accused of crimes, to be tried in other colonies or in England; and allowed the quartering of troops in the colonists' barns and empty houses. The laws naturally rekindled resistance; the American colonists dubbed them the "Intolerable Acts."

Over the following months, the Americans' relationship with the mother country continued to deteriorate. By the mid-1770s about two-and-a-half million people lived in the thirteen colonies, which were grouped into three sections: Connecticut, Massachusetts, New Hampshire, and Rhode Island made up New England; Delaware, Maryland, New Jersey, New York, and Pennsylvania were known as the middle colonies, while North and South

Carolina, Georgia, and Virginia made up the southern colonies. The imposition of the Intolerable Acts compelled twelve of them (various reasons have been given for Georgia abstaining) to hold the First Continental Congress. Philadelphia was the obvious place for the representatives to decide upon a course of action. With a population of almost twenty-five thousand it was the second largest city in the English-speaking world. And it was located midway between the northern and southern colonies. Convened on September 5, 1774, in Philadelphia's recently built Carpenter's Hall, the Congress continued until late October.

The fifty-five delegates addressed several issues concerning taxation and the growing schism with Britain—to define colonial rights, to identify how parliament had violated them, and to find a way to have them restored. It is stressed that the colonists considered themselves British first—acknowledging allegiance to the monarch but not to the parliament—and Virginians, New Englanders or whatever, second. Anyway, they wrote a letter to the king, listing their complaints and insisting on their rights as British subjects. He rejected their submissions. Although they had not even hinted at seeking independence from the crown, the calling of the Congress was construed as an act of treason and parliament launched punitive expeditions. By April 1775 the colonial militia were engaged in a civil war, fighting British soldiers at Lexington and Concord in Massachusetts.

As had been arranged at the first Congress, the Second Continental Congress, this time with sixty-five delegates from all thirteen colonies, met on May 10, 1775, in the Assembly Room of the State House in Philadelphia, to consider further their declining relationship with Britain. John Hancock was named president of the Congress, and George Washington was appointed commanding general of the reformed New England militia, now assembled under the banner of the Continental Army. The first gathering of the Second Congress continued until mid-December 1776.

Early in July 1775 it sent the Olive Branch Petition (aka The Humble Petition or The Second Petition) to England. "A protest against the harsh regime inflicted upon the North [Americans], . . . in particular the imposition of new, harsher taxes," it was their last attempt to avoid a war. Although their appeal was framed in "terms of deep loyalty to the King," he gave it short shrift, and told parliament on October 26, 1775, "It is now become the part of wisdom, and [in its effects] of clemency, to put a speedy end to these disorders by the most decisive exertions"; in short, "Put down these rebels." Even in the face of escalating fighting, by the following spring the colonists remained divided about whether they should secede from Britain. In a motion of June 7, 1776, Richard Henry Lee of Virginia exhorted the Congress to declare its independence, but the weighty question was not resolved and debate of his resolution was deferred for a few weeks.

The Congress appointed a committee of five to set down the reasons why the colonies should become an independent nation. Mostly the work of

Thomas Jefferson, the resulting Declaration of Independence "turned the . . . complaints over issues such as taxes and trade restrictions into a struggle for universal human rights." On July 2 twelve of the colonies voted in favor of Lee's resolution; New York joined them a week later, and on July 4 all the delegates ratified the Declaration. Knowing that their action was treasonable and punishable by death the disaffected colonists, pushed to the limit, "had become a nation fighting for a cause: freedom from England and King George III." What had started as a civil war had become a War of Independence.

The Second Continental Congress continued to meet in the State House, turning its attention to fighting the war, and trying to find ways to pay for the new Continental Army, which desperately needed basic supplies and equipment. Against all odds, George Washington's rag-tag military, with a little help from its friends—notably the French—overcame what was then the most powerful nation in the world. The history of the war is quite another story; suffice it to say that Lord Charles Cornwallis' forces surrendered at Yorktown, Virginia, on October 19, 1781; however, minor battles continued for another 2 years until in February 1783 King George III proclaimed the Cessation of Hostilities. The Paris Peace Treaty signed on September 3 formally ended the war. The last of the British fleet sailed from New York 2 months later.

In 1777 the Congress, attempting to formalize an agreement that would weld thirteen states into a unified nation, adopted the "Articles of Confederation and Perpetual Union of the United States of America." Intended to establish a central government powerful enough to achieve tasks without detracting from the rights of individual former colonies, the Articles were ratified by 1781. Their weaknesses soon became evident: Congress had little authority; the new central government had no authority to collect taxes, control trade, or oversee the general affairs of the country—in fact, the decisions that Congress made could be ignored easily by individuals or by the states. The Constitutional Convention met in May 1787 at the Pennsylvania State House to revise the Articles.

Most of the fifty-five delegates (from every state except Rhode Island)—lawyers, doctors, merchants, and farmers, many in their twenties and thirties—had formerly served in the Continental Congress. George Washington was unanimously selected as president of the convention. The Assembly Room doors and windows were kept tightly closed through the 4 months of suffocating summer; historian Catherine Drinker Bowen explained that the State House "was commodious and cool in the mornings, but oppressively hot by the afternoons. Open windows invited an invasion of insects and so was avoided." The content of the United States Constitution, and the story of how it was forged by 4 months of vigorous argument over the details, is not the subject of this essay. However, according to Bowen, "The word 'miracle' was used by both George Washington and James Madison in . . . describing the results of the Constitutional Convention." She adds,

Indeed, many delegates were so enmeshed in the heated debates . . . that when they saw the finished document ready for signing, they expressed amazement at the excellence of the outcome of their work . . . [These] 'details,' as finally agreed on, were to change the United States from a confederation to a workable, lasting Federal Republic. Two balanced powers: Congress and the Executive, state and central government, with the judiciary as umpire. It was to be a triumphant conclusion.[4]

TRANSMUTATION FROM STATE HOUSE TO NATIONAL SHRINE

The Pennsylvania State House was subjected to several alterations, quasi-restorations, and conscientious restorations that accomplished its transmutation to Independence Hall. According to Charlene Mires, as it became inadequate to serve local functions, the rivalry for its future use raised the possibility for its elevation to a national shrine and a "sacred place with global significance."[5] That evolution took place in four stages: first, a period of neglect from 1799 to 1824; then, a quarter-century of stirring interest; then, 30 years of "intense emotional regard," prompted in part by the approaching centennial; and, finally the period when something was achieved.

During the War of Independence the British occupied Philadelphia from September 1777 until the following June, using the State House for troop quarters and as a military hospital. According to a contemporary source, they left the building in "a most filthy and sordid situation [with] the inside torn much to pieces." After the war, the Pennsylvania State Assembly cleaned and repaired it, remodeling the upper floor for its own meetings; the Congress continued to use the Assembly Room. In June 1783 the State House was besieged by eighty disgruntled veterans demanding back pay, so the Congress relocated in Princeton, New Jersey. After moving to Annapolis, Maryland, Trenton, New Jersey, and New York City—all erstwhile *de facto* national capitals—it returned to Philadelphia for the Constitutional Convention in 1789, as noted. Throughout the 1790s Congress met in Philadelphia's recently completed county office building (aka Congress Hall) while a permanent national capital was being developed beside the Potomac.

Meanwhile, general repairs and alterations had been made to the State House so that the Pennsylvania Assembly could again use the Assembly Room. Major changes were accomplished by the century's end:

The steeple had been removed in 1781, and the stair tower was now capped by a low hipped roof. Two handsome edifices flanked the wing buildings: one to the east to serve as City Hall; one to the west for the county offices. . . . Behind City Hall was the new brick building of the American Philosophical Society. The State House Yard had been landscaped in the new romantic taste, with artificial mounds and declivities, serpentine paths, informally disposed clumps of elms and willows, and benches for the enjoyment of the public.[6]

In 1770 what was still the Province of Pennsylvania, having acquired the land now known as Independence Square, had enclosed it within a 7-foot high wall, entered at the middle of the Walnut Street side through solid wooden doors in an arched gateway. The "romantic" landscaping of State House Yard was not initiated until 1784 by Samuel Vaughan, "a wealthy Jamaica sugar planter then living in Philadelphia." Shortly after it was completed, the ubiquitous Reverend Manasseh Cutler described it in his journal as a "fine display of rural fancy and elegance."

When the Pennsylvania legislature moved to Lancaster in 1799 and the following year the federal government was permanently relocated in Washington, D.C., the Assembly Room and second floor of the State House stood empty. Although city courts still sat in the Supreme Court Room, the building, as most unused buildings do, fell into disrepair.

In 1802 the state of Pennsylvania allowed the painter Charles Willson Peale to occupy the east end of the lower floor, the whole upper floor, and the garden of the State House for his museum. He changed the second floor, returning the long gallery and the south-facing rooms to their original disposition to exhibit his portraits of famous Americans, as well as to display his large and eclectic natural history collection, that then included "such awe-inspiring specimens as a stuffed grizzly bear, an 'Ourang Outang,' and the skeleton of a mammoth, as well as 760 varieties of birds and 4,000 insects." Peale has been described as "a sympathetic tenant" who looked after the building; he also meticulously cared for the State House yard, planting trees and making general improvements. His second son Rembrandt (also an accomplished portraitist, whose brothers were Raphaelle, Rubens, and Titian), established a studio in the Assembly Room.

Ten years later the state legislature permitted the City and County of Philadelphia to demolish the east and west wings and linking loggias, to replace them with larger "modern" office buildings of fire-resistant construction. The architect for the alterations, built in 1813 and 1815, was Robert Mills, who had some experience in fire-proofing records repositories, and is best-remembered as the designer of the Washington Monument in the national capital. After having worked for a few years in the Philadelphia office of Benjamin Henry Latrobe, in 1808 Mills had set up in private practice.

He also proposed to replace the State House steeple. The stone clock case was removed from the west wall as Mills wanted to relocate the clock at the front of the building. He also suggested, among several other changes, a portico at the south entrance. As one historian gratefully remarks, "It seems fortunate that Mills' proposal was not carried out." Nevertheless, his new wings remained in place until the end of the nineteenth century. Mills moved to Baltimore late in 1814.

Needing to raise money, in 1816 the Commonwealth of Pennsylvania considered subdividing the State House yard into lots and selling them, as well as selling the building itself. But to "put it beyond the reach of private developers"

the City bought the property as a package for $70,000 and took possession on June 29, 1818. In the interim, control of the State House was vested in the Philadelphia County Commissioners and they embarked upon an "elaborate program of alterations" that was little short of vandalism. Constance Greiff writes,

> Decorative plasterwork was added to the interior; on the exterior the original simple front doorway was replaced by one with a more elaborate Corinthian surround, and the marble trim was painted. The change that aroused public sentiment, however, was a wanton act of destruction, the motives for which have never been ascertained. The paneling and other architectural woodwork of the Assembly Room were stripped from the walls, dismantled, and sold. . . . Almost forty years later [former editor of *The Democratic Press*] John Binns still described the commissioners' action as a "sacrilegious outrage."[7]

Other sources say that the paneling was "removed and preserved in the attic." Whatever happened to it, the enduring public indignation, Greiff suggests, "reveals the aura of veneration that already clung to that space, if not to the entire building, and the desire to preserve the room's appearance for future generations."

The movement toward establishing a national shrine was given impetus in September 1824 by the week-long visit to Philadelphia of George Washington's former comrade-in-arms, the Marquis de Lafayette. Historian Lloyd Kramer comments that the aging French hero's extended tour of the United States "was a galvanizing experience for the country [that became] one of the first and most remarkable expressions of American nationalism, national identity." He adds, "Lafayette returned at a time when the nation faced political divisions, a tense election and was struggling to establish a national identity."

The Frenchman's visit occasioned elaborate preparations, most of them "centering around the State House, which became the principal point of interest." A huge arch of faux masonry (really painted canvas) on a wooden frame was built in Chestnut Street, in front of the building. The interior decoration of the old Assembly Room was designed by the Philadelphia architect and engineer William Strickland, who had trained for a while under Latrobe. According to one account, the walls and ceiling were painted stone color, and the windows were draped with star-studded scarlet and blue cloth. Any available wall space was crammed with portraits of Revolutionary heroes and U.S. presidents.

Four years later the City of Philadelphia invited bids for a bell tower and steeple to replace those demolished in 1781. Strickland's successful submission followed the general design of the original structure although it employed more ornamentation than the original and included a clock face on each side. Although it was not an exact replica, some have suggested that this was the first example of historic restoration in America. A new bell and clock were commissioned, and the project was completed in summer 1828. An alternative

steeple design by the English-born architect, John Haviland, then one of Philadelphia's most important practitioners, had been rejected. But he would be given other work at the State House.

In the 2 years following Charles Willson Peale's death in 1826 his museum was moved from the State House. The second floor was then rented to the U.S. government "for judicial purposes." At the end of 1830 Haviland was commissioned to restore the Assembly Chamber "to its ancient form." He is believed to have done little more than replace the paneling that had been removed in 1816. But it was always going to be difficult to find an appropriate use for the room in which the Continental Congress had ratified the Declaration of Independence and the Federal Convention had perfected the Constitution. They were hard acts to follow, so to speak. Following the restoration, the space was sometimes rented for art exhibitions, but its main use was as a reception room for visiting dignitaries.

In 1852 the City decided to celebrate Independence Day each year in the "said State House, known as Independence Hall." This seems to have been the first formal use of the term *Independence Hall* to indicate the whole building. In July 1854 delegates from ten of the original states gathered there to consider creating a monument to the Declaration of Independence but nothing came of it. The following February the mayor of Philadelphia opened the room to the public, refurnished and hung with over one hundred portraits acquired from Peale's collection. Despite their need for space, the city's Common Council and Select Council moved into the second floor rooms because by this time the Assembly Room had become a shrine.

> Perhaps the best expression of this veneration is in the grandiloquent words of the famed orator Edward Everett, who, on July 4, 1858, said of the State House, or as it has now come to be known, Independence Hall: "Let the rain of heaven distill gently on its roof and the storms of winter beat softly on its door. As each successive generation of those who have benefitted by the great Declaration made within it shall make their pilgrimage to that shrine, may they not think it unseemly to call its walls Salvation and its gates Praise."[8]

For 20 years after 1852 Independence Hall was set apart for what one writer has called "patriotic purposes," which included the lying of state of Philadelphian soldiers killed in the Civil War and, on April 23, 1865, Abraham Lincoln. In those decades the building was routinely maintained—nothing more. That changed as the Centennial of Independence approached; then, "the city councils confirmed the sacred status of the Assembly Room by setting it aside forever as a shrine."

In 1872 a committee was appointed to facilitate the restoration and refurnishing of Independence Hall. The Pennsylvania State Capitol at Harrisburg and private sources returned furniture believed to have been in the Assembly Room in 1776; portraits of the founding fathers were hung in the room; the president's dais was rebuilt, and four columns, thought—albeit erroneously—to

have supported the ceiling, were set up. Encrusted layers of paint were removed from the first floor interiors to reveal the carved ornament beneath. Woodwork in the hallway and stair tower was also repaired. The Supreme Court Room was refitted as a national museum of Revolutionary War period relics. In 1873 the Philadelphia philanthropist Henry Seybert donated a large bell and a new clock for the steeple. After the Centennial celebrations, except for an unrealized proposal in 1878 by the architect Theophilus Parsons Chandler, Jr. to add fireproof the wings, little change was made to Independence Hall until the end of the century.

In 1896 Philadelphia's municipal offices were moved to the newly completed City Hall. In March, intent upon enhancing Independence Hall as a "sacred site," the local branch of the Daughters of the American Revolution commissioned the Philadelphia engineer and architect T. Mellon Rogers to restore the second floor. This began a "restoration" program, completed in February 1897 that extended to the entire building. Architects Bruce Laverty and Robert Hotes write that "unencumbered by either documentary research or on-site building analysis," Rogers spent 2 years replacing many of the original interiors with his personal take on colonial architecture (described by one writer as "ice cream saloon" style). Of course, the result was far from accurate and even farther from satisfactory; for example, Rogers replaced Mills' 1812 office wings with buildings and arcades that resembled the original design, but differed in "dimension and detail."

Two years later the Philadelphia Chapter of the American Institute of Architects (AIA), reacting to this "historical sacrilege," established the Committee for the Preservation of Historic Monuments and offered to "re-restore" Independence Hall. Just then the City did not have funds available, but the AIA's later restoration (1921–1923) rescued the second floor from most of Rogers' vandalism. The work, based on rigorous architectural analysis and measurements, was supervised by Horace Wells Sellers, "who probably knew the building better than anyone since Edmund Woolley himself." In fact, under Sellers' leadership the AIA committee directed the restoration of many other buildings in the historic heart of Philadelphia, including Congress Hall (1912–1913) and Old City Hall (1917–1922). Greiff praises the AIA restorations as "landmarks in the field," noting that much of their work "was so accurate that the National Park Service left it undisturbed in its subsequent restoration of the buildings." The AIA Committee, under architect Thomas Pym Cope, undertook further restoration of Independence Hall around 1940; there was other minor work until 1975.

On June 30, 1942—America's entry into World War II saw a surge in patriotism—representatives of more than fifty groups formed the voluntary nonpolitical, nonprofit Independence Hall Association, which campaigned to "achieve recognition and protection of Independence Hall and the surrounding buildings." Almost exactly 6 years later, Congress created Independence National Historical Park "for the purpose of preserving for the benefit of the

American people as a national historical park, certain historical structures and properties of outstanding national significance located in Philadelphia and associated with the American Revolution and the founding and growth of the United States." About 30 years later Independence Hall, the "primary historic structure within the park," was thoroughly researched, analyzed, and restored for the nation's Bicentennial.

The federal area comprises three city blocks between Walnut and Chestnut Streets from Second to Fifth Streets as well as historically significant outlying sites, "private institutions preserved and interpreted through cooperative agreements"—in all, more than twenty components. According to the NPS,

> The city and State have both made vital contributions to the park concept. The city, while retaining title, gave custody of the Independence Square and its group of buildings to the National Park Service; the State assumed responsibility for the development of the three-block mall north of Independence Hall. . . . Extensive research and restoration have been carried out on every building, and a green and finely scaled urban landscape created where once there was mostly decay and neglect.

The integrity of the site—and in a way the ideals it represents—was challenged by the Department of Homeland Security's draconian antiterrorism proposals in 2006. Among its proposed $2 million measures was the construction of a 7-foot-high wrought-iron fence about 130 feet behind Independence Hall, effectively bisecting the square—one rather more emotive critique of the proposal preferred the word *cleaving*—where the Declaration of Independence was publicly read for the first time. City and state officials successfully protested that such "overkill" would "turn an enduring symbol of American freedom into an eyesore." The NPS conceded in January 2007 that the fence would not be built and gave wordy assurances that

> the existing bicycle barricades will be removed from Independence Square and from Block 1, the Liberty Bell Center area. Relatively un-intrusive technologies and increased security patrols will supplement the defined secured visitor use area, screening, and existing security patrols. The efficiency of this . . . system in fulfilling the twin purposes of protecting cultural resources and providing a safe, quality visitor experience will be evaluated annually.

Reviewing Mires' *Independence Hall in American Memory*, Jonathon Chu sums up the history of Independence Hall:

> Begun as an expression of the genteel extension of British imperial fashion to colonial America, Independence Hall became the site of raucous electioneering, Charles Wilson Peale's museum of natural curiosities, the embodiment of hopes for urban renewal, and a shrine representing a bridge to our shared past. It has, in brief, been transformed from a minor colonial assembly building to the physical manifestation of America's Eden, the place and moment of the creation of the United States.[9]

The seminal documents that underpin the nation—the Declaration of Independence and the U.S. Constitution—could have been composed and polished in another city, say New York or Boston. They emanated from Philadelphia. They could have been ratified in any room large enough to house the delegates attending the Second Continental Congress and the Constitutional Convention. Both those momentous processes took place in the Philadelphia State House. That's what makes this rather ordinary building, despite it being repeatedly changed and rechanged, an icon of American architecture.

THE LIBERTY BELL: AN ICON WITHIN AN ICON

On July 4, 1993, *The Philadelphia Inquirer* quoted Nelson Mandela: "[The Liberty Bell is] a very significant symbol for the entire democratic world." Indeed, quite apart from its association with Independence hall, in itself it has become an American icon. Historian Edward M. Riley called it "the most venerated symbol of patriotism in the United States, [whose] fame as an emblem of liberty is worldwide. In the affections of the American people today it overshadows even Independence Hall" and observed that "its history, a combination of facts and folklore [established it as] the tangible image of political freedom."

As noted, the governing Assembly of the Province of Pennsylvania commenced building the State House (Independence Hall) in Philadelphia in 1732. The attenuated project included a brick tower on the south side, crowned with a wooden steeple completed early in 1751. The bell that was hung in it could not be heard everywhere in the burgeoning city or in nearby rural areas, so the superintendents Isaac Norris, Thomas Leech, and Edward Warner were authorized to obtain a "good Bell of about two thousand pounds weight" to replace it. At the beginning of November they wrote to Robert Charles, the colony's London agent, instructing him to

> Let the Bell be cast by the best Workmen & examined carefully before it is Shipped with the following words well shaped in large letters round in vizt. "By order of the Assembly of the Province of Pensylvania [*sic*] for the State house in the City of Philadelphia 1752" and Underneath "Proclaim Liberty thro' all the Land to all the Inhabitants thereof. Levit[icus] XXV.10"

The Old Testament passage relating to the Jewish law of Jubilee—the 50th year in a cycle when all bondslaves were set free and all debts were cancelled—seems to have been Norris' idea. A member of the Religious Society of Friends (Quakers), he wanted the bell to bear "a Bible inscription that would reflect the inspirations of freedom-loving members of the colony." Since the restoration of Britain's Stuart monarchy in 1660, and the consequent reascendance of the state church—the Church of England—the Quakers, more than most

other Nonconformist denominations, had suffered discrimination, not to say persecution. The freedom they enjoyed in the New World following King Charles II's 1681 land grant to William Penn was reason to "proclaim liberty." One writer comments that the selected scripture was "particularly apt [because] Penn's charter, which became Pennsylvania's constitution, spoke of personal and religious freedom, Native American rights, and the rights of citizens to be part of the process of enacting laws."

Anyway, the bell was to be delivered in Philadelphia before the planned removal of the scaffolding around the steeple at the end of summer 1752. Robert Charles commissioned master founder Thomas Lester of the Whitechapel Foundry, Britain's oldest manufacturing company. After an 11-week Atlantic crossing on the *Hibernia*, the bell reached Philadelphia in good condition late in August 1752. Before it was lifted to the steeple, it was thought prudent to test it on the ground. Just as well. In Norris' words: "I had the mortification to hear that it was cracked by a stroke of the clapper without any further violence."

The now-useless bell was put into the hands of two "ingenious workmen" John Pass and John Stow, to be broken up and recast. Little is known of the pair; the former was a Philadelphia-born brass founder, the latter a native of Malta with experience in iron founding. They recast the bell, adding more copper to the alloy because (stating the obvious) they announced that Lester's bell was "too brittle." In March 1753 the replacement was successfully tested before being hung in the State House steeple. While it was loud enough, not all Philadelphians appreciated its tone—a fault that was attributed, ironically, to an excess of copper in its composition. Norris recorded that the local bell makers "were so teized [*sic*] by the witicisms [*sic*] of the Town that they . . . will be very soon ready to make a second essay."

Pass and Stow, asked to recast their bell, completed the work in June 1753. It was considered adequate, but not by all. Norris wrote to Robert Charles: "We got our Bell new cast here and it has been used some time but tho [*sic*] some are of opinion it will do, I Own I do not like it." He suggested that it should be broken up and the metal returned to the Whitechapel Foundry for yet another recasting, and negotiations were opened with Thomas Lester. In March 1754, Charles, on the Assembly's authority, ordered a completely new bell from the Whitechapel Foundry. The Assembly decided to pay for the new bell, although it sounded no better than the one recast by Pass and Stow. The latter remained in the steeple, to be rung for special events, while the new bell was hung in a cupola and used to ring the time.

In October 1777, British troops occupied Philadelphia. Because any bells remaining in the city were in danger of being melted down to be recast as cannon, all were spirited away. For almost a year the State House bell was hidden under the floorboards of the Zion Reformed Church in Allentown, Pennsylvania. When it was returned to Philadelphia after the British retreat in summer 1778, the wooden structure of the State House steeple was in a parlous

state; indeed, it had been for some time. The bell was rehung temporarily, but later, when the dangerously rotting steeple had to be demolished, it was lowered into the upper level of the tower, which was then covered with a low-pitched roof.

In 1828, architect William Strickland replaced the steeple. A new bell, weighing twice as much, was installed because the original one had cracked—or at least shown signs of cracking. It probably remained in the tower. But the new bell soon suffered the same fate as the first. There are contradictory stories—some historical claims supported in part by evidence, some much more appealing romantic myths—about the causes of the cracking, and about exactly when it happened. One version is that it cracked in 1832, while pealing in celebration of Washington's birthday; at the other end of the emotional spectrum is that it happened when the bell was tolling on the death of Chief Justice John Marshall in July 1835. Neither is supported by documentary evidence. Several newspapers reported that it tolled in April 1841 at the passing of President William Harrison, and it is clear that the city fathers proposed to ring it on Washington's birthday in 1846. Because a hairline fissure was visible William Eckel, the superintendent of the State House, authorized its repair. On February 26, *The Philadelphia Public Ledger* reported,

> The old Independence Bell rang its last clear note on Monday last . . . and now hangs in the great city steeple irreparably cracked and dumb. It had been cracked before but was set in order of that day by having the edges of the fracture filed so as not to vibrate against each other. . . . It gave out clear notes and loud, and appeared to be in excellent condition until noon, when it received a sort of compound fracture in a zig-zag direction through one of its sides which put it completely out of tune and left it a mere wreck of what it was. The "zig-zag" fracture mentioned above extended the crack from the top of the machined slot (the end of the original crack) to the top the bell. It was now beyond repair.

A CHANGING ROLE

Riley wrote that "it is difficult to find the exact beginnings of . . . veneration for the Liberty Bell," noting that "even after Independence Hall began its evolution as a patriotic shrine, [the bell], rarely mentioned earlier, still received no notice." Indeed, he says,

> Little, if any, thought was given it as a patriotic relic. But patriotism was the next logical step. In the first half of the 19th century the bell became the subject of legendary tales recited in prose and poetry; they have found their way into children's textbooks. . . . Accepted by all classes of people, these legends have done more than anything else to make the bell an object of veneration.[10]

Historians trace Liberty Bell folklore to George Lippard's fictional piece "Fourth of July, 1776" (popularly known as "Ring Grandfather Ring") that

first appeared in Philadelphia's *Saturday Courier Magazine* in January 1849; it was republished in *Legends of the American Revolution* in 1876. Populist historian Benson J. Lossing assisted the transformation from legend to history before 1850 and the prolific Joel Tyler Headley completed the metamorphosis, with variations by 1854. Riley commented that the story "found poetic expression . . . [once] the first poem [was] written, it found its way into school readers and into collections of patriotic verse."

With the literary excitation of popular interest, the bell itself was brought out of hiding. In 1852 it was placed on a temporary wooden base in Independence Hall's Assembly Room; 2 years later "a massive pedestal [with] thirteen sides ornamented by Roman *fasces*, liberty caps, and festooned flags" replaced the platform. As the Centennial drew near the bell was moved to the hallway and mounted on the wooden frame that had long supported it in the tower. Remaining in Independence Hall, it was moved three more times: first to the Supreme Court Chamber; then suspended in the tower room; in 1895 it was returned to the Assembly Room in a glass case. The case was removed in 1915, and the bell was exhibited on a movable frame and pedestal, so that visitors were able to touch it. Meanwhile, its increasing significance as a national symbol generated popular demand for it to be transported around the United States so that more people could see it. In winter 1885 it was taken to New Orleans and through the South; trips to Chicago in 1893, Atlanta in 1895, Charleston in 1902, Boston in 1903, and San Francisco in 1915 followed. All this moving served to enlarge the crack in the bell until its condition had so dangerously deteriorated that the practice had to be stopped.

To celebrate the Bicentennial, the bell was given its own million-dollar glass and steel pavilion, designed by Mitchell/Giurgola Associates. In 2003 it was moved again, to the $13 million Liberty Bell Center, designed by Bohlin Cywnski Jackson as part of a $314 million overhaul of Independence Mall.

The Liberty Bell has always been owned by the City of Philadelphia. At first an icon of the religious freedom enjoyed by the Quakers, its intended purpose was to call together the governing Assembly of the Province of Pennsylvania and to summon the citizenry for special events or announcements. In fact, in 1772 people living near the State House formally complained that they were "incommoded and distressed [by the frequent] ringing of the great Bell in the steeple." But, as has been observed elsewhere in this book, the meanings of icons are in the minds of the people. Others have noted that "as decades passed, the bell became a different symbol." First referred to as the "Old State House Bell," the bell became the "Bell of the Revolution" or "Old Independence." One writer remarks that once it became established in the collective mythology, retrospective tradition held that "it continued tolling for the First Continental Congress in 1774, the Battle of Lexington and Concord in 1775 and its most resonant tolling was on 8 July 1776, when it summoned the citizenry for the reading of the Declaration of Independence." Those myths were debunked by credible historians as early as 1945.[11]

The Liberty Bell was given its name in 1835 when abolitionists adopted its biblical inscription as the motto of their cause. In the February 1835 issue of the tract, *The Anti-Slavery Record* published by R. G. Williams for the American Anti-Slavery Society, the editor wrote:

> *The Liberty Bell.* Being in Philadelphia a few days since, I was invited after viewing the room in which the Declaration of Independence was signed, to ascend the tower of the State House. . . . On our ascent, we did not fail to examine the celebrated Bell. . . . It is remarkable that the following inscription was on the bell when it was cast. It was considered a sort of prophecy: "proclaim liberty throughout all the land, and to all the inhabitants thereof." May not the emancipationists in Philadelphia hope to live to hear the same bell rung, when liberty shall in fact be proclaimed to all the inhabitants of this favored land? Hitherto . . . its peals have been a mockery, while one sixth of "all inhabitants" are in abject slavery."

On August 28, 1963 Dr. Martin Luther King Jr., in his unforgettable "I have a dream" speech—yet another icon—delivered on the steps of the Lincoln Memorial in Washington, D.C., said in part:

> When we let freedom ring, when we let it ring from every village and every hamlet, from every state and every city, we will be able to speed up that day when all of God's children, black men and white men, Jews and Gentiles, Protestants and Catholics, will be able to join hands and sing in the words of the old negro spiritual, "Free at last! Free at last! Thank God Almighty, we are free at last!"

NOTES

1. Riley, Edward M., Independence National Historic Park, Philadelphia, PA (1956). Introduction. www.nps.gov/history/history/online_books/hh/17/hh17a.htm

2. UNESCO, "Independence Hall," World Heritage List Nomination, 1979, 18.

3. Shackleton, Robert, *The Book of Philadelphia*. Philadelphia: Penn Publishing, 1918, 62, 72.

4. Bowen, Catherine Drinker, "Miracle at Philadelphia," *Futurecasts Online Magazine*, 8(May 2006). www.futurecasts.com

5. Mires, Charlene, *Independence Hall in American Memory*. Philadelphia: University of Pennsylvania, 2002.

6. Stabile, Susan M., *Memory's Daughters: The Material Culture of Remembrance in Eighteenth-Century America*. Ithaca, NY: Cornell University Press, 2004, 229.

7. Greiff, Constance M., *Independence: The Creation of a National Park*. Philadelphia: University of Pennsylvania, 1987. www.ushistory.org/iha/dreams/dreams08.htm

8. Riley, Edward M., "Evolution of a Shrine." www.nps.gov/history/history/online_books/hh/17/hh17g.htm

9. Chu, Jonathon M., "[Review of Mires, *Independence Hall in American Memory*]." *The Historian*, 66(2004).

10. Riley, Edward M., "The Story of a Symbol." www.nps.gov/history/history/online_books/hh/17/hh17h.htm

11. Warren, Charles, "Fourth of July myths," *William and Mary Quarterly*, Third Series, 2(July 1945), 238–272.

FURTHER READING

Armentrout, David, and Patricia Armentrout. *The Constitution*. Vero Beach, FL: Rourke, 2005.

Batchelor, Penelope Hartshorne. "Independence Hall: its Appearance Restored." In Charles E. Peterson, ed. *Building Early America*. Radnor, PA: Chilton, 1976. See also Lee H. Nelson, "Independence Hall: Its Fabric Reinforced." In Charles E. Peterson, ed. *Building Early America*. Radnor, PA: Chilton, 1976.

Beard, Alice, and Francis Rogers. *Old Liberty Bell*. Philadelphia: New York: Frederick A. Stokes, 1942.

Boland, Charles Michael. *Ring in the Jubilee: The Epic of America's Liberty Bell*. Riverside, CT: Chatham, 1973.

Gibson, Deirdre, Mary Whelchel Konieczny, et al. *Cultural Landscape Report Independence Mall*. Denver, CO: National Park Service, 1994.

Hakim, Joy. *From Colonies to Country: 1710-1791*. New York: Oxford University Press, 1999.

Jackson, J. "How Independence Hall Was Built." *American Institute of Architects Journal* (October 1945), 160–166.

Kimball, David. *Venerable Relic: The Story of the Liberty Bell*. Philadelphia: Eastern National Park and Monument Association, 1989.

Maass, John. "Architecture and Americanism, or, Pastiches of Independence Hall." *Historic Preservation*, 22(April 1970), 17–25.

Mires, Charlene. *Independence Hall in American Memory*. Philadelphia: University of Pennsylvania, 2002.

Nash, Gary B. *Landmarks of the American Revolution*. New York: Oxford University Press, 2003.

National Park Service. *Independence: A Guide to Independence National Historical Park*. Washington, D.C.: The Service, 1982.

Nelson, Lee H. "Restoration in Independence Hall: A Continuum of Historic Preservation." *Antiques*, 90(July 1966), 64–68.

Olin, Laurie. "The Remaking of Independence Mall." *Places*, 13(Fall 2000), 53–59. See also George L. Claflen, Jr., "Framing Independence Hall," *Places*, 13(Fall 2000), 60–69.

Riley, Edward M. *The Story of Independence Hall*. Gettysburg, PA: Thomas, 1990.
Shackleton, Robert. *The Book of Philadelphia*, Philadelphia: Penn Publishing, 1918.
Weigley, Russell F., ed. *Philadelphia: A 300-year History*. New York: Norton, 1982.

INTERNET SOURCES

Independence National Historical Park home page. www.nps.gov/inde
Independence National Historical Park home page. www.nps.gov/inde/liberty-bell
.html
U.S. History: Liberty Bell home page. www.ushistory.org/libertybell/index.html